·AN
international

AN
international

Survey

OF RECENT

Painting

AND *Sculpture*

THE MUSEUM OF MODERN ART

NEW YORK

1984

Published on the
occasion of the exhibition
*An International
Survey of Recent Painting
and Sculpture,*
May 17–August 19, 1984,
The Museum of
Modern Art, New York

The exhibition
and publication were
made possible
by a grant from AT&T
and by additional support
from the National Endowment
for the Arts

Edited by
Harriet Schoenholz Bee
and Jane Fluegel
Designed by
Stephen Doyle and Thomas Kluepfel
Production by Nan Jernigan
Cover photography by Neil Selkirk
Composition by
Cyber-Graphics, Inc., New York
Printed by Baronet Litho,
Johnstown, New York
Cover and vellum insert printed by
Colorcraft Lithographers, New York
Bound by
Sendor Bindery, New York

The Museum of Modern Art
11 West 53 Street
New York, New York 10019
Printed in
the United States
of America

An International Survey of Recent Painting and Sculpture

Kynaston McShine

Contents

Magdalena Abakanowicz
Alice Adams
Mac Adams
Robert Adrian X
Nicholas Africano
Jean Michel Alberola
Peter Alexander
Davida Allen
Gregory Amenoff
Giovanni Anselmo
Ida Applebroog
Siah Armajani
Armando
Christian Ludwig Attersee
Frank Auerbach
Miquel Barceló
Georg Baselitz
Jean Michel Basquiat
Jake Berthot
Jean Charles Blais
Erwin Bohatsch
Peter Bömmels
Peter Booth
Jonathan Borofsky
Richard Bosman
Paul Boston
Troy Brauntuch
Roger Brown
Chris Burden

Scott Burton
Elizabeth Butterworth
Michael Byron
Miriam Cahn
Luciano Castelli
Marc Camille Chaimowicz
Louisa Chase
Sandro Chia
Francesco Clemente
Tony Coleing
Jan Commandeur
Stephen Cox
Tony Cragg
Enzo Cucchi
Walter Dahn
Richard Deacon
Nicola De Maria
Gianni Dessì
David Deutsch
Antonio Dias
Martin Disler
Jiři Georg Dokoupil
Ger van Elk
Donald Evans
Luciano Fabro
Rafael Ferrer
Rainer Fetting
R. M. Fischer
Eric Fischl

Peter Fischli
Joel Fisher
Barry Flanagan
Alphons Freijmuth
William Garbe
Jedd Garet
Dana Garrett
General Idea
Steve Gianakos
Patrice Giorda
Jack Goldstein
Antony Gormley
Toni Grand
Jene Highstein
Howard Hodgkin
K. H. Hödicke
Hans van Hoek
Bryan Hunt
Jörg Immendorff
Mark Innerst
Oliver Jackson
Yvonne Jacquette
Neil Jenney
Bill Jensen
Roberto Juarez
Anish Kapoor
Mel Kendrick
Jon Kessler
Anselm Kiefer

Per Kirkeby
Bernd Koberling
Vitaly Komar
Robert Kushner
Cheryl Laemmle
Bertrand Lavier
Christopher LeBrun
Jean Le Gac
Robert Longo
Nino Longobardi
Markus Lüpertz
Kim MacConnel
Rory McEwen
Bruce McLean
Carlo Maria Mariani
Alexander Melamid
Helmut Middendorf
Malcolm Morley
Robert Moskowitz
Elizabeth Murray
David Nash
George Negroponte
Gustavo Ojeda
Tom Otterness
Mimmo Paladino
Blinky Palermo
Giulio Paolini
Mike Parr
Ed Paschke

A. R. Penck
Giuseppe Penone
Emmanuel Pereire
Judy Pfaff
Sigmar Polke
Katherine Porter
Kenneth Price
Martin Puryear
Markus Raetz
Carl Fredrik Reuterswärd
Gerhard Richter
Bruce Robbins
Susan Rothenberg
Reiner Ruthenbeck
David Salle
Salomé
Patrick Saytour
Italo Scanga
Hubert Schmalix
Julian Schnabel
Andreas Schulze
Sean Scully
Joel Shapiro
Alexis Smith
Ned Smyth
Robert Stackhouse
Gary Stephan
Thomas Stimm
Donald Sultan

Mark Tansey
Riduan Tomkins
David True
Toon Verhoef
Emo Verkerk
Didier Vermeiren
Claude Viallat
Darío Villalba
John Walker
David Weiss
William T. Wiley
Thornton Willis
Christopher Wilmarth
Robert Wilson
Terry Winters
Bill Woodrow
Robert Zakanitch
Bernd Zimmer
Gilberto Zorio
Zush
Michael Zwack

PREFACE

An International Survey of Recent Painting and Sculpture, which this publication accompanies and documents, is the first exhibition in the Museum's new, expanded facilities. It is a most appropriate choice because it reaffirms two basic tenets of this Museum since its founding: the conviction that art transcends national boundaries, and a deep, continuing commitment to art of the present and future, as well as the past.

On behalf of the trustees and staff of the Museum, I wish to express our deep appreciation to AT&T, which has most generously provided funds to make this exhibition and publication possible. This major grant to an exhibition of very recent works represents an important example of enlightened corporate sponsorship. AT&T clearly recognizes that experiment and innovation, so highly prized in business and industry, must be equally valued and supported in the arts. We owe very warm thanks to Charles L. Brown, Chairman of the Board and Chief Executive Officer of AT&T; Edward M. Block, Vice President for Public Relations; James L. Brunson, Corporate Vice President for Public Relations; members of their staffs; and many other representatives of AT&T. We appreciate not only their active interest and unstinting cooperation but also their patience with special problems inherent in planning a large international loan exhibition to coincide with reopening the expanded Museum.

Our gratitude is also due the National Endowment for the Arts which provided additional support for this exhibition. This grant exemplifies the Endowment's long and distinguished record of furthering contemporary art and contributing importantly to the vitality of the arts in this country.

The individual most responsible for this ambitious undertaking is Kynaston McShine, Senior Curator in the Department of Painting and Sculpture. As director of the exhibition, he has dedicated great effort and thought to seeking out stimulating new work by artists all over the world. The result reflects not only his eye and his judgment but also his conviction, courage, and integrity. In his research, in the organization and installation of the exhibition, and in the preparation of this publication, he has greatly benefited from close collaboration with Monique Beudert of the Department of Painting and Sculpture, who deserves particular thanks. They have both had the devoted support of the staff of the Museum, which complemented its customary professionalism with special enthusiasm and determination in coping with unusual demands imposed by the reopening of the Museum. Since this exhibition inaugurated the newly designated International Council Galleries, it is also appropriate here to thank The International Council of The Museum of Modern Art for its continuing and generous support.

Finally, we are, as always, deeply grateful to the lenders without whose generosity no exhibition like this would be possible. Above all, we thank and honor the artists whose creativity and vision we celebrate in this exhibition.

RICHARD E. OLDENBURG

An International Survey of Recent Painting and Sculpture

celebrates the opening of the newly expanded Museum of Modern Art. Featuring work of the last decade by an international group of artists, it is the first contemporary survey of painting and sculpture organized by the Museum in some years. Given the diversity of the current international art scene, the choices were difficult. It is one thing to judge the past but to select the present is another matter. Nevertheless, 195 works by 165 artists from 17 countries were assembled in an attempt to report on current artistic endeavor, demonstrate some of the concerns that transcend international boundaries, and investigate the traditions that continue to have validity for today's artistic imagination. ◆ There are many considerations in planning a show of this type. Because the Museum is simultaneously reinstalling its collection galleries, this seemed the occasion for showing only works on loan. Although some of the artists selected are represented in the Museum collection, the emphasis has been placed on introducing new artists and showing their work in a context that will, one hopes, create a better understanding of it.

The exhibition, like the Museum itself, is international in scope. Except in a very few museums committed to the presentation of new work in this country, current art from abroad is seldom seen in any full and meaningful context. The United States has few large group exhibitions of international artists. Although commercial galleries have organized many exhibitions of foreign artists, only a small number have in the end been seen here (this is especially true of sculptors, because of the cost of shipping their work). In this regard Europeans have had a distinct advantage over Americans. The broad international surveys such as Documenta and the Venice Biennale, as well as the considerable activity of museums in France, Germany, Great Britain, Netherlands, Switzerland, and other countries, have enabled Europeans to see in greater depth the new developments in contemporary art, including those from the United States. Comparable expositions of recent art in this country have focused primarily on artists of the United States or a limited selection of Europeans. Unfortunately, this has led to an almost excessive familiarity with a few artists' careers as well as to a certain imbalance between artists' reputations, favoring some and ignoring the true quality of others who may perhaps be equally or even more deserving of attention. And sometimes the public, following the media, confuses reading about contemporary art with looking at it. Thus it is the intent of this exhibition to enable The Museum of Modern Art's public to see a broad range of current art from around the world in a sympathetic context.

The process of selection cannot help but be a personal one. Some artists appear by what seems an unassailable right, some because they seem to have been overlooked in the past. Whatever the criteria, however, the selection was made after a careful and thoughtful scrutiny of a great deal of contemporary art. Choices were made without fear of fashion, without fear of passion or of seriousness.

This exhibition is open-ended. It has not sought to identify or concentrate on any national characteristics. The concerns expressed in the work are basic, universal. Some address problems inherent in making art, paying particular attention to the painterly or the sculptural or to the adoption of unique techniques and mediums. Many reveal an abiding reverence for color and form and a preoccupation with drawing. Beyond technique, the most striking quality is the personal aspect of much of the work. The personal takes various forms: from the straightforwardly autobiographical, that is, the direct representation of the artist in a self-portrait, to the mythic, the artist employing ancient myths and metaphors to present his personal vision. The artist as creator, dreamer, storyteller, narcissist, as the instrument of divine inspiration, is represented in many works. Several artists have a strong awareness of art history, risking allusion, approaching mimesis.

The artist's situation, his role in a complex society, is a repeated concern. Urban imagery is used both straightforwardly and as a metaphor for decadence and decay. Such urban concerns, melancholy as they are, are often a component of broader and more urgent political issues that transcend geographical boundaries and confront a larger society. Although some artists express those concerns directly in their work, others dream of the exotic as a refuge from reality. They seek a more colorful adventure as a romantic antidote to the banal everyday life of Berlin, New York, Paris, or Los Angeles.

The alternative approach is a more poetic, interiorized, even hermetic attitude toward art, a search for the elemental in both meaning and form. The primordial is reinvested with meaning. Collective history and shared fictions are revised and revivified. These interests can lead to concrete, specific imagery, but also to abstraction, employing elementary forms to convey complex thoughts and emotions. Although abstraction can result in a more romantic, private style of painting—and on occasion to the decorative—it is frequently rooted in nature. Inspiration ranges from underwater life to the structure of flora and fauna to the effects of light.

If several of these works invoking nature provide the expected quiet, delicate contemplation, others exploit the natural for grandiloquence.

Although some artists' flaunting of the large gesture connotes violence, others use gestural energy to convey a certain style or attitude. One of the currents running through much of today's art, participating in this "stylishness," is a sense of irony, a mordant humor. Seemingly detached, it is as pertinent, as valid an expression of concern about contemporary life as a more open or direct gesture.

This exhibition does not encompass mediums other than painting and sculpture. However one cannot help but register the current tendency of painters and sculptors to cross the border into other disciplines such as photography, film, video, and even architecture. While these "crossovers" have become expected in recent years, less familiar to a general audience is the attraction to music and performance. Represented here are several artists active not only in painting and sculpture but also in performance art. Inevitably, some of their theatrical concerns present themselves in their work, most often in a narrative or autobiographical form.

If one were to think of this exhibition and the whole of contemporary art as an arena, the sphere of action would be not only personal conflict but also the larger contradictions of contemporary culture. Yet there is a liveliness in the current international art scene that stems from the freedom and diversity enjoyed by artists today. There is an energy in the work of artists who come not only from Europe and the United States but also from Australia, Brazil, Canada, and other nations, that makes an international exhibition such as this exciting. The artists demonstrate an integrity, imagination, and ambition that affirm the health of their profession. Although the exhibition itself has been limited, in most instances, to a single work per artist, this catalog is intended to be a lively Baedeker serving as a more complete compendium of each artist's accomplishments.

An International Survey of Recent Painting and Sculpture is meant to provide a framework, an eye, a lens for the scrutiny of current artistic ambitions. Those who see this exhibition will, one trusts, understand that art is about looking and not about reading or listening. It is the intent of the exhibition to provide intellectual and visual pleasure—and to encourage everyone to be in favor of the art of our time.

The Survey

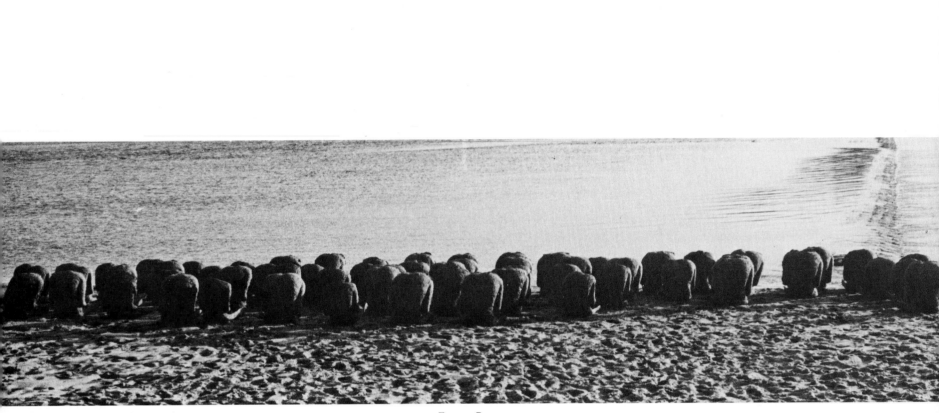

EIGHTY BACKS
At the Wisla River, Poland, 1981

MAGDALENA ABAKANOWICZ
Born Falenty, Poland, 1930,
lives in Warsaw, Poland

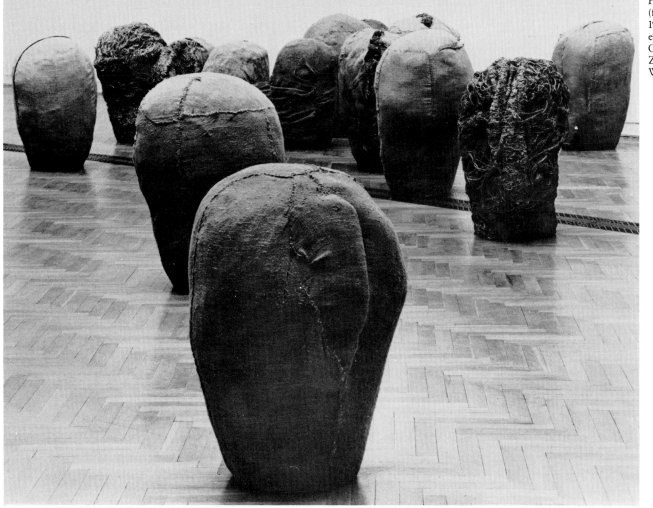

HEADS
(from Alterations cycle)
1975. Burlap and thread, fifteen pieces,
each approx. 42 in (106.6 cm) high.
Collection the artist. Installation at
Zacheta State Collection,
Warsaw, Poland, 1975

MONADS
1982. Four sewn burlap forms,
each approx. 23⅝ in x 23⅝ in x 8 ft 2⅜ in
(60 x 60 x 250 cm). Galerie Alice Pauli,
Lausanne, Switzerland. Installation at
Nationalgalerie, Berlin, 1982

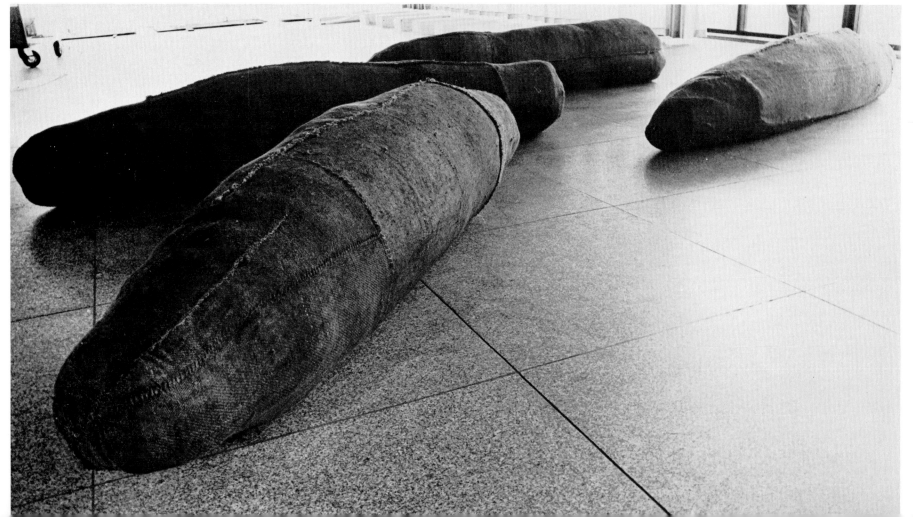

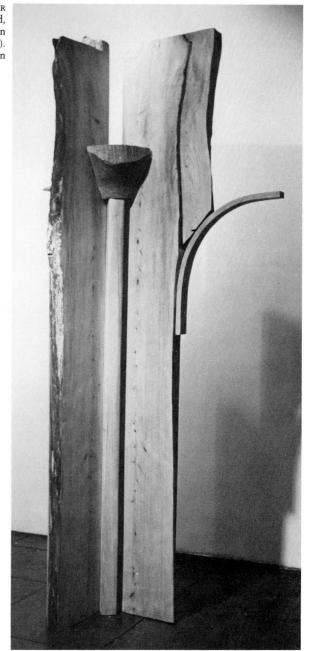

One-half Door and Corner
1981. Wood,
8 ft x 36 in x 22 in
(243.8 x 91.4 x 55.9 cm).
Private collection

ALICE ADAMS · Born New York, 1930, lives in New York

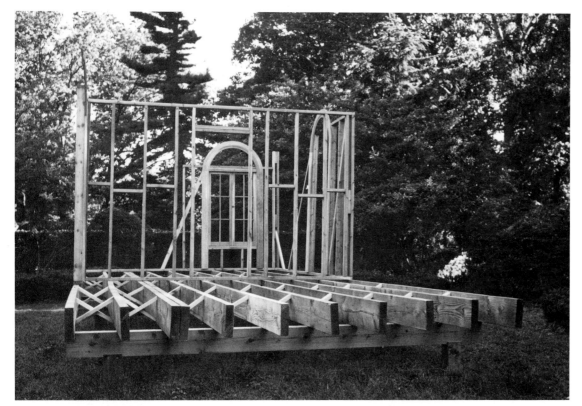

Adams' House
1977. Wood, 10 x 12 x 28 ft
(304.8 x 365.8 x 853.4 cm).
Installation in
Wood exhibition at
Nassau County Museum
of Fine Arts,
Roslyn, New York, 1977

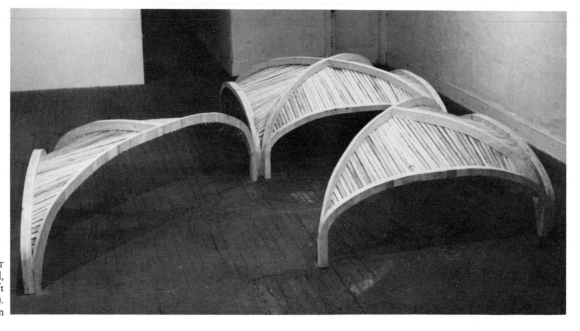

Large Vault
1975. Wood,
54 in x 15 ft x 15 ft
(137.2 x 457.2 x 457.2 cm).
Private collection

Right
Three Arches
1979. Oak and cypress,
8 ft x 9 ft 7 in x 7 ft
(243.8 x 292.1 x 213.4 cm).
Hal Bromm Gallery,
New York

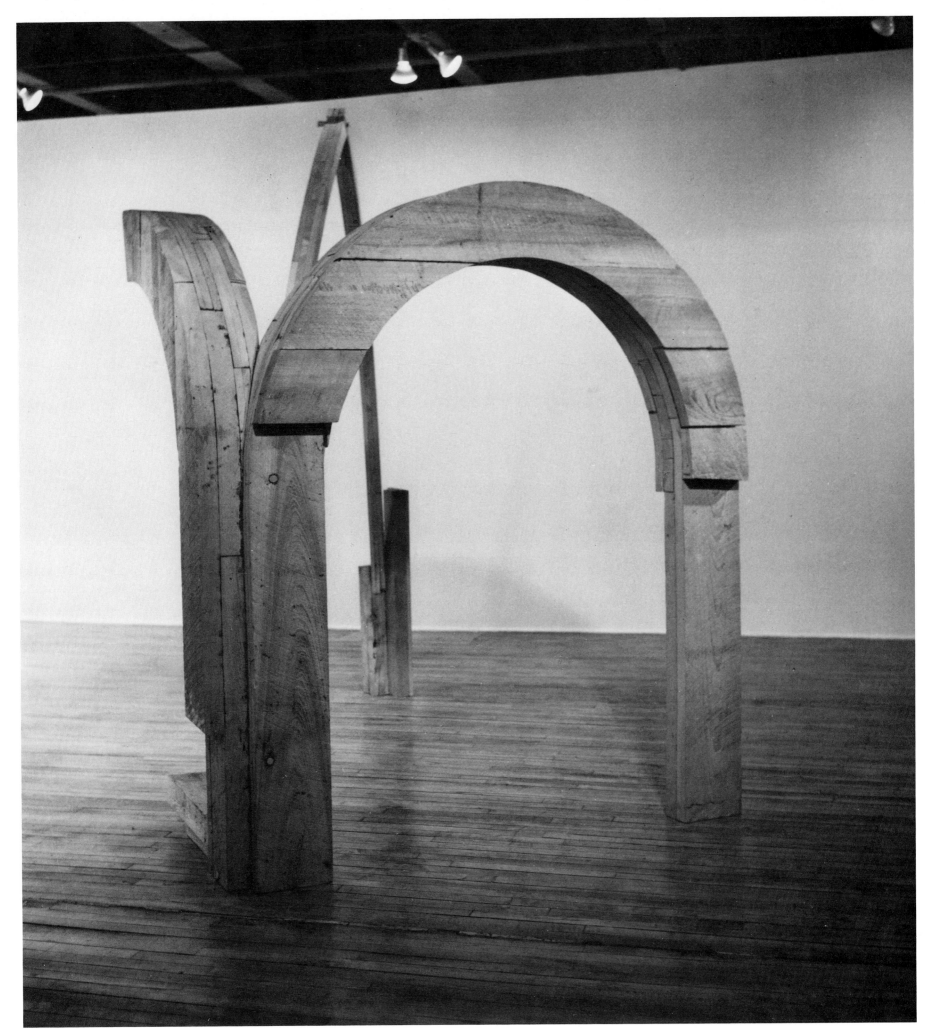

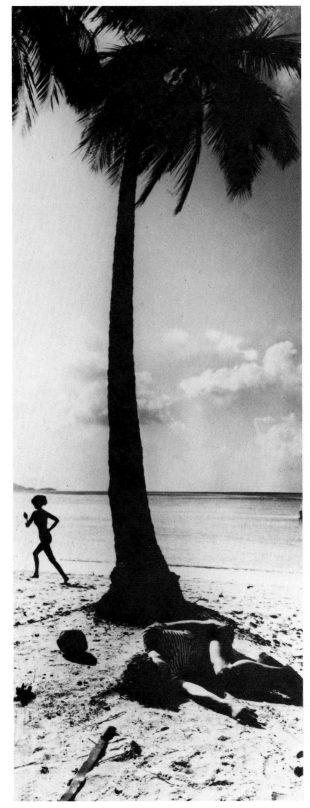

THE PALM
1978. Black-and-white photograph,
6 ft x 30 in (182.9 x 76.2 cm).
Collection the artist

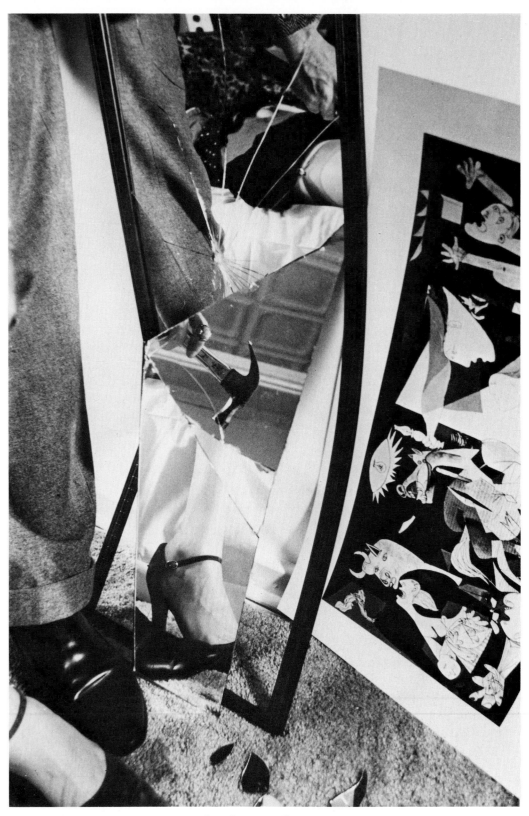

STILL LIFE WITH *GUERNICA*
1977. Black-and-white photograph,
40 x 30 in (101.6 x 76.2 cm).
Collection the artist

MAC ADAMS · Born South Wales, Great Britain, 1943, lives in New York

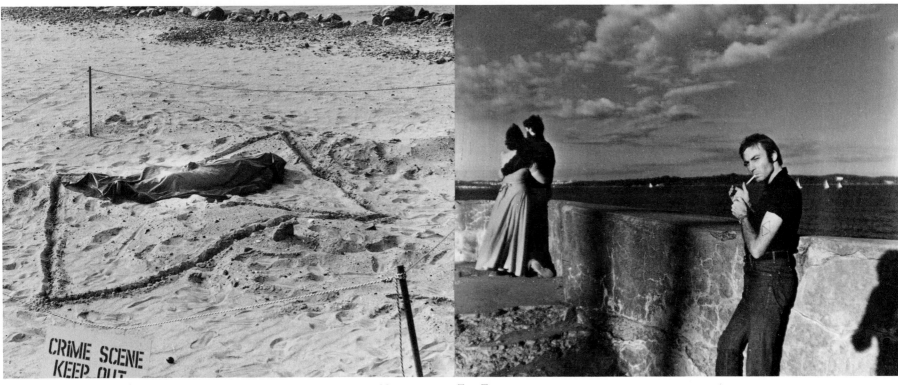

MYSTERY OF THE TWO TRIANGLES
1978. Two black-and-white photographs
overall 30 in x 6 ft 8 in (76.2 x 203.2 cm).
Collection Morton G. Neumann, Chicago, Illinois

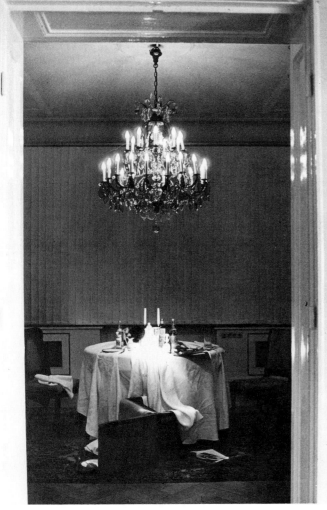

THE GLASS CHANDELIER
1981. Mixed materials,
approx. 10 x 12 x 15 ft (304.8 x 365.8 x 457.2 cm).
Installation at DAAD Galerie,
Berlin, 1981

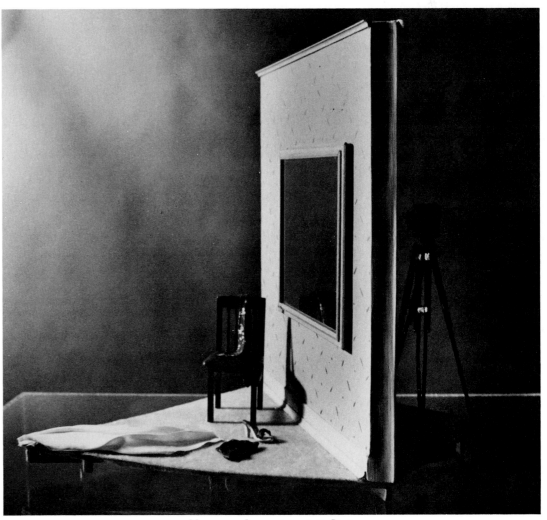

MODEL FOR LOOKING THROUGH BLUE
1981. Mixed materials, 12 x 12 x 15 in
(30.5 x 30.5 x 38.1 cm). Collection the artist.
Courtesy Friedus/Ordover Gallery, New York.
Model of sculpture constructed for the exhibition

9.

8.

3.

11.

10.

6.

18.

13.

23.

22.

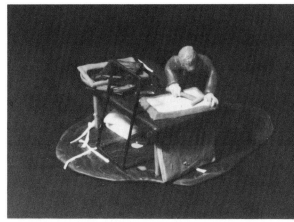

16.

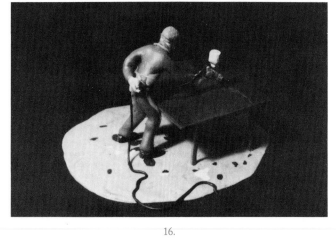

7.

24.

14.

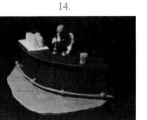

2.

15.

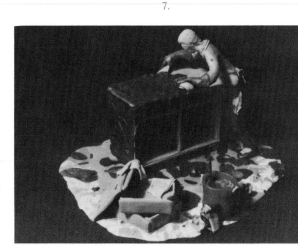

12.

19.

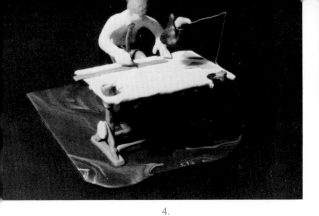

4.

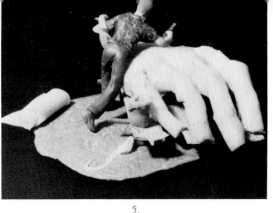

5.

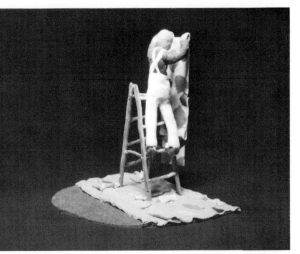

20.

1.

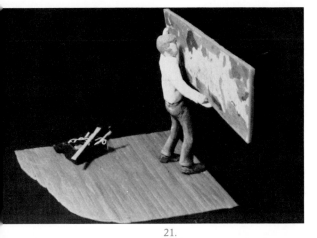

21.

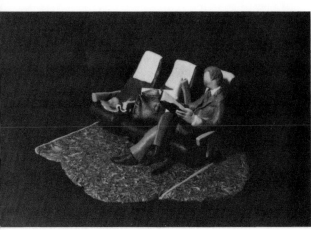

17.

24 Jobs
1979. Colored modeling clay, each figure 3½ in (9 cm) high.
Museum Moderner Kunst, Vienna, Austria

1. *Theater Usher, Royal Alexandria Theater*
2. *Hotel Desk Clerk, Albion Hotel*
3. *Packer and Shipper, ? Paint Co.*
4. *Display Designer, Vincent De Vita Enterprises*
5. *Exhibition Sculptor, Ontario Department of Lands and Forests*
6. *Fruit Picker*
7. *Picture Framer, Lord's Picture Framing*
8. *Computer Clerk, Canadian Pacific Railway (Car Accounting)*
9. *Laborer, Toronto Parks Department*
10. *Film Extra, "Hudson's Bay" Television Series, Etc.*
11. *Scenic Artist, Display Services, ABC Television*
12. *Baths Attendant, Fulham Borough Council Public Baths*
13. *Art-school Model, Ontario College of Art, Putney Art School*
14. *Display Artist, Harris Display*
15. *Barman, The Bull and Star, The Admiral, The Quebec*
16. *Spray Painter, Spalding's Sporting Goods*
17. *Exhibition Officer/Designer, National Coal Board*
18. *Art Mover, Jon Holt Fine-Art Transport*
19. *Furniture Restorer*
20. *Painter and Decorator, Brian Pollard*
21. *Gallery Assistant, Waddington's Gallery*
22. *Fake Painter, Portobello Bookstore*
23. *Managing Partner, Fulham Artisans*
24. *Houseman*

Above right
GREAT MOMENTS IN MODERN ART NO. 1 (YVES KLEIN, THE
PAINTER OF SPACE, LAUNCHES HIMSELF INTO THE VOID)
1982. Colored modeling clay, approx. 5⅛ in (13 cm) high.
Collection Dr. Horst Köhn, Vienna, Austria

ROBERT ADRIAN X
Born Toronto, Ontario, Canada, 1935,
lives in Vienna, Austria

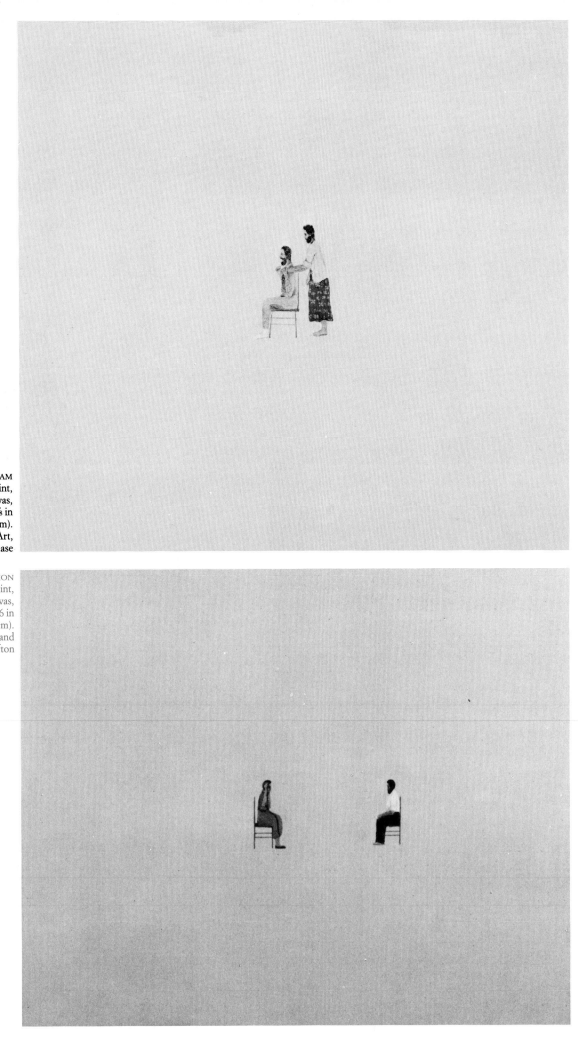

NICHOLAS AFRICANO
Born Kankakee, Illinois, 1948,
lives in Normal, Illinois

THE SCREAM
1976. Synthetic polymer paint,
oil, and wax on canvas,
6 ft 1⅞ in x 6 ft 10⅝ in
(187.5 x 209.7 cm).
The Museum of Modern Art,
New York. Purchase

THE CRUEL DISCUSSION
1977. Synthetic polymer paint,
wax, and oil on canvas,
6 ft 1 in x 7 ft 6 in
(185.4 x 228.6 cm).
Collection Loretta and
Robert K. Lifton

22

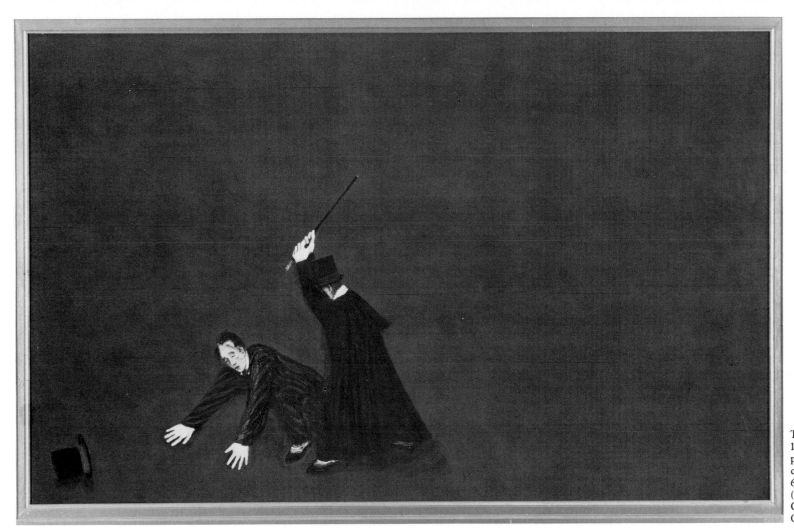

THE CAREW MURDER
1982. Synthetic polymer
paint, oil, and wax on
canvas, with wood frame,
67 in x 8 ft 7½ in
(170.2 x 262.9 cm).
Galerie Rudolf Zwirner,
Cologne, West Germany

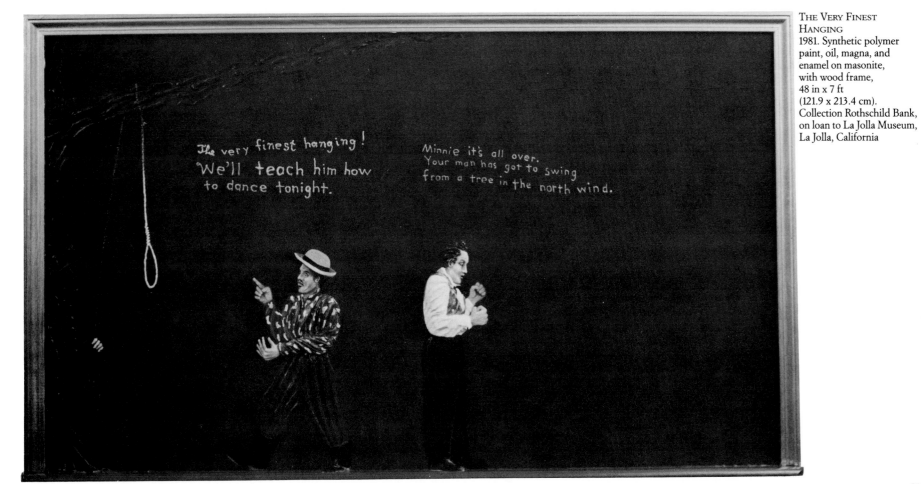

THE VERY FINEST
HANGING
1981. Synthetic polymer
paint, oil, magna, and
enamel on masonite,
with wood frame,
48 in x 7 ft
(121.9 x 213.4 cm).
Collection Rothschild Bank,
on loan to La Jolla Museum,
La Jolla, California

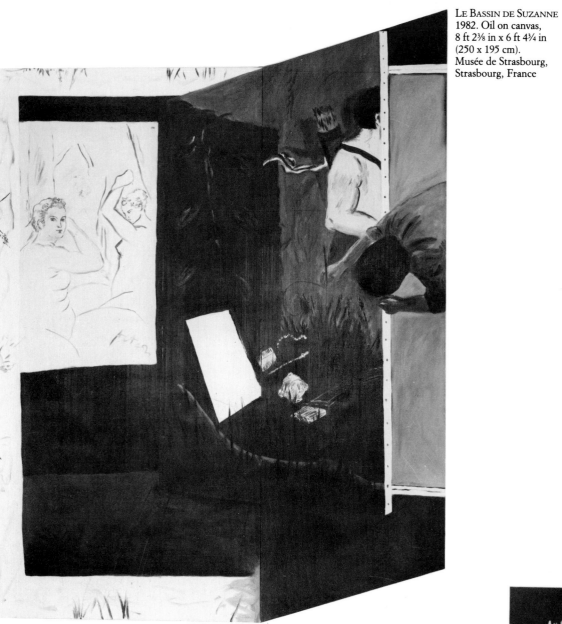

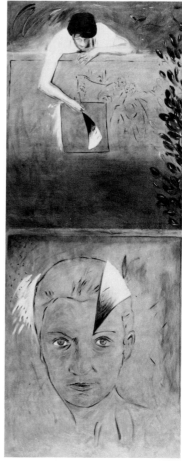

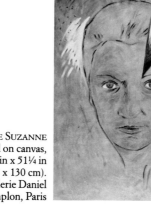

LE BASSIN DE SUZANNE
1982. Oil on canvas,
8 ft 2⅜ in x 6 ft 4¾ in
(250 x 195 cm).
Musée de Strasbourg,
Strasbourg, France

LA NUIT DE SUZANNE
1982. Oil on canvas,
10 ft 7½ in x 51¼ in
(324 x 130 cm).
Galerie Daniel
Templon, Paris

ACTEON SOUS LE JET
1983. Oil on canvas,
6 ft 4¾ in x 8 ft 6⅜ in (195 x 260 cm).
Collection Daniel Templon, Paris

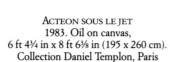

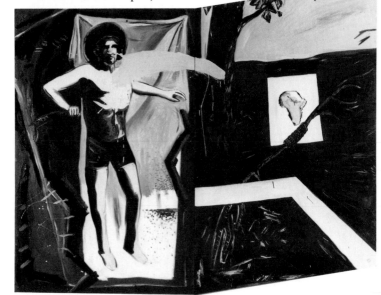

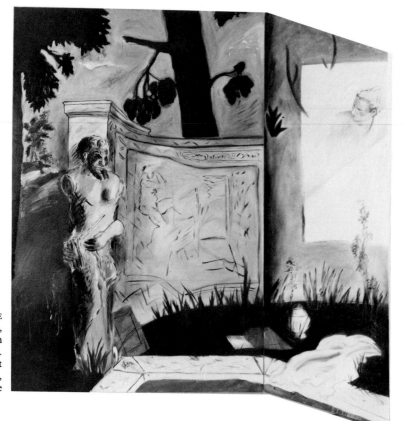

L'ABSENCE DE SUZANNE
1982. Oil on canvas,
6 ft 4¾ in x 6 ft 4¾ in
(195 x 195 cm).
Fond National d'Art
Contemporain,
Sélestat, France

Jean Michel Alberola
Born Saïda, Algeria, 1953,
lives in Le Havre, France

L'Allegorie de Suzanne
1982. Oil on canvas,
6 ft 4¾ in x 8 ft 6⅛ in
(195 x 260 cm).
Galerie Bruno Bischofberger,
Zurich, Switzerland

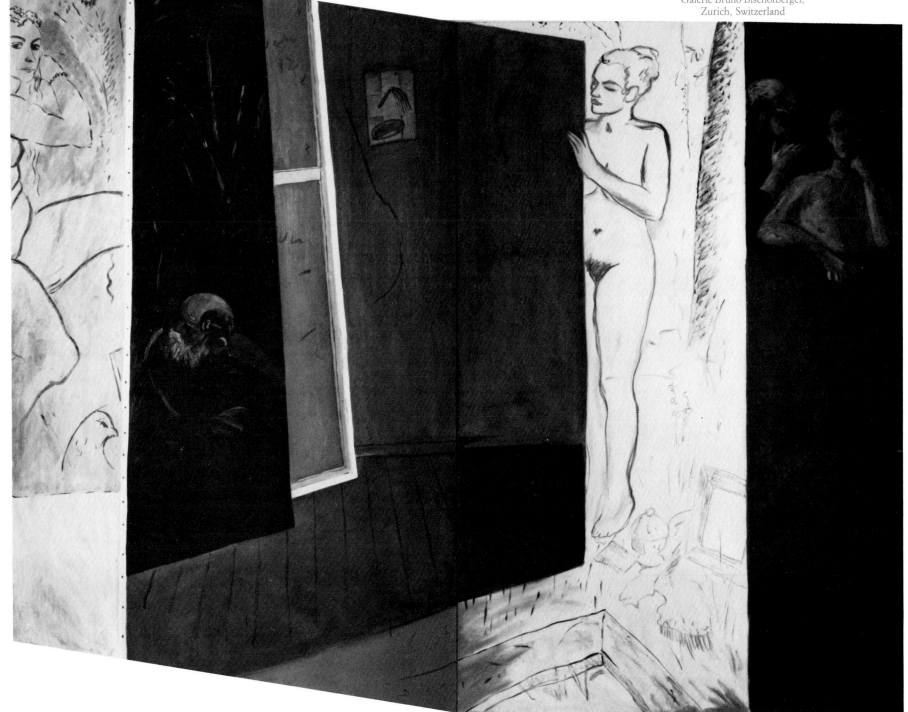

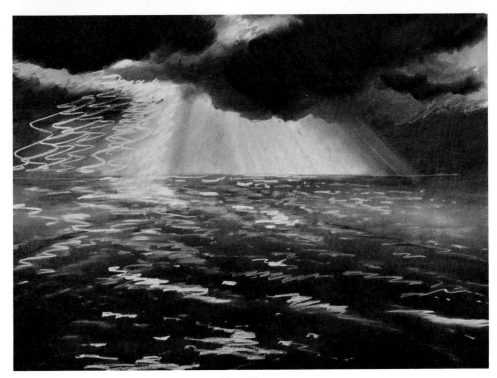

HOLY TOLEDO
1975. Pastel on board,
30 x 40 in (76.2 x 101.6 cm).
Collection Joan and Jack Quinn,
Los Angeles, California

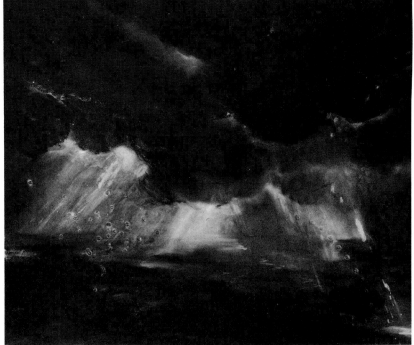

CHULA VISTA
1977. Pastel on paper,
25 x 30 in (63.5 x 76.2 cm).
Collection Jim and Morgan Butler,
Los Angeles, California

DORADO
1982. Synthetic polymer paint
and fabric collage on velvet,
7 ft 10 in x 9 ft 7 in (238.8 x 292.1 cm).
Collection the artist.
Courtesy Charles Cowles Gallery, New York

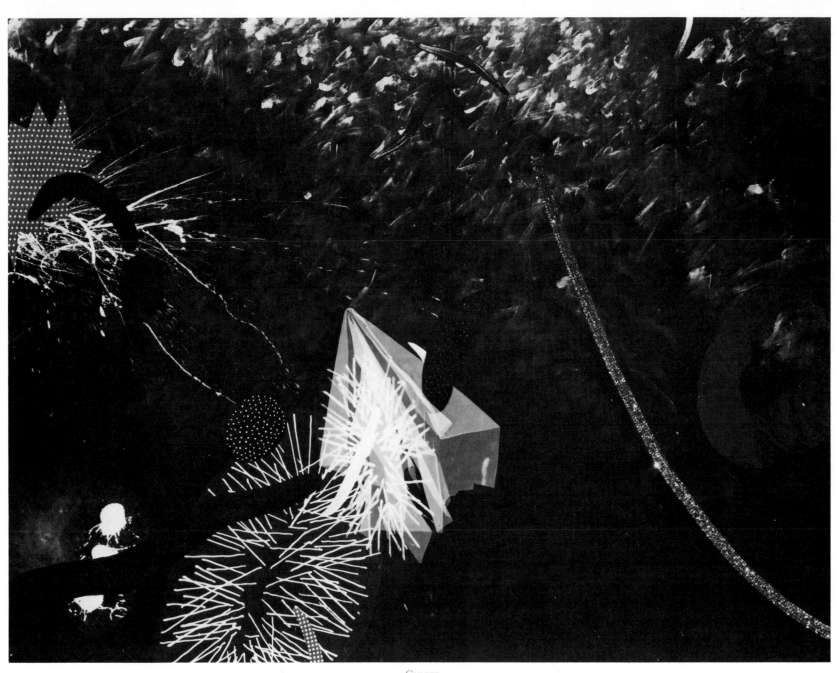

GULPER
1982. Synthetic polymer paint and fabric collage on velvet,
9 ft x 11 ft 10 in (274.3 x 360.7 cm).
Los Angeles County Museum of Art, Los Angeles, California.
Modern and Contemporary Art Council Fund

PETER ALEXANDER
Born Los Angeles, California, 1939,
lives in Venice, California

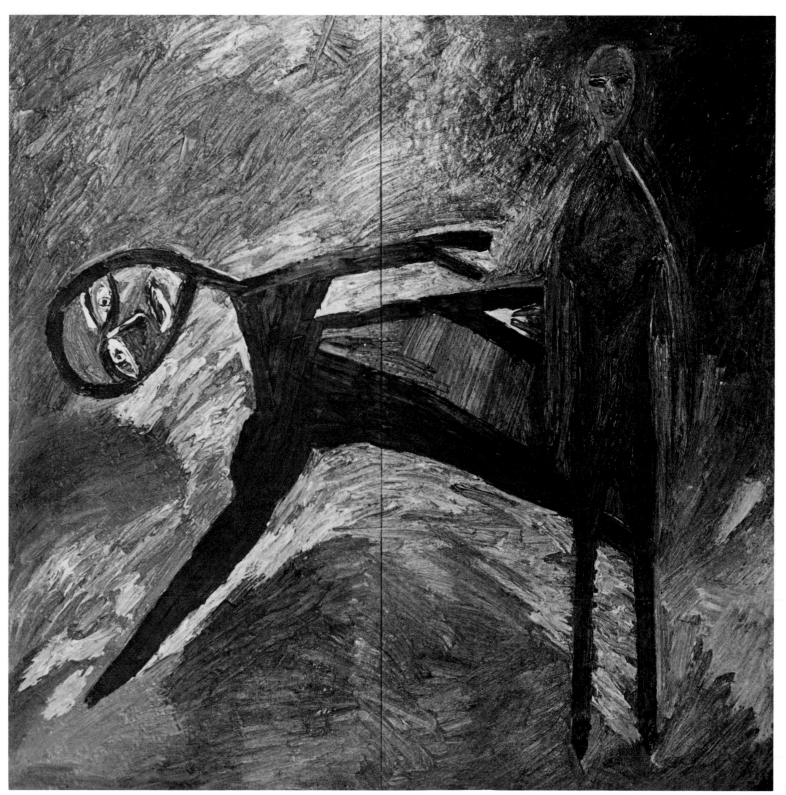

DEATH OF MY FATHER, II
1983. Oil on canvas,
71⅛ x 71⅛ in (182 x 182 cm).
Ray Hughes Gallery,
Brisbane, Australia

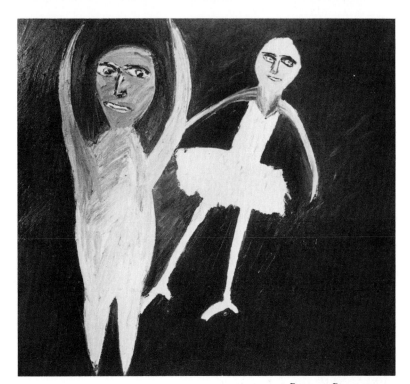

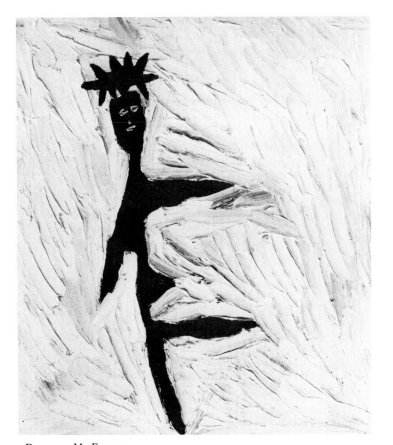

DAVIDA ALLEN
Born Charleville, Queensland, Australia, 1951,
lives at Purga Creek, near Brisbane, Australia

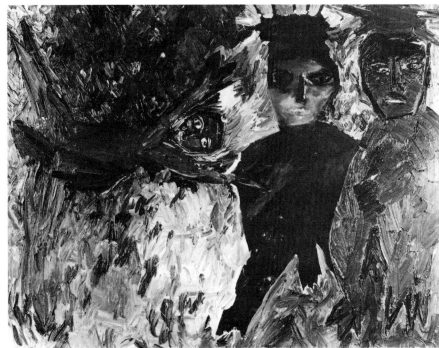

RUSSIA
1981. Oil on canvas,
66½ in x 6 ft 2½ in
(168.9 x 189.2 cm).
Private collection

THE LONGING
1982. Oil on canvas,
7 ft 4 in x 8 ft 4 in
(223.5 x 254 cm).
Robert Miller Gallery,
New York

GREGORY AMENOFF
Born St. Charles,
Illinois, 1948,
lives in New York

Right
IN THE FIFTH SEASON
1983. Oil on canvas,
8 ft 4 in x 7 ft 4 in
(254 x 223.5 cm).
Collection
Donald B. Marron

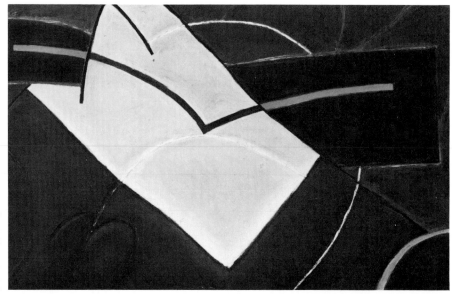

UNDER THE INFLUENCE
1981. Oil on canvas,
66 in x 6 ft 6 in
(167.6 x 198.1 cm).
Collection Michael Rea,
New York

OUT FROM THE POINT
1977. Oil on canvas,
60 in x 8 ft
(152.4 x 243.8 cm).
Rose Art Museum,
Brandeis University,
Waltham, Massachusetts

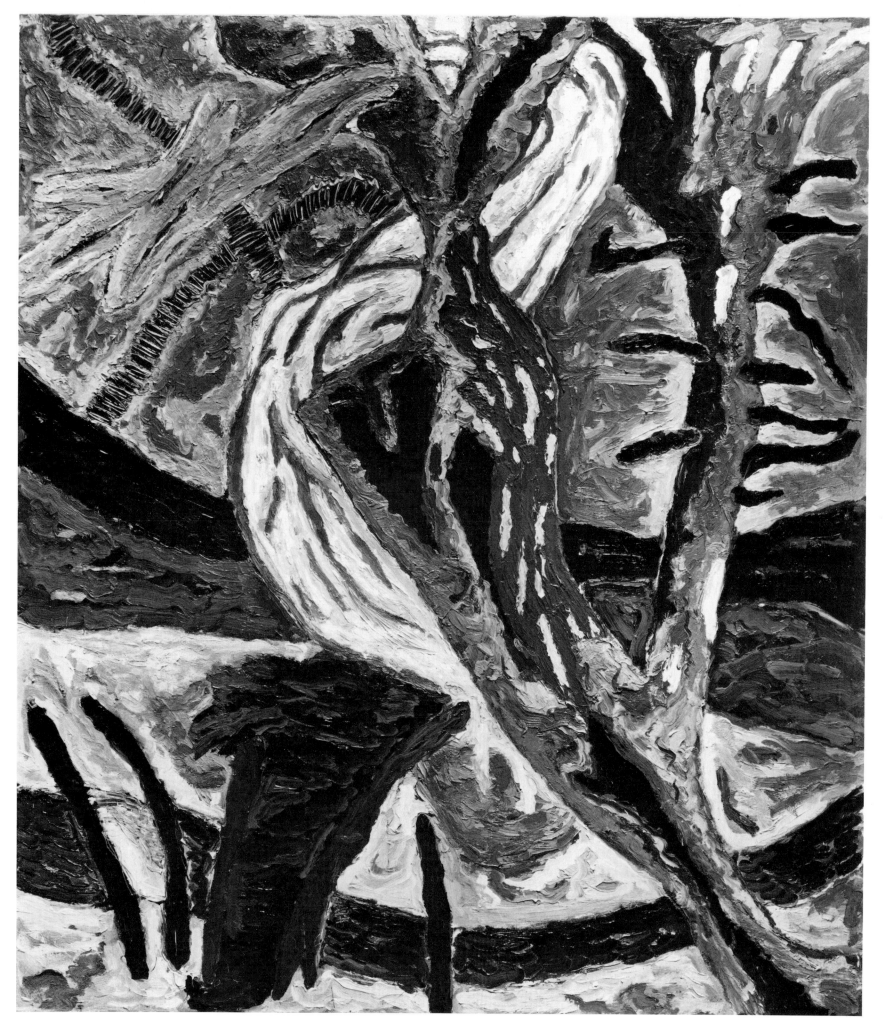

GIOVANNI ANSELMO
Born Borgofranco d'Ivrea, Italy, 1934,
lives in Turin, Italy

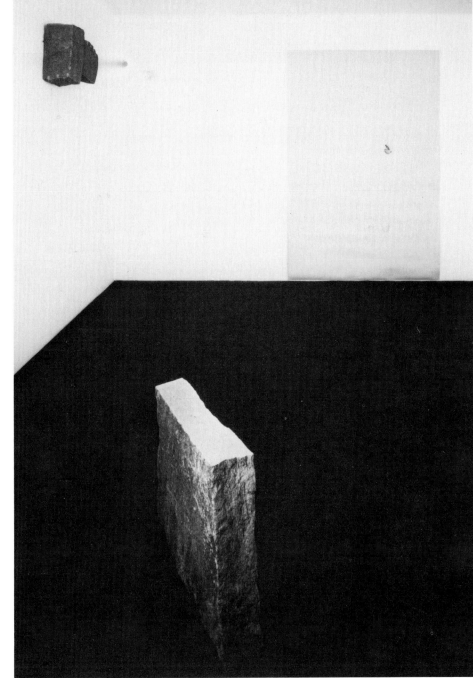

*IL PANORAMA CON MANO CHE LO
INDICA MENTRE VERSO OLTREMARE I
GRIGI SI ALLEGGERISCONO*
THE PANORAMA WITH HAND
POINTING TOWARD IT WHILE IN THE
DIRECTION OF OLTREMARE THE
GRAYS GRADUALLY FADE AWAY
1982–84. Pencil on linen paper, five
stones, steel cable, and Oltremare, size
variable. Collection the artist. Courtesy
Marian Goodman Gallery, New York

*IL PAESAGGIO CON MANO CHE LO
INDICA MENTRE A NORD I GRIGI SI
ALLEGGERISCONO*
THE LANDSCAPE WITH HAND
POINTING TOWARD IT WHILE IN THE
NORTH THE GRAYS GRADUALLY
FADE AWAY
1982. Pencil on linen paper, stone with
magnetic needle, and two stones and
steel cable, size variable. Galleria
Salvatore Ala, Milan, Italy

*IL PAESAGGIO CON MANO
CHE LO INDICA MENTRE
VERSO OLTREMARE I GRIGI SI
ALLEGGERISCONO*
THE LANDSCAPE WITH
HAND POINTING TOWARD
IT WHILE IN THE
DIRECTION OF OLTREMARE
THE GRAYS GRADUALLY
FADE AWAY
1982. Pencil on linen paper,
twenty stones, synthetic
polymer paint on wall, and
steel cable, size variable.
Installation at Galleria
Salvatore Ala, Milan, Italy, 1982

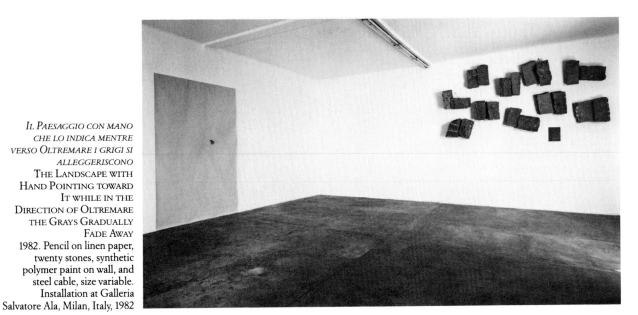

Detail of
Il Paesaggio con mano che lo indica mentre verso Oltremare i grigi si alleggeriscono

HOTEL TAFT
1979–80. Ink and Rhoplex on vellum, two panels,
each 7 ft x 54 in (213.4 x 137.2 cm);
overall 7 ft x 9 ft 6 in (213.4 x 289.6 cm).
Collection William and Marsha Goodman,
New York

IDA APPLEBROOG
Born Bronx, New York, 1929, lives in New York

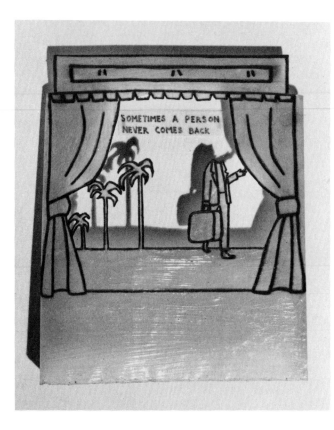

SOMETIMES A PERSON
NEVER COMES BACK
1977. Synthetic polymer paint
and Rhoplex on vellum, 12 x 9 in
(30.5 x 22.3 cm). Collection
Robert Ryman, New York

SURE I'M SURE (from Dyspepsia Works)
1979–80. Ink and Rhoplex on vellum, seven panels,
each 12 x 9½ in (30.5 x 24.1 cm);
overall 12 in x 6 ft 3 in (30.5 x 190.5 cm).
Collecton the artist. Courtesy Ronald Feldman Fine Arts, New York

TRINITY TOWERS
1982. Synthetic polymer paint and Rhoplex
on vellum, two panels, each
7 ft 1 in x 55 in (215.9 x 139.7 cm).
Ronald Feldman Fine Arts, New York

FIFTH BRIDGE
1979. Wood and steel,
12 x 90 x 36 ft
(365.8 x 2,743.2 x 1,097.2 cm).
Installation at Wave Hill,
Bronx, New York, 1979

SIAH ARMAJANI
Born Teheran, Iran, 1939,
lives in Minneapolis,
Minnesota

HIRSHHORN
EMPLOYEE LOUNGE
1981. Painted wood construction,
approx. 12 ft 11 in x 28 ft x 35 ft
(390 x 850 x 1,070 cm).
Hirshhorn Museum
and Sculpture Garden,
Smithsonian Institution,
Washington, D.C.

DICTIONARY FOR BUILDING:
THE GARDEN GATE
1982–83. Painted wood,
7 ft 11 in x 6 ft 1 in x 40 in
(241.3 x 185.4 x 101.6 cm).
Walker Art Center,
Minneapolis, Minnesota.
Purchased with the aid
of funds from William D. and
Stanley Gregory and the Art
Center Acquisition Fund

MORNING, NOON,
AND NIGHT WINDOWS
1979–80. Redwood,
aluminum, plexiglass, and
paint, in three sections,
left to right, 56 x 37 x 12¾ in
(142.2 x 94 x 32.8 cm);
56 x 34¾ x 3 in
(142.2 x 83.3 x 7.6 cm);
56 x 37 x 6½ in
(142.2 x 94 x 16.5cm).
Collection Mr. and Mrs.
Robert Shapiro

READING HOUSE
1980. Wood, shingles, and paint,
16 x 32 x 22 ft (487.7 x 975.4 x 670.6 cm).
Installation at Winter Olympic Games,
Lake Placid, New York, 1980

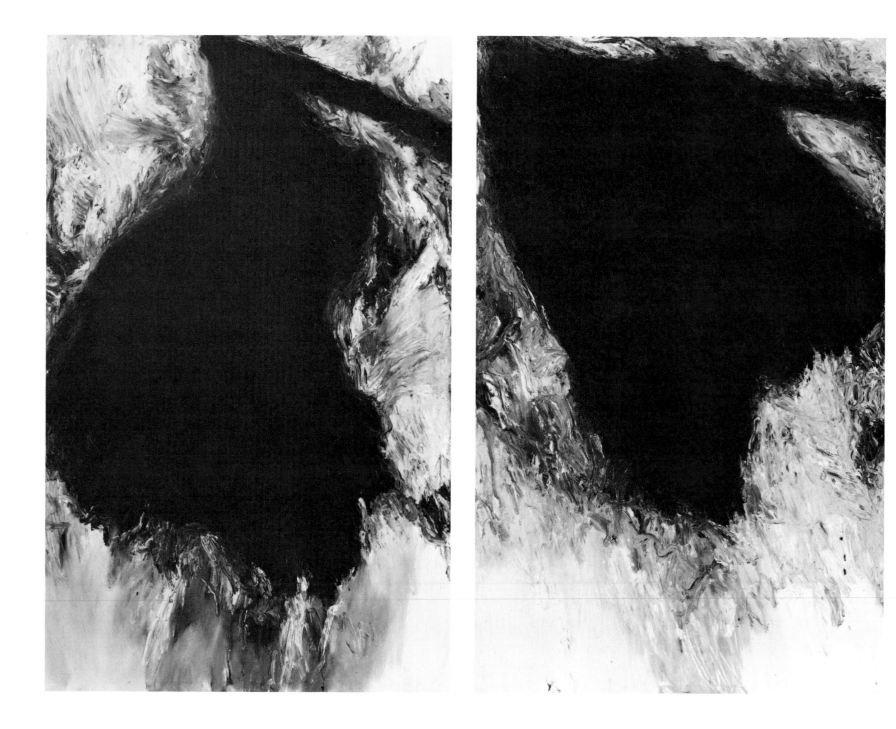

Fahne
Flag
March 1982. Oil on canvas,
7 ft 10½ in x 61 in (240 x 155 cm).
Private collection, Berlin

Fahne
Flag
January 1982. Oil on canvas, 7 ft 10½ in x
68⅞ in (240 x 175 cm). Haags Gemeentemuseum,
The Hague, Netherlands

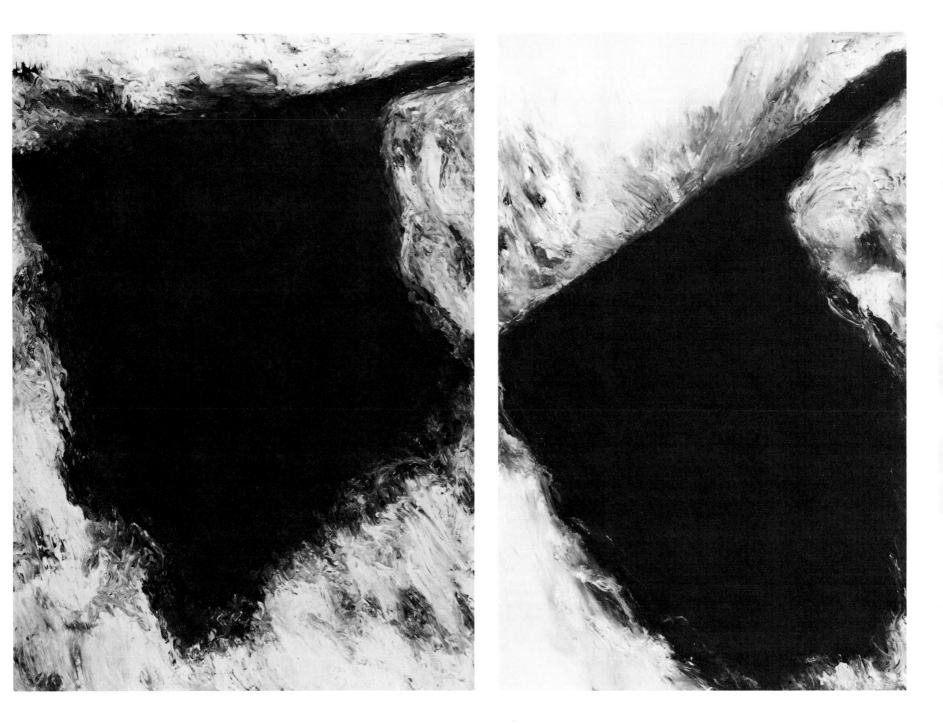

FAHNE
FLAG
January 1982. Oil on canvas,
7 ft 10½ in x 68⅞ in (240 x 175 cm).
Collection the artist

FAHNE
FLAG
March 1982. Oil on canvas,
7 ft 10½ in x 61 in (240 x 155 cm).
Collection the artist

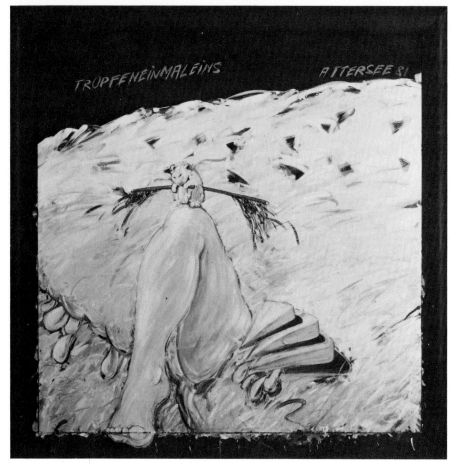

TROPFENEINMALEINS
DROPS ONE TIMES ONE
1981. Synthetic polymer paint and lacquer on canvas,
with painted wood frame, 46½ x 46½ in (118 x 118 cm).
Collection Patricia Dreyfuss, Vienna, Austria

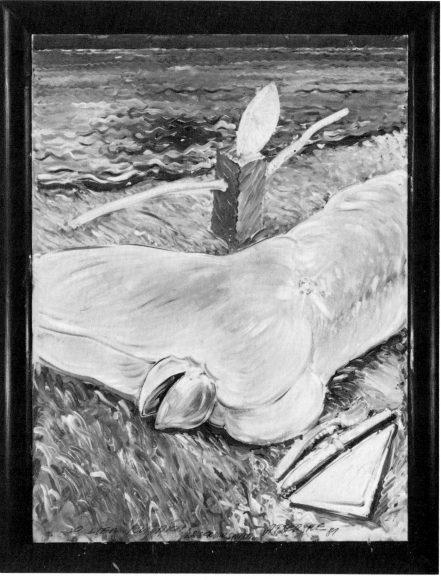

SO LIEB ICH DICH, WASSER UND SAND
I SO LOVE YOU, WATER AND SAND
1981. Synthetic polymer paint and lacquer on canvas,
with black wood frame, 41⅜ x 31½ in (105 x 80 cm).
Collection Wolfgang Strack, Hamburg, West Germany

TISCHECKSONNEN
TABLE CORNER SUNS
1980. Synthetic polymer paint and lacquer on canvas,
with painted wood frame, 47⅜ x 37⅜ in (120.5 x 95.5 cm).
Collection Dr. Hannes Pflaum, Vienna, Austria

CHRISTIAN LUDWIG ATTERSEE
Born Pressburg
(now Bratislava, Czechoslovakia),
1940, lives in Vienna, Austria

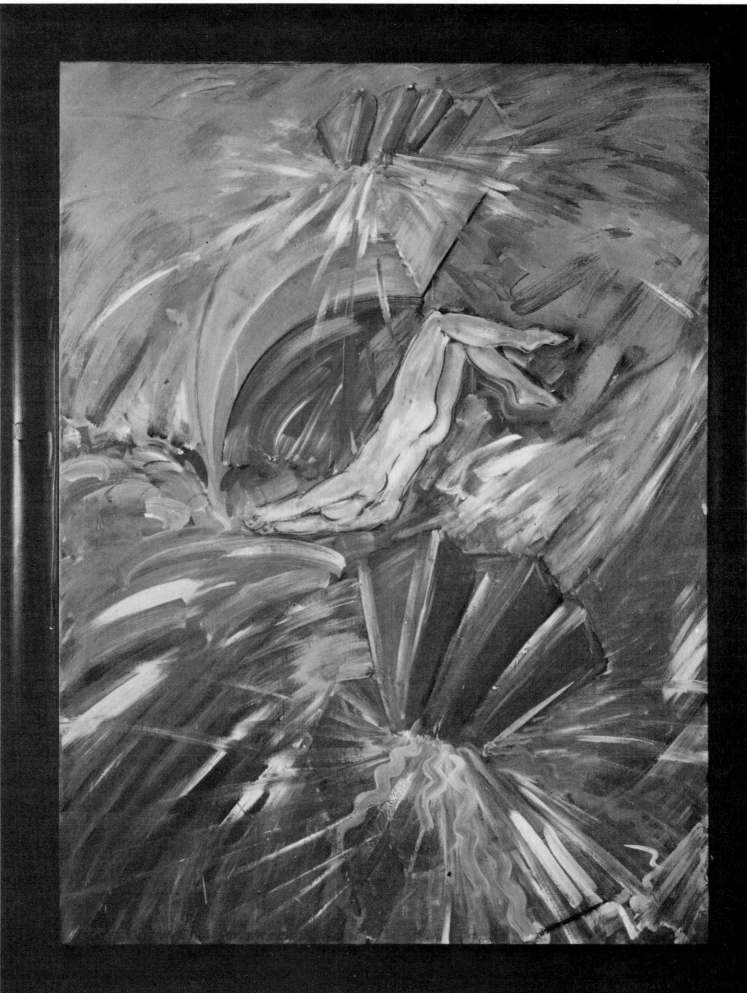

Brettsonne
Board Sun
1981. Synthetic polymer
paint and lacquer on
canvas, with black wood
frame, 47¼ x 37⅛ in (120 x
95 cm). Hochschule für
Angewandte Kunst,
Vienna, Austria

CAMDEN THEATRE
IN THE RAIN
1977. Oil on board,
48 x 54 in
(121.9 x 137.2 cm).
Private collection,
London

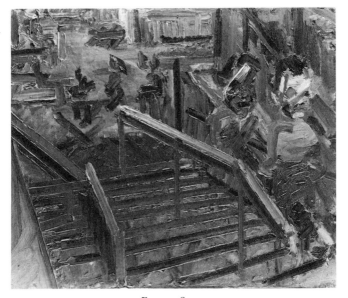

EUSTON STEPS
1981.
Oil on board,
40 x 50 in
(101.6 x 127 cm).
Marlborough
Fine Art, Ltd.,
London

HEAD OF JULIA, II
1980. Oil on board,
20 x 22 in
(50.8 x 55.9 cm).
New Academy
of Art Studies,
London

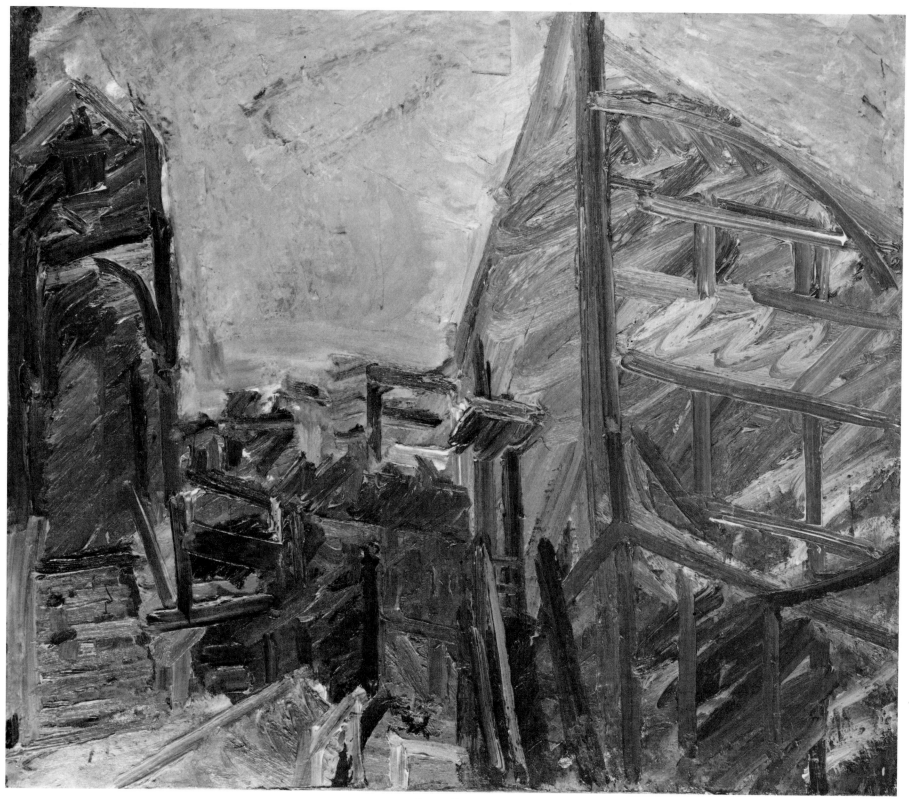

To the Studios
1982–83. Oil on board, 40½ x 48 in (103 x 122 cm).
Marlborough Fine Art, Ltd., London

FRANK AUERBACH · Born Berlin, 1931, lives in London

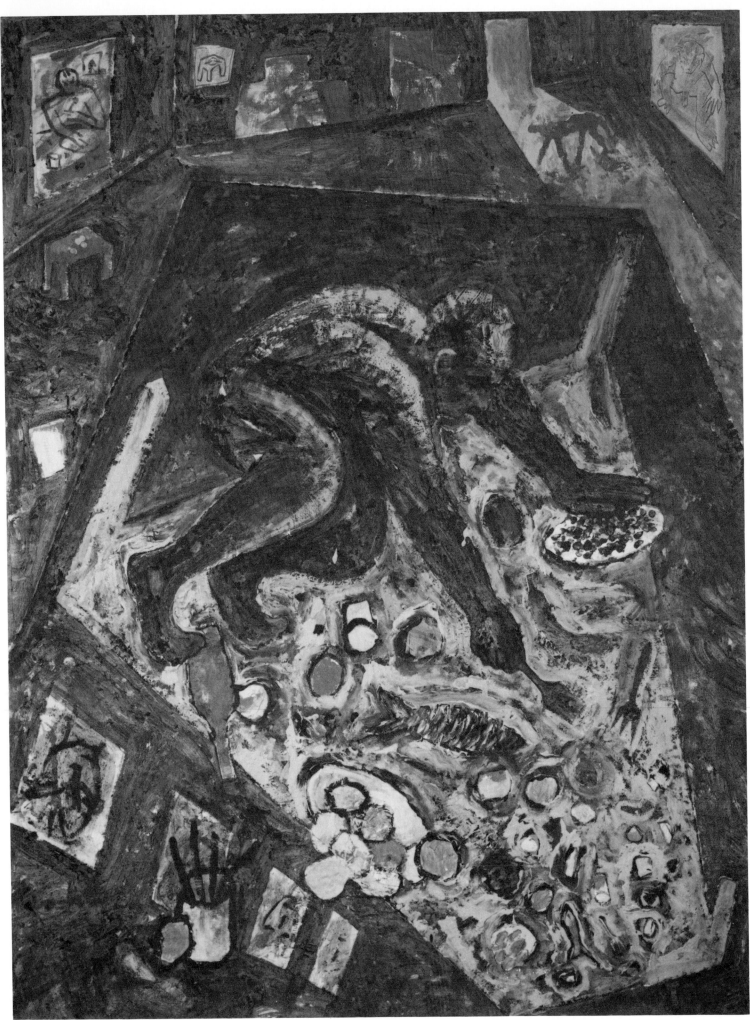

Tavola calda
Hot Table
1983. Oil on canvas,
8 ft 4⅜ in x 6 ft 6 in
(255 x 198 cm).
Galleria Lucio Amelio,
Naples, Italy

NUDE ASCENDING A STAIRCASE
1981. Pigment, latex, and oil on canvas,
51¼ x 6 ft 4¾ in (130 x 195 cm).
Private collection

PAINTER AND HIS REFLECTION
1982. Mixed mediums on canvas,
6 ft 4¾ in x 51¼ in (195 x 130 cm).
Private collection

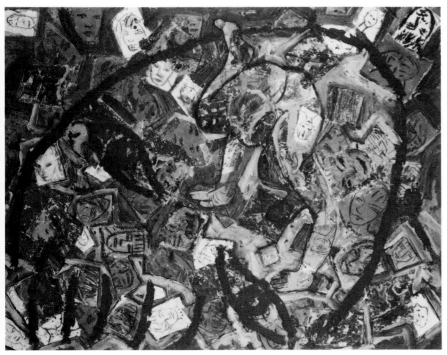

PAINTER WITH MORE THAN SEVENTY SELF-PORTRAITS
1983. Oil on canvas, 6 ft 6 in x 8 ft 4⅜ in (198 x 255 cm).
Galleria Lucio Amelio, Naples, Italy

MIQUEL BARCELÓ
Born Felanitx, Majorca, Spain, 1957,
lives in Paris

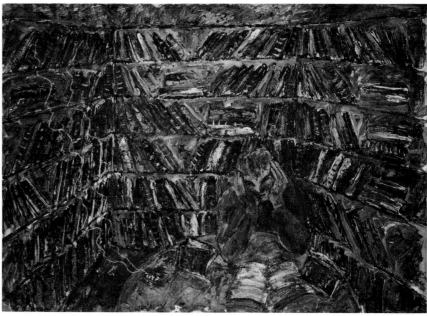

LIBRARY
1983. Mixed mediums on
canvas, 6 ft 6¾ in x 9 ft 10⅛ in
(200 x 300 cm).
Private collection

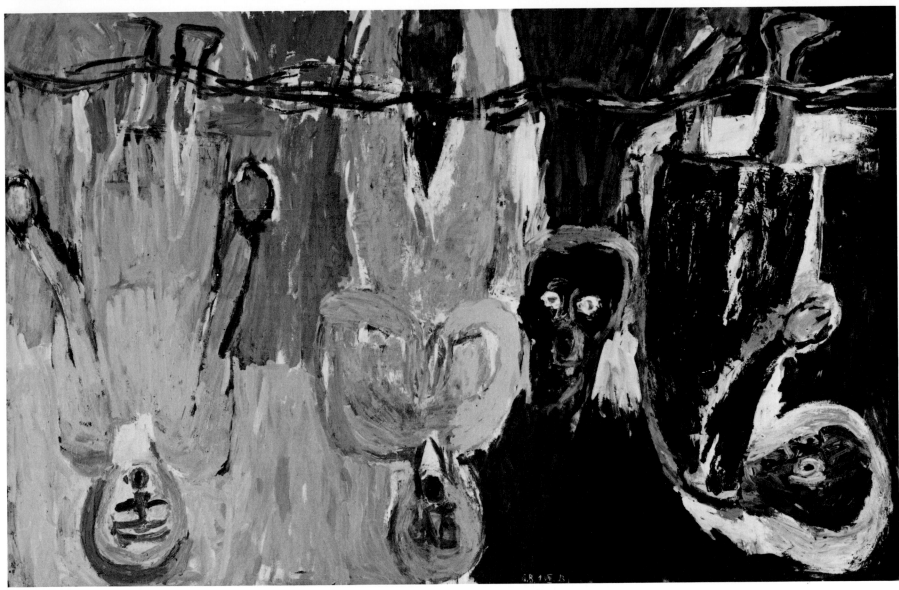

Brückechor
Die Brücke Choir
1983. Oil on canvas,
9 ft 1 in x 14 ft 7 in
(280 x 450 cm).
Mary Boone Gallery, New York,
and Galerie Michael Werner, Cologne,
West Germany

Georg Baselitz
Born Deutschbaselitz, Germany, 1938,
lives in Derneburg, near Hildesheim, West Germany

MANNLICHER AKT
MALE NUDE
1975. Oil on canvas,
6 ft 6¾ in x 63¾ in
(200 x 162 cm).
Private collection

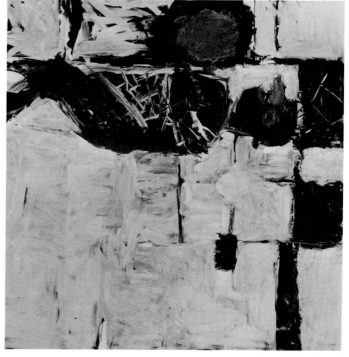

ADLER IM BETT
EAGLE IN BED
1982. Oil on canvas,
8 ft 2½ in x 8 ft 2½ in
(250 x 250 cm).
Private collection,
Geneva, Switzerland

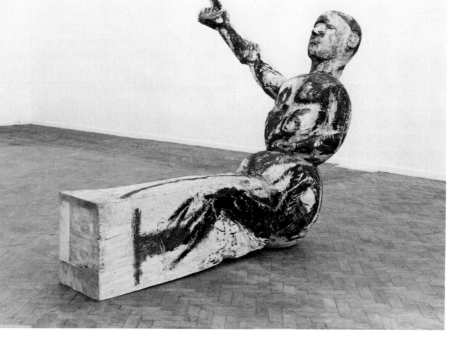

MODEL FOR A SCULPTURE
1980. Painted limewood,
6 ft 6¾ in x 9 ft 10 in x 19⅝ in
(200 x 300 x 50 cm).
Museum des 20. Jahrhunderts,
Vienna, Austria

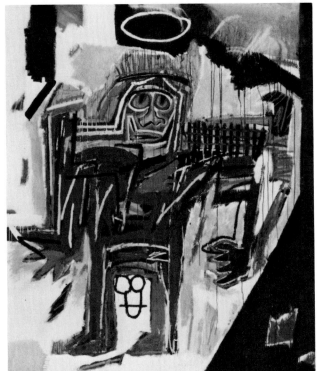

PATER
1982. Synthetic polymer paint
and oil stick on canvas,
7 x 6 ft (213.4 x 182.9 cm).
Private collection

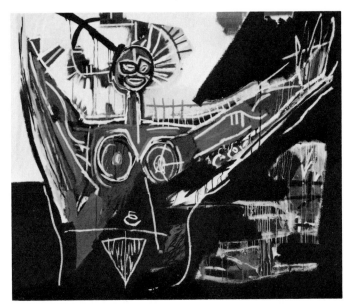

MATER
1982. Synthetic polymer paint
and oil stick on canvas,
6 x 7 ft (182.9 x 213.4 cm).
Private collection

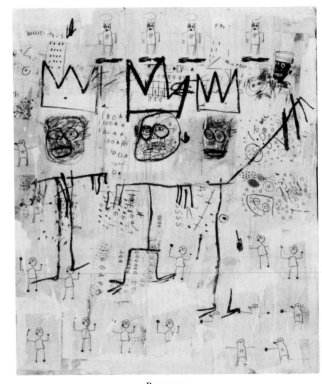

UNTITLED
1983. Silkscreen print on
prepared and stretched canvas,
57 in x 6 ft 2 in (144.8 x 188 cm).
Private collection

RUFFIANS
1982. Synthetic polymer paint,
oil stick, and collage on canvas,
68⅞ x 59 in (175 x 150 cm).
Collection Dr. Donald Dworken

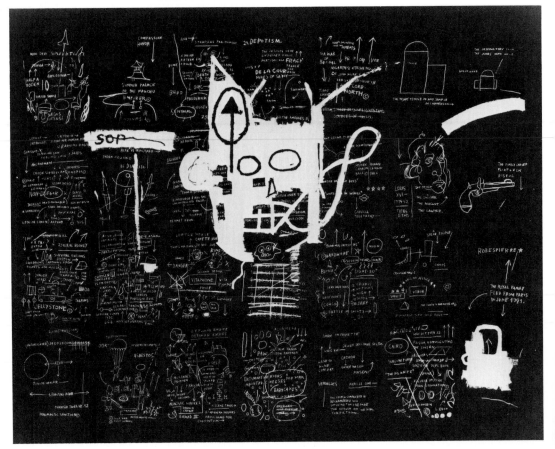

SELF-PORTRAIT
1982. Synthetic polymer paint
and oil stick on canvas,
6 ft 4 in x 7 ft 10 in
(193 x 238.8 cm).
Galerie Beyeler, Basel, Switzerland

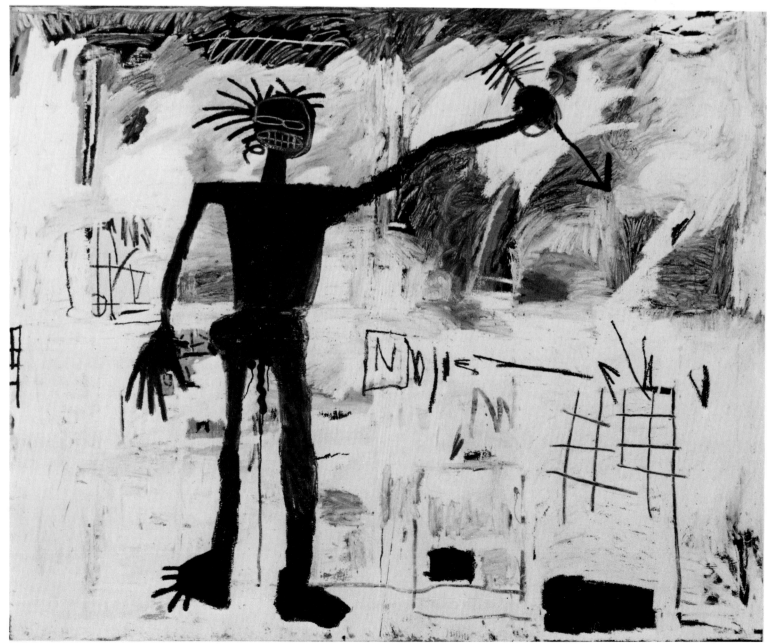

PAINTING–FOR BILL
1976–77. Oil on canvas,
6 x 8 ft (182.9 x 243.8 cm).
Dallas Museum of Fine Arts,
Dallas, Texas

DOUBLE BAR ORANGE SQUARE
1977. Oil on canvas,
40 x 40 in (101.6 x 101.6 cm).
Collection Renee and David McKee

UNTITLED (PARROT)
1982–83. Oil on linen,
16 x 12 in (40.6 x 30.5 cm).
Collection Blake Nevius

POND
1982. Oil on linen, 16 x 12 in
(40.6 x 30.5 cm). Collection the artist.
Courtesy David McKee Gallery, New York

JAKE BERTHOT
Born Niagara Falls, New York, 1939,
lives in New York

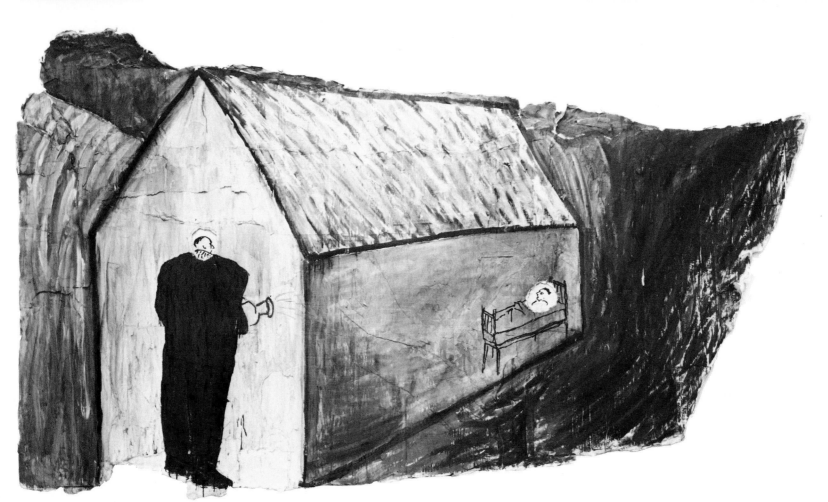

UNTITLED
1982. Paint on torn paper posters,
7 ft 2⅜ in x 13 ft 5⅜ in
(220 x 410 cm).
Galerie Yvon Lambert,
Paris

The artist's studio,
Paris, 1981

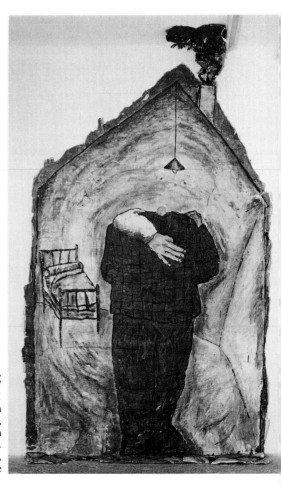

*AU FEU,
LES POMPIERS!*
FIRE! FIREMEN!
1982. Paint on
torn paper posters,
13 ft 1½ in x 7 ft 8½ in
(400 x 235 cm).
Galleria Ugo Ferranti,
Rome

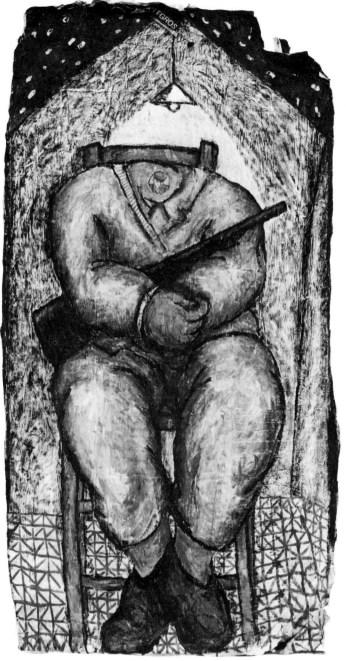

Le Guardian de nuit
GUARDIAN OF THE NIGHT
1982. Paint on torn paper posters,
8 ft 10¼ in x 51¼ in
(270 x 130 cm).
Galleria Ugo Ferranti, Rome

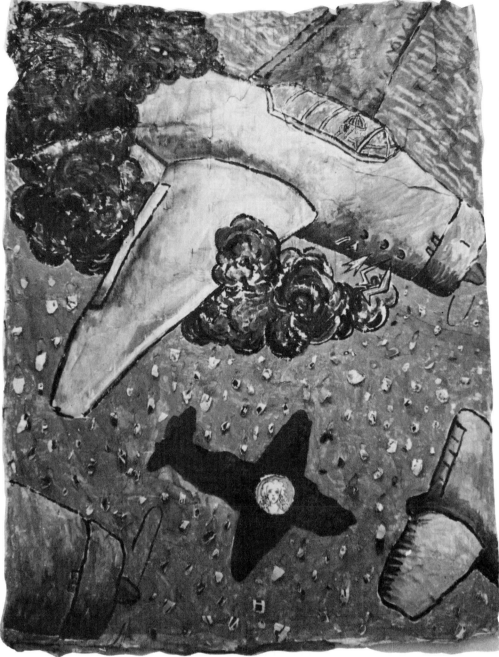

Sans retour
NO RETURN
1981–82. Oil on torn paper posters,
9 ft 2¼ in x 8 ft 6⅜ in (280 x 260 cm).
Fond Nationale d'Art Contemporain,
Sélestat, France

JEAN CHARLES BLAIS
Born Nantes, France, 1956, lives in Paris

ERWIN BOHATSCH

Born Murzzuschlag, Austria, 1951, lives in Fehring, Austria

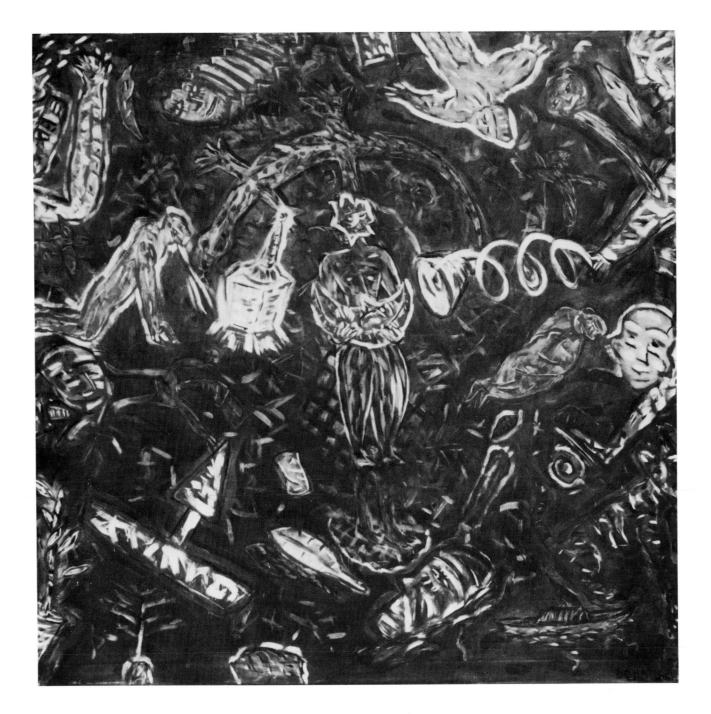

DER GEFUNDENE MOND
THE DISCOVERED MOON
1982. Mixed mediums on canvas,
6 ft 2⅞ in x 6 ft 6¼ in
(190 x 200 cm).
Collection Peter Lüchau

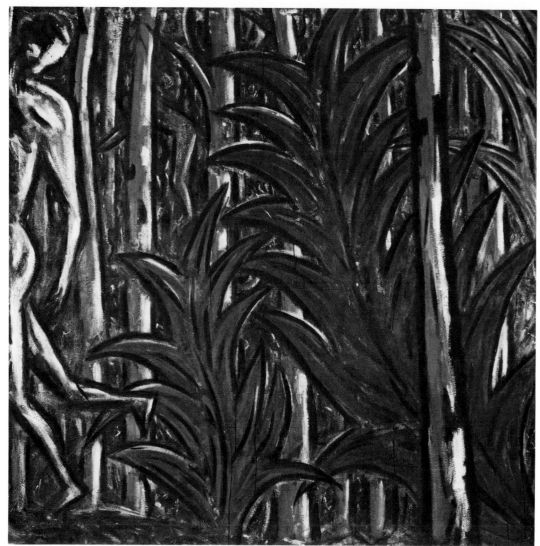

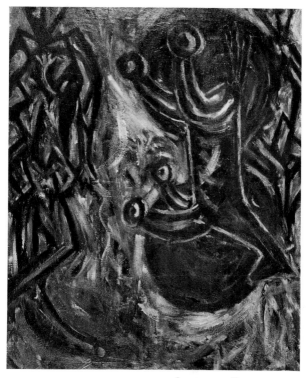

Abschied
Farewell
1983. Mixed mediums on canvas,
6 ft 6¾ in x 6 ft 6¾ in
(200 x 200 cm). Galerie Krinzinger,
Innsbruck, Austria

Sturzendes Pferd
Falling Horse
1983. Mixed mediums on canvas,
59 x 49⅝ in (150 x 126 cm).
Galerie Krinzinger, Innsbruck, Austria

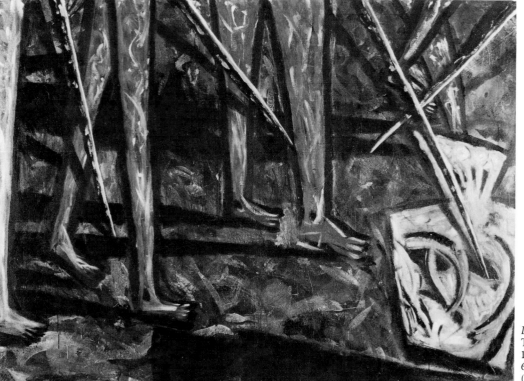

Die Verstossene Maske
The Outcast Mask
1983. Mixed mediums on canvas,
6 ft 8¼ in x 9 ft 2¼ in
(204 x 280 cm). Galerie Krinzinger,
Innsbruck, Austria

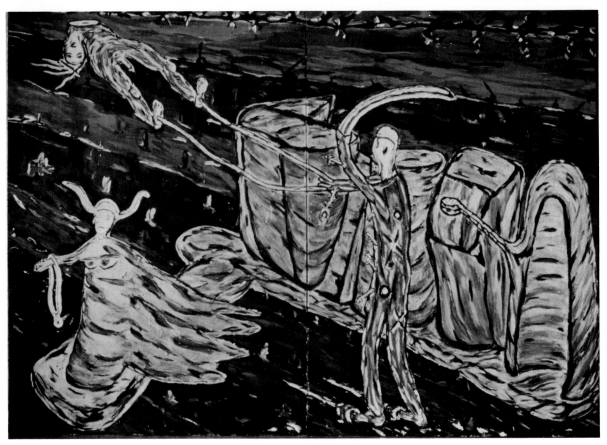

Sprung aus der Geschichte
Leap Out of History
1982. Dispersion and "gold-bronze" on nettle cloth,
in two parts, overall 7 ft 2⅜ in x 10 ft 6 in
(220 x 320 cm). Galerie Paul Maenz, Cologne,
West Germany

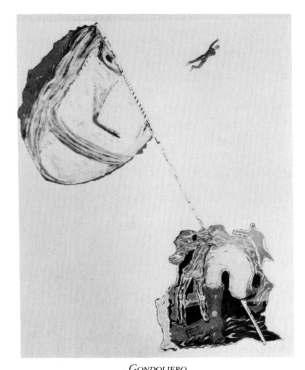

Gondoliero
Gondolier
1980. Dispersion on board,
papier mâché, and bamboo stick,
in four parts, overall approx.
9 ft 2¼ in x 6 ft 6¾ in
(280 x 200 cm). Galerie
Bruno Bischofberger, Zurich,
Switzerland

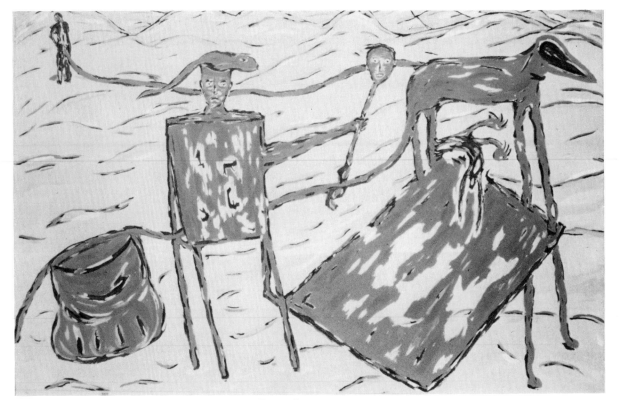

Erstes Selbstporträt
First Self-Portrait
1981. Dispersion on nettle cloth,
54⅜ in x 7 ft ⅝ in (138 x 215 cm).
FER Collection, Laupheim, West Germany

DER ZEITZÜCHTER
THE TIME BREEDER
1983. Oil and hair on canvas,
7 ft 10½ in x 70⅞ in
(240 x 180 cm).
Collection the artist.
Courtesy Galerie Paul Maenz,
Cologne, West Germany

PETER BÖMMELS
Born Frauenburg, West Germany, 1951,
lives in Cologne, West Germany

SPITZBERGEN
1981. Dispersion on nettle cloth,
7 ft 2⅝ in x 71⅝ in
(220 x 182 cm). Galerie Paul Maenz,
Cologne, West Germany

PAINTING 1981
1981. Oil on canvas,
8 ft ½ in x 6 ft 6 in
(244.3 x 198.2 cm).
Collection James Baker,
Queensland, Australia

PAINTING 1979
1979. Oil on canvas,
71⅞ in x 10 ft
(182.5 x 304.5 cm).
Collection James Baker,
Queensland, Australia

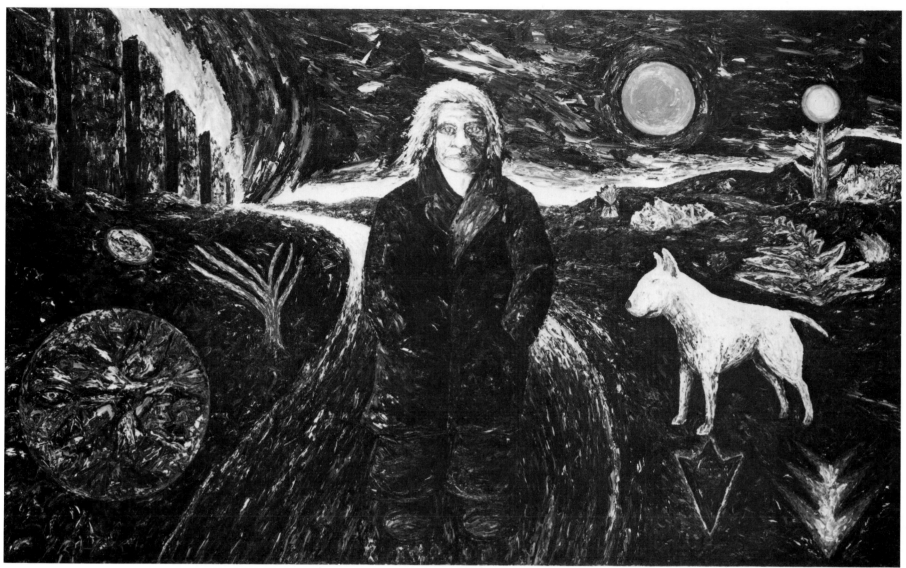

PAINTING 1977
1977. Oil on canvas, 71⅞ in x 10 ft (182.5 x 304.5 cm).
National Gallery of Victoria, Melbourne, Australia.
Presented by the artist in memory of Les Hawkins, 1978

PETER BOOTH
Born Sheffield, England, 1940,
lives in Melbourne, Australia

SELF-PORTRAIT AT 2,719,997
1981. Synthetic polymer paint on
canvas, wood, and polyethylene.
11 ft 6 in x 7 ft 5 in x 21 ft 3 in
(350.5 x 226 x 647.7 cm) (variable).
The Museum of Modern Art, New York.
Gift of the Louis and Bessie Adler
Foundation, Inc., Seymour M. Klein,
President

Installation at
Paula Cooper Gallery,
New York, 1980

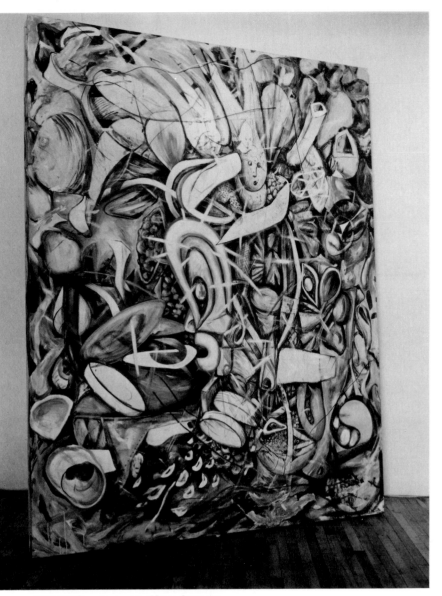

2,841,780 PAINTING WITH HAND SHADOW
1981–83. Synthetic polymer paint on canvas,
with light mounted on wall behind canvas,
9 ft 1 in x 6 ft 11 in (276.9 x 210.8 cm).
Collection Doris and Charles Saatchi, London

JONATHAN BOROFSKY
Born Boston, Massachusetts, 1942,
lives in Venice, California

RUNNING MAN AT 2,550,116
1978–79. Synthetic polymer paint on plywood,
7 ft 5½ in x 9 ft 2¼ in (227.3 x 280 cm).
Collection Doris and Charles Saatchi, London

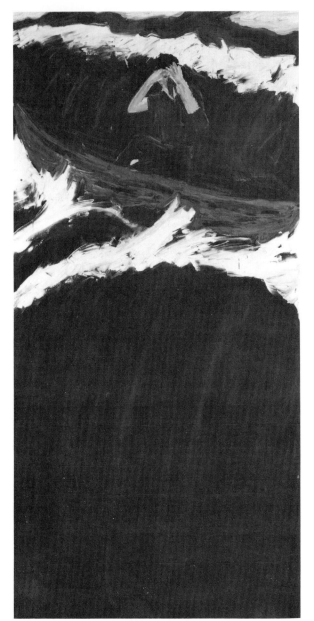

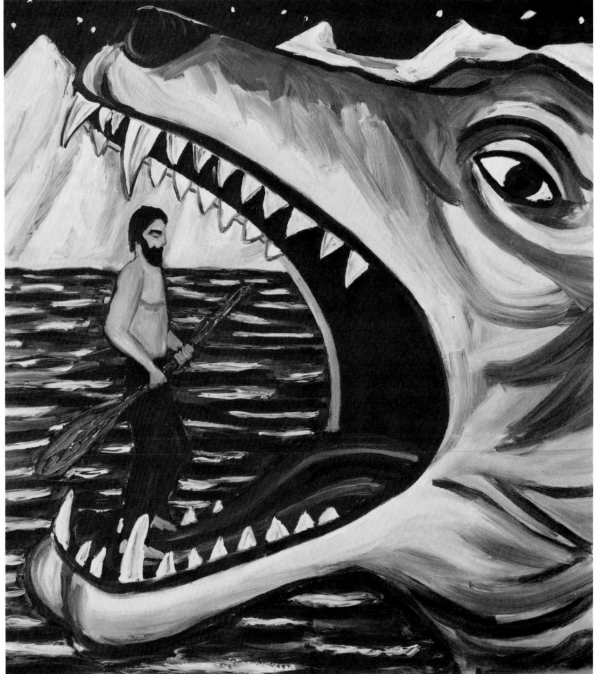

VERTICAL BOAT
1980. Oil on canvas,
7 ft 7½ in x 45 in
(232.4 x 114.3 cm).
Collection Brooke and
Carolyn Alexander,
New York

RICHARD BOSMAN · Born Madras, India, 1944, lives in New York

THE NORSEMAN
1980. Oil on canvas,
7 ft x 6 ft 3 in (213.4 x 190.5 cm).
Collection Mr. and Mrs.
Morton J. Hornick

A JOB TO DO
1983. Oil on canvas,
8 x 8 ft (243.8 x 243.8 cm).
Collection Barry Lowen,
Los Angeles, California

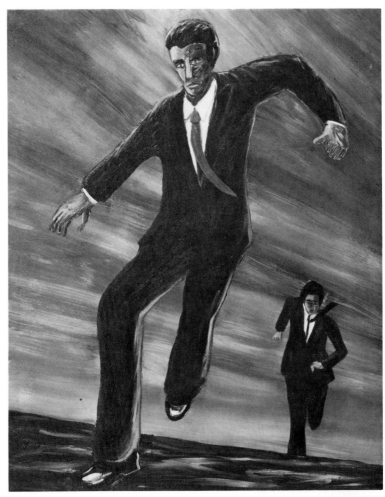

THE CHASE
1982. Oil on canvas,
6 ft 10 in x 66½ in
(208.3 x 168.9 cm).
Collection Duke Comegys

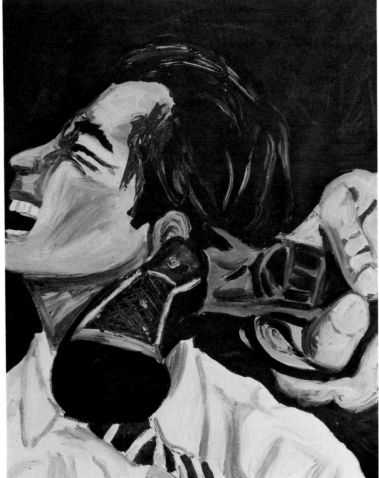

PISTOL WHIP
1982. Oil on canvas,
52 x 42 in (132 x 106.7 cm).
Collection Mr. and Mrs.
Gregory Clarke

Far right
THE RED CURTAIN
1981. Oil on canvas,
ft x 66 in (213.4 x 167.6 cm).
The Morton G. Neumann
Family Collection, Chicago,
Illinois, and New York

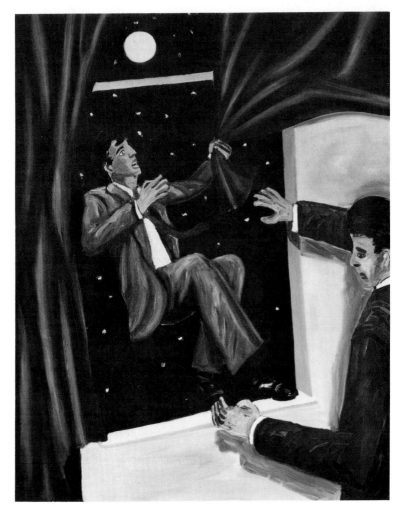

63

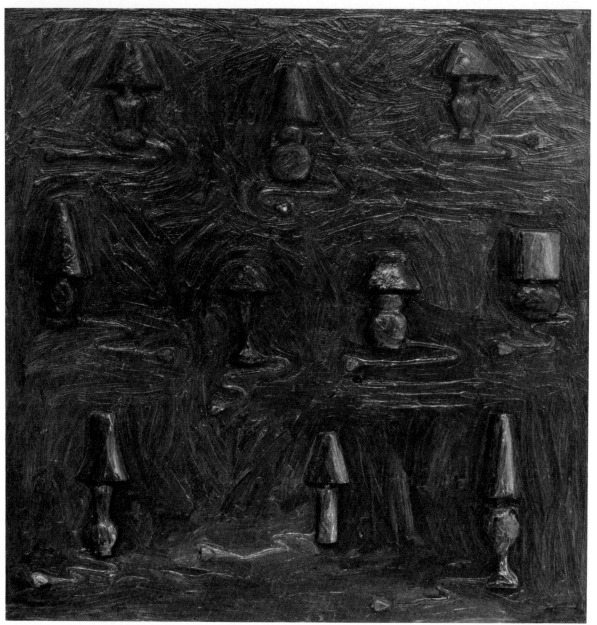

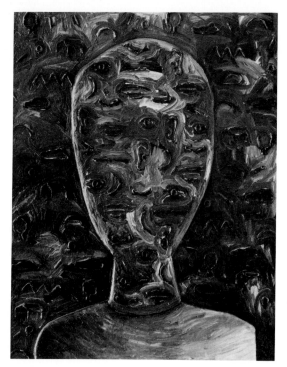

MAN IN A LANDSCAPE
1982. Oil, wax, and lead
on foamed synthetic polymer,
53⅜ x 42⅛ in (135 x 107 cm).
Private collection,
Melbourne, Australia

LAMPS
1982. Oil, wax, and foamed synthetic polymer on canvas,
43¼ x 43¼ in (110 x 110 cm).
Reconnaissance Gallery, Melbourne, Australia

NIGHT TIME
1982. Synthetic polymer paint on foamed synthetic polymer,
52 in x 6 ft 3½ in (132 x 192 cm).
Private collection, Melbourne, Australia

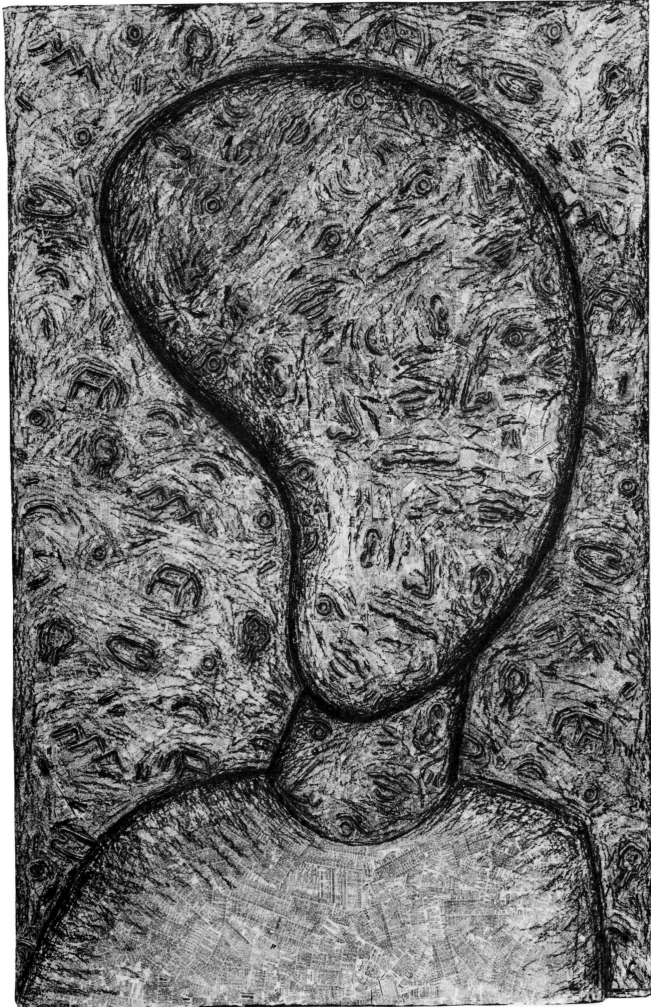

MAN IN A LANDSCAPE, I
1983. Oil, lead, newspaper,
and oil stick on Styrofoam,
8 ft x 48 in
(243.8 x 121.9 cm).
Collection Kim Kingston

PAUL BOSTON
Born Fitzroy, Australia, 1952,
lives in Melbourne, Australia

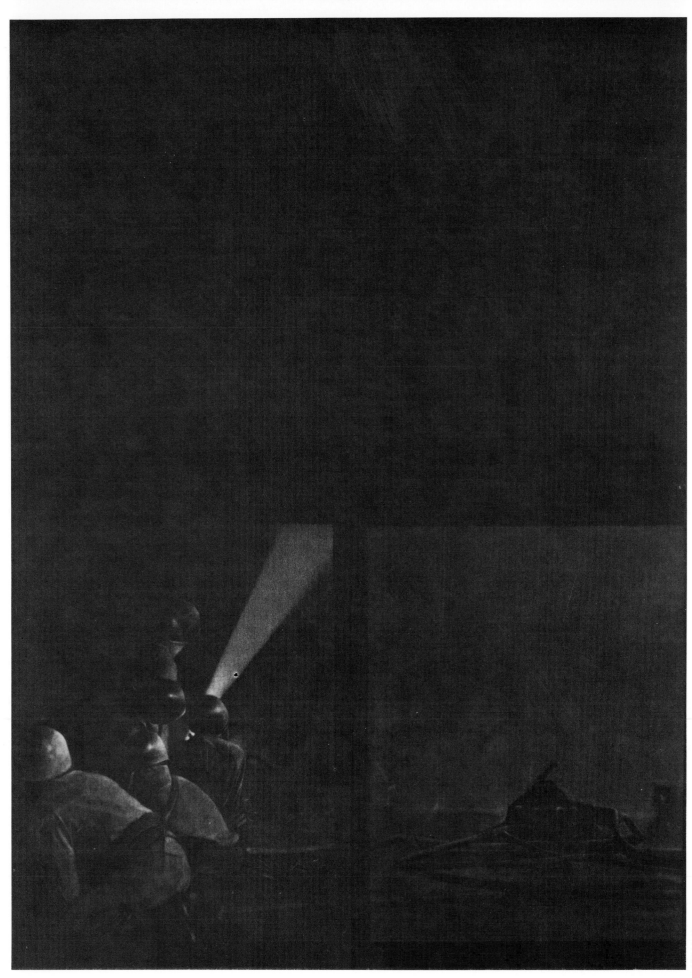

UNTITLED
1982. White pencil on black paper,
8 ft x 68 in (243.8 x 172.7 cm).
Private collection

UNTITLED
1981. White pencil on black paper,
6 ft 10½ in x 30 in (209.5 x 76.2 cm).
Collection Mr. and Mrs. Howard Rubenstein

UNTITLED
1981. White pencil on black paper,
6 ft 10½ in x 30 in (209.5 x 76.2 cm).
Metro Pictures, New York

UNTITLED
1981. White pencil on black paper,
6 ft 10½ in x 30 in (209.5 x 76.2 cm). Collection
Doris and Charles Saatchi, London

TROY BRAUNTUCH
Born Jersey City, New Jersey, 1954,
lives in New York

UNTITLED
1980. White pencil on black paper,
40 x 53¼ in (101.6 x 135.2 cm).
Private collection

ROGER BROWN

Born Hamilton, Alabama, 1941,
lives in Chicago, Illinois

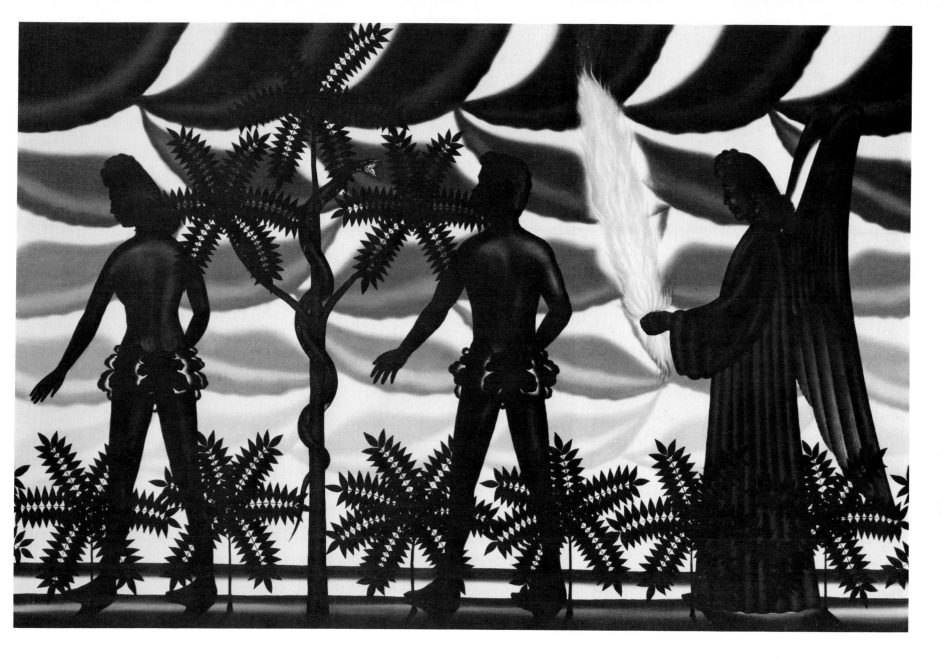

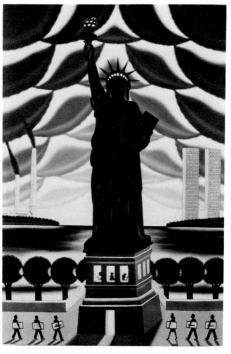

LIBERTY INVITING
ARTISTS TO TAKE PART
IN AN EXHIBITION
AGAINST INTERNATIONAL
LEFTIST TERRORISM
(IRA, PLO, FALN,
RED BRIGADE,
SANDINISTAS,
BULGARIANS)
1982. Oil on canvas,
6 ft x 48 in
(182.9 x 121.9 cm).
Collection William and
Susan Kleinman,
Indianapolis, Indiana

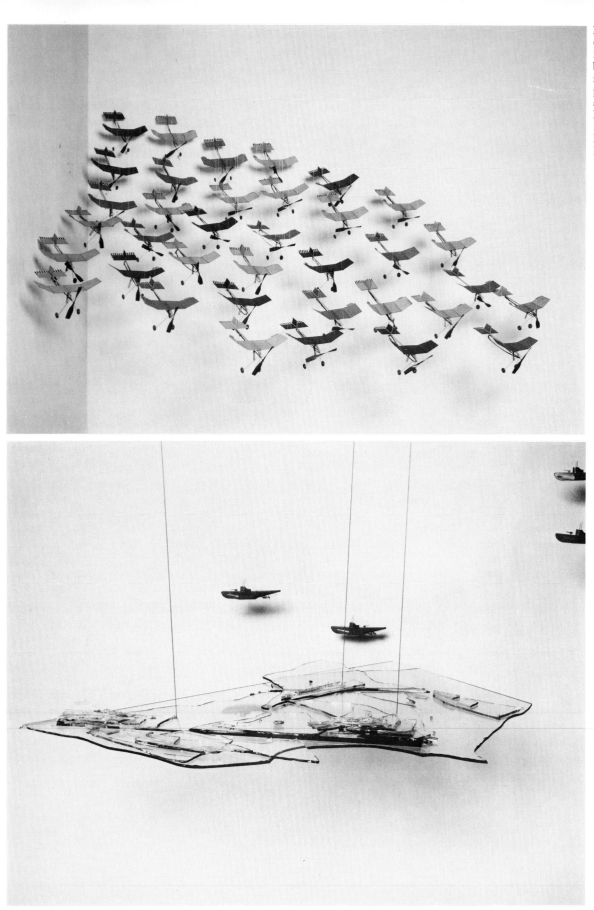

R.O.G.
(RISE OFF THE GROUND)
1980. Rubber-band planes,
balsa wood, paper, and
firecrackers: thirty-seven
planes in green, orange,
and blue, wing span and
length of each plane,
10 in (25.4 cm). Ronald
Feldman Fine Arts,
New York

CHRIS BURDEN
Born Boston, Massachusetts, 1946,
lives in Venice, California

THE GLASS SHIP
1983. Plate glass, silicone,
and lead soldiers,
2½ x 52 x 39 in (6.3 x 132.1 x 99 cm).
Ronald Feldman Fine Arts,
New York

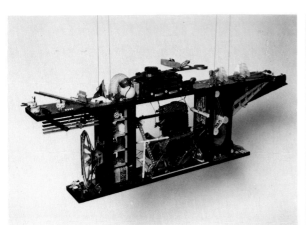

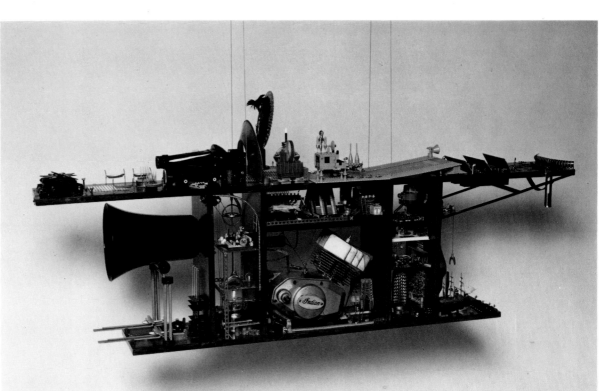

Above
THE NIÑA
1982. Wood, toys, paint, motorcycle engine, and electronic parts,
20 x 57 x 8 in (50.8 x 144.8 x 20.3 cm).
Ronald Feldman Fine Arts, New York

Right
THE PINTA
1982. Wood, toys, paint, motorcycle engine, and electronic parts,
30 x 70 x 10½ in (76.2 x 177.8 x 26.7 cm).
Ronald Feldman Fine Arts, New York

Below
THE SANTA MARIA
1982. Wood, toys, paint, motorcycle engine, and electronic parts,
30 in x 6 ft 3½ in x 15¼ in (76.2 x 191.8 x 38.7 cm).
Collection Marilyn Oshman Lubetkin, Houston, Texas

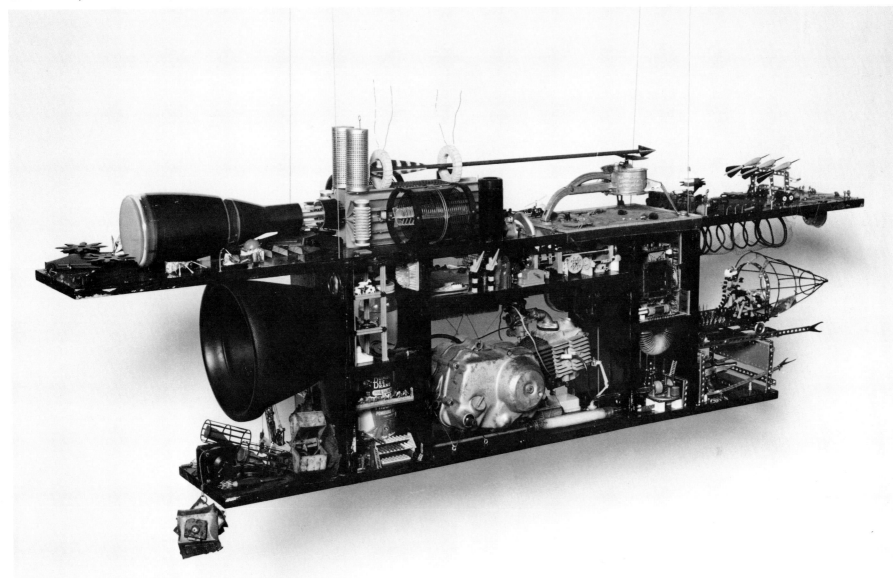

SCOTT BURTON
Born Greensboro,
Alabama, 1939,
lives in New York

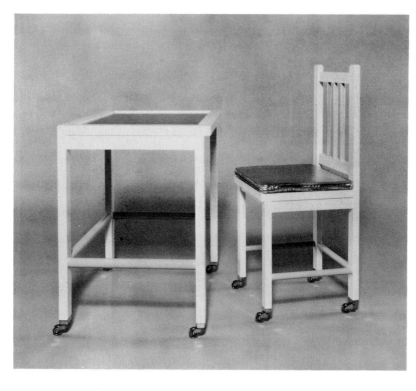

CHILD'S TABLE AND CHAIR
1983. Lacquered wood, leather,
foam rubber, steel, and brass:
chair, 27 x 12 x 12 in
(68.6 x 30.5 x 30.5 cm);
table, 21 x 22 x 17 in
(53.3 x 55.9 x 43.2 cm).
Collection Ivor Shearer, New York

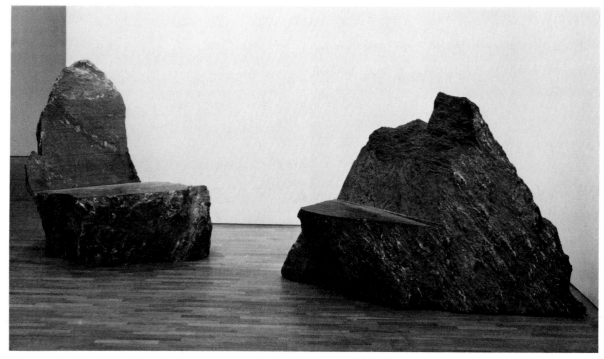

PAIR OF ROCK CHAIRS
1980–81. Gneiss: left, 49⅜ x 36 x 47 in (125.1 x 91.4 x 119.5 cm);
right, 44 in x 46 in x 6 ft 2 in (112 x 117 x 187.8 cm).
The Museum of Modern Art, New York. Acquired through the Philip Johnson,
Mr. and Mrs. Joseph Pulitzer, Jr., and Robert Rosenblum Funds

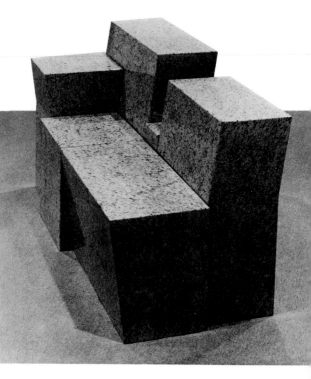

DALLAS SETTEE
1982. Granite, 36 x 65¼ x 35 in (91.4 x
165.7 x 88.9 cm). Dallas Museum of
Fine Arts, Dallas, Texas. Purchased
through a grant from the National
Endowment for the Arts with matching
funds from Robert K. Hoffman, the
Roblee Corporation, Laura L.
Carpenter, Nancy M. O'Boyle,
and an anonymous donor

BRONZE CHAIR
1972–75. Cast bronze,
48 x 18 x 20 in
(121.9 x 45.7 x 50.8 cm).
Collection the artist

Below
PAIR OF TWO-PART CHAIRS
1983–84. Polished granite, each chair
33⅛ x 24 x 30⅛ in (85 x 61 x 76.5 cm).
Walker Art Center, Minneapolis,
Minnesota. Gift of Butler Family
Fund and Art Center
Acquisition Fund

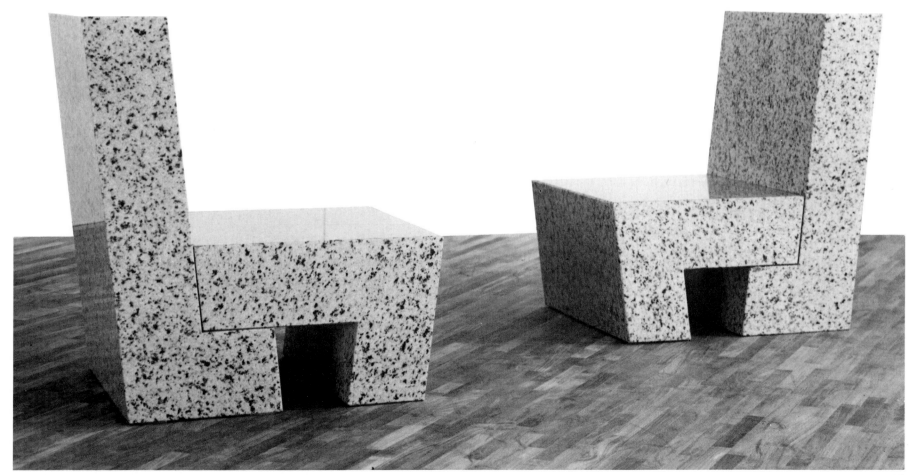

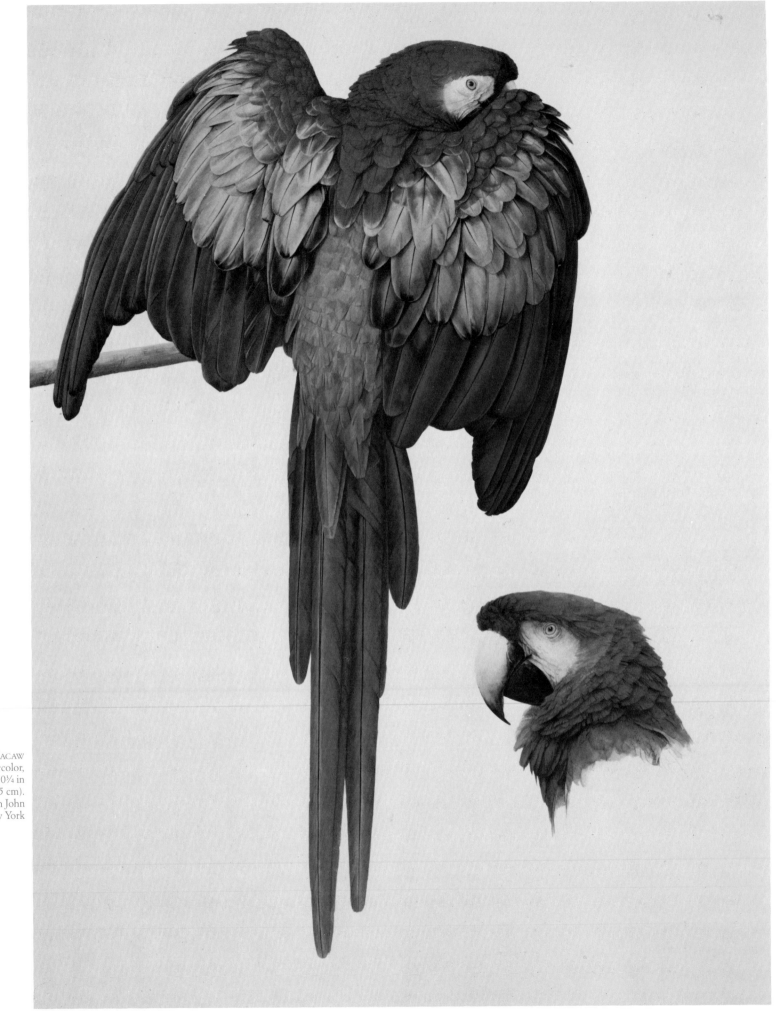

SCARLET MACAW
1979. Watercolor,
27⅞ x 20¾ in
(70.7 x 52.5 cm).
Collection John
Richardson, New York

ELIZABETH BUTTERWORTH
Born Rochdale, England, 1949,
lives in London

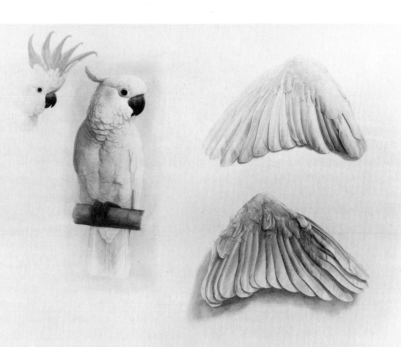

Citron-crested Cockatoo with Wing Studies
1982. Watercolor, 23¾ x 27¼ in (60.3 x 70.5 cm).
Collection Mrs. Samuel P. Reed

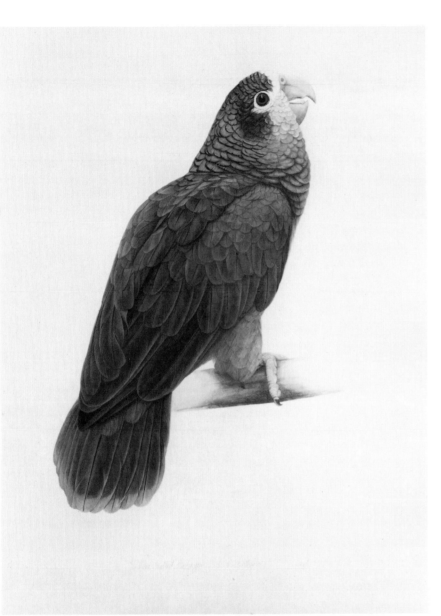

Yellow-billed Amazon Parrot
1980. Watercolor,
11½ x 9½ in (29.2 x 24.1 cm).
Collection Rodolphe d'Erlanger

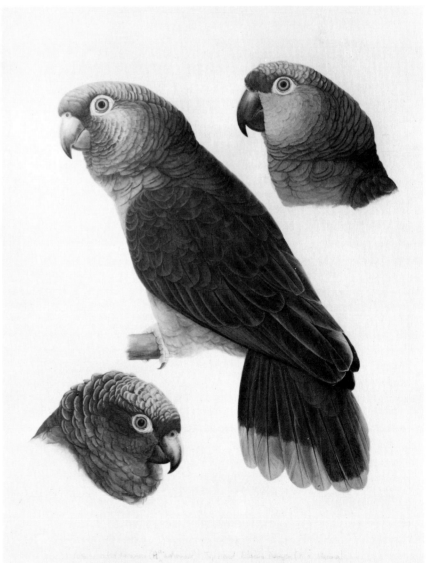

Yellow-cheeked Amazon Parrot,
Head of Lilacine Amazon Parrot, and
Head of Salvins Amazon Parrot
1980. Watercolor, 11½ x 9½ in (29.2 x 24.1 cm).
Collection Rodolphe d'Erlanger

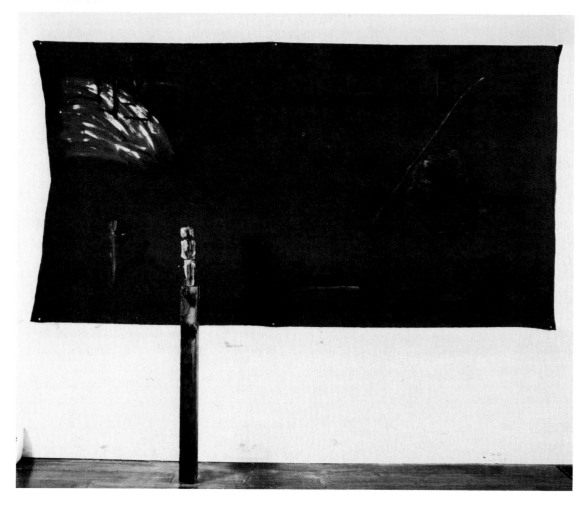

TEMPTATION OF ST. ANTHONY
IN FORM OF A WOMAN (AFTER SASETTA)
1983. Oil on cloth with sculptural element,
65 in x 10 ft 3 in (165.1 x 312.4 cm).
Lawrence Oliver Gallery,
Philadelphia, Pennsylvania

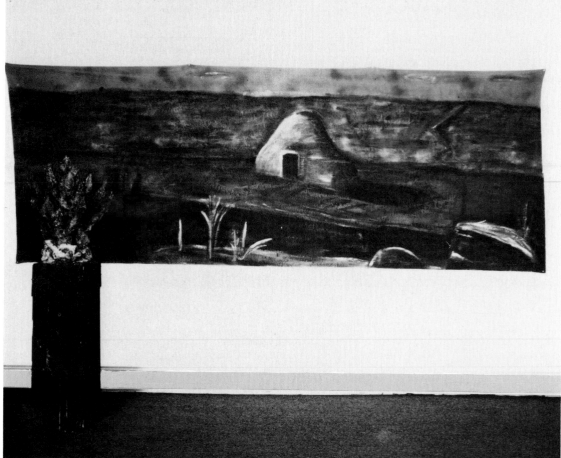

LOOKING TO THE WEST
IN A DIMINISHING LIGHT
1983. Oil on cloth with sculptural
element, 48 in x 12 ft (121.9 x
365.8 cm). Lawrence Oliver Gallery,
Philadelphia, Pennsylvania

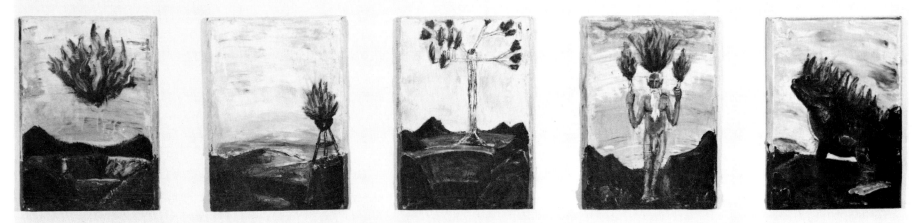

FIVE ILLUMINATIONS CONCERNING FIRE
1983. Oil on plaster on wood, in five parts, each 16 x 12 in (40.6 x 30.5 cm). Lawrence Oliver Gallery, Philadelphia, Pennsylvania

Detail of
Kingdom of One

KINGDOM OF ONE
1983. Oil on cloth with sculptural element,
67 in x 8 ft 5 in (170.2 x 256.5 cm).
Collection Mr. and Mrs. Harvey J. Gushner.
Courtesy Lawrence Oliver Gallery, Philadelphia,
Pennsylvania, and Willard Gallery, New York

MICHAEL BYRON
Born Providence, Rhode Island, 1954,
lives in New York

MIRIAM CAHN
Born Basel, Switzerland, 1949,
lives in Basel

HANDELSSCHIFF (from
Das Fliehen des Mannes)
MERCHANT SHIP (from
The Flight of Men)
1981–82. Black chalk on
parchment paper,
9 ft 6⅛ in x 13 ft 5½ in
(290 x 440 cm).
Collection the artist

EINBAUM
CANOE
1980. Charcoal
on parchment
paper, 61⅜ in x
7 ft 11¼ in (156 x 242 cm).
Kupferstichkabinett,
Oeffentliche
Kunstsammlung,
Basel, Switzerland

MANNLICHES FELD
(from *Wach Raum*)
MANLY FIELD
(from Wake Room)
1982. Black chalk on
parchment paper,
in six parts,
overall 10 ft 10 in x
23 ft 7½ in
(330 x 720 cm).
Collection the artist

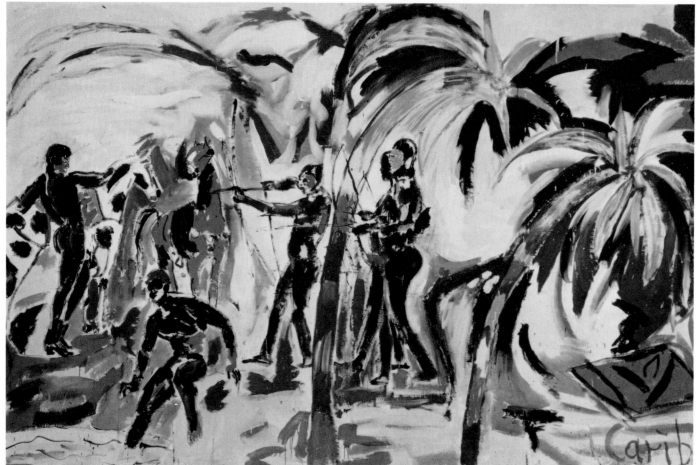

CARIB
1982. Dispersion on canvas,
9 ft 10⅛ in x 16 ft 4⅞ in (300 x 500 cm).
Collection the artist

(with Salomé)
SEILTANZER, I
TIGHTROPE WALKER, I
1979. Mixed mediums on canvas,
in two parts, overall 7 ft 10½ in x
13 ft ½ in (240 x 400 cm).
Galerie Bruno Bischofberger,
Zurich, Switzerland

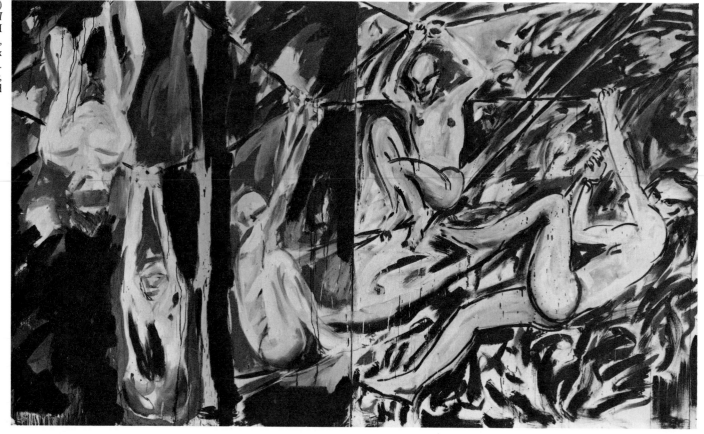

LUCIANO CASTELLI
Born Lucerne, Switzerland, 1951,
lives in Berlin

LUCIANO UND DER SCHWAN
LUCIANO AND THE SWAN
1981. Dispersion on canvas,
63 in x 6 ft 6¾ in (160 x 200 cm).
Private collection, Paris

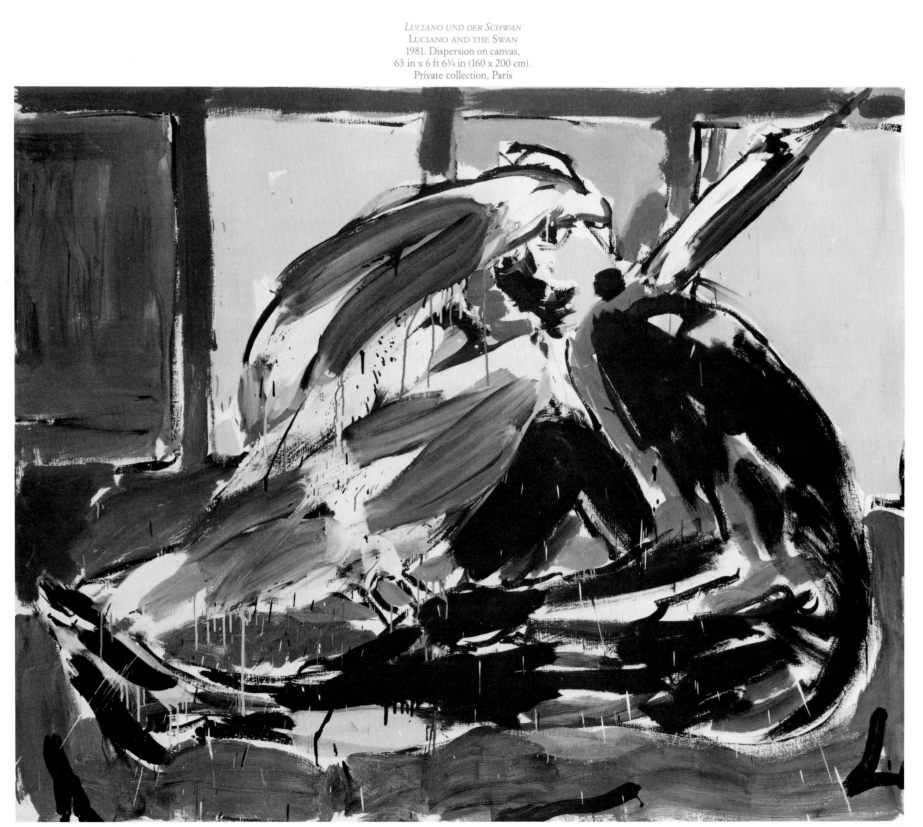

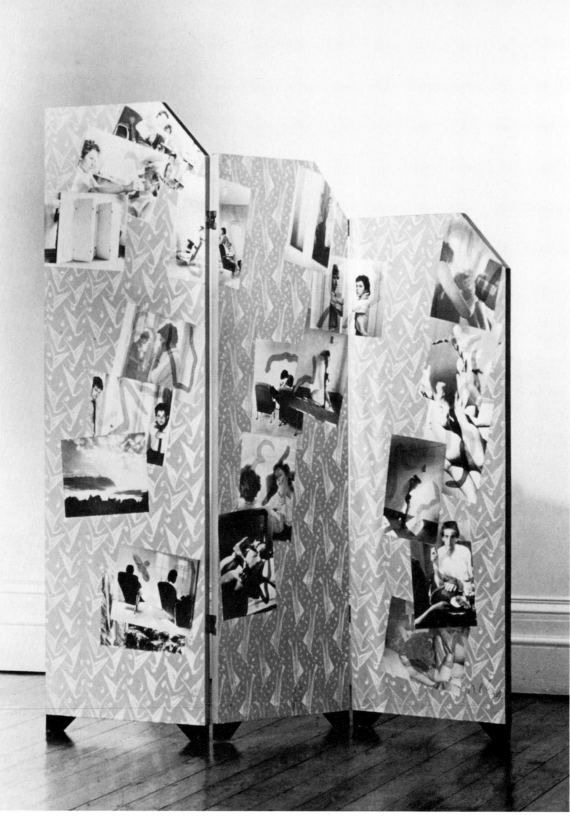

THREE-PART SCREEN
1979. Photographs on painted plywood,
overall approx. 6 x 6 ft (182.9 x 182.9 cm).
Nigel Greenwood Inc. Ltd., London

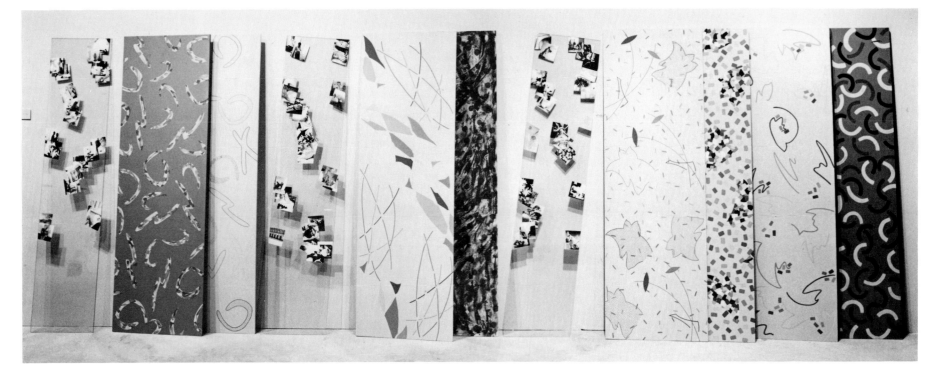

VIENNA TRIPTYCH, LEANING…AND SURROUNDED
BY CHORUS GIRLS AND SENTINELS
1982. Six glass panels, painted photographs,
eight wood panels and paint,
70⅞ in x 19 ft 8¼ in (180 x 600 cm).
Nigel Greenwod Inc. Ltd., London

HIER UND DORT
HERE AND THERE
1979. Installation with slide
projection, pendulum, text,
and furniture by Josef Hoffmann,
at Galerie Nächst St. Stephan,
Vienna, Austria, 1979

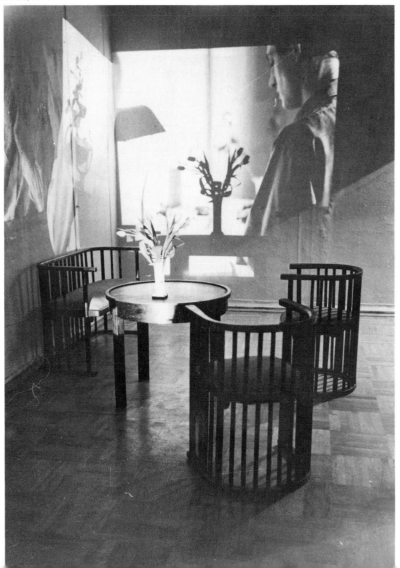

MARC CAMILLE CHAIMOWICZ
Born Paris, 1947, lives in London

83

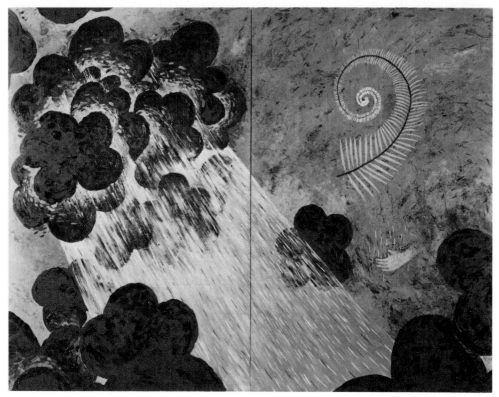

LOUISA CHASE
Born Panama City, Panama, 1951,
lives in New York

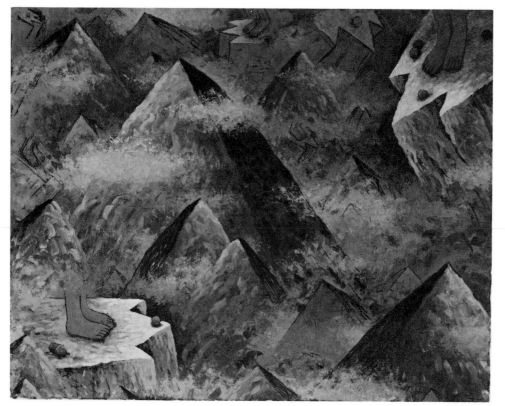

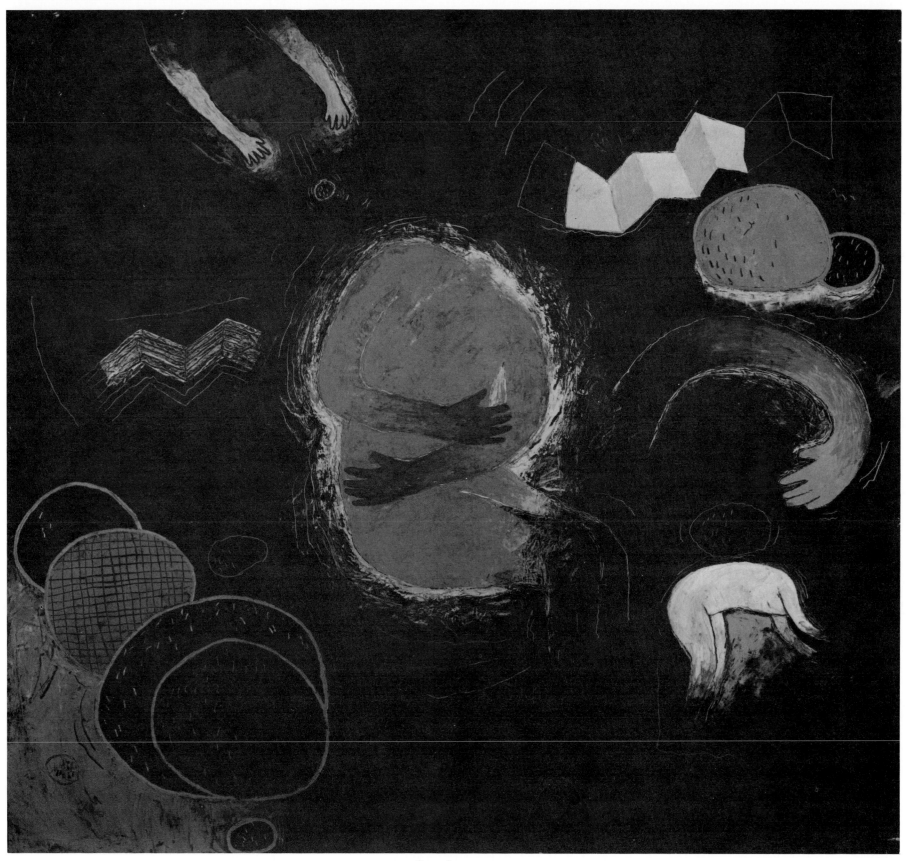

SAINT SEBASTIAN
1979. Oil on canvas,
6 ft x 6 ft 6 in (182.9 x 198.1 cm).
Collection Mera and Donald Rubell

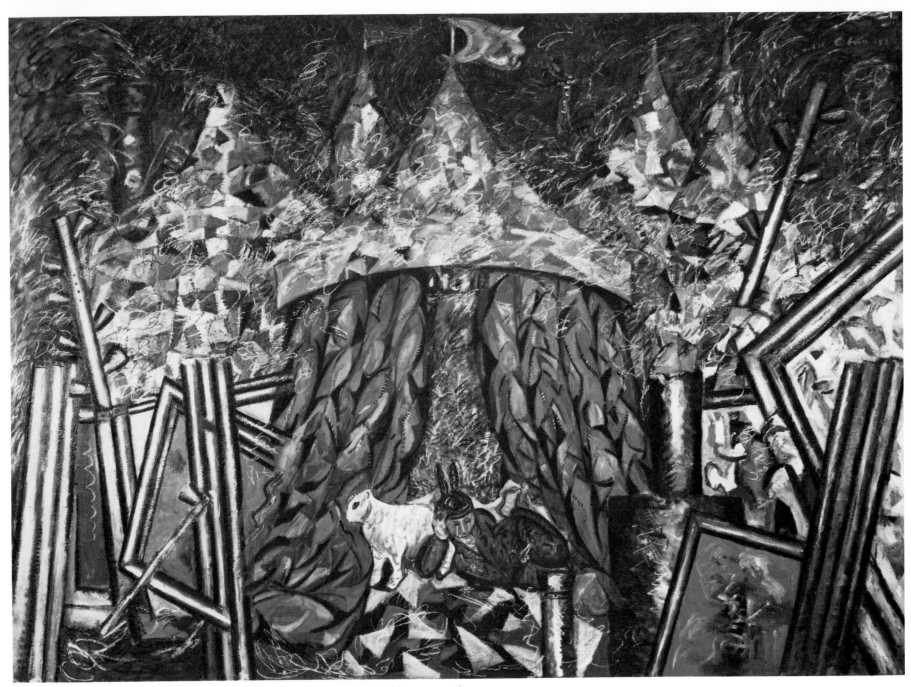

Malinconico Accampamento
Melancholic Encampment
1982. Oil on canvas,
9 ft 6⅛ in x 13 ft 3 in
(290 x 404 cm).
Collection Gerald S. Elliott

Sandro Chia
Born Florence, Italy, 1946, lives in Rome and
Ronciglione, Italy, and New York

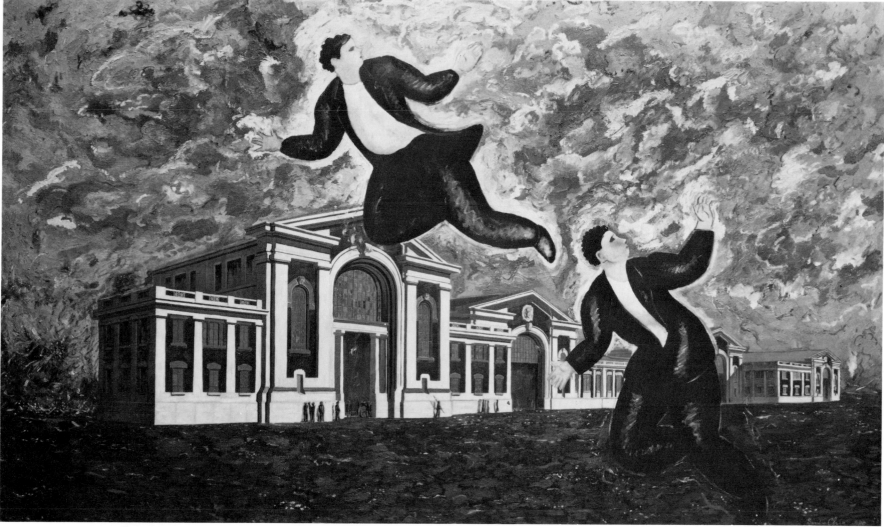

Genova
1980. Oil on canvas,
7 ft 5 in x 13 ft
(226 x 396 cm).
Collection Heiner
Bastian, Berlin

Ossa, cassa, fossa
Bones, Coffin, Ditch
1978. Oil on canvas,
69 in x 6 ft 10½ in
(175 x 210 cm).
Private collection,
Turin, Italy

FRANCESCO CLEMENTE
Born Naples, Italy, 1952,
lives in Rome; Madras, India;
and New York

CONVERSION TO HER
1983. Fresco of plaster on three Styrofoam
and fiberglass panels, 8 ft x 9 ft 4¾ in x
2¾ in (244 x 286.7 x 7 cm).
The Museum of Modern Art, New York.
Mr. and Mrs. Sid R. Bass Fund

MOON
1980. Tempera on handmade paper
mounted on cloth, 8 ft ½ in x 7 ft 7 in
(245 x 231 cm). Private collection

SEMEN
1983. Oil on linen, 7 ft 9 in x 11 ft 11½ in
(236 x 395 cm). Collection Mrs. Gustavo Cisneros

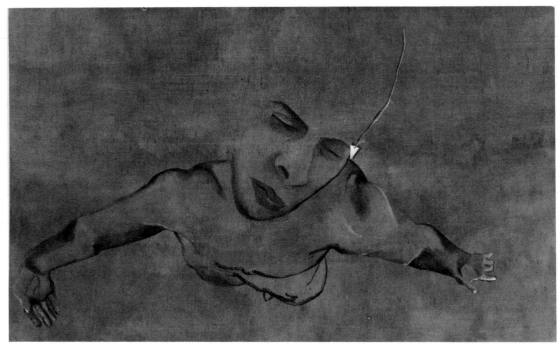

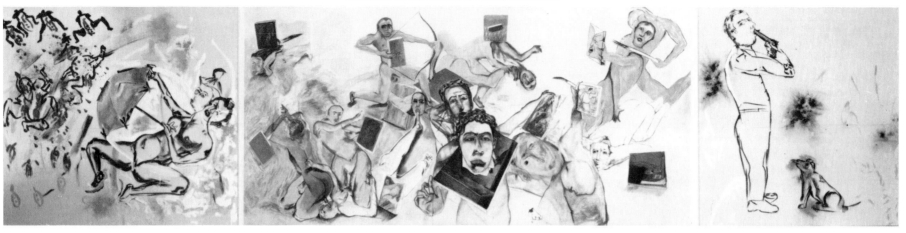

THE BATTLE OF PAINTING
1981. Oil on canvas, in three parts, overall
7 ft 6 in x 31 ft 4⅜ in (228.5 x 956 cm).
Collection Thomas Ammann, Zurich, Switzerland

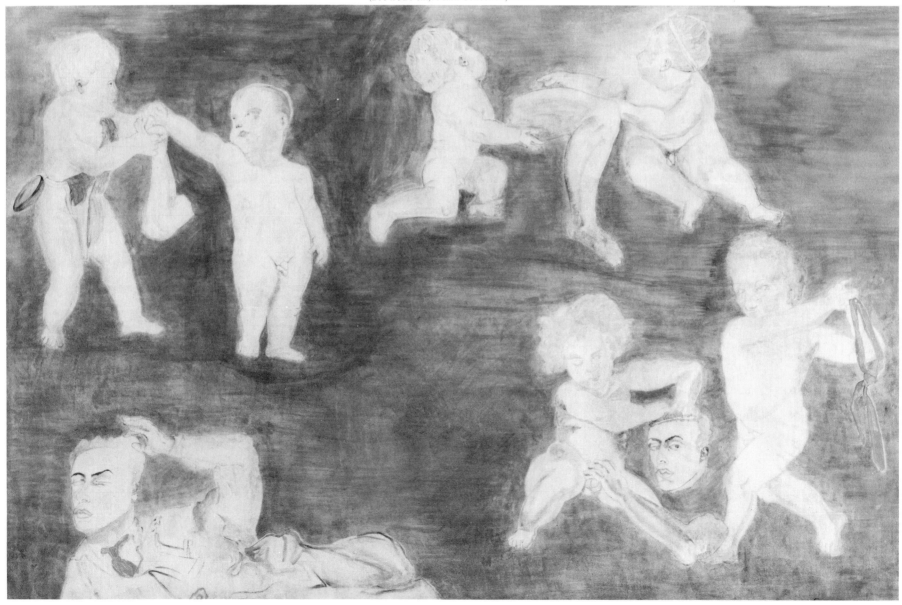

PRIAPEA
1980. Fresco, 6 ft 6¾ in x 10 ft 6 in
(200 x 320 cm). Marx Collection, Berlin

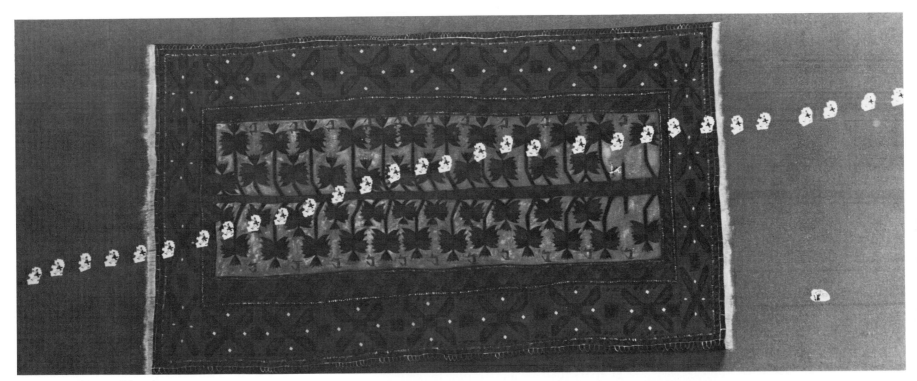

RECENT WARS–AFGHANISTAN
1982. Oil on canvas, 66⅞ in x 14 ft 1¼ in
(170 x 430 cm). Ray Hughes Gallery,
Brisbane, Australia

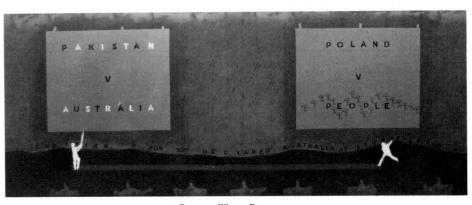

RECENT WARS–POLAND
1982. Oil on canvas, 66⅞ in x 14 ft 1¼ in
(170 x 430 cm). Ray Hughes Gallery,
Brisbane, Australia

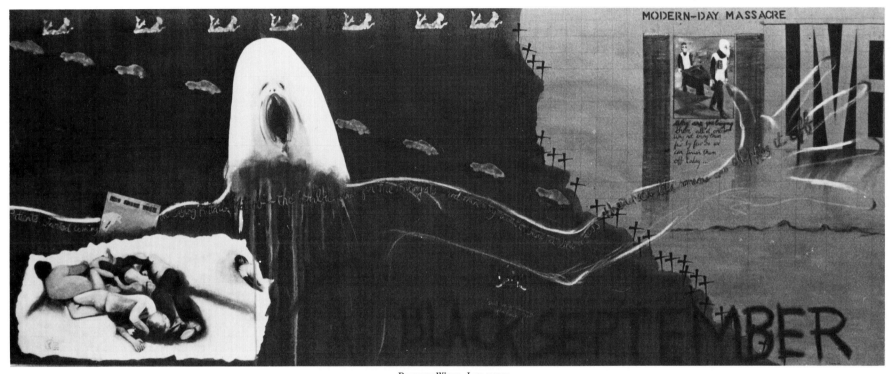

RECENT WARS–LEBANON
1982. Oil on canvas, 66⅞ in x 14 ft 1¼ in
(170 x 430 cm). Ray Hughes Gallery,
Brisbane, Australia

UNTITLED 3
1981. Synthetic polymer paint on canvas,
7 ft 2⅝ in x 61 in (220 x 155 cm).
Art & Project, Amsterdam, Netherlands

UNTITLED 4
1981. Synthetic polymer paint on canvas,
9 ft 2¼ in x 7 ft 2⅝ in (280 x 220 cm).
Art & Project, Amsterdam, Netherlands

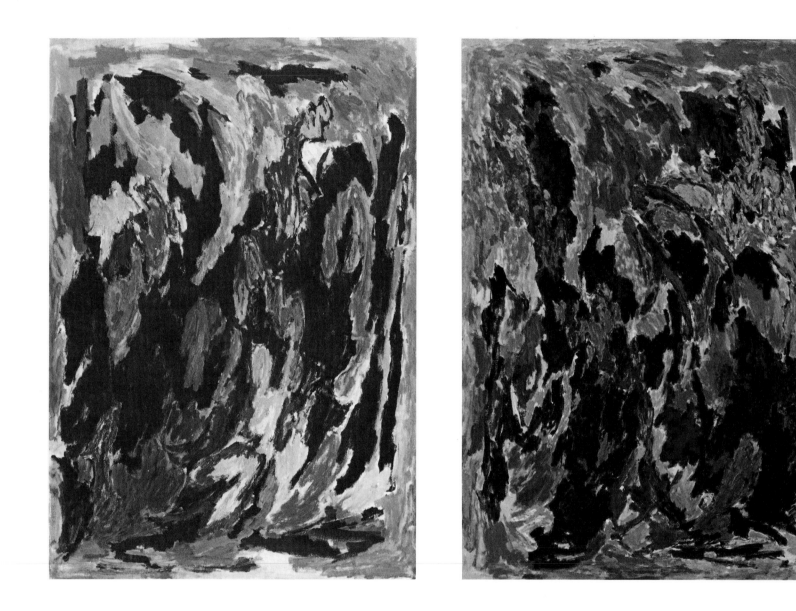

JAN COMMANDEUR
Born Avenhorn, Netherlands, 1954, lives in Amsterdam

Right
UNTITLED 2
1981. Synthetic polymer paint on
canvas, in four parts, left to right,
15¾ x 15¾ in (40 x 40 cm);
55¼ x 7⅞ in (140.5 x 20 cm);
6 ft 8¼ in x 7⅞ in (203.5 x 20 cm);
8 ft 7½ in x 15¾ in (263 x 40 cm).
Collection Banque Paribas Nederland, N.V.

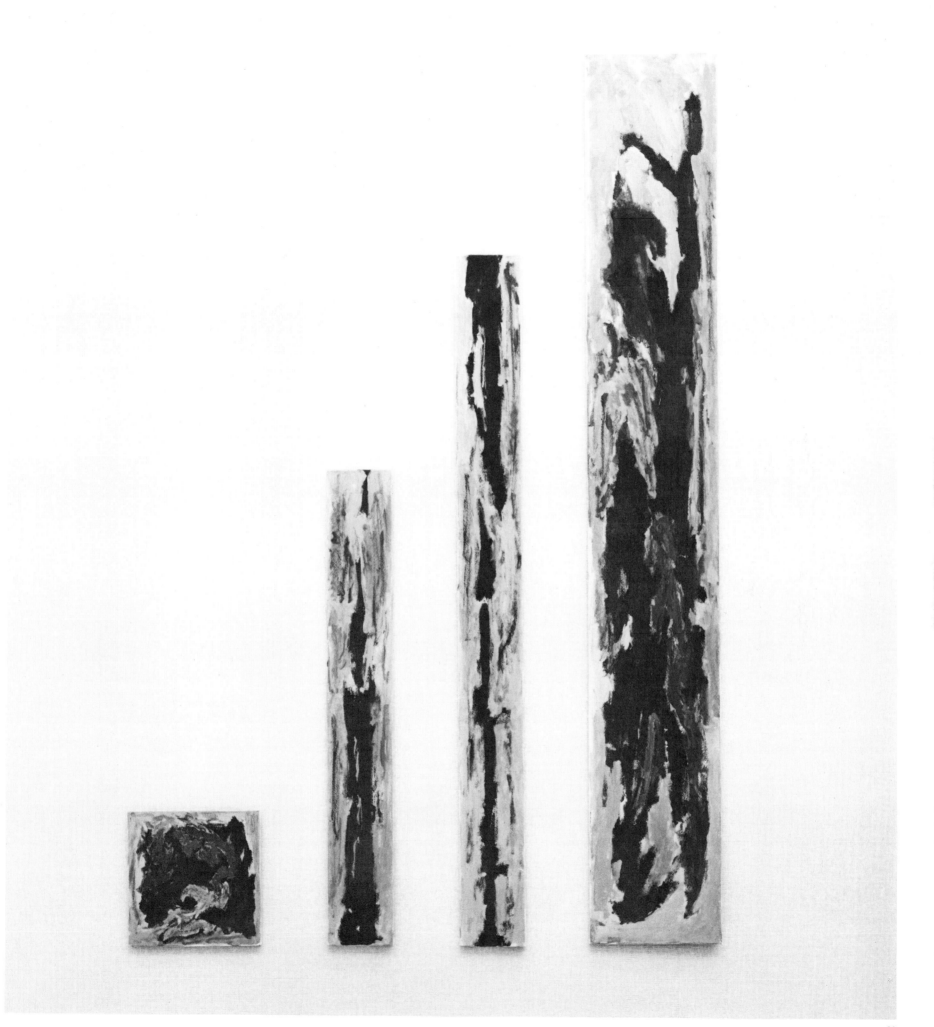

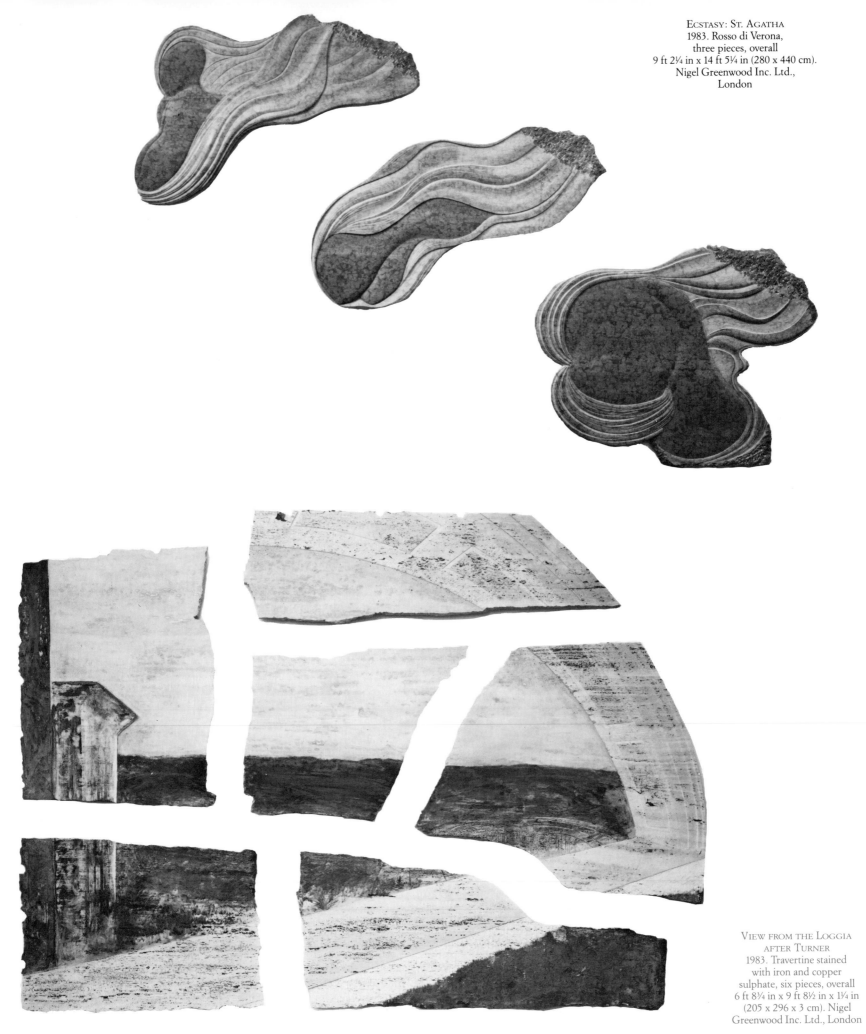

ECSTASY: ST. AGATHA
1983. Rosso di Verona,
three pieces, overall
9 ft 2¼ in x 14 ft 5¼ in (280 x 440 cm).
Nigel Greenwood Inc. Ltd.,
London

VIEW FROM THE LOGGIA
AFTER TURNER
1983. Travertine stained
with iron and copper
sulphate, six pieces, overall
6 ft 8¼ in x 9 ft 8½ in x 1¼ in
(205 x 296 x 3 cm). Nigel
Greenwood Inc. Ltd., London

GETHSEMANE
1982. Peperino stone, fifteen pieces, overall 10 ft x 20 ft x 2 in (304.8 x 609.6 x 5.1 cm). The Trustees of the Tate Gallery, London

STEPHEN COX
Born Bristol, England, 1946, lives in London and Italy

TONDO: RUMA
1982. Peperino stone, 31½ in (80 cm) diam.
Nigel Greenwood Inc. Ltd., London

TONY CRAGG
Born Liverpool, England, 1949,
lives in Wuppertal, West Germany

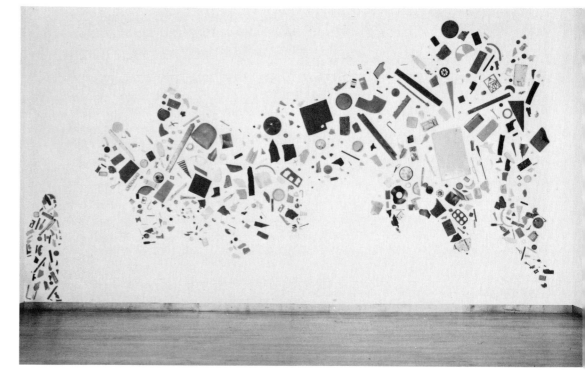

BRITAIN SEEN FROM THE NORTH
1981. Mixed materials,
12 ft 1½ in x 22 ft 11 in (369.6 x 698.5 cm)
The Trustees of the Tate Gallery, London

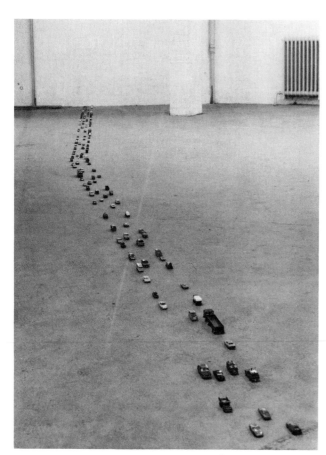

AUTOBAHN
1979. Metal and plastic toy cars.
Installation at Kunstlerhaus Weidenhalle,
Hamburg, West Germany, 1979

HOOVER
1981. Mixed materials.
Installation at Musée
d'Art et d'Industrie,
St.-Étienne, France, 1981

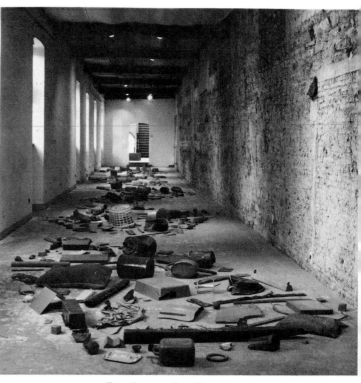

FIVE COLORS–FIVE OBJECTS
1980. Five objects on wall (green bottle, blue sheet of paper,
red rock, yellow fish, orange frying pan),
mixed materials of each color on floor. Installation at
Museum voor Hedendaagse Kunst, Ghent, Belgium, 1980

96

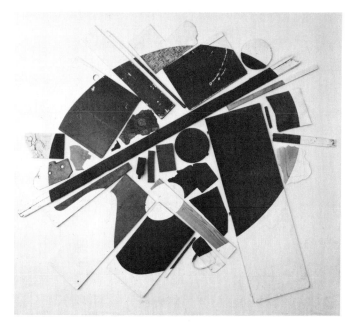

PALETTE
1982. White paint on mixed materials.
Installation at Galerie Chantal
Crousel, Paris, 1982

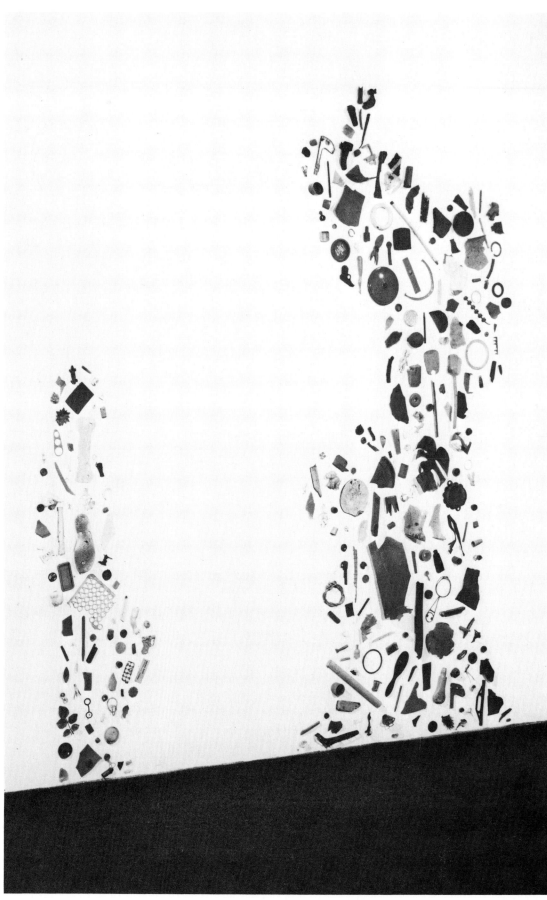

LOOKING AT SCULPTURE
1980. Mixed materials,
10 ft 6 in x 8 ft 2⅜ in
(320 x 250 cm). Collection
Angelo Baldassare, Bari, Italy

UNTITLED
1978. Oil on canvas,
9½ x 11 in (24 x 28 cm).
Collection Thomas Ammann,
Zurich, Switzerland

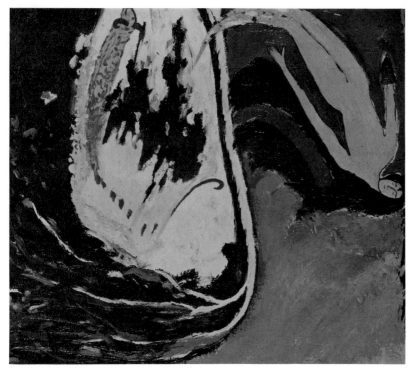

EROICI MARI ROSSI
1981. Oil on canvas,
6 ft 6¾ in x 8 ft 6 in (200 x 259 cm).
Collection Thomas Ammann,
Zurich, Switzerland

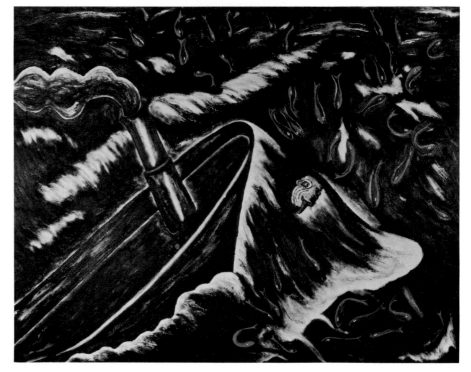

Paesaggio barbaro
BARBARIC LANDSCAPE
1983. Oil on canvas,
9 ft 9 in x 12 ft 11½ in
(297 x 395 cm).
Staatsgalerie Stuttgart,
Stuttgart, West Germany

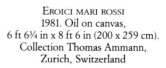

Right
TESTE DI TERRA COTTA
1980. Charcoal on paper on canvas
and terra-cotta sculpture:
drawing, 8 ft 11⅛ in x 19 ft 3½ in
(272 x 588 cm); sculpture, 10⅝ x 15 x 12 in
(27 x 38.1 x 30.4 cm).
Collection Joshua Mack,
Byram, Connecticut

ENZO CUCCHI
Born Morro d'Alba, Italy, 1950, lives in Ancona, Italy

DISEGNO TONTO
SILLY DRAWING
1982. Charcoal on paper
on canvas and painted
canvas object, 6 ft 8 in x
13 ft 5½ in (203 x 410 cm).
Kunsthaus, Zurich,
Switzerland

(with Jiři Georg Dokoupil)
DEUTSCHER WALD
GERMAN FOREST
1981. Dispersion on
nettle cloth, in two parts,
overall 7 ft 2⅝ in x
9 ft 8⅛ in (220 x 295 cm).
Collection Rudolph Scharpff,
Weinheim/Bergstrasse,
West Germany

TRINKER
DRINKER
1982. Dispersion on
nettle cloth, 6 ft 6¾ in x
59 in (200 x 150 cm).
Private collection

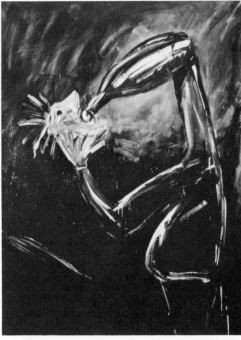

DER KETTENRAUCHNER
THE CHAIN-SMOKER
1982. Dispersion on
nettle cloth, 6 ft 6¾ in x
59 in (200 x 150 cm).
Collection Lewis and Susan
Manilow, Chicago, Illinois

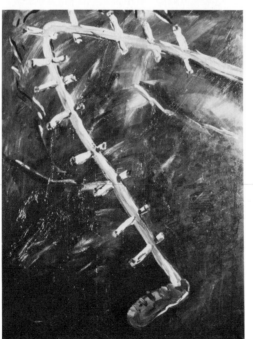

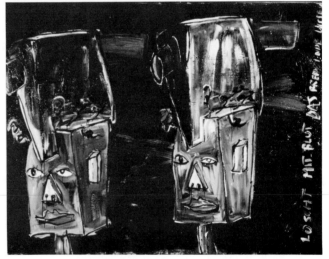

SELBST DOPPELT
SELF DOUBLED
1982. Dispersion on
nettle cloth, 6 ft 6¾ in x
8 ft 2½ in (200 x 250 cm).
Galerie Paul Maenz,
Cologne, West Germany

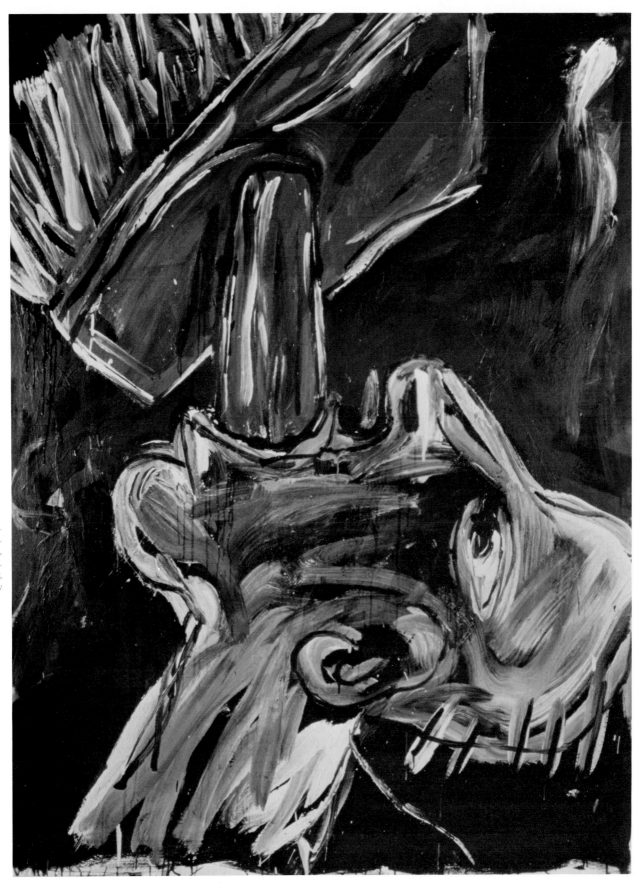

Einen Besen fressen...
Eating a Broom...
1981. Dispersion on canvas,
6 ft 6¼ in x 59 in (200 x 150 cm).
Collection Helmut Seiler,
West Germany

WALTER DAHN
Born Krefeld, West Germany, 1954,
lives in Cologne, West Germany

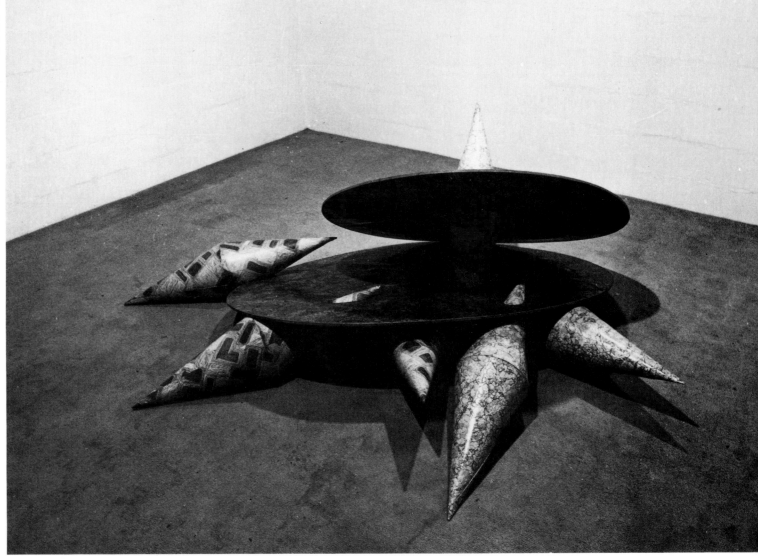

BOYS AND GIRLS
1982. Linoleum and plywood,
7 ft x 60 in x 30 in (213.4 x
152.4 x 76.2 cm). The British
Council, London

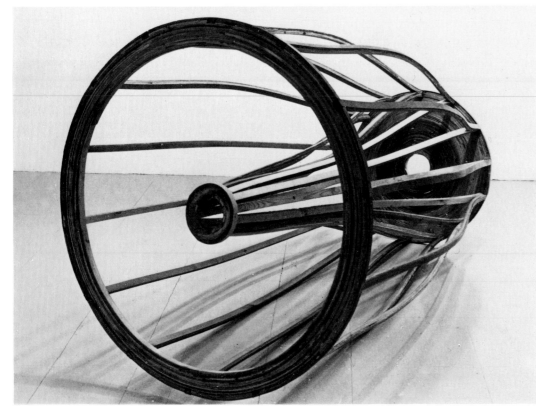

ART FOR OTHER PEOPLE No. 5
1982. Laminated wood,
42 in x 42 in x 6 ft
(106.7 x 106.7 x 182.9 cm).
Collection Doris and Charles
Saatchi, London

RICHARD DEACON
Born Wales, Great Britain, 1949,
lives in London

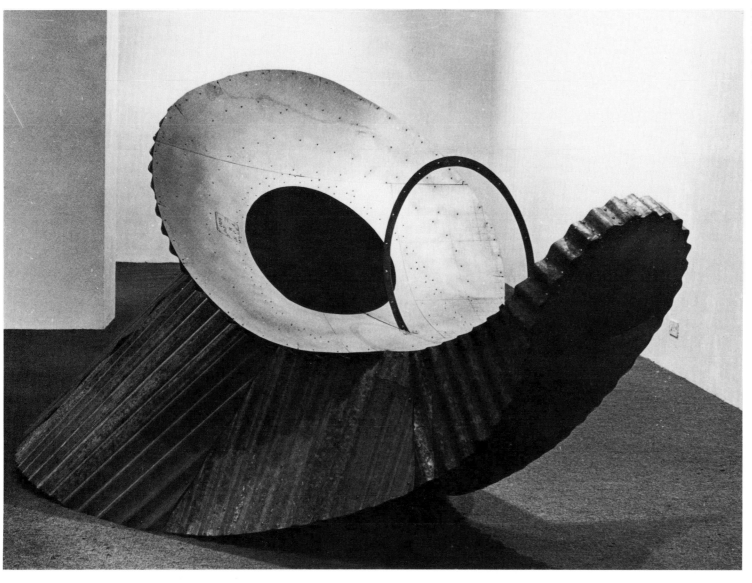

IF THE SHOE FITS
1981. Galvanized, corrugated,
and sheet steel, 10 ft x 60 in x
60 in (304.8 x 152.4 cm).
Collection Doris and Charles
Saatchi, London

THE EYE HAS IT
1983. Wood, stainless steel,
galvanized steel, brass, and cloth,
39⅜ in x 9 ft 10⅛ in x 39⅜ in
(100 x 300 x 100 cm) (variable).
The Arts Council of
Great Britain, London

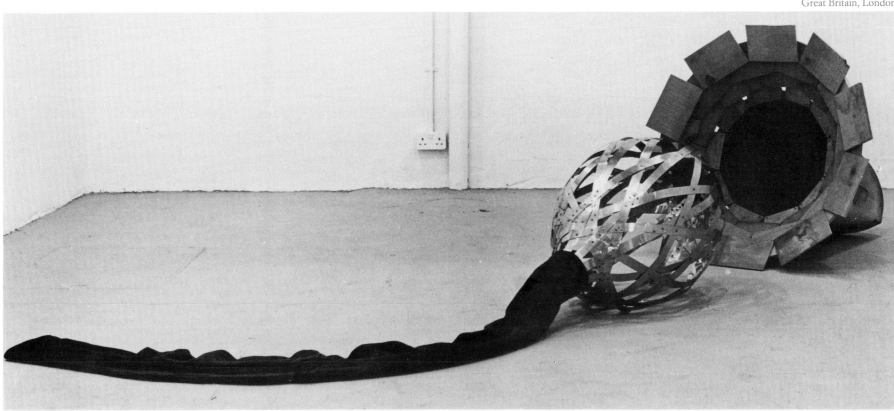

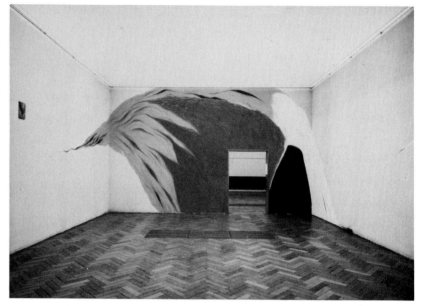

La Testa dell'artista
(poesia che non rimane)
The Head of the Artist
(which May Not Remain)
1980. Installation at Stedelijk Museum,
Amsterdam, Netherlands, 1980

Torre a scoppia
Tower of Explosion
1982. Fresco.
Installation at
Galleria Marilena Bonomo,
Spoleto, Italy, 1982

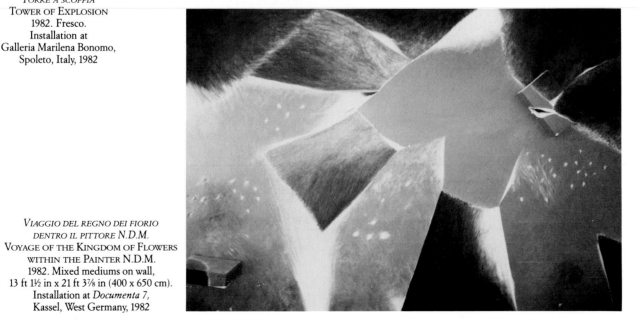

Viaggio del regno dei fiorio
dentro il pittore N.D.M.
Voyage of the Kingdom of Flowers
within the Painter N.D.M.
1982. Mixed mediums on wall,
13 ft 1½ in x 21 ft 3⅞ in (400 x 650 cm).
Installation at *Documenta 7*,
Kassel, West Germany, 1982

Sono Africano, sono Asiatico
I Am African, I Am Asian
1980–81. Mixed mediums on paper on canvas,
7 ft 2⅜ in x 8 ft 10¼ in (220 x 270 cm).
Collection Anders Wall, Stockholm, Sweden

NICOLA DE MARIA
Born Foglianese, Italy, 1954, lives in Foglianese and Turin, Italy

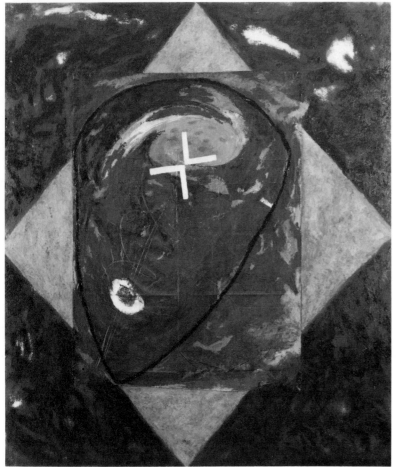

FIGURA D'INTESA
IMAGE OF UNDERSTANDING
1983. Oil on linen,
7 ft 1½ in x 6 ft 2 in
(217.2 x 188 cm).
Salvatore Ala Gallery,
New York

GIANNI DESSÌ
Born Rome, 1955, lives in Rome

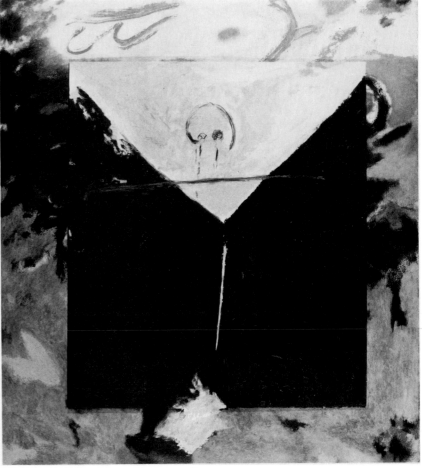

ELEGIA
ELEGY
1983. Oil and charcoal on wood and canvas,
7 ft 2⅜ in x 6 ft 6¾ in (220 x 200 cm).
Galleria Salvatore Ala, Milan, Italy

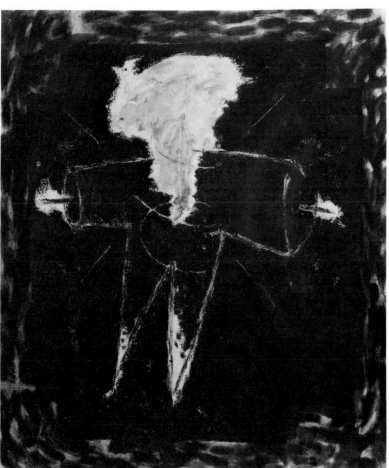

SPIRITOSO
WITTY
1983. Oil and clay on linen,
7 ft 1½ in x 6 ft 2 in
(217.2 x 188 cm).
Salvatore Ala Gallery,
New York

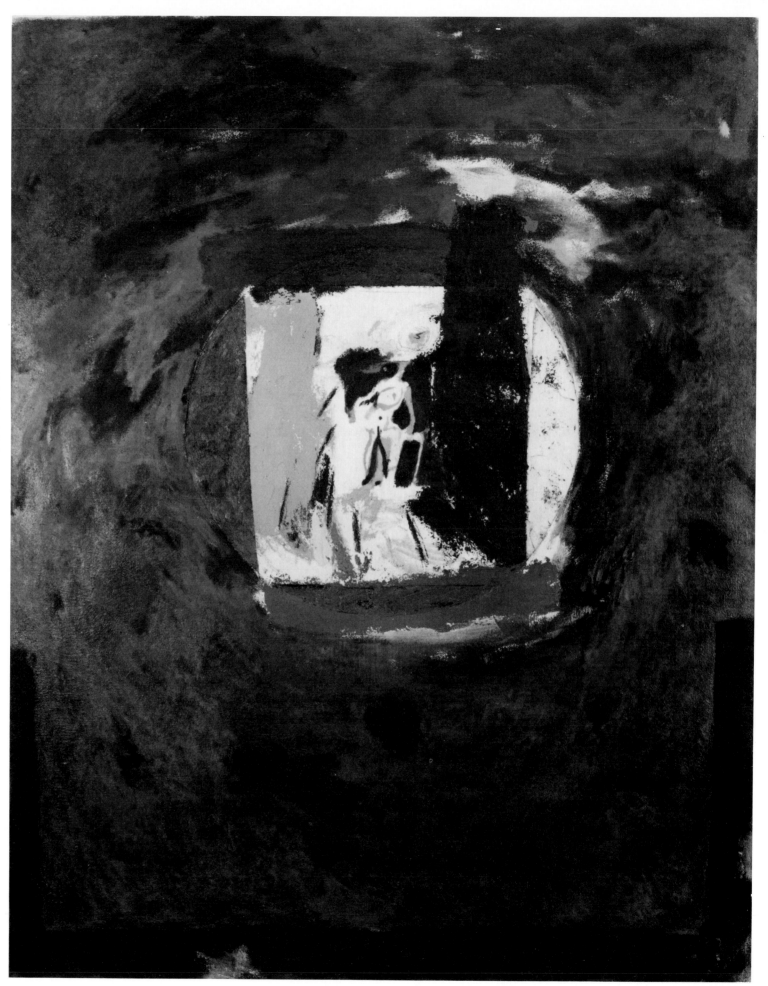

QUADRIVIO
CROSSROADS
1983. Oil and paper
on canvas, 7 ft 10½ in x
6 ft 3 in (240 x 190.5 cm).
Salvatore Ala Gallery,
New York

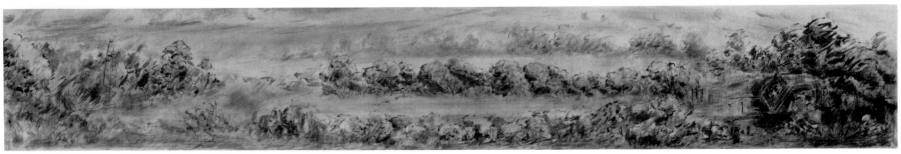

UNTITLED
1982. Ink on paper on canvas, 24 in x 12 ft (61 x 365. 8 cm). Private collection

DAVID DEUTSCH
Born Los Angeles,
California, 1943,
lives in New York

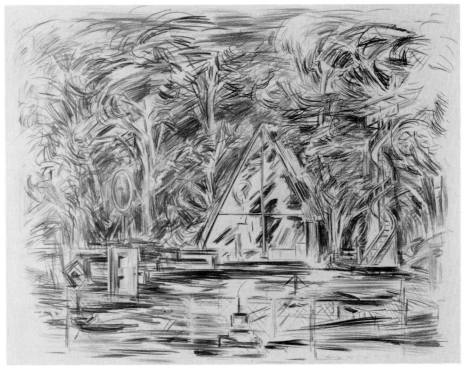

UNTITLED
1980. Pencil on paper, 6 ft x 7 ft 7 in (182.9 x 231.1 cm). Private collection

UNTITLED
1980. Ink on paper, 6 ft x 15 ft (182.9 x 457.2 cm). Private collection

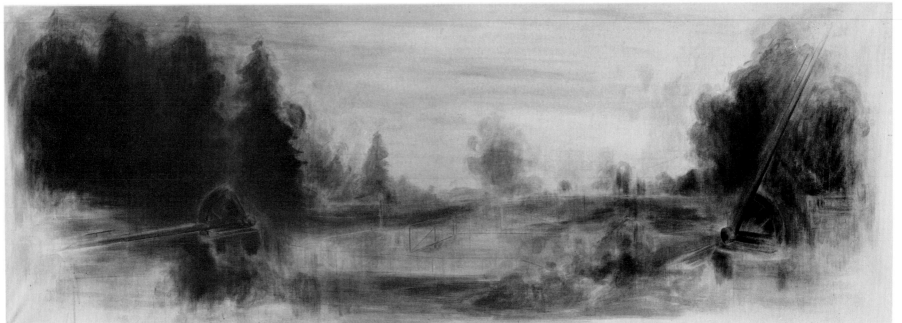

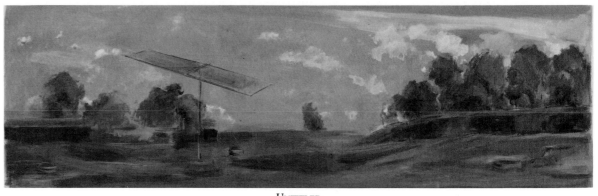

UNTITLED
1982. Synthetic polymer paint and gouache on paper on canvas, 6 ft 3 in x 20 ft (190.5 x 609.6 cm). Private collection

BELL LABS NO. 1
1978. Ink on paper, 54 in x 7 ft 6 in (137.2 x 228.6 cm). Collection Sanders, Amsterdam, Netherlands

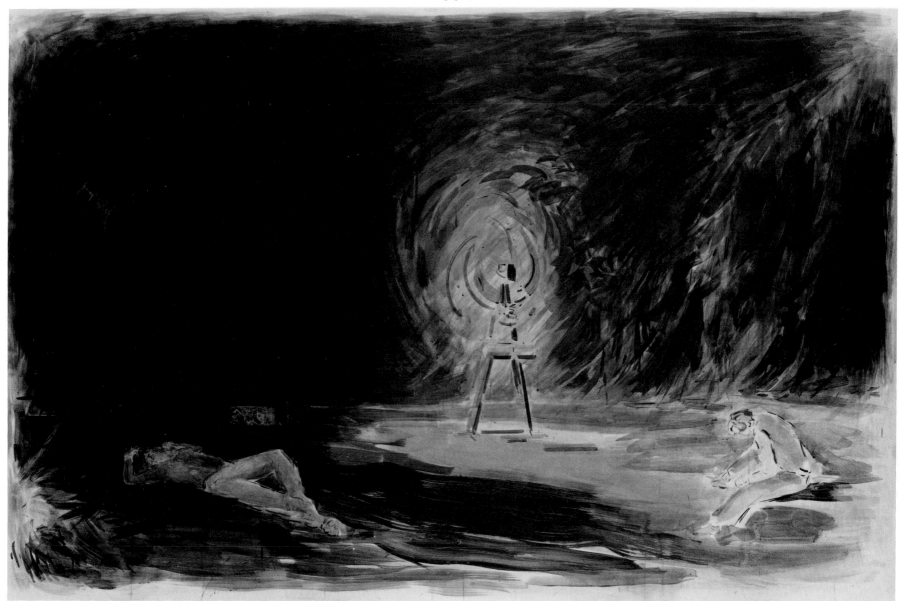

RE-ARRANGING
1981. Graphite, iron oxide,
and gold paint on paper,
57⅛ x 48 in (145 x 122 cm).
Galerie Walter Storms,
Munich, West Germany

THE THIEF AND THE HOUSE OWNER
1982. Graphite, iron oxide,
copper paint, and gold paint on canvas,
21⅜ x 51⅛ in (55 x 130 cm).
Collection the artist

HISSING
1983. Graphite, iron oxide,
and copper paint on canvas,
63¾ x 51⅛ in (162 x 130 cm).
Collection the artist

THE SERPENTS' PIT
1982. Graphite, iron oxide,
gold paint, and bronze paint on canvas,
25⅝ x 43¼ in (65 x 110 cm).
Collection the artist

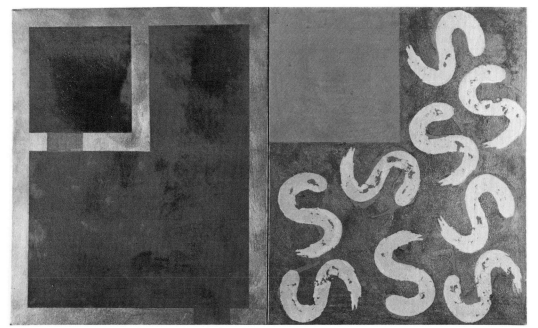

ANTONIO DIAS
Born Paraiba, Brazil, 1944,
lives in Milan, Italy

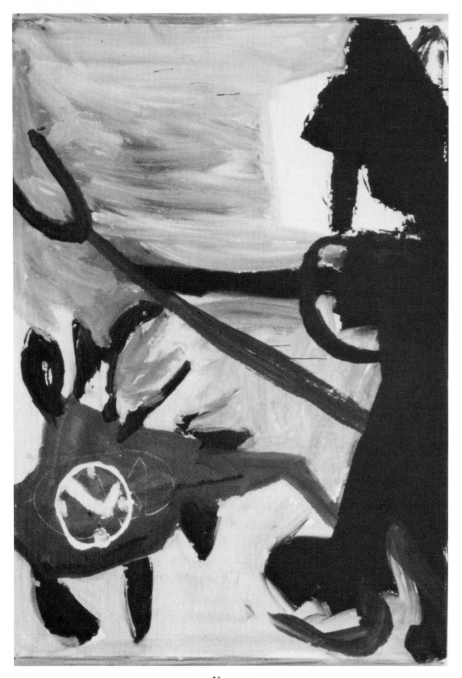

UNTITLED
1981. Synthetic polymer paint on canvas, 6 ft 10⅝ in x 66⅞ in (210 x 170 cm).
Private collection

MARTIN DISLER
Born Seewen, Switzerland, 1949,
lives in Zurich, Switzerland; New York;
and Harlingen, Netherlands

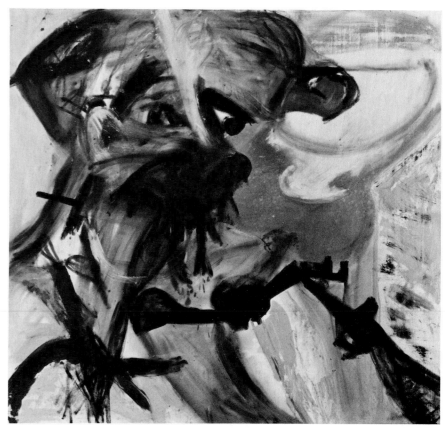

LOOSING THE FACE
1982. Synthetic polymer paint on canvas, 9 ft 4¼ in x 9 ft 11⅝ in (285 x 305 cm).
FER Collection, Laupheim, West Germany

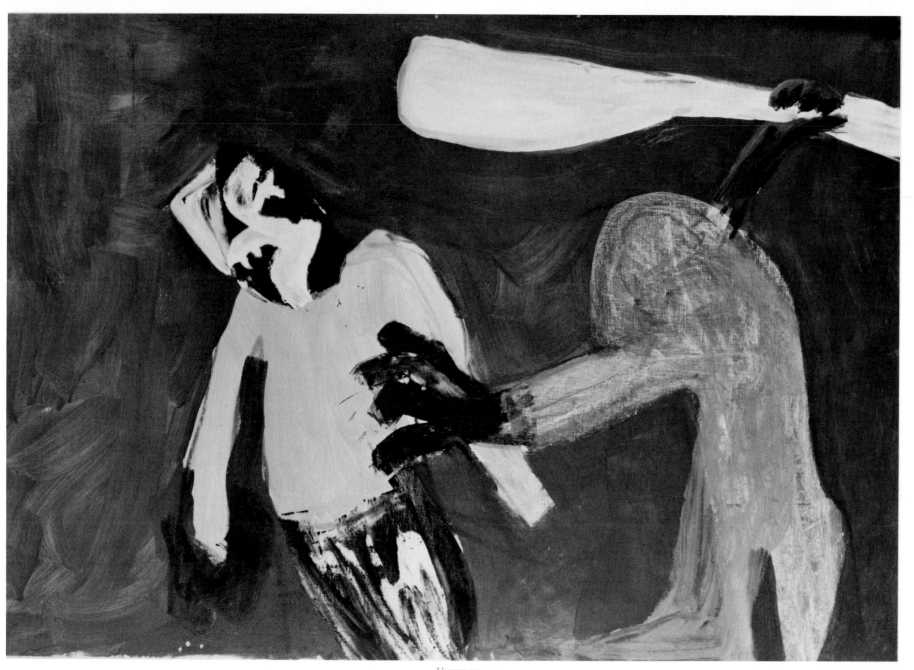

UNTITLED
1980. Oil on canvas, 6 ft 7½ in x 9 ft 6⅛ in (202 x 290 cm).
Collection Thomas Ammann, Zurich, Switzerland

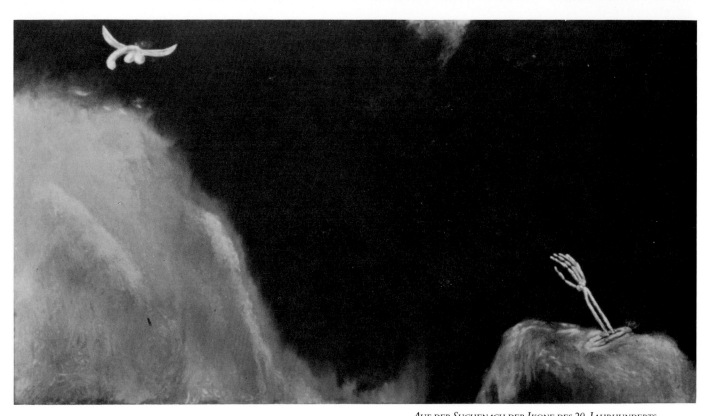

BLAUES BILD ÜBER DIE LIEBE
BLUE PAINTING ABOUT LOVE
1982. Dispersion on nettle cloth,
7 ft 6½ in x 7 ft 6½ in
(230 x 230 cm). Collection Gerd de
Vries, Cologne, West Germany

AUF DER SUCHENACH DER IKONE DES 20. JAHRHUNDERTS
IN SEARCH OF THE TWENTIETH-CENTURY ICON
1983. Dispersion on nettle cloth, 6 ft 6¾ in x
12 ft 3⅝ in (200 x 375 cm).
Galerie Paul Maenz, Cologne, West Germany

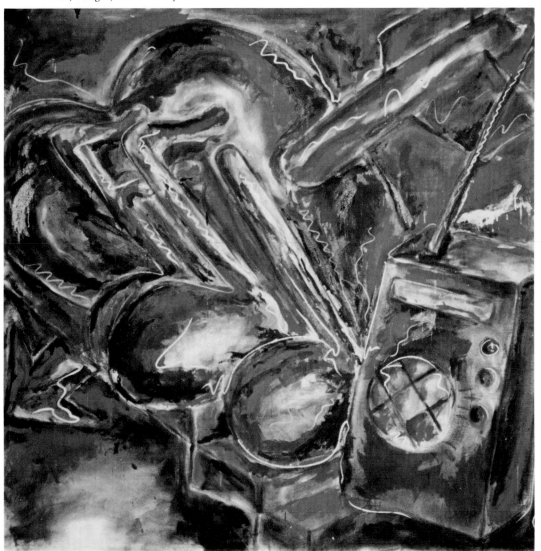

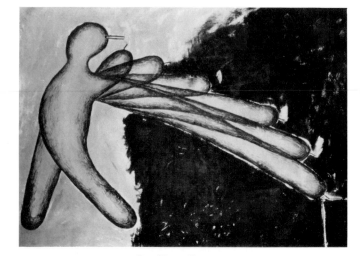

DER NAIVE FUTURISMUS
THE NAIVE FUTURISM
1980. Synthetic polymer paint
on nettle cloth, 50 in x 6 ft
(127 x 182.9 cm). Private collection

GEBURTSTAG DES GEFANGENEN FACHMANNS
BIRTHDAY OF THE IMPRISONED EXPERT
1982. Dispersion on canvas, in two parts, left, 8 ft 2⅛ in x
7 ft 10½ in (250 x 240 cm); right, 8 ft 2⅛ in x 23⅝ in
(250 x 60 cm). Metzger Collection, on extended loan to
Museum Folkwang, Essen, West Germany

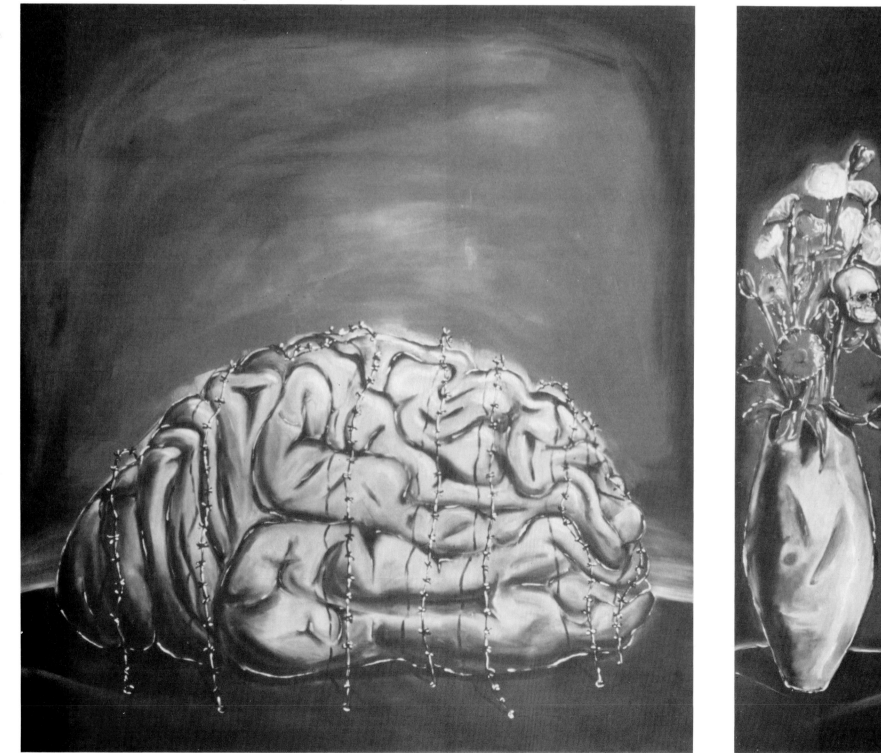

THREE PETS
1981. Photograph and synthetic polymer paint
on canvas, in frame, 9 ft 5 in x
9 ft 5 in (287 x 287 cm).
Marian Goodman Gallery, New York, and
Art & Project, Amsterdam, Netherlands

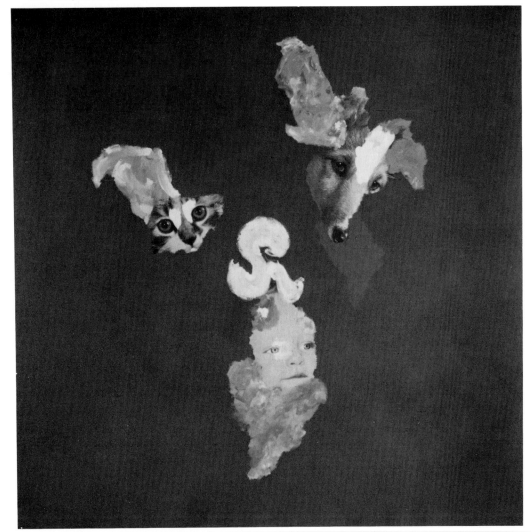

OLYMPIC SPORTIVE
1979. Color photographs and synthetic
polymer paint on canvas, and rubber strings,
12 ft 3⅜ in x 13 ft 2¼ in x 7 ft 10½ in
(375 x 402 x 240 cm). Museum Boymans–
van Beuningen, Rotterdam, Netherlands

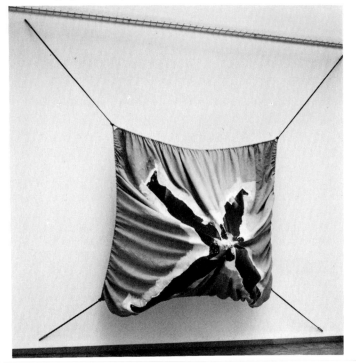

SEVEN CUBIST MOUTH PIECE
1979. Synthetic polymer paint
and photographs on clay, seven pieces, each
24 x 12 in (61 x 30.5 cm) diam.; installed,
overall 24 in x 15 ft x 12 in (61 x 457.2 x 30.5 cm).
Australian National Gallery,
Canberra, Australia

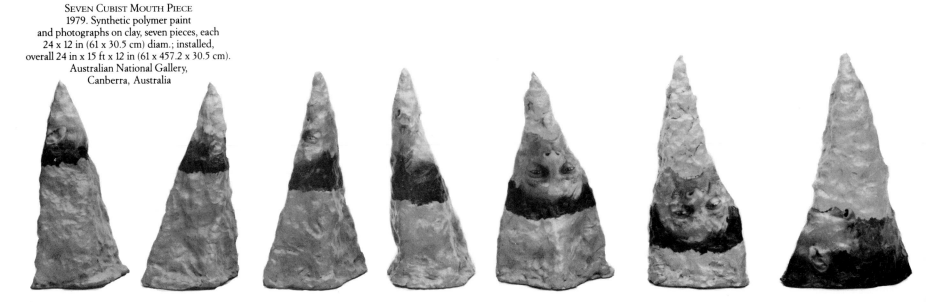

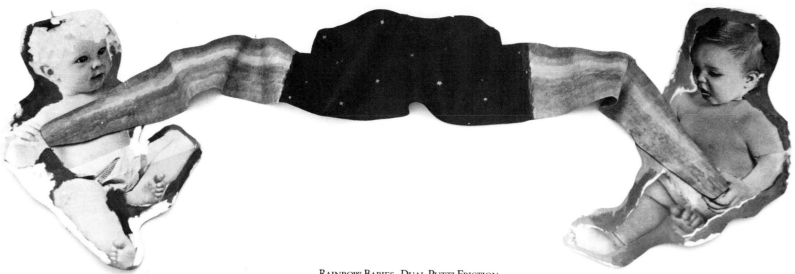

RAINBOW BABIES–DUAL PUTTI FRICTION
1980. Color photographs and synthetic polymer paint on canvas,
39⅜ x 12 ft 9½ in (100 x 390 cm).
Museum Boymans–van Beuningen, Rotterdam, Netherlands

UNTITLED
1982. Photograph and synthetic
polymer paint on canvas,
9 ft 6¼ in x 9 ft 6¼ in
(289.7 x 289.7 cm).
Rijksmuseum Kröller-Müller,
Otterlo, Netherlands

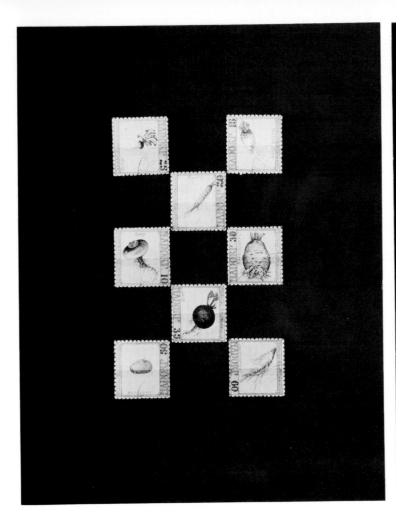

NADORP 1963–ROOT VEGETABLES
1975. Watercolor and rubber stamp on
paper, eight pieces, framed, 11½ x 8⅜ in
(29.3 x 21.3 cm). Hood Museum
of Art, Dartmouth College, Hanover,
New Hampshire. Bequest of
Jay R. Wolf, Class of 1951

Above right
NADORP 1961–APPLES OF NADORP
1976. Watercolor, rubber stamp,
and collage on paper, framed,
11½ x 8⅜ in (29.3 x 21.3 cm).
Private collection, New York

NADORP 1953–WINDMILLS
1977. Watercolor and stamp
on paper, twenty pieces, framed,
11½ x 8⅜ in (29.3 x 21.3 cm).
Private collection, New York

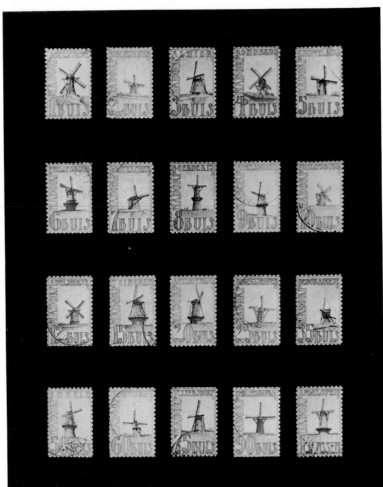

A page from the 16th edition of *The Catalogue of the World,*
1977. Photocopied page, 11 x 8½ in (27.9 x 21.6 cm).
Private collection, New York

DONALD EVANS
Born Morristown, New Jersey, 1945,
died in Amsterdam, Netherlands, 1977

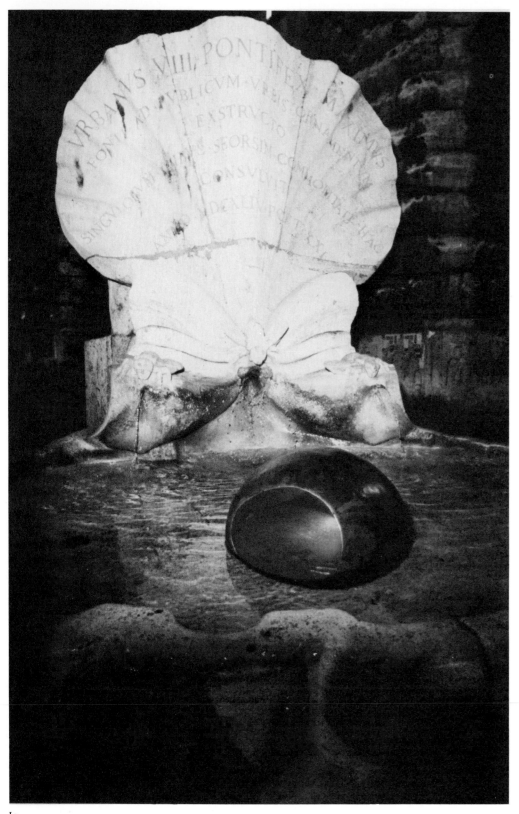

Cupola rossa
Red Cupola
1980. Installation at Museum van
Hedendaagse Kunst, Ghent, Belgium

Io
I
1978. Gilded bronze,
25¼ x 69¼ in (64 x 176 cm) diam.
Collection the artist.
Photographed in the Fontana
delle Api (Bernini), Rome

LUCIANO FABRO
Born Turin, Italy, 1936,
lives in Milan, Italy

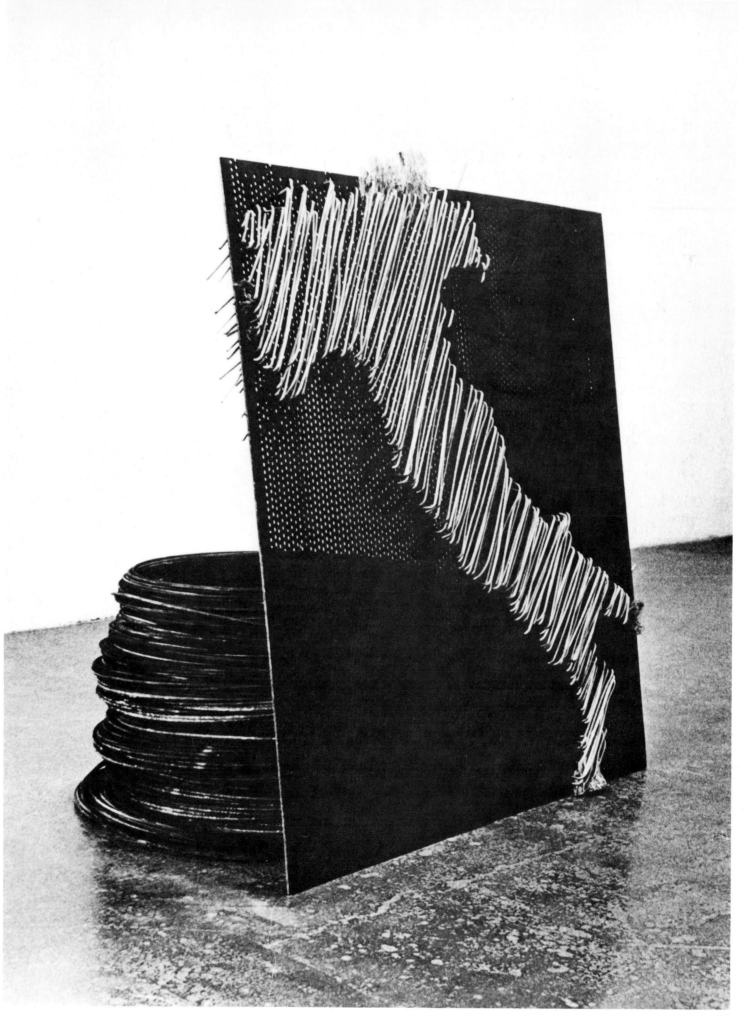

ITALIA A PENNELLO
1982. Steel, iron, aluminum,
copper, and brass, overall
approx. 47¼ x 47¼ x 23⅝ in
(120 x 120 x 60 cm).
FER Collection,
Laupheim, West Germany

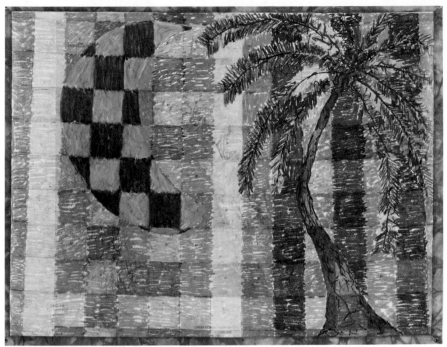

La Luna y la palma, II
The Moon and the Palm, II
1979. Oil pastel on navigational chart,
44 x 60 in (111.8 x 152.4 cm).
Nancy Hoffman Gallery, New York

RAFAEL FERRER
Born San Juan, Puerto Rico, 1933,
lives in Philadelphia, Pennsylvania

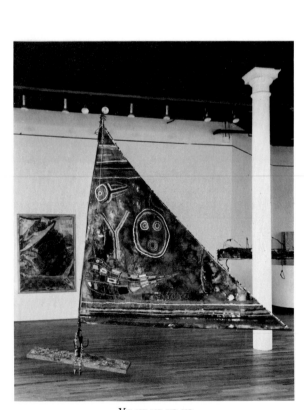

YO-YO-YO-YO-YO
1975. Mixed mediums, 8 ft 9 in x 8 ft 10 in x
9½ in (266.7 x 269.2 x 24.1 cm).
Nancy Hoffman Gallery, New York

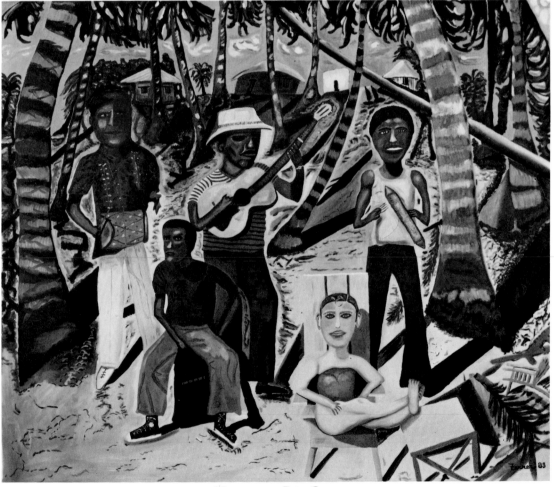

MERENGUE EN BOCA CHICA
1983. Oil on canvas, 60 in x 6 ft (152.4 x 182.9 cm).
The Metropolitan Museum of Art, New York.
Kathryn E. Hurd Fund

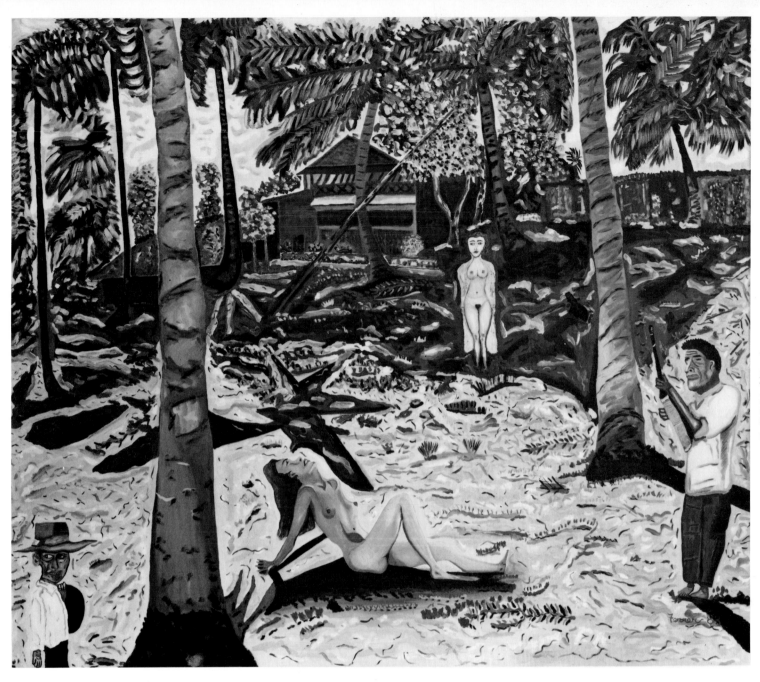

EL MUSICO CIEGO
THE BLIND MUSICIAN
1983. Oil on canvas,
60 in x 6 ft (152.4 x 182.9 cm).
Collection Ann Abrons
and David Sharpe

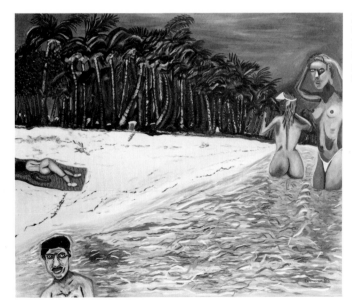

EN LA ISLETA
ON THE ISLE
1983. Oil on canvas,
60 in x 6 ft
(152.4 x 182.9 cm).
Collection Larry Wein

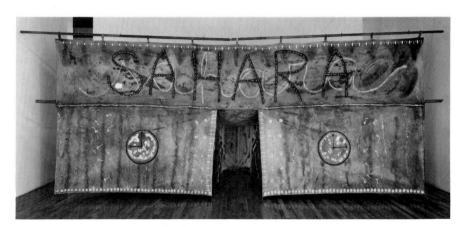

SAHARA, LA VIDA SECRETA
SAHARA, THE SECRET LIFE
1976–77. Mixed mediums, 7 ft 3 in x 19 ft x 9 ft 2 in (221 x 579.1 x
279.4 cm). Nancy Hoffman Gallery, New York

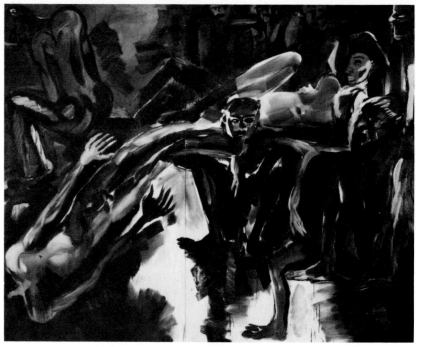

ROTES MAUERBILD
RED WALL-PAINTING
1979. Dispersion on nettle cloth, 6 ft 6¾ in x 67 in (200 x 170 cm).
Collection Thomas Ammann, Zurich, Switzerland

THE TURKISH BATH
1983. Oil on canvas, 9 ft 6¼ in x 11 ft 9¾ in (290 x 360 cm). Collection the artist

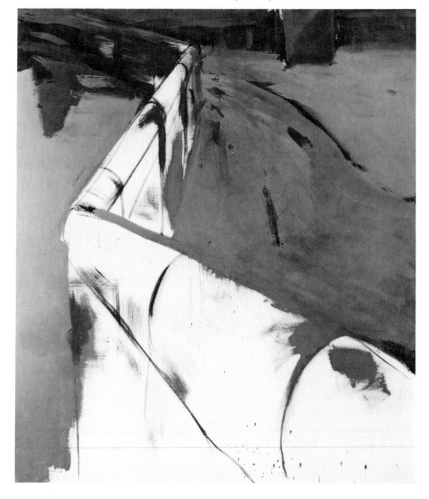

SELBSTPORTRÄT ALS INDIANER
SELF-PORTRAIT AS AN INDIAN
1982. Dispersion on canvas, 8 ft 2⅜ in x 6 ft 6¾ in (250 x 200 cm). Metzger Collection,
on extended loan to Museum Folkwang, Essen, West Germany

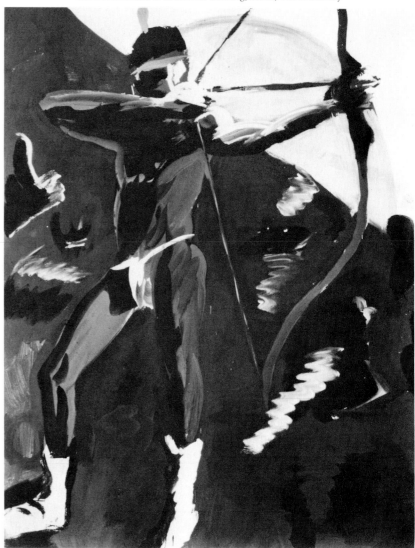

RAINER FETTING
Born Wilhelmshaven, West Germany, 1949,
lives in New York

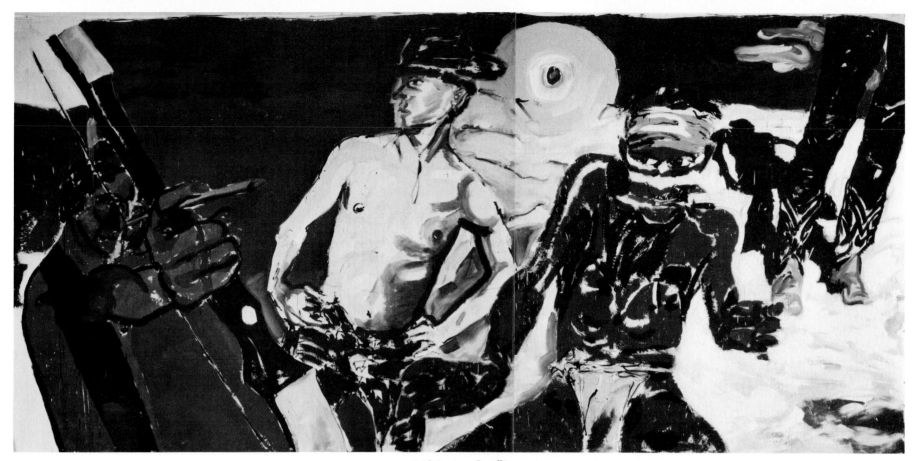

(with Luciano Castelli)
ROOM FULL OF MIRRORS
1981. Synthetic resin on linen, 16 ft 4⅞ in x 32 ft 9¾ in (500 x 1,000 cm). Collection the artists

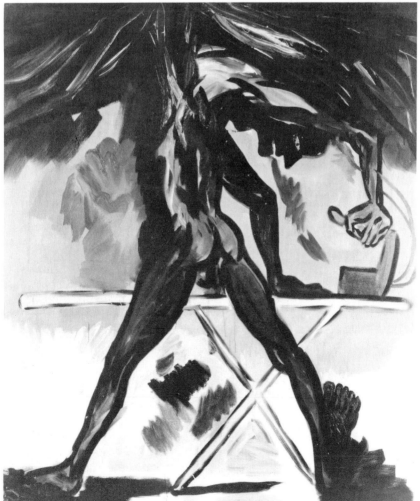

IKARUS BUGELT, II
ICARUS IRONING, II
1982. Oil on canvas,
7 ft 8 in x 6 ft 6¾ in
(230 x 200 cm).
Galerie Raab, Berlin

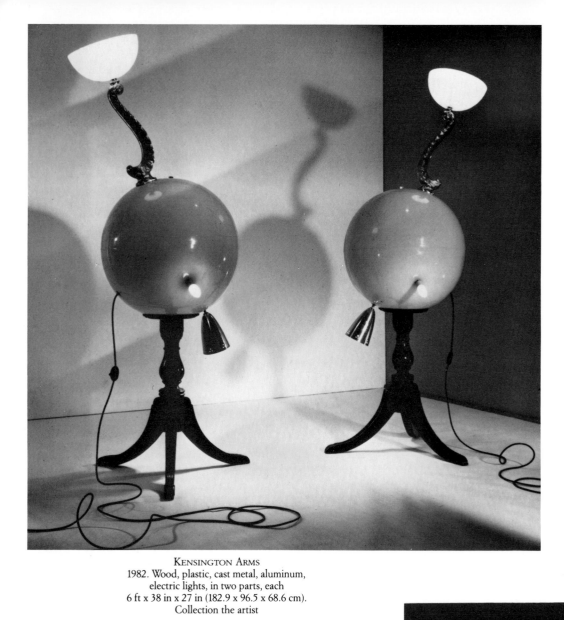

KENSINGTON ARMS
1982. Wood, plastic, cast metal, aluminum,
electric lights, in two parts, each
6 ft x 38 in x 27 in (182.9 x 96.5 x 68.6 cm).
Collection the artist

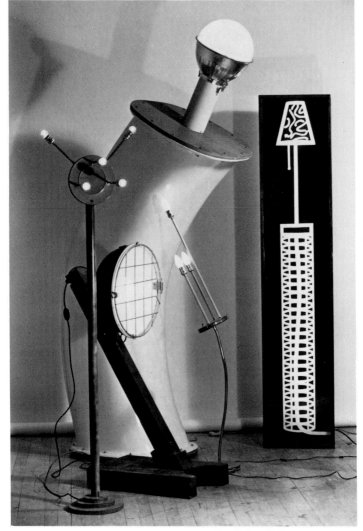

Studio installation,
New York, 1979

R. M. FISCHER
Born New York, 1947,
lives in New York

WATER UNDER THE BRIDGE
1983. Installation at
Brooklyn Bridge Anchorage, 1983

126

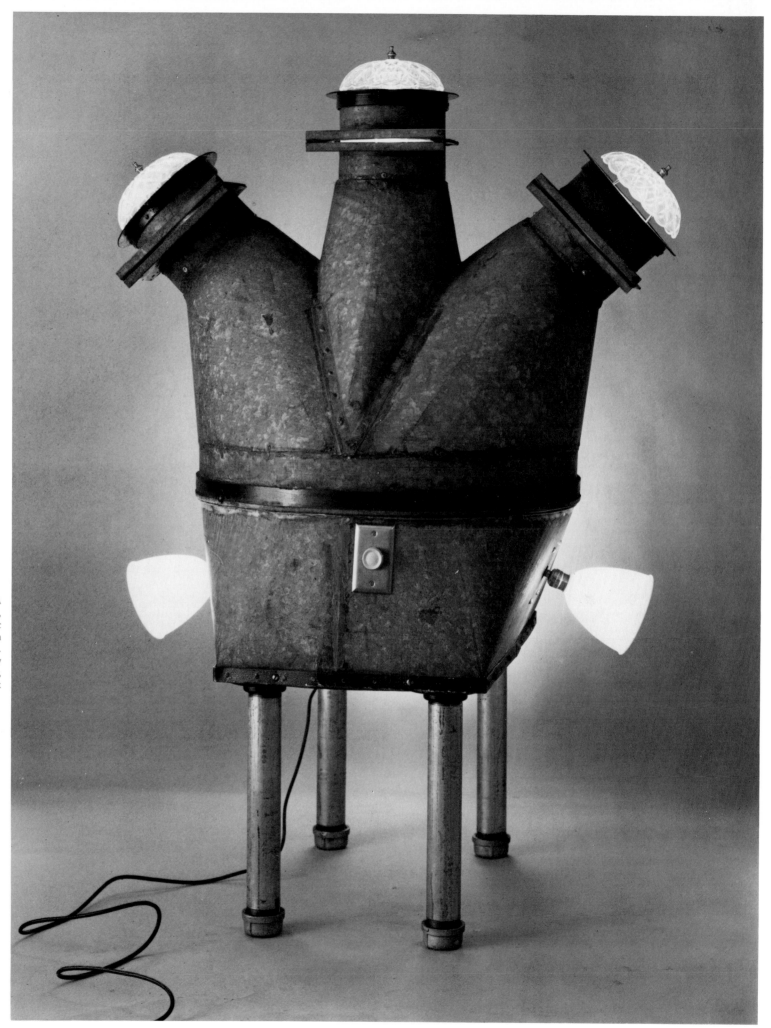

BERTHA
1982. Galvanized steel, steel,
wood, glass, plastic, and electric
lights, 60 x 38 x 34 in
(152.4 x 96.5 x 86.4 cm).
Collection the artist. Courtesy
Baskerville and Watson Gallery,
New York

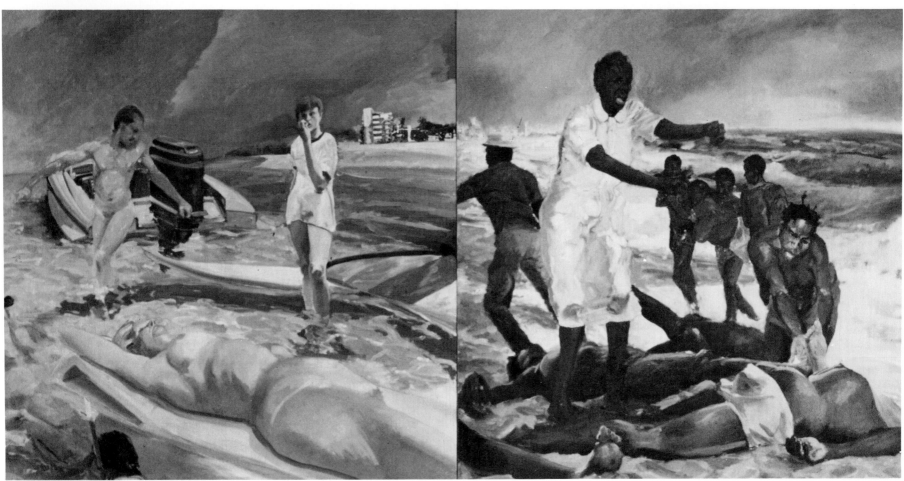

A Visit to/a Visit from the Island
1983. Oil on canvas, 7 x 14 ft (213.3 x 426.7 cm). Whitney Museum of American Art, New York

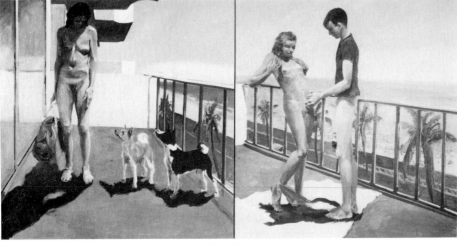

Dog Days
1983. Oil on canvas, 7 x 14 ft (213.4 x 426.7 cm).
Collection Tom and Charlotte Newby

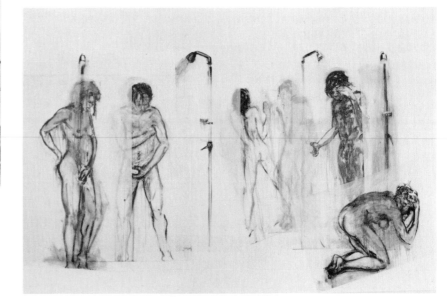

Figures in Shower
1982. Oil wash on glassine,
8 ft x 13 ft 8 in (243.8 x 416.5 cm).
Collection the artist

ERIC FISCHL
Born New York, 1948,
lives in New York

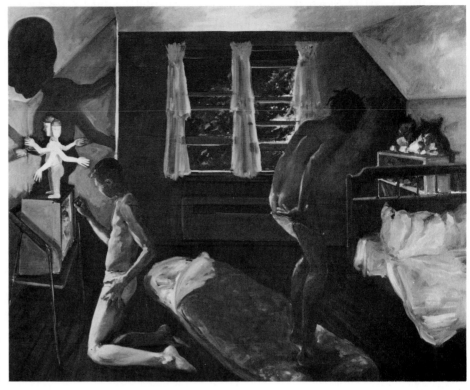

SLUMBER PARTY
1983. Oil on canvas,
7 x 9 ft (213.4 x 274.3 cm).
The Downe Collection

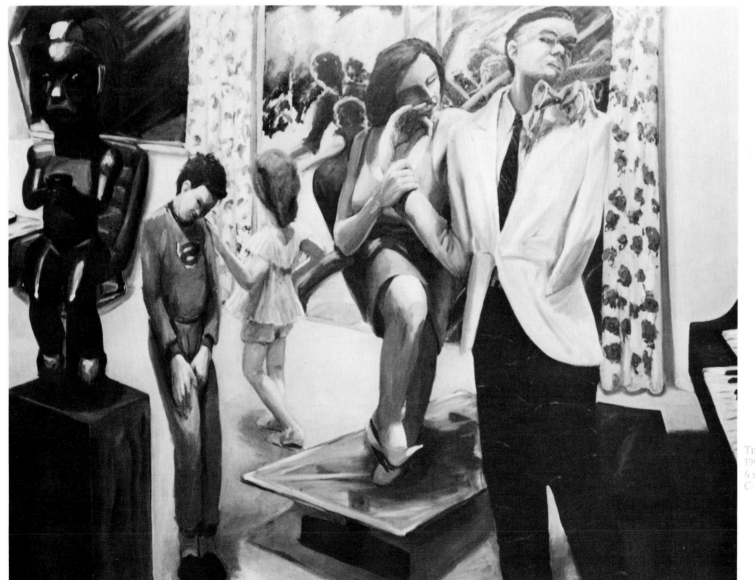

PLÖTZLICH DIESE ÜBERSICHT
SUDDENLY IT ALL MAKES SENSE
1982. Unfired clay, ranging from
2⅜ x 2¾ x 2 in (6 x 7 x 5 cm) to 32¼ x
20⅞ x 2 in (82 x 53 x 5 cm).
Collection the artists

Der Junge Bob Dylan
bei seiner ankunft
in New York
(The Young Bob Dylan
Arriving in New York)

Below, left to right

Lois Lane trinkt Kaffee mit
Clark Kent und spurt nicht
dass er Superman ist
(Lois Lane Drinks Coffee with
Clark Kent and Doesn't Sense
that He Is Superman)

It's a Small, Small World

Nero geniesst den Überlick auf
des brennende Rom
(Nero Enjoying the View
of Rome Burning)

Eiffelturm, kurz nach
Baubeginn
(The Eiffel Tower Early on
in Construction)

*Mick Jagger und Brian Jones
befriedicht auf dem Heimweg
nachdem sie "I Can't Get
No Satisfaction" komponiert haben
(Mick Jagger and Brian Jones
Going Home Satisfied after Composing
"I Can't Get No Satisfaction")*

FISCHLI and WEISS
PETER FISCHLI
Born Zurich, Switzerland, 1952, lives in Zurich
DAVID WEISS
Born Zurich, 1946, lives in Zurich

Right

**Presley's Manager bringt
einem Huhn das tanzen bei
(Presley's Manager Teaches
a Chicken how to Dance)**

Below, left to right

Alchemist

*Der Erste Fisch beschliesst
an Land zu gehen
(The First Fish Decides
to Go on Shore)*

*Sehnsucht nach Allem
(Longing for Everything)*

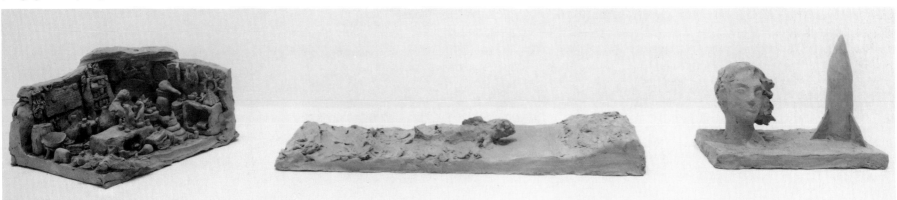

131

APOGRAPH (VALUR)
1982. Conté crayon on paper, 6 x 6 in
(15.2 x 15.2 cm). Private collection

APOGRAPH (KNOT)
1983. Conté crayon on handmade paper,
6 x 6 in (15.2 x 15.2 cm). Private collection

VALUR
1982. Plaster, 29 x 15 x 12 in (73.7 x
38.1 x 30.5 cm). Private collection

JOEL FISHER · Born Salem, Ohio, 1947, lives in New York

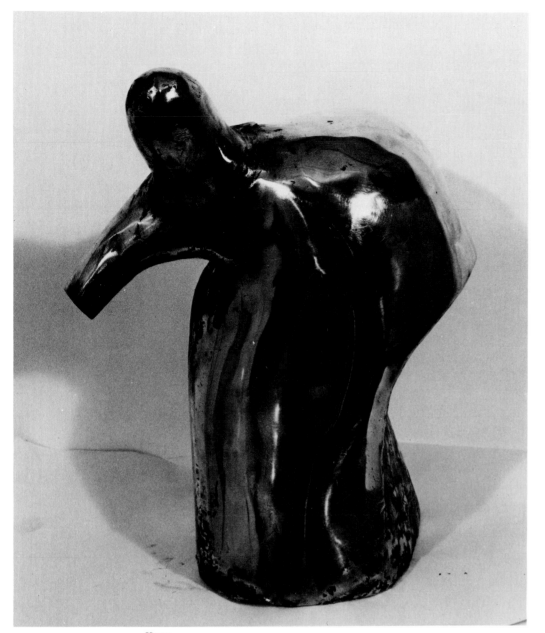

KNOT
1983. Bronze, 13 x 11 x 7 in (33 x 27.9 x 17.8 cm).
Nigel Greenwood Inc. Ltd., London

APOGRAPH (BOX)
1981. Conté crayon on handmade paper, 6 x 6 in
(15.2 x 15.2 cm). Private collection

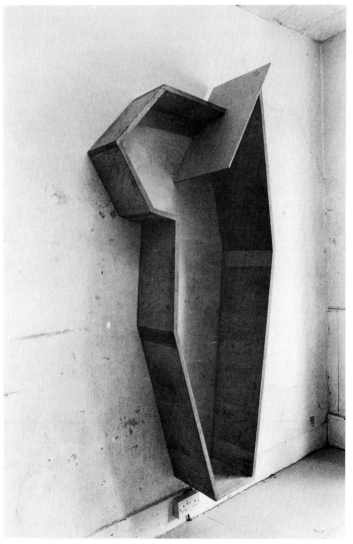

BOX
1981. Maple plywood,
6 ft 6 in x 35 in x 18 in
(198.1 x 88.9 x 45.7 cm).
Private collection

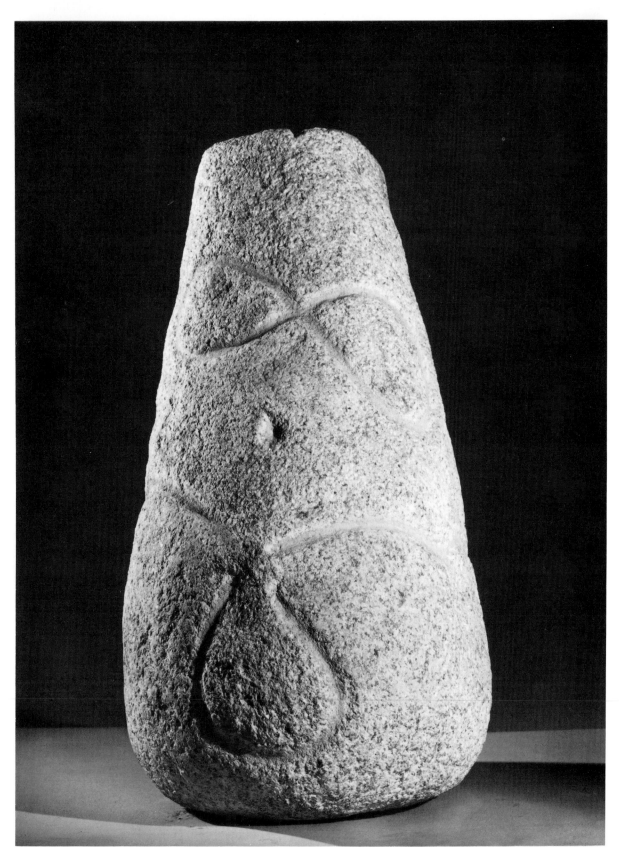

CORNISH BUB
1979. Granite, 20 x 11⅞ x 13 in (51 x 30 x 33 cm). Collection E. J. Power, London

BARRY FLANAGAN
Born Prestatyn, Wales, 1941,
lives in London

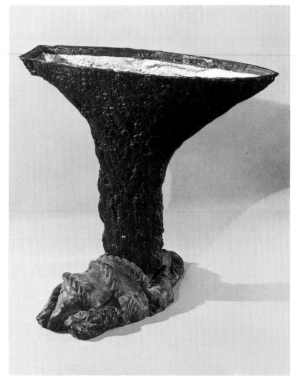

VESSEL (IN MEMORIAM)
1980. Unique bronze,
partially gilded, 23 x 24 x
18 in (58.4 x 60.9 x 45.7 cm).
The Pace Gallery, New York

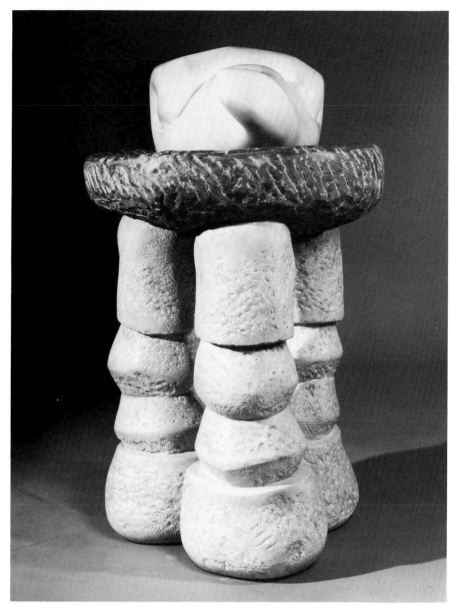

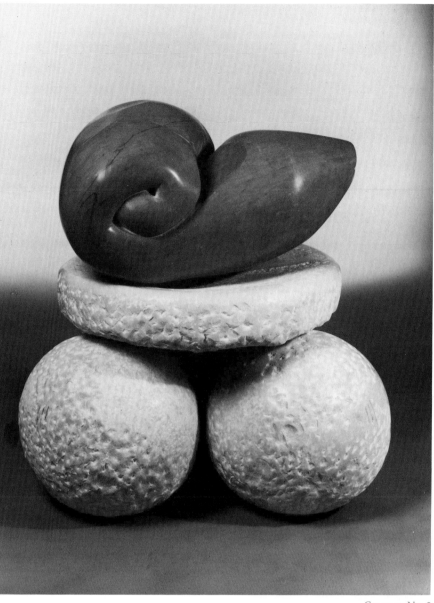

CARVING NO. 1
1981. Marble, 36½ x 26 x 19½ in (92.7 x 66 x 49.5 cm).
Tochigi Prefecturial Museum of Fine Arts,
Tochigi-ken, Japan

CARVING NO. 2
1981. White Arni marble and gray Imperial,
24½ x 24 x 3¾ in (62.2 x 61 x 50.8 cm).
The Trustees of the Tate Gallery, London

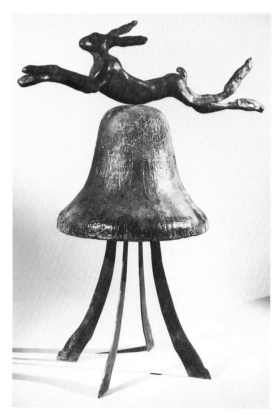

HARE AND BELL
1981. Bronze,
50 x 37¾ x 22½ in
(127 x 96 x 57 cm).
Collection Mr. and Mrs.
James Kirkman, London

135

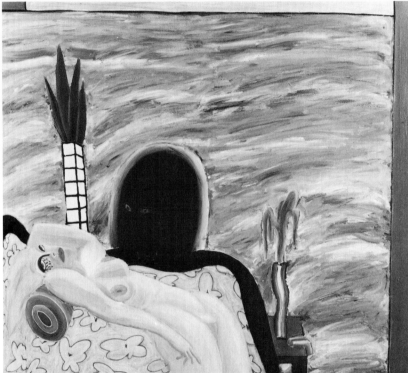

ALPHONS FREIJMUTH
Born Haarlem, Netherlands, 1940,
lives in Amsterdam, Netherlands

SENTIMENTAL SELF-PORTRAIT
1979–80. Synthetic polymer paint on canvas,
15¼ x 23⅝ in (40 x 60 cm).
Collection James Leyer, Amstelveen, Netherlands

RECLINING NUDE, AFTER *THE DREAM* BY LUCASSEN
1975. Synthetic polymer paint on canvas,
63 x 70⅞ in (160 x 180 cm).
Collection Mr. and Mrs. J. D. K. Oey, Rotterdam, Netherlands

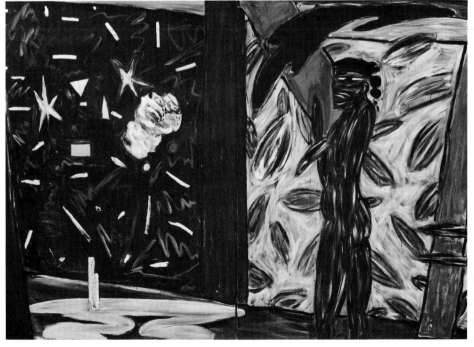

MYLO, III
1980. Synthetic polymer paint
on canvas, 70⅞ in x
8 ft 6⅜ in (180 x 260 cm).
Collection Arno van Orsouw,
Amsterdam, Netherlands

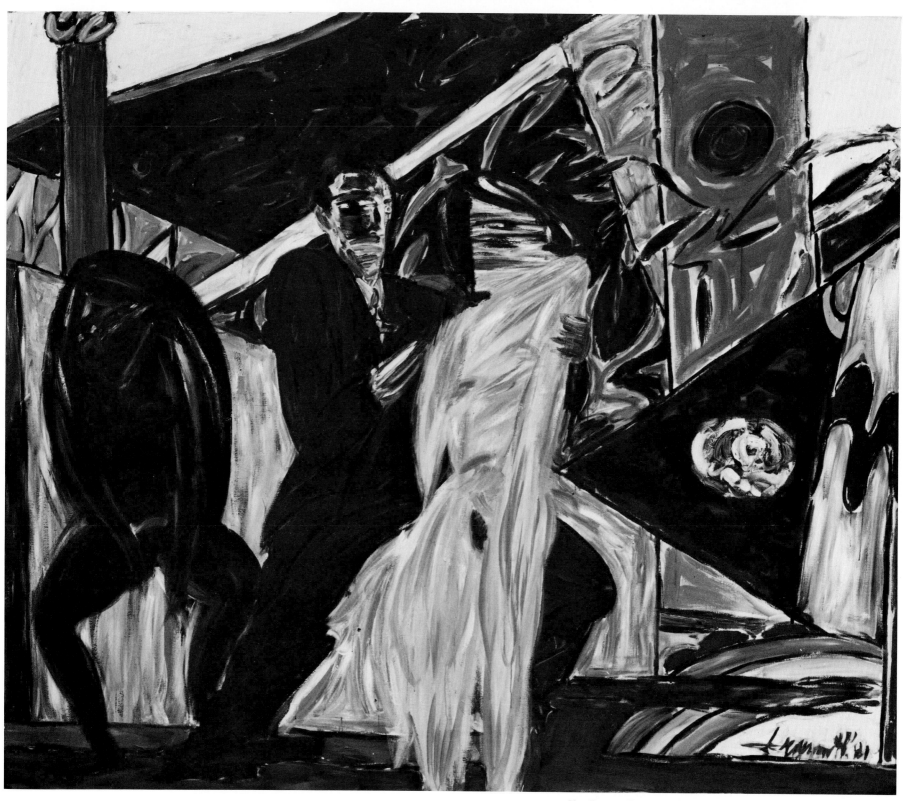

THE DANCE, II
1981. Synthetic polymer paint on canvas,
6 ft 6¾ in x 7 ft 10½ in (200 x 240 cm)
Collection Drs. A. Bitterman, Amsterdam, Netherlands

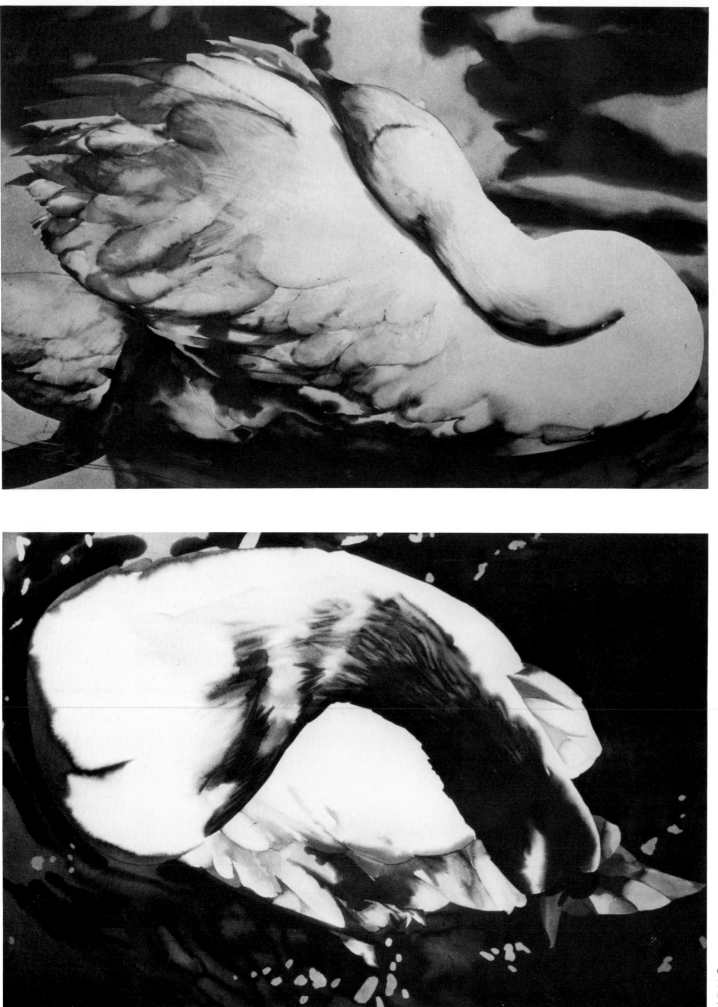

GULL POND SWAN
1982. Watercolor, 40 x 60 in
(101.6 x 152.4 cm). Collection Frederick
and Diane Prince, Newport, Rhode Island

GULL POND SWAN
1982. Watercolor, 40 x 60 in
(101.6 x 152.4 cm). Collection Transco
Energy Company, Houston, Texas

WILLIAM GARBE

Born New York, 1948,
lives in New York

UNTITLED
1982. Watercolor,
60 x 40 in (152.4 x 101.6 cm).
Collection the artist

JEDD GARET
Born Los Angeles,
California, 1955,
lives in New York

MEDITERRANEAN SHOWPLACE
1982. Synthetic polymer
paint on canvas, 69 x 55 in
(175.3 x 139.7 cm).
Robert Miller Gallery,
New York

OVAL ENEMIES
1981. Synthetic polymer
paint on canvas,
70 in x 8 ft 11 in
(177.8 x 241.3 cm).
Robert Miller Gallery,
New York

PICTURE
1981. Synthetic polymer paint on canvas, 6 ft 1 in x 57 in (185.4 x 144.8 cm). Collection Paine Webber, Inc., New York

Dana Garrett
Born Los Angeles, California, 1953,
lives in New York

Skully
1982. Synthetic polymer paint on canvas, 9 ft x 68 in (274.3 x 172.7 cm).
Collection Robert Miller. Courtesy Tracey Garet Gallery, New York

JACK-O'-LANTERN
1982. Synthetic polymer paint on canvas, 58 in x 7 ft 4 in (147.3 x 223.5 cm).
Collection the artist. Courtesy Tracey Garet Gallery, New York

DOUBLE-DOG BOY
1980. Oil on canvas, 20 x 45 in (50.8 x 114.3 cm). Collection
the artist. Courtesy Tracey Garet Gallery, New York

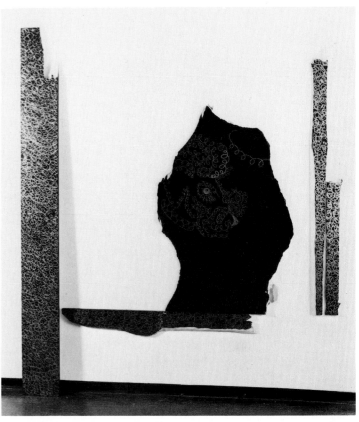

BLACK POODLE FRAGMENTS
1981. Enamel on wood and
dry wall, in five parts,
overall 7 ft 3 in x
6 ft 3 in (221 x 190.5 cm).
Carmen Lamanna Gallery,
Toronto, Ontario, Canada

THE BOUTIQUE FROM THE MISS GENERAL IDEA PAVILION
1980. Galvanized metal and plexiglass, containing various multiples,
prints, and publications by the artists,
overall 60¼ in x 11 ft ½ in x 8 ft 6 in (153.7 x 339.1 x 259.1 cm).
Carmen Lamanna Gallery, Toronto, Ontario, Canada

TABLEAU VIVANT, NATURA MORTA
(Mural fragment from the 1984
Miss General Idea Pavilion)
1983. Oil, pastel, and synthetic
polymer paint on canvas, 6 ft x 48 in
(182.9 x 121.9 cm). Carmen Lamanna
Gallery, Toronto, Ontario, Canada

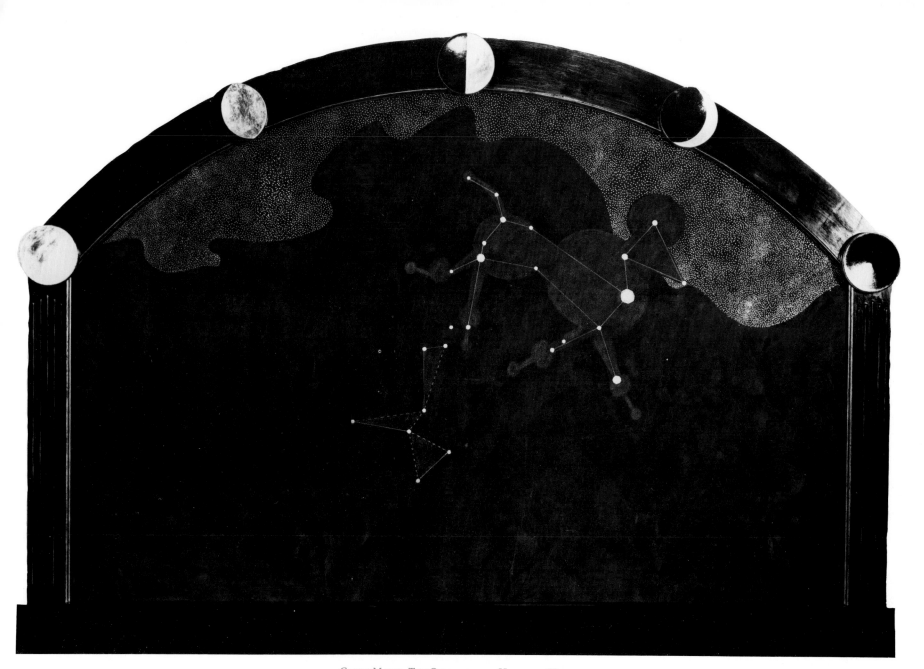

CANUS MAJOR: THE ORIGIN OF THE HEAVENLY WATERS
1983. Latex paint and gold leaf on canvas and wood, 7 ft x 10 ft 2¼ in (213.4 x 310.5 cm).
Carmen Lamanna Gallery, Toronto, Ontario, Canada

GENERAL IDEA

A. A. BRONSON
born Vancouver, British Columbia, Canada, 1946,
lives in Toronto, Ontario, Canada

FELIX PARTZ
born Winnepeg, Ontario, Canada, 1945,
lives in Toronto

JORGE ZONTAL
born Parma, Italy, 1944,
lives in Toronto

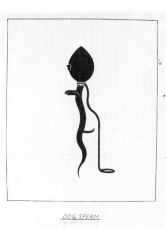

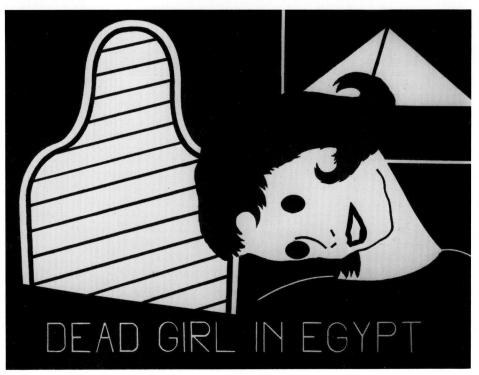

DEAD GIRL IN EGYPT, 2
1980. Synthetic polymer paint on canvas,
20 x 30 in (50.8 x 76.2 cm).
Collection the artist

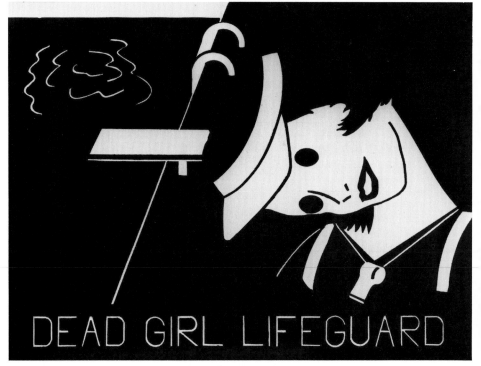

DEAD GIRL LIFEGUARD
1980. Synthetic polymer paint on canvas, 20 x 30 in (50.8 x 76.2 cm).
Collection the artist. Courtesy Asher/Faure
Gallery, Los Angeles, California

DOG SPERM
1981. Ink and pencil on paper, 20 x 16 in
(50.8 x 40.6 cm). Collection the artist

MISSIONARY SPERM
1981. Ink and pencil on paper, 20 x 16 in
(50.8 x 40.6 cm). Collection the artist

SCUBA SPERM
1981. Ink and pencil on paper, 20 x 16 in
(50.8 x 40.6 cm). Collection the artist

BONDAGE SPERM
1981. Ink and pencil on paper, 20 x 16 in
(50.8 x 40.6 cm). Collection the artist

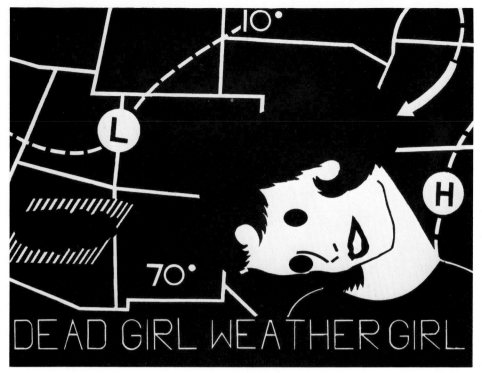

DEAD GIRL WEATHER GIRL
1980. Synthetic polymer paint on canvas, 20 x 30 in (50.8 x 76.2 cm).
Collection the artist. Courtesy Asher/Faure
Gallery, Los Angeles, California

THE OFFICE PARTY
1979. Ink and pencil on paper,
40 x 60 in (101.6 x 152.4 cm).
Collection Diamond Family, New York

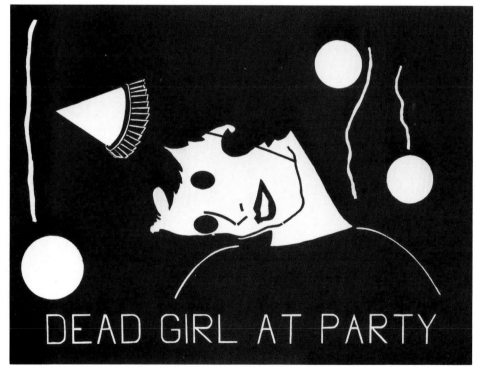

DEAD GIRL AT PARTY
1980. Synthetic polymer paint on canvas, 20 x 30 in (50.8 x 76.2 cm).
Collection the artist. Courtesy Asher/Faure
Gallery, Los Angeles, California

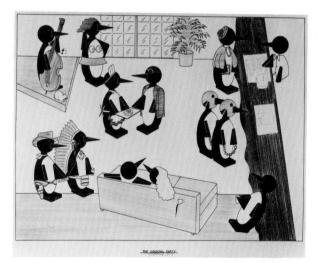

THE COCKTAIL PARTY
1979. Ink and pencil on paper, 30 x 40 in
(76.2 x 101.6 cm). Collection Mr. and Mrs.
F. Mark Wyatt, Washington, D.C.

STEVE GIANAKOS · Born New York, 1938, lives in New York

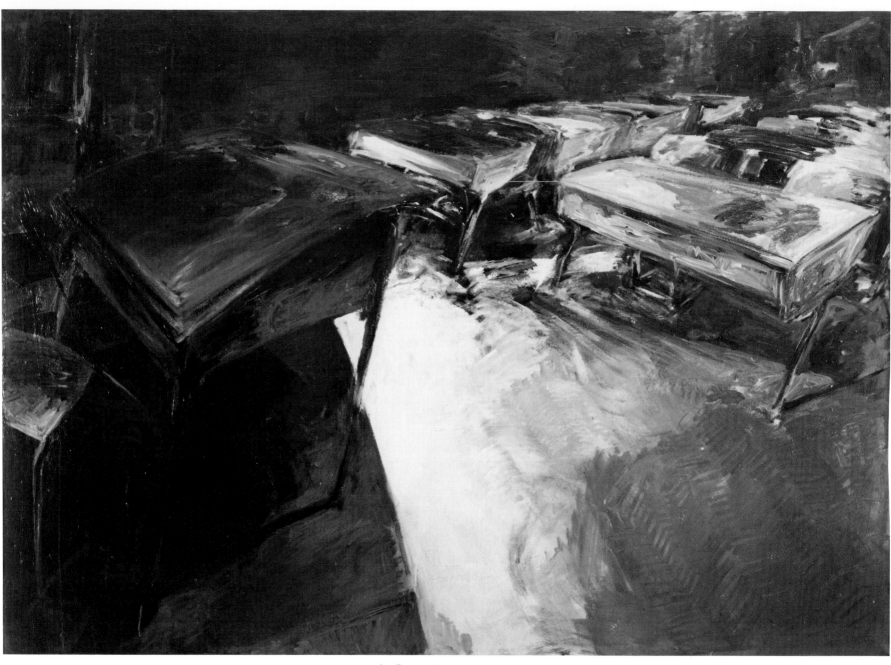

La Grande Institution no. 1
The Great Institution No. 1
1983. Oil on canvas, 57 in x 6 ft 10⅝ in (145 x 210 cm).
Galerie Daniel Templon, Paris

Patrice Giorda
Born Lyons, France, 1952, lives in Florence, Italy, and Lyons

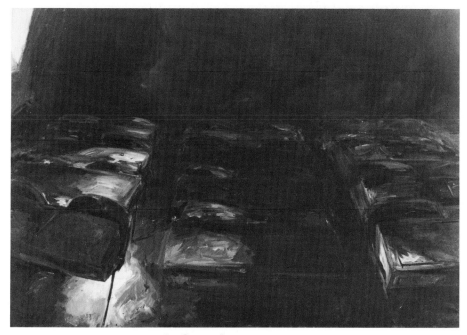

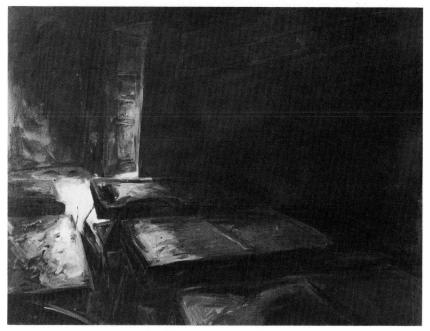

La Grande Institution no. 5
THE GREAT INSTITUTION NO. 5
1983. Oil on canvas, 57 in x 6 ft 10⅝ in (145 x 210 cm).
Galerie Daniel Templon, Paris

La Grande Institution no. 4
THE GREAT INSTITUTION NO. 4
1983. Oil on canvas, 59 in x 6 ft 6¾ in (150 x 200 cm).
Galerie Daniel Templon, Paris

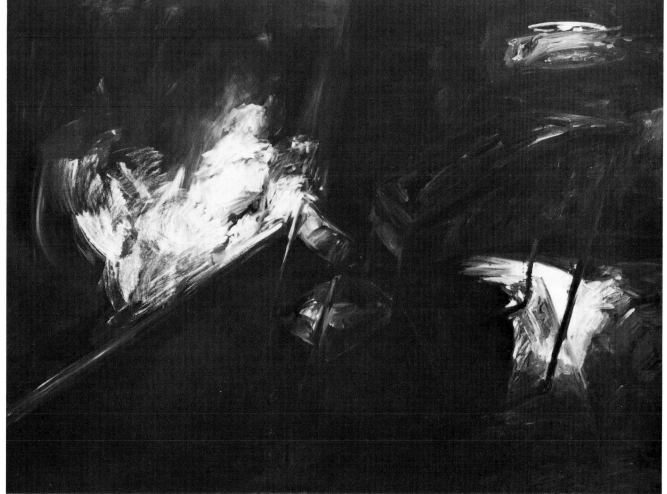

La Grande Institution no. 6
THE GREAT INSTITUTION NO. 6
1983. Oil on canvas,
57 in x 6 ft 6¾ in (145 x 200 cm).
Galerie Daniel Templon, Paris

UNTITLED
1983. Synthetic polymer paint on canvas,
8 x 15 ft (243.8 x 457.2 cm).
Collection Morton Landowne

Still from *The Jump*, 1978, 16mm color film

JACK GOLDSTEIN

Born Montreal, Quebec, Canada, 1945,
lives in New York

UNTITLED
1981. Synthetic polymer paint on masonite,
40 x 60 in (101.6 x 152.4 cm).
Collection Barbara and Eugene Schwartz

UNTITLED
1983. Synthetic polymer paint on canvas,
8 x 14 ft (243.8 x 426.7 cm).
Collection Simon Cerigo

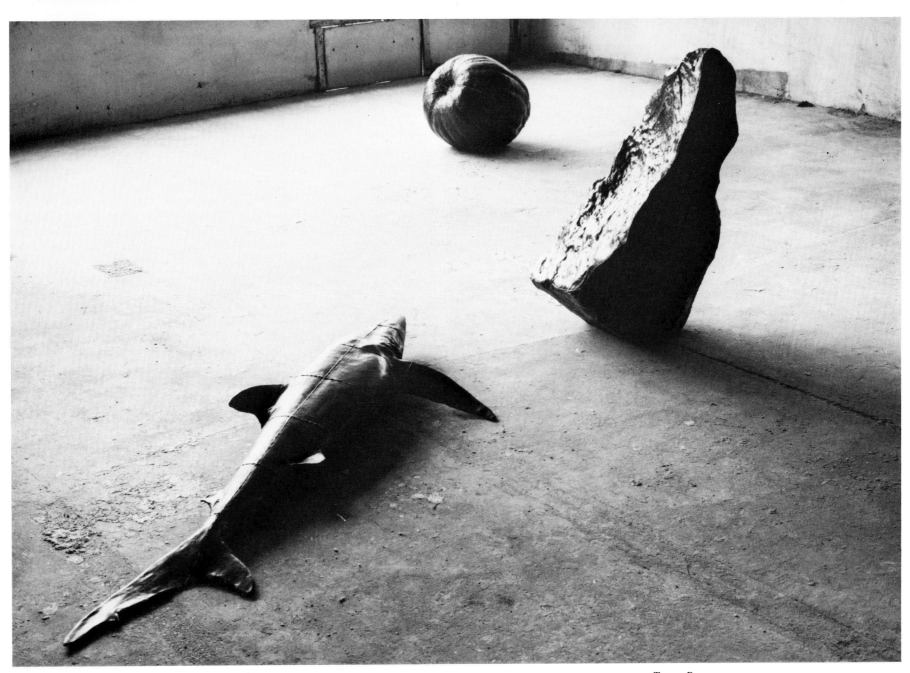

THREE BODIES
1981. Lead and earth, three pieces: shark, 6 ft 4 in (193 cm) long; rock, 33 in (83.8 cm) high;
pumpkin, 22 in (55.8 cm) diam. Collection Salvatore Ala, New York

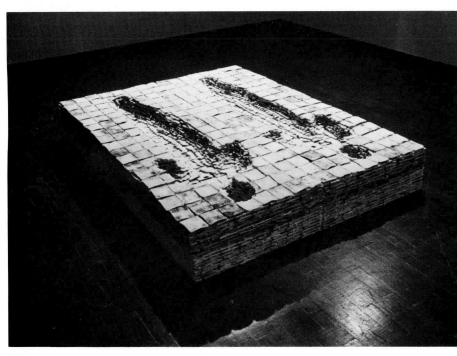

BED
1980–81. Bread and wax,
11 in x 7 ft 2 in x 66 in
(27.9 x 218.4 x 167.6 cm).
Collection the artist

ANTONY GORMLEY
Born London, 1950,
lives in London

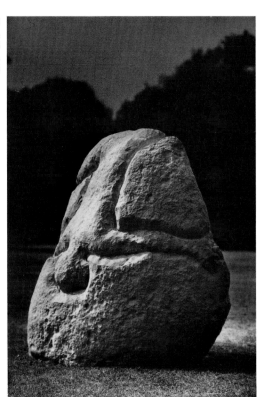

MAN: ROCK
1982. Portland stone,
52 x 36 x 24 in
(132 x 91.4 x 60.1 cm).
Collection the artist

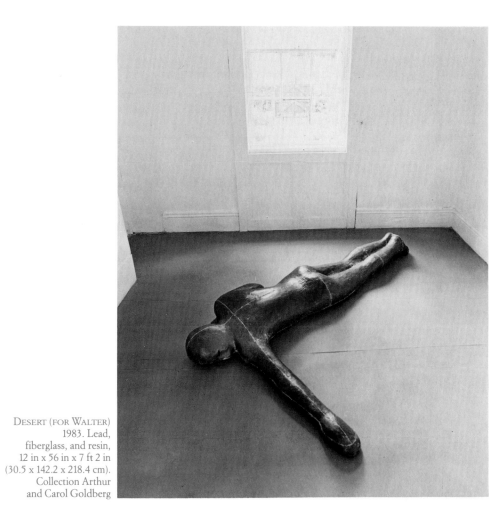

DESERT (FOR WALTER)
1983. Lead,
fiberglass, and resin,
12 in x 56 in x 7 ft 2 in
(30.5 x 142.2 x 218.4 cm).
Collection Arthur
and Carol Goldberg

LAND, SEA, AND AIR
1982–83. Lead and fiberglass,
three figures, over life-size.
Private collection, New York

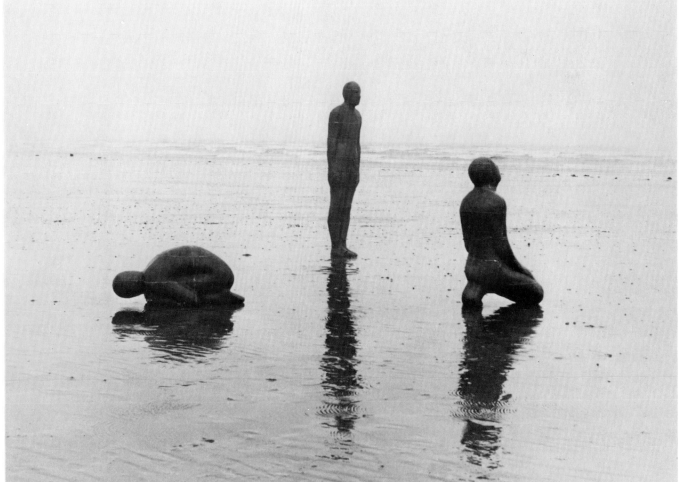

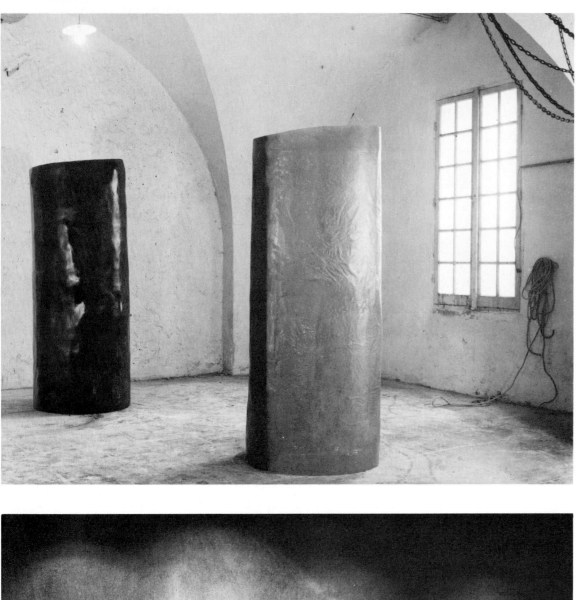

TONI GRAND
Born Gallargues, France, 1935,
lives in Mouriès, France

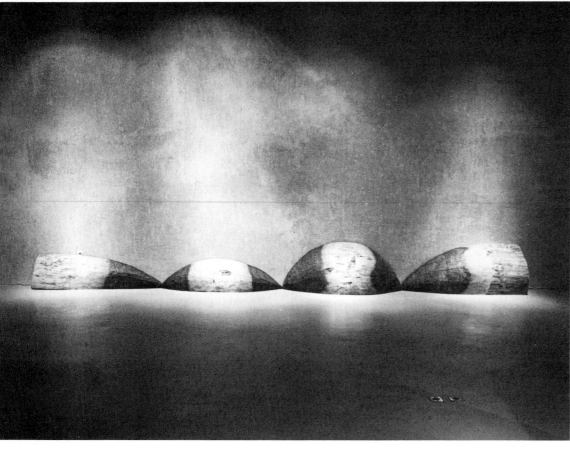

UNTITLED
1981. Steel, twelve elements,
each approx. 15¾ x 31½ x
31½ in (40 x 80 x 80 cm).
Galerie Eric Fabre, Paris.
Installation at St. Trophime
Cloister, Arles, France, 1981

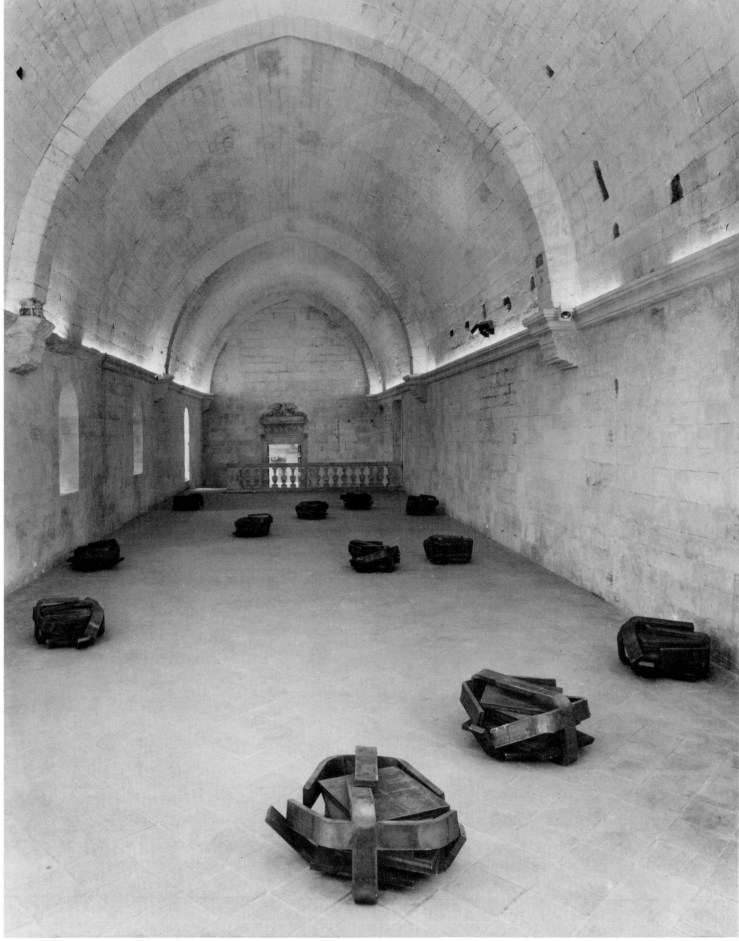

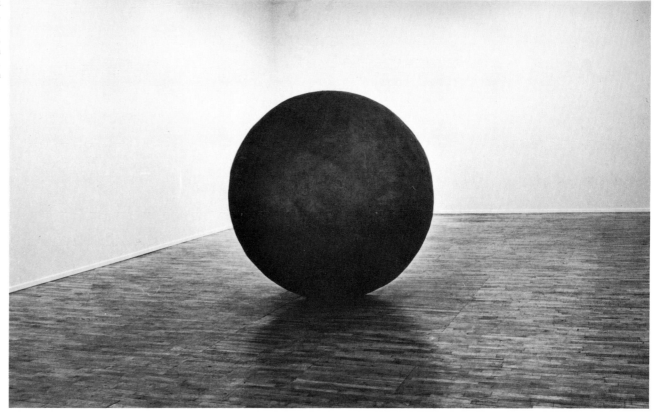

Installation of three iron castings in the courtyard of San Nicola, Bari, Italy

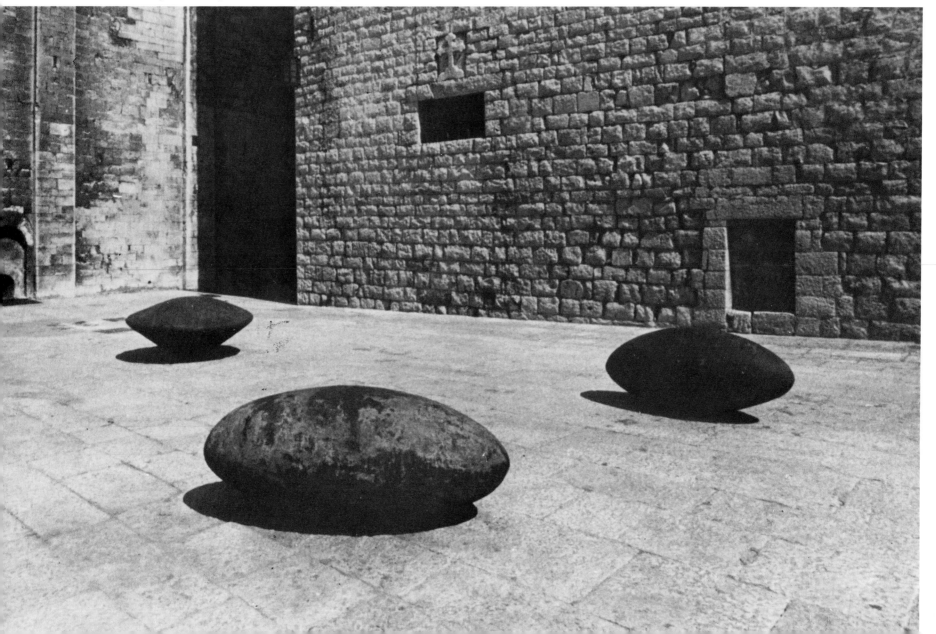

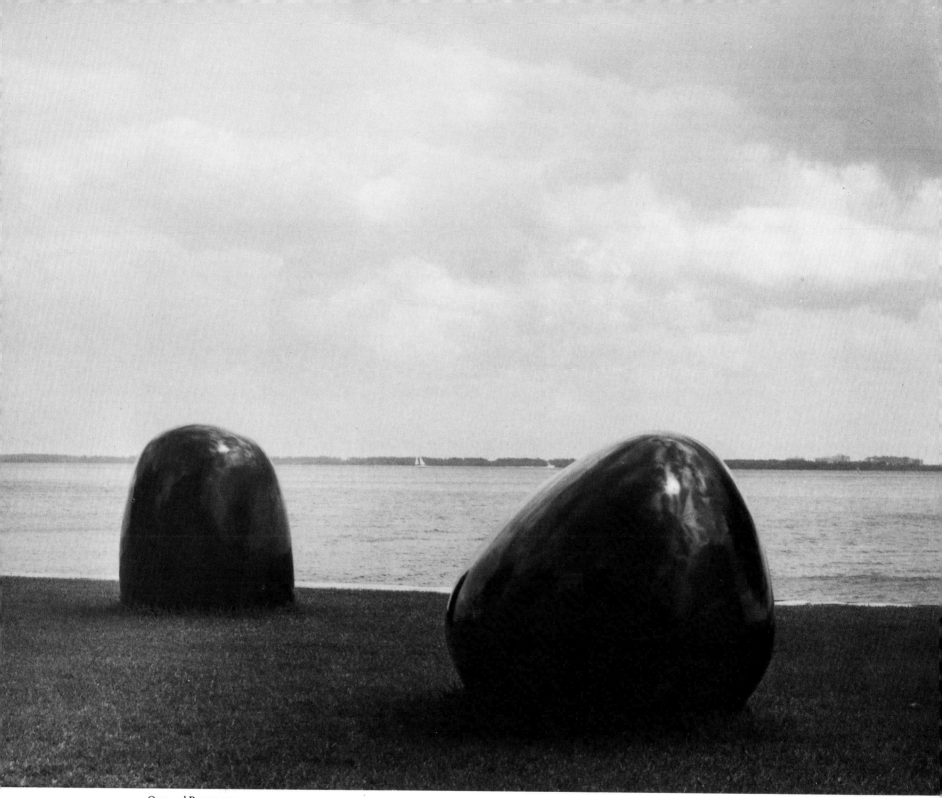

One and Blackfish
1980–81. Limestone, left, 65 x 48 x 60 in
(165.1 x 121.9 x 152.4 cm);
right, 62 in x 60 in x 8 ft
(157.5 x 152.4 x 243.8 cm).
Collection Martin Z. Margulies,
Miami, Florida

JENE HIGHSTEIN
Born Baltimore, Maryland, 1942, lives in New York

MR. AND MRS. TERENCE CONRAN
1978–81. Oil on wood, 39½ x 49½ in (100.3 x 125.7 cm).
Collection B. Lifton, Miami Beach, Florida

THE MOON
1978–80. Oil on wood, 17⅞ x 22 in (44.9 x 55.9 cm).
Collection R. B. Kitaj, London

THE GREEN CHATEAU
1976–80. Oil on wood, 38⅜ x 48½ in (98.2 x 123.2 cm).
Collection Dr. and Mrs. Barron, Glencoe, Illinois

INTERIOR WITH FIGURES
1977–83. Oil on wood, 49½ x 56 in (125.7 x 142.2 cm).
Private collection

HOWARD HODGKIN · Born London, 1932, lives in London and Wiltshire, England

KUSAMBA, II
1981. Synthetic polymer paint on canvas, 6 ft 6¾ in x 9 ft 10⅛ in (200 x 300 cm). Collection the artist

K. H. HÖDICKE
Born Nürnberg, Germany, 1938,
lives in Berlin

TURN–TOWER
1980–81. Synthetic polymer paint
on canvas, 7 ft 6½ in x 67 in
(230 x 170 cm). Galerie Gmyrek,
Düsseldorf, West Germany

Sirenen
SIRENS
1982. Synthetic polymer
paint on canvas,
7 ft 6½ in x 67 in
(230 x 170 cm).
Private collection

Sirenen
SIRENS
1982. Synthetic polymer
paint on canvas,
7 ft 6½ in x 67 in
(230 x 170 cm).
Private collection

Im Aufwind
IN AN UPWIND
1981. Synthetic polymer paint
on canvas, 7 ft 6½ in x 67 in
(230 x 170 cm). Galerie Gmyrek,
Düsseldorf, West Germany

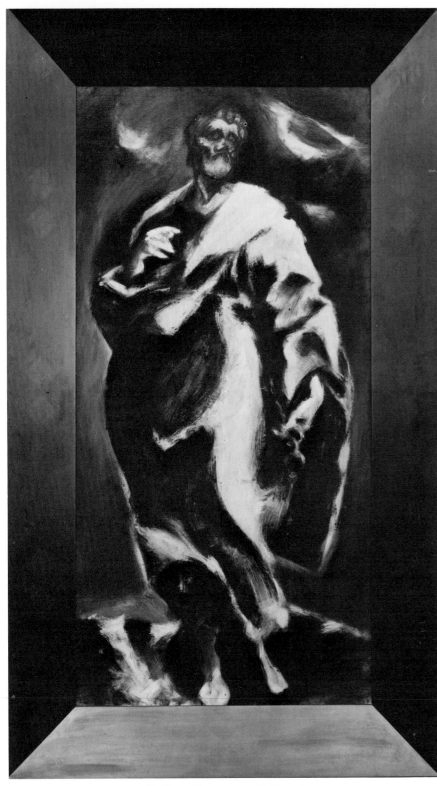

ST. PETER (STUDY AFTER EL GRECO)
1975. Oil on canvas, including frame,
8 ft 5¼ in x 59 in (257 x 150 cm).
St. Willibrordus Church, Deurne,
Netherlands

JAN IN WHITE SHIRT
1976. Oil on canvas, including frame,
65 x 56¾ in (165 x 144 cm).
Collection the artist

LAOCOÖN (STUDY AFTER EL GRECO)
1976. Oil on canvas, including frame,
6 ft 3 in x 11 ft 11 in (190 x 241 cm).
St. Willibrordus Church, Deurne,
Netherlands

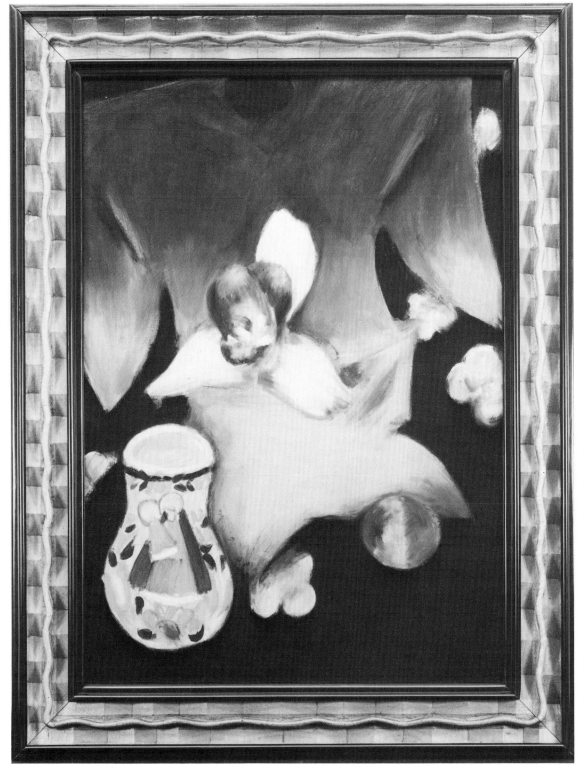

RED KIMONO
1975. Oil on canvas, including frame,
7 ft 2 in x 66¼ in (218 x 168 cm).
Private collection

HANS VAN HOEK · Born Deurne, Netherlands, 1947, lives in Liessel, Netherlands

KING CREST
1976. Spruce, silk, and aluminum leaf,
8 x 64 x 7 in (20.3 x 162.6 x 17.8 cm).
The Solomon R. Guggenheim Museum, New York.
Exxon Corporation Purchase Award

TOWER OF BABEL
1975. Cast plaster, 39 x 15¼ x
15¼ in (99 x 38.7 x 38.7 cm).
Collection the artist. Courtesy
Blum Helman Gallery, New York

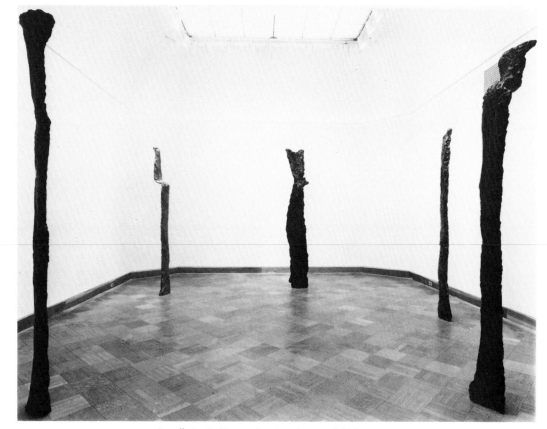

Installation in *Twenty American Artists* exhibition
at San Francisco Museum of Modern Art, San Francisco, California, 1980

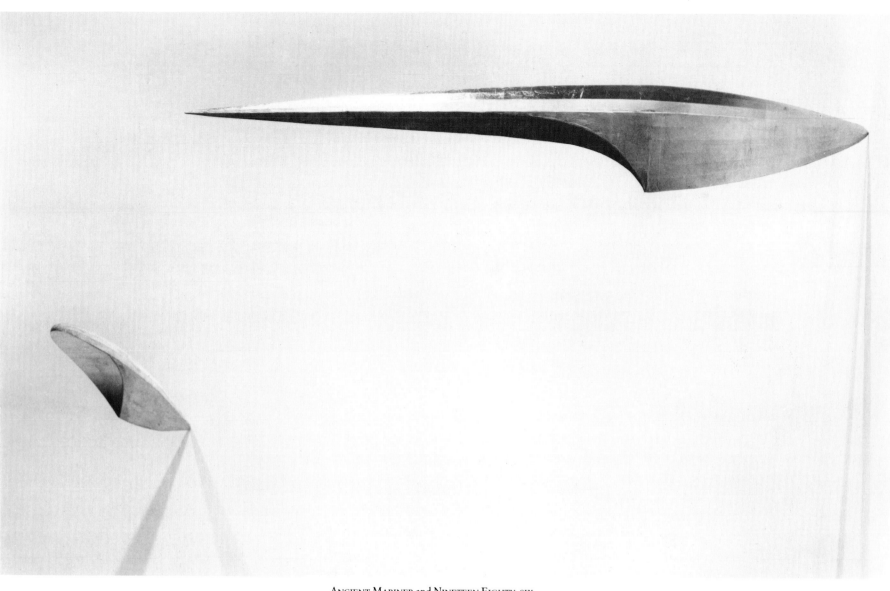

ANCIENT MARINER and NINETEEN EIGHTY-SIX
1980. Left, wood and silk paper with gold leaf, 64 in (162.6 cm) long x 7 in (17.8 cm) diam.;
right, wood and silk paper with copper leaf, 65 in (165.1 cm) long x 9 in (23 cm) diam.
Installation in Biennial Exhibition at Whitney Museum of American Art, New York, 1981

BRYAN HUNT
Born Terre Haute, Indiana, 1947, lives in New York

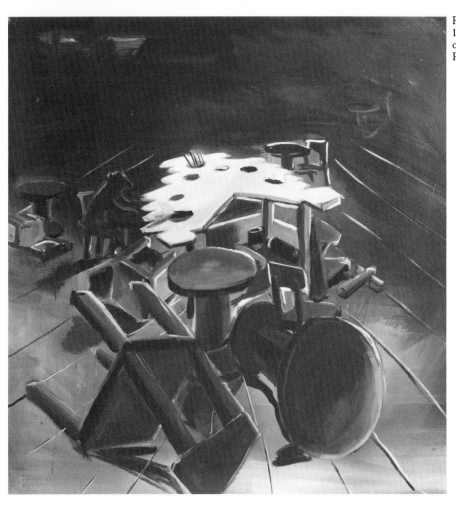

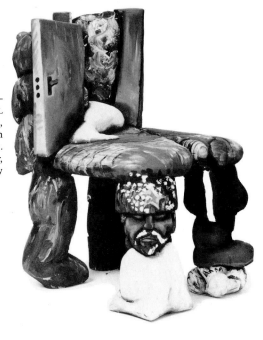

PALETTE
1979. Synthetic polymer paint
on canvas, 59 x 59 in (150 x 150 cm).
Private collection

POSITION NO. 4–
RUSSIA STOOL
1979. Painted limewood,
33½ x 25½ x 19⅜ in
(85 x 65 x 50 cm).
Galerie Michael Werner,
Cologne, West Germany

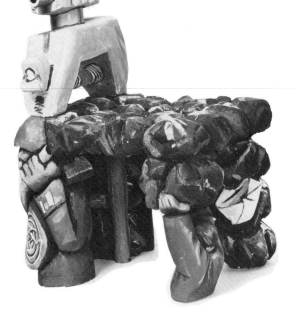

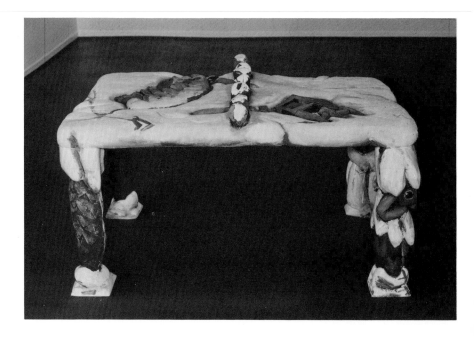

POSITION NO. 6
1979. Painted limewood,
33½ x 19¼ x 25¼ in (85 x
49 x 64 cm). Galerie
Michael Werner, Cologne,
West Germany

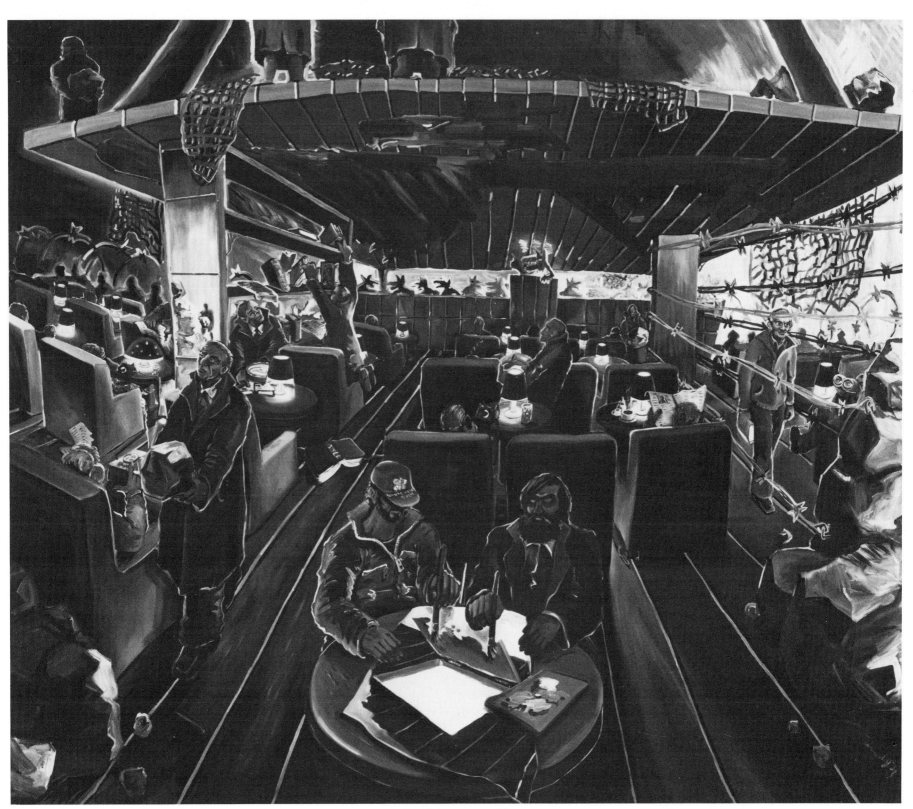

CAFÉ DEUTSCHLAND, IV
1978. Synthetic resin on canvas, 9 ft 4 in x 10 ft 10 in
(282 x 330 cm). Private collection. Courtesy
Mary Boone Gallery, New York, and Galerie Michael
Werner, Cologne, West Germany

Left
SITUATION
1979. Painted limewood,
36¼ x 38½ x 62½ in
(92 x 98 x 159 cm).
Galerie Michael Werner,
Cologne, West Germany

JÖRG IMMENDORFF
Born Bleckede, near Lüneburg, Germany, 1945,
lives in Düsseldorf, West Germany

DOMINION OVER THE EARTH
1983. Oil on board,
10 x 26 in (25.4 x 66 cm).
Collection Barry Blinderman

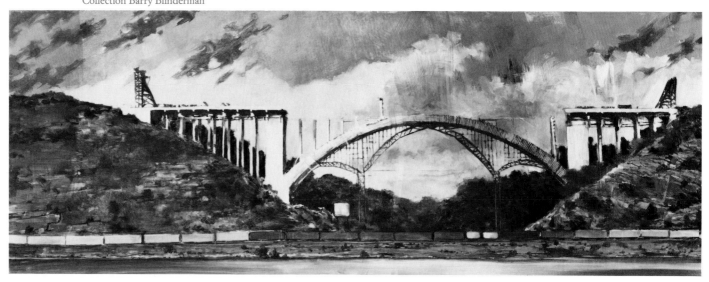

AT THE RACES
1981. Oil on board,
10 x 9½ in (25.4 x 24.1 cm).
Collection Douglas S. Cramer,
Los Angeles, California

MARK INNERST
Born York, Pennsylvania, 1957,
lives in New York

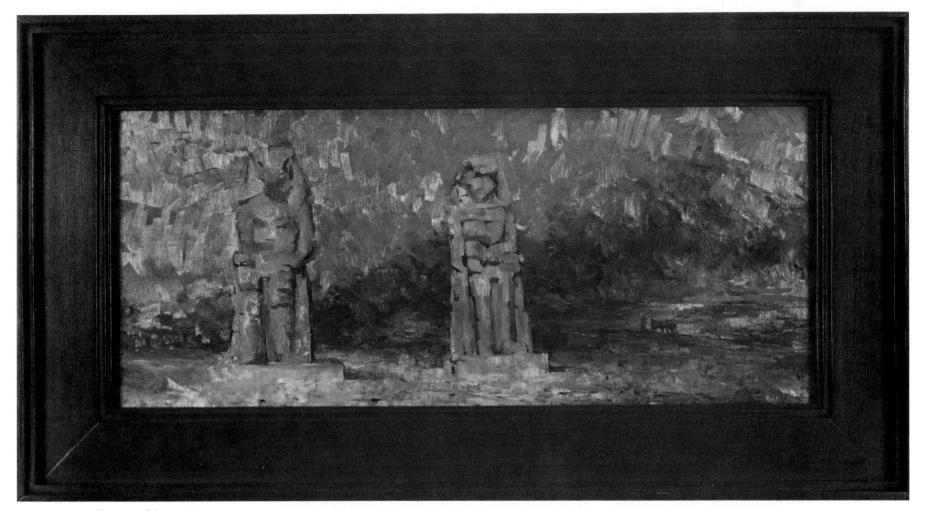

UNTITLED (MEMNON)
1984. Oil on board,
7¼ x 11½ in (18.4 x 29.2 cm).
Grace Borgenicht Gallery, New York

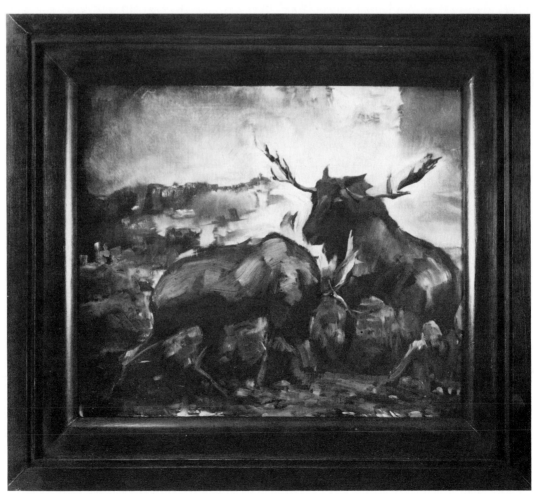

UNTITLED (MOOSE)
1984. Oil on board,
10 x 11¾ in
(25.4 x 29.8 cm).
Collection Curt
Marcus, New York

UNTITLED
1978. Oil and enamel on canvas,
9 ft 11½ in x 7 ft 1¼ in
(303.5 x 216.5 cm). Collection
the artist. Courtesy Quay Gallery,
San Francisco, California

OLIVER JACKSON • Born St. Louis, Missouri, 1935, lives in Oakland, California

UNTITLED
1981. Oil and enamel on canvas, 9 ft ¼ in x 15 ft (275 x 457.2 cm). Seattle Art Museum, Seattle, Washington

UNTITLED
1981. Oil and enamel on canvas, 7 x 9 ft (213.4 x 274.3 cm). Private collection

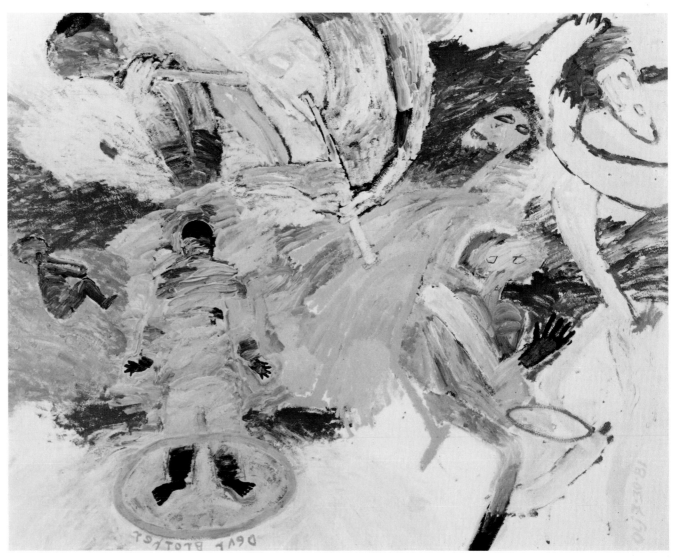

171

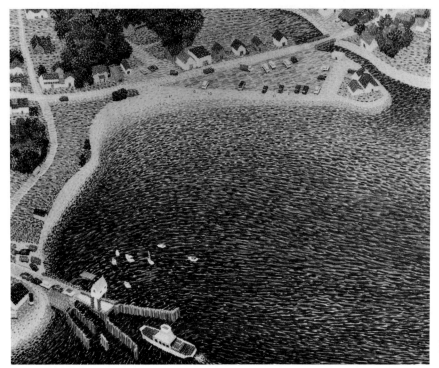

LINCOLNVILLE BEACH
FROM THE AIR
1977. Oil on canvas, 68 x
56 in (142.2 x 172.7 cm).
Brooke Alexander, Inc.,
New York

NORTHWEST AND SOUTHWEST VIEWS FROM THE EMPIRE STATE BUILDING
1980. Oil on canvas, two panels, each 68 x 56 in (172.7 x 142.2 cm).
Collection General Cinema Corporation, Chestnut Hill, Massachusetts

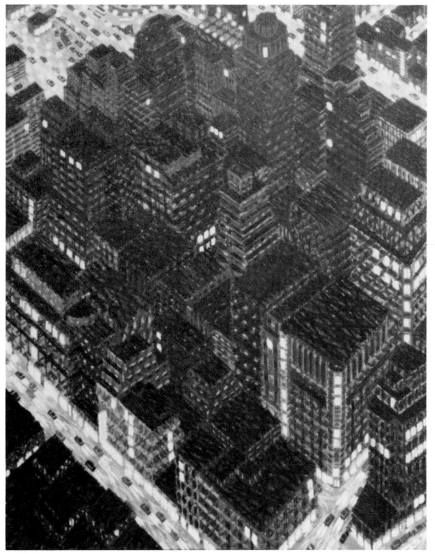 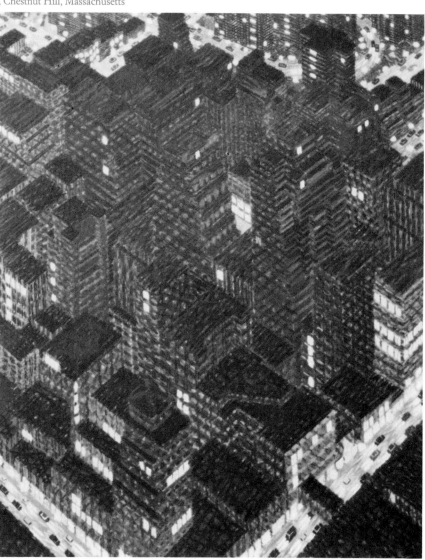

FERRY NEAR
BATTERY PARK
1981. Oil on canvas,
6 ft 4 in x 62 in
(193 x 157.5 cm).
Brooke Alexander,
Inc., New York

YVONNE JACQUETTE
Born Pittsburgh, Pennsylvania, 1934,
lives in New York and Maine

FLATIRON INTERSECTION
1979. Oil on canvas, 60 in x 6 ft 8 in (152.4 x 203.2 cm).
Collection Mr. and Mrs. Sidney Kahn, New York

THREE-MILE ISLAND DAY, I
1982. Pastel on light gray paper, 17 x 13¾ in (43.2 x 34.9 cm).
Brooke Alexander, Inc., New York

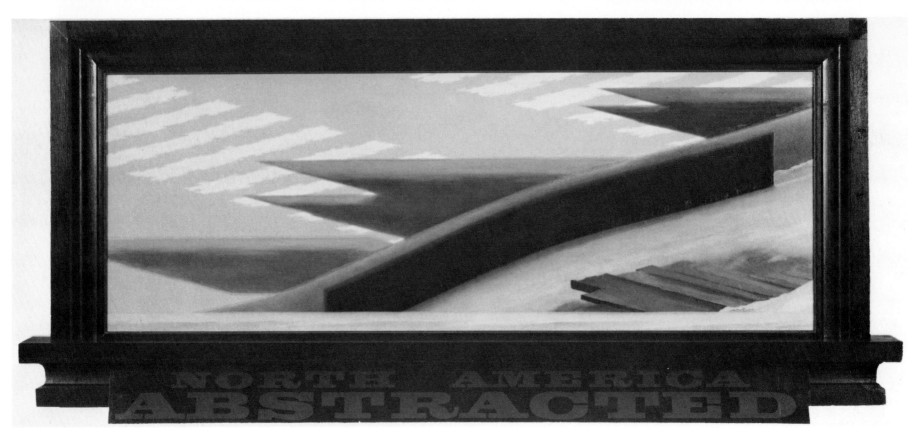

NORTH AMERICA ABSTRACTED
1978–80. Oil on wood, 38 in x 7 ft 1¼ in x 5¼ in (96.5 x 216.5 x 13.3 cm).
Whitney Museum of American Art, New York. Purchase, with funds from the
Burroughs Wellcome Purchase Fund, the Wilfred P. and Rose Cohen Purchase Fund,
and the Painting and Sculpture Committee

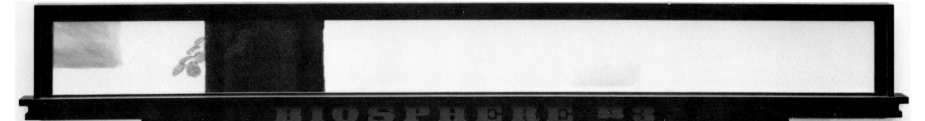

BIOSPHERE NO. 3
1971–75. Oil on wood, 32½ in x 21 ft 6½ in (82.5 x 656.6 cm).
The Edward R. Broida Trust, Los Angeles, California

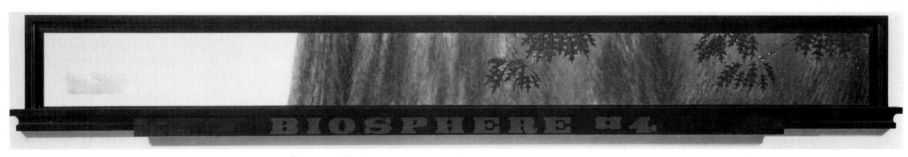

BIOSPHERE NO. 4
1971–76. Oil on wood, 31½ in x 21 ft 6½ in (80 x 656.6 cm).
Collection the artist

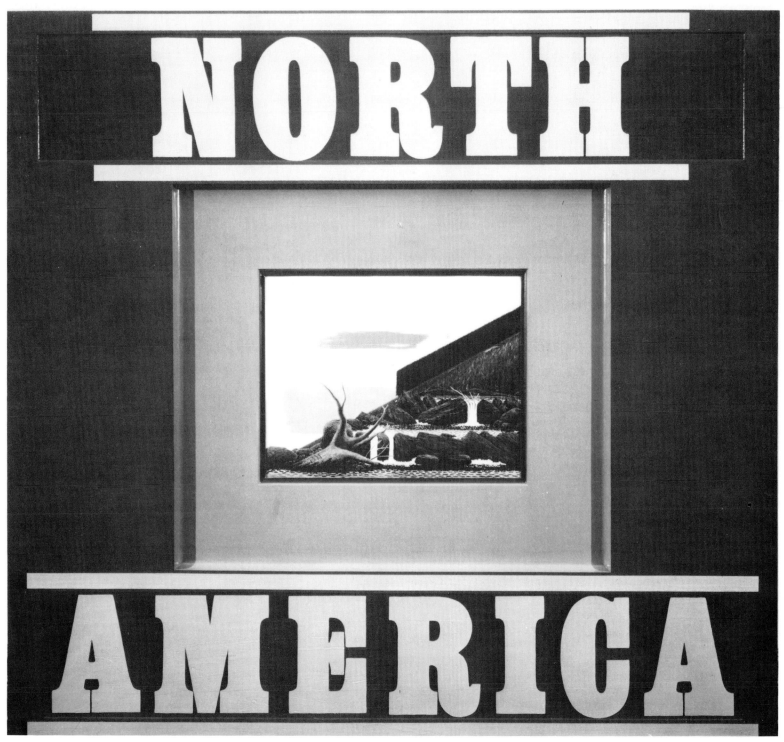

THE BRUCE HARDIE MEMORIAL
1978–82. Oil on wood, 6 ft 2 in x 6 ft 8 in (188 x 203.2 cm).
Collection the artist

NEIL JENNEY • Born Torrington, Connecticut, 1945, lives in New York

THE TEMPEST
1980–81. Oil on linen,
30 x 22 in (76.2 x 55.9 cm).
Private collection. Courtesy
Washburn Gallery, New York

BILL JENSEN
Born Minneapolis, Minnesota, 1945, lives in New York

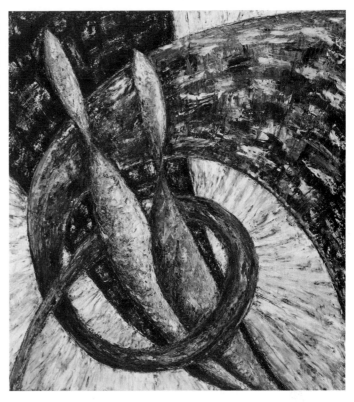

DELUGE
1980–81. Oil on linen, 26 x
24 in (66 x 60.1 cm).
The Museum of Modern Art,
New York. Promised
gift of Mr. and Mrs.
Gifford Phillips

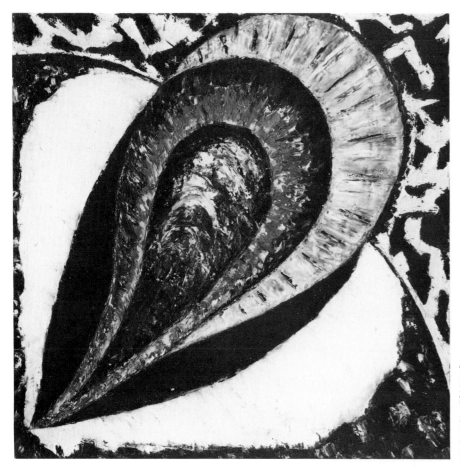

THE MEADOW
1980–81. Oil on linen,
22 x 22 in (55.9 x 55.9 cm).
Whitney Museum of
American Art, New York.
Purchase, with funds from
the Wilfred P. and Rose
Cohen Purchase Fund

THE FAMILY
1980. Oil on linen,
20 x 36 in (50.8 x 91.4 cm).
Collection Henry and
Maria Feiwel

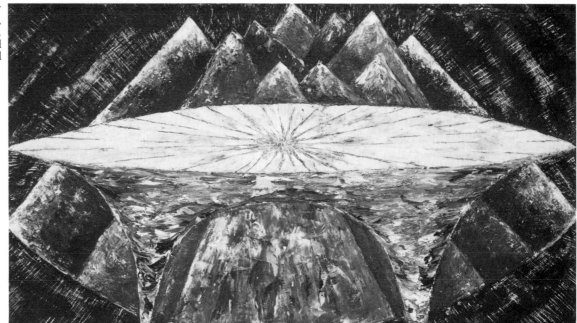

ROBERTO JUAREZ
Born Chicago, Illinois, 1952, lives in New York

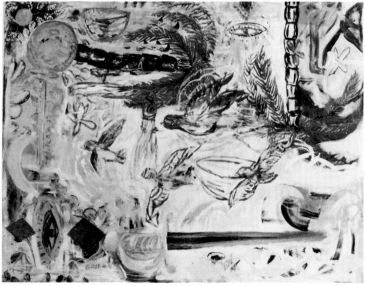

POLY SHELL
1982. Synthetic polymer
paint on canvas, 6 x 8 ft
(182.8 x 243.8 cm).
Collection Mr. and Mrs.
Rosenzweig

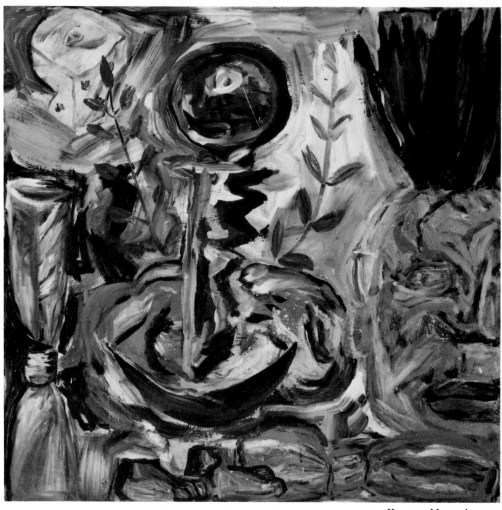

KEY AND MOON ANCHOR
1981. Synthetic polymer
paint on canvas, 6 ft 6 in x
6 ft 8 in (198.1 x 203.2 cm).
Collection Werner and
Elaine Dannheiser

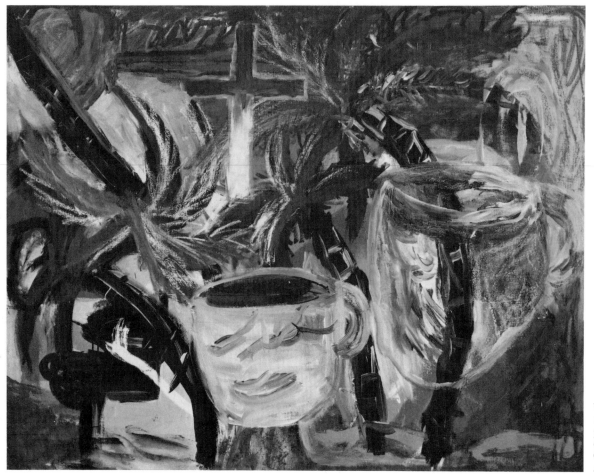

VIEJA LUNA
1981. Synthetic polymer
paint on canvas, 57 in x
6 ft 1 in (144.8 x 185.4 cm).
Collection Mr. and Mrs.
Aaron Katz

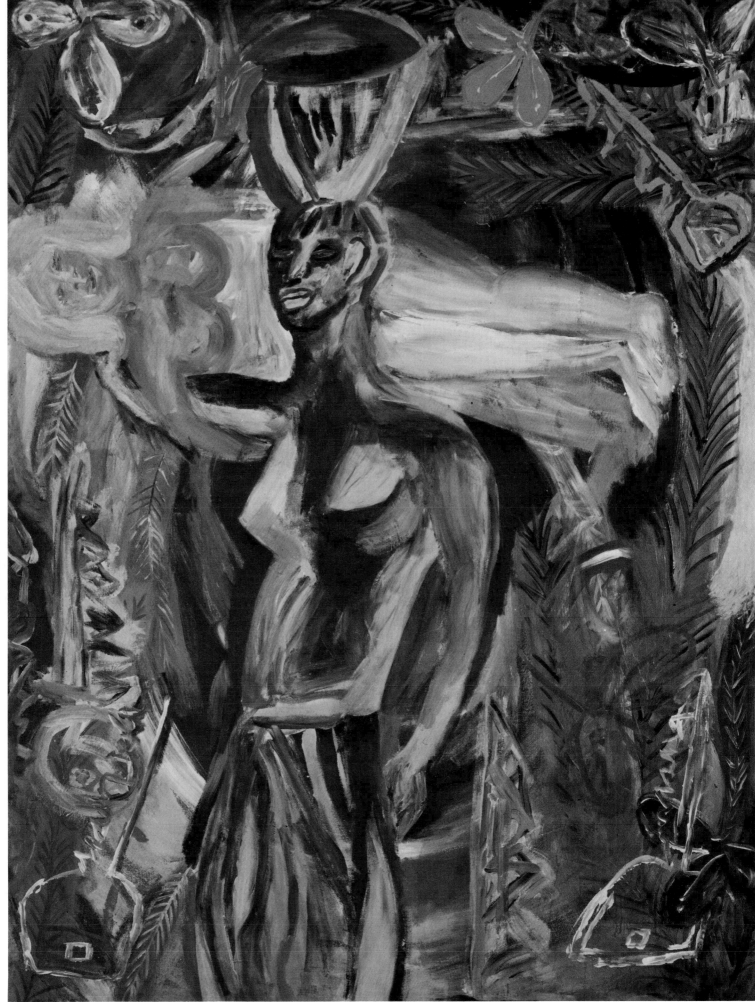

STATUE WITH DOLL
(IN KEYHOLE)
1981. Synthetic polymer
paint on canvas, 8 x 6 ft
(243.8 x 182.8 cm).
Private collection

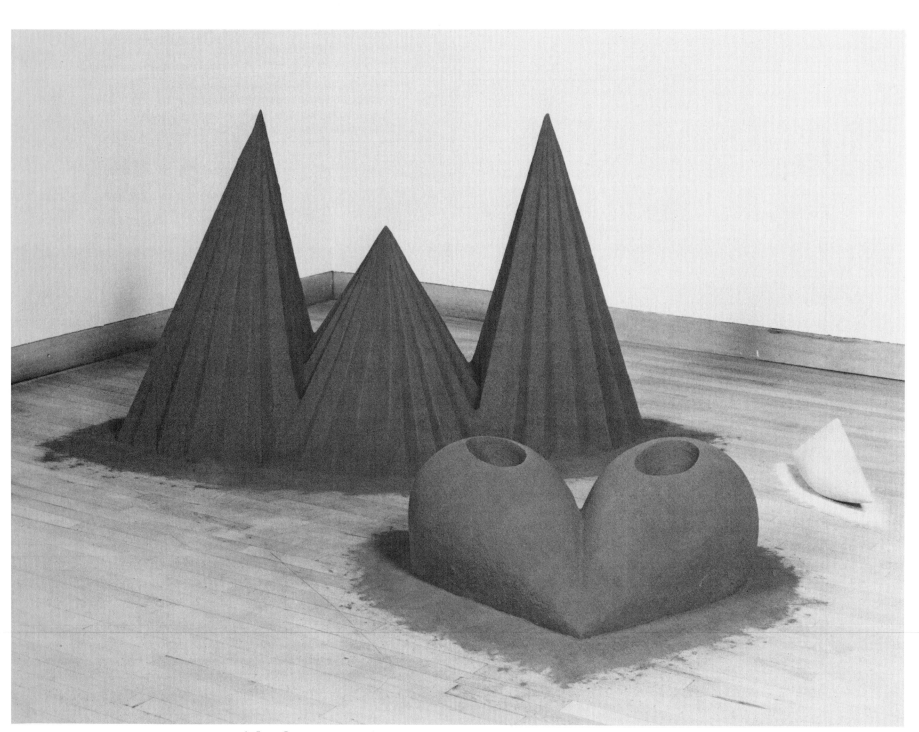

As If to Celebrate...
1981. Wood, cement,
and pigment, size variable.
The Trustees of the Tate
Gallery, London

ANISH KAPOOR
Born Bombay, India, 1954, lives in London

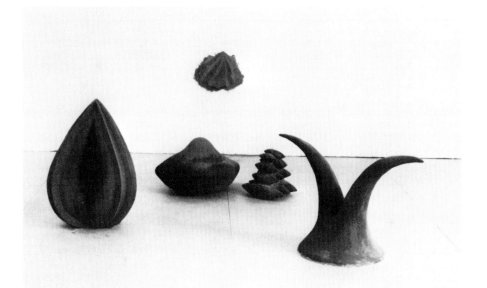

RED IN THE CENTER
1982. Bonded earth
and pigment, size variable.
Walker Art Gallery,
Liverpool, England

TO REFLECT AN
INTIMATE PART OF THE RED
1981. Wood, cement, and
pigment, size variable.
Lisson Gallery, London

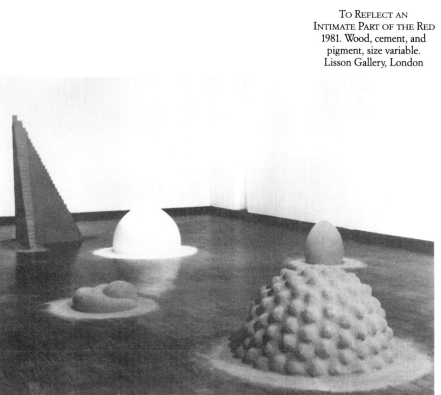

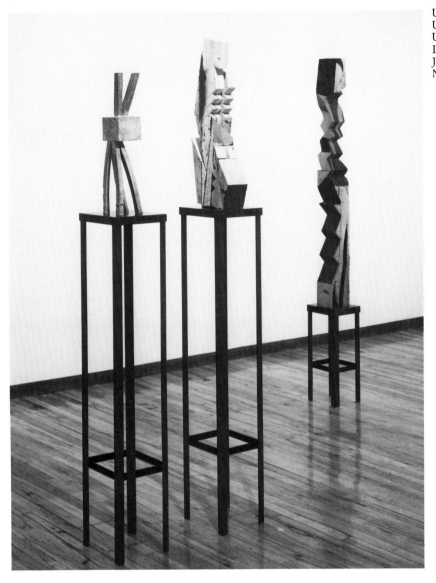

UNTITLED RED COLUMN, 1983;
UNTITLED POPLAR, 1983; and
UNTITLED BRONZE, 1982.
Installation at
John Weber Gallery,
New York, 1980

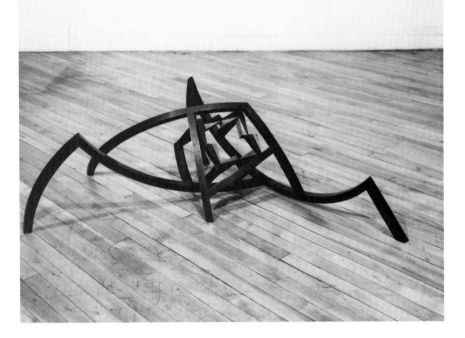

UNTITLED BRONZE
1981. Bronze, 16¼ x 54½ x 30 in
(41.3 x 138.4 x 76.2 cm).
Private collection

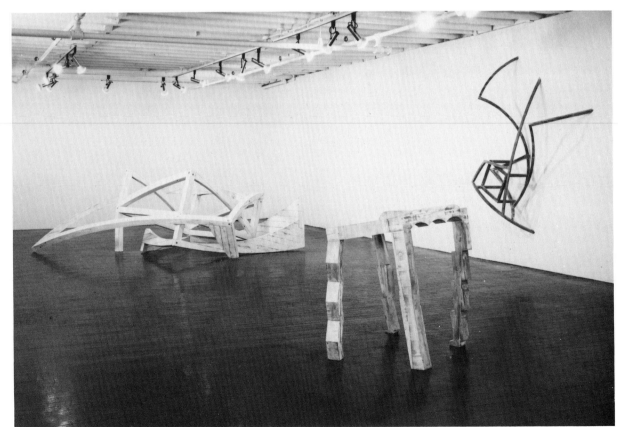

Installation at
John Weber Gallery,
New York, 1983

MEL KENDRICK
Born Boston, Massachusetts, 1949,
lives in New York

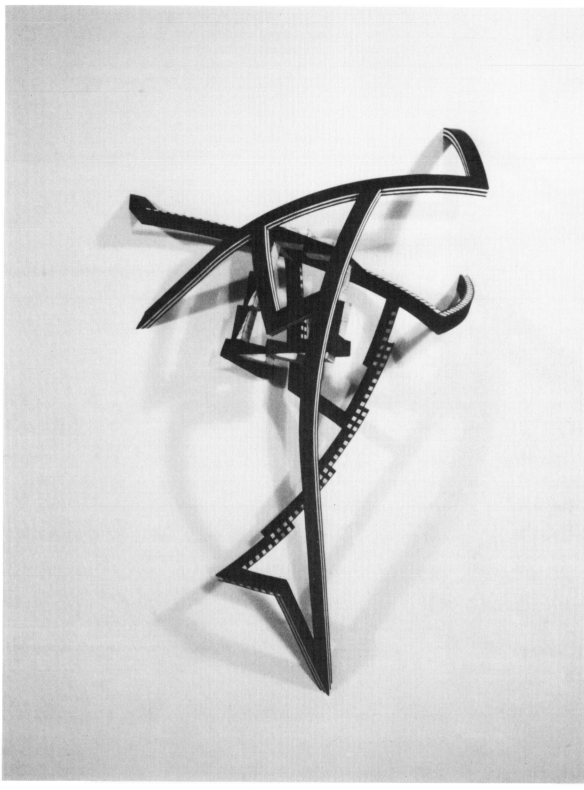

BEHIND THE CROSS
1982. Wood and plaster, 6 ft 2 in x 44 x 21 in (188 x 111.8 x 53.3 cm).
Addison Gallery of American Art, Phillips Academy, Andover, Massachusetts.
Given in memory of Lindsay Bradford, Jr., by his friends

SEARCH FOR TOMORROW
1983. Mixed materials with electric lights,
7 ft x 24 in x 24 in
(213.4 x 61 x 61 cm). Collection
the artist

THE SECRET STORM
1983. Mixed materials with electric lights
and motors, 36 x 21 x 12 in
(91.4 x 53.3 x 30.5 cm). Collection
Elaine and Werner Dannheisser

JON KESSLER
Born Yonkers, New York, 1957, lives in New York

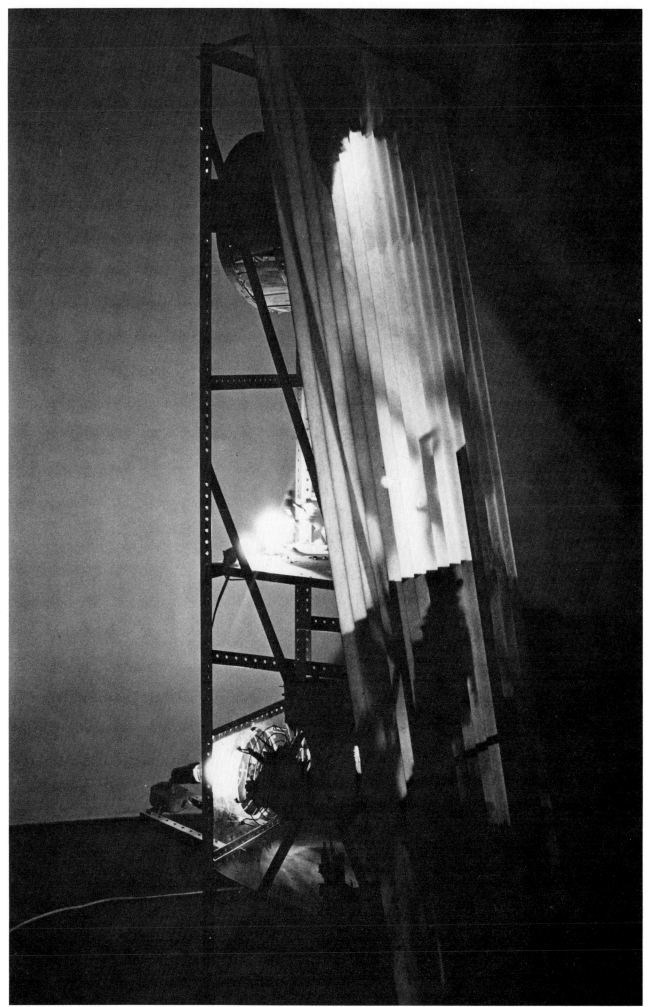

THE GUIDING LIGHT
1983. Mixed materials,
approx. 6 ft 2 in x 38 in x
36 in (188 x 96.5 x 91.4 cm).
Collection the artist

BILDERSTREIT
PAINTING DISPUTE
1976–77. Oil on canvas, 10 ft 10 in x 11 ft
(330.2 x 335.3 cm). Collection Doris and
Charles Saatchi, London

WEGE DER WELTWEISHEIT
ROUTES OF WORLD WISDOM
1977. Oil on woodcut, 9 ft 10⅛ in x
9 ft 10⅛ in (300 x 300 cm).
Collection Doris and Charles Saatchi, London

DAS WÖLUND-LIED
THE WÖLUND SONG
1982. Oil, straw, and lead on canvas,
9 ft 4 in x 12 ft 8 in (284.5 x 386 cm). Collection
Doris and Charles Saatchi, London

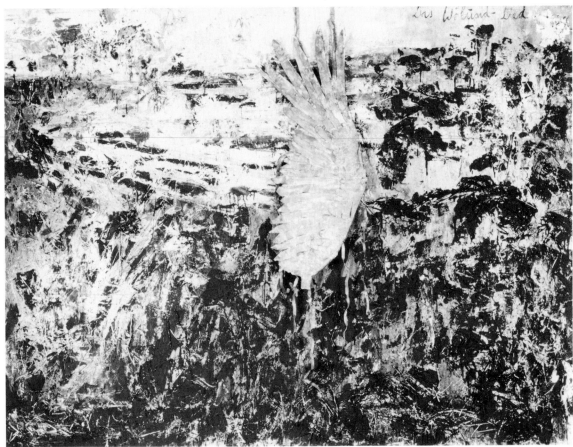

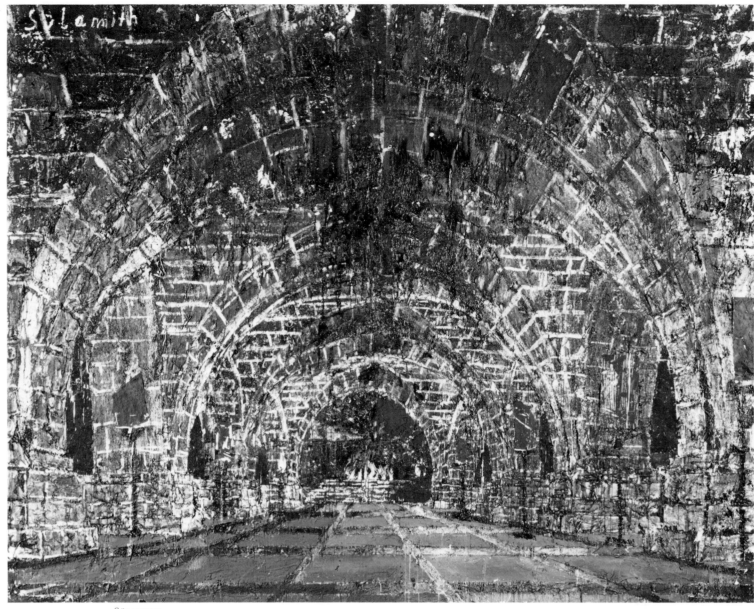

SÜLAMITH
1983. Oil, emulsion, woodcut, shellac, and
straw on canvas, 9 ft 6¼ in x
12 ft 1⅜ in (290 x 370 cm). Collection
Doris and Charles Saatchi, London

ANSELM KIEFER
Born Donaueschingen, Germany, 1945,
lives in Hornbach, Odenwald,
West Germany

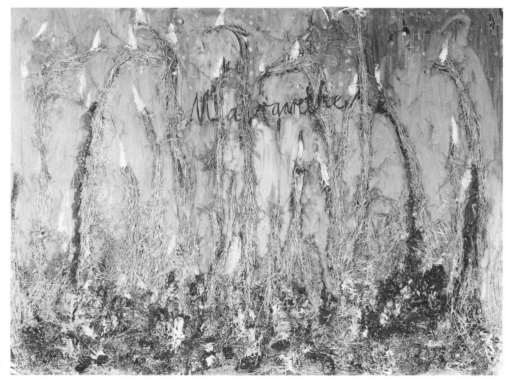

MARGARETHE
1982. Oil and straw on canvas,
9 ft 2¼ in x 12 ft 5⅜ in
(280 x 380 cm). Collection
Doris and Charles Saatchi, London

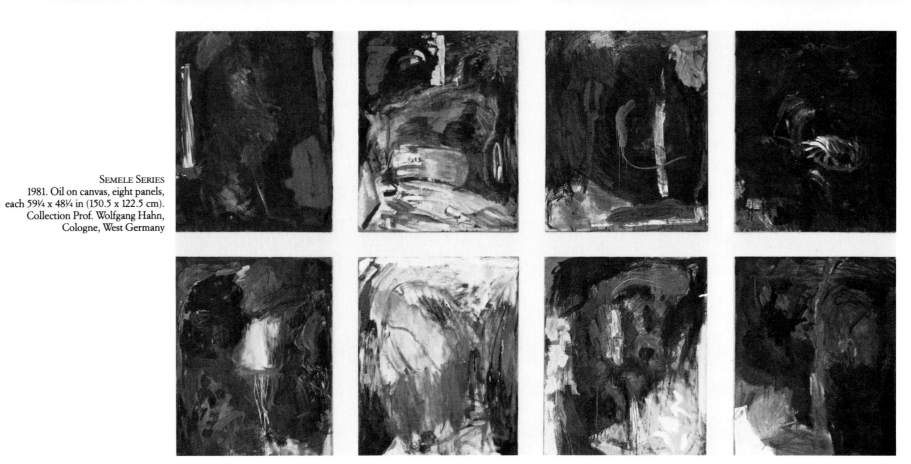

SEMELE SERIES
1981. Oil on canvas, eight panels,
each 59¼ x 48¼ in (150.5 x 122.5 cm).
Collection Prof. Wolfgang Hahn,
Cologne, West Germany

PER KIRKEBY
Born Copenhagen, Denmark, 1938,
lives in Copenhagen
and Laesø, Denmark,
and Karlsruhe, West Germany

CANDLES
1982. Oil on canvas,
51⅛ x 6 ft 6¾ in
(130 x 200 cm).
Galerie Ascan Crone,
Hamburg, West Germany

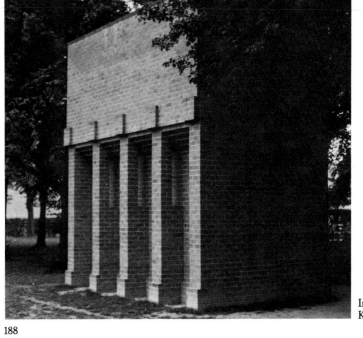

Installation at *Documenta 7,*
Kassel, West Germany, 1982

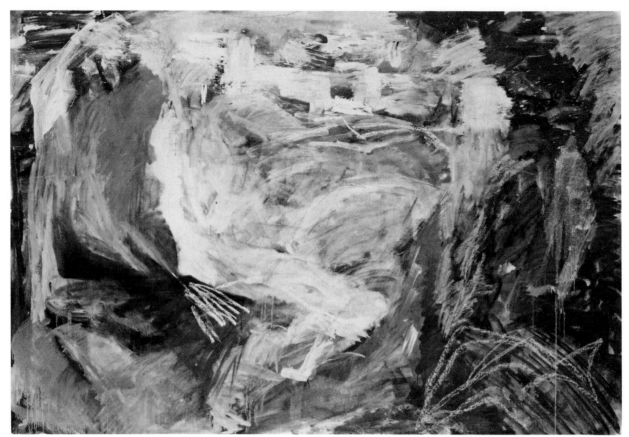

UNTITLED (HELEN)
1979. Oil on canvas,
54¾ in x 6 ft 8¾ in
(139 x 205 cm).
Private collection

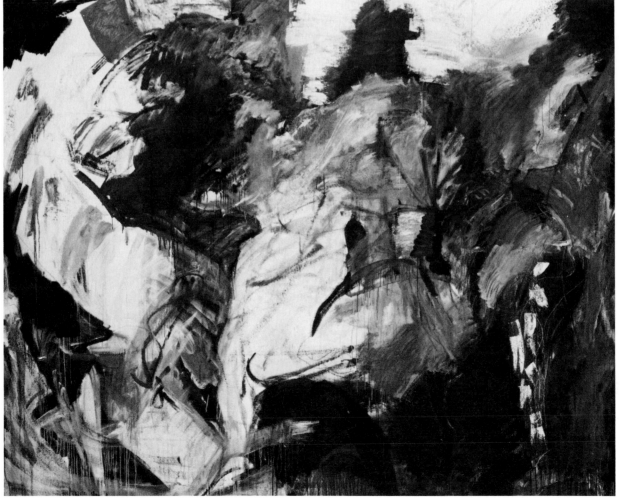

UNTITLED
1980. Oil on canvas,
6 ft 7¾ in x 8 ft 6⅜ in
(202.5 x 260 cm).
Galerie Ascan Crone,
Hamburg, West Germany

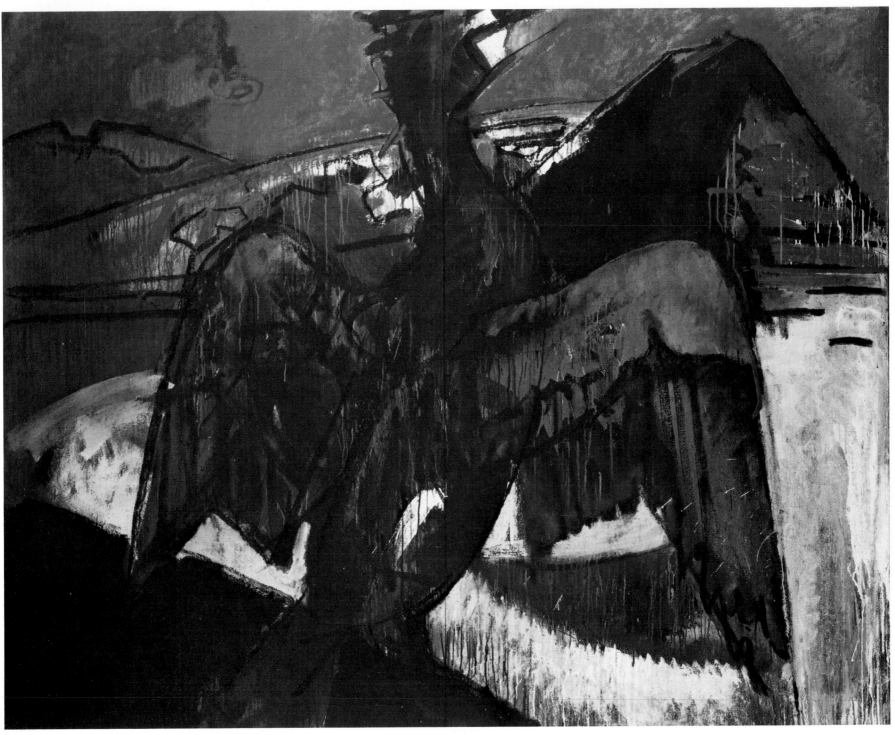

Im Zeichen des Kormorans
IN THE SIGN OF THE CORMORANT
1980–81. Synthetic resin and oil on jute,
6 ft 2¾ in x 7 ft 10½ in (190 x 240 cm).
Collection H. E. Berg

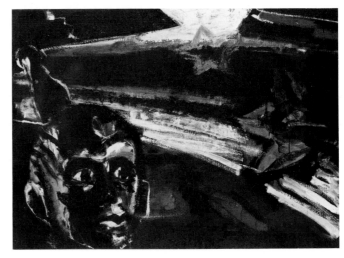

Ausgang des Tals
EXIT FROM THE VALLEY
1981. Synthetic resin and oil
on jute, 47¼ x 70 in (120 x
170 cm). Studio d'Arte
Cannaviello, Milan, Italy

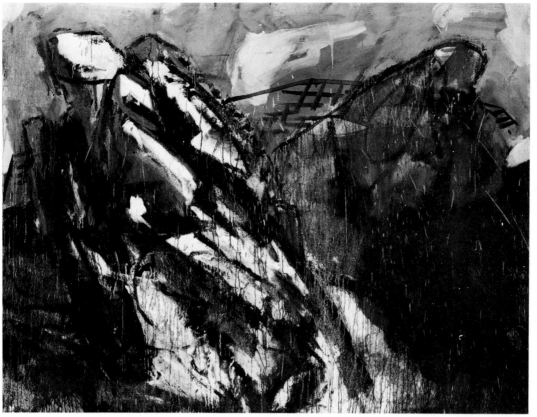

Blocklava Tagtraum
LAVA ROCK DAYDREAM
1980. Synthetic resin and oil
on canvas, 6 ft 2¾ in x
8 ft ½ in (190 x 245 cm).
Galerie Reinhard Onnasch,
Berlin

BERND KOBERLING
Born Berlin, 1938,
lives in Berlin

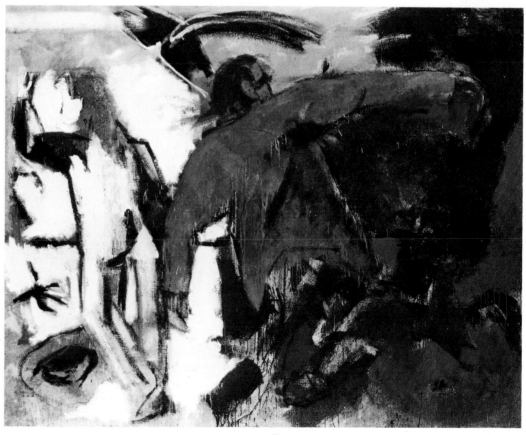

Fluchten
FLIGHTS
1982–83. Synthetic resin and oil on jute,
6 ft 2¾ in x 8 ft ½ in (190 x 245 cm).
Private collection, Cologne, West Germany

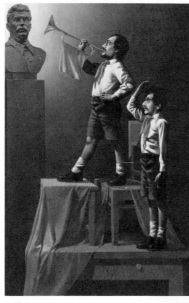

Double Self-Portrait
as Young Pioneers
1982–83. Oil on canvas,
6 ft x 50 in (182.9 x 127 cm).
Collection Martin Sklar

KOMAR AND MELAMID

VITALY KOMAR
Born Moscow, Soviet Union, 1943,
lives in New York

ALEXANDER MELAMID
Born Moscow, Soviet Union, 1945,
lives in New York

SCENES FROM THE FUTURE:
THE GUGGENHEIM MUSEUM
1975. Oil on masonite,
15¾ x 12 in (40 x 30.5 cm).
Collection Tibor and Bente
Hirsch, New York

SCENES FROM THE FUTURE:
MUSEUM OF MODERN ART
1983–84. Oil on canvas,
6 ft x 63 in (182.9 x 160 cm).
Ronald Feldman Fine Arts,
New York

Right
SCENES FROM THE FUTURE:
KENNEDY AIRPORT
1975. Oil on masonite,
12 x 15¾ in (30.5 x 40 cm).
Collection Tibor and Bente
Hirsch, New York

LENIN LIVED, LENIN LIVES, LENIN WILL LIVE! 1981–82. Oil on canvas, 6 ft x 50¼ in (182.9 x 127.6 cm). Collection Jörn Donner, Helsinki, Finland

VIEW OF THE KREMLIN IN A ROMANTIC LANDSCAPE 1981–82. Oil on canvas, 6 ft x 7 ft 3 in (182.9 x 221 cm). Collection Robert and Maryse Boxer, London

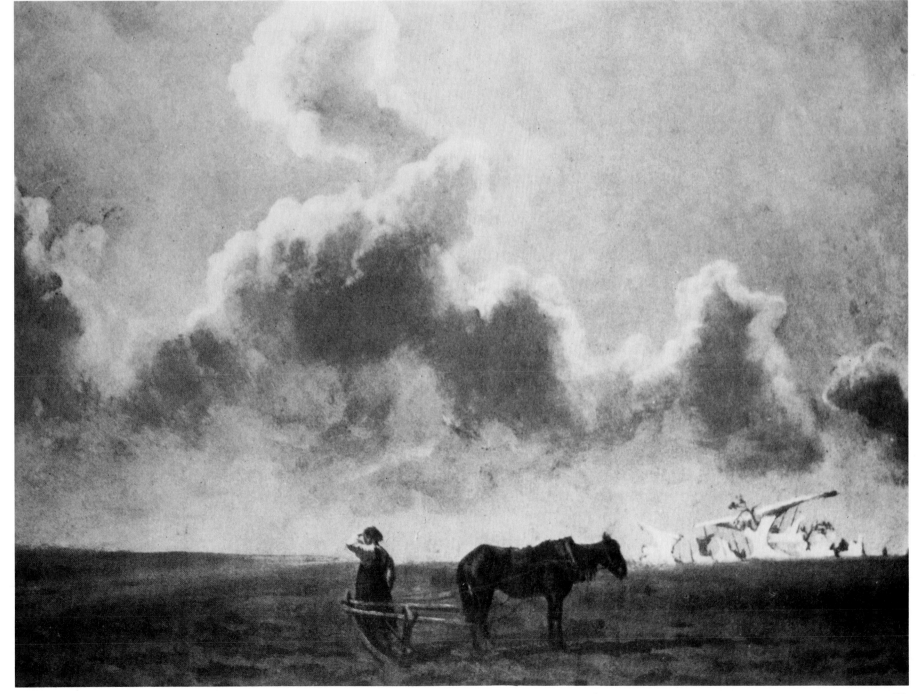

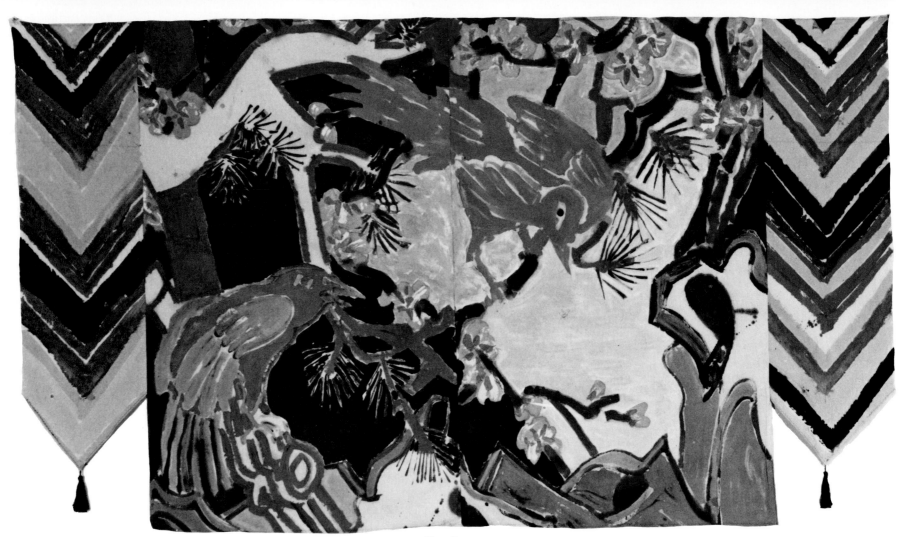

TWO BIRDS
1977. Synthetic polymer paint on fabric,
69 in x 10 ft 1 in (175.3 x 307.3 cm).
Collection Eddo and Maggie Bult

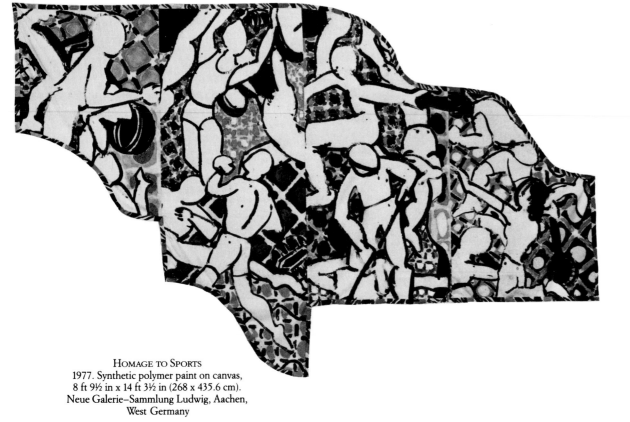

ROBERT KUSHNER
Born Pasadena, California, 1949,
lives in New York

HOMAGE TO SPORTS
1977. Synthetic polymer paint on canvas,
8 ft 9½ in x 14 ft 3½ in (268 x 435.6 cm).
Neue Galerie–Sammlung Ludwig, Aachen,
West Germany

Right
BIARRITZ
1975. Synthetic polymer paint
on synthetic fabric, cotton lace,
and fringe, 6 ft 2 in x 7 ft 1 in
(188 x 215.9 cm). Private collection.
Used in *Persian Line: Part II,*
performance by the artist in
New York, 1975.

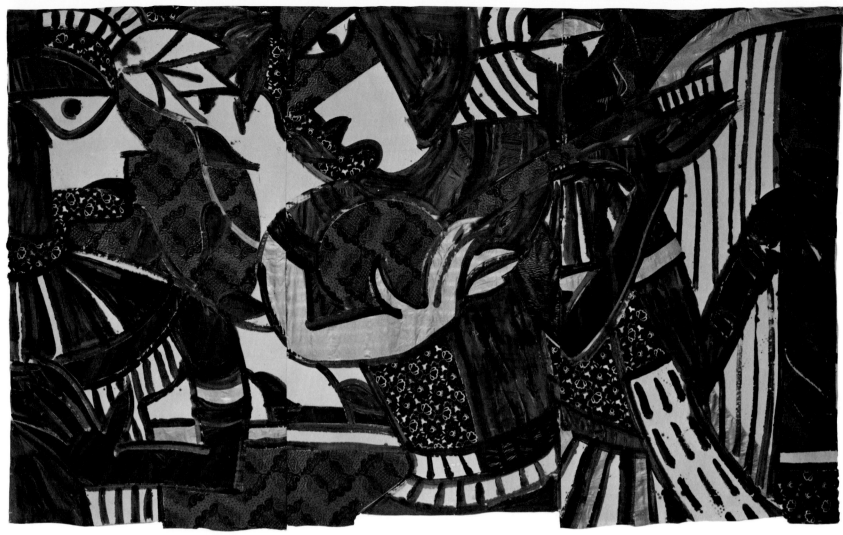

EVENING SONG
1981. Synthetic polymer paint with bronze powder
on fabric and canvas, 8 ft 8⅝ in x
14 ft 6⅝ in (265.6 x 441 cm).
The Museum of Modern Art, New York.
Given with deepest thanks by
Joy E. Feinberg of Berkeley, California

ROSE GATE
1980. Synthetic polymer paint on mixed fabrics,
7 ft 5 in x 9 ft 3 in (226 x 281.9 cm).
Collection the artist. Courtesy Holly Solomon
Gallery, New York

UNTITLED
1978. Oil on canvas,
6 x 8 ft (157.5 x 243.8 cm).
Collection the artist

UNTITLED
1978. Oil on canvas,
6 x 8 ft (157.5 x 243.8 cm).
Collection the artist

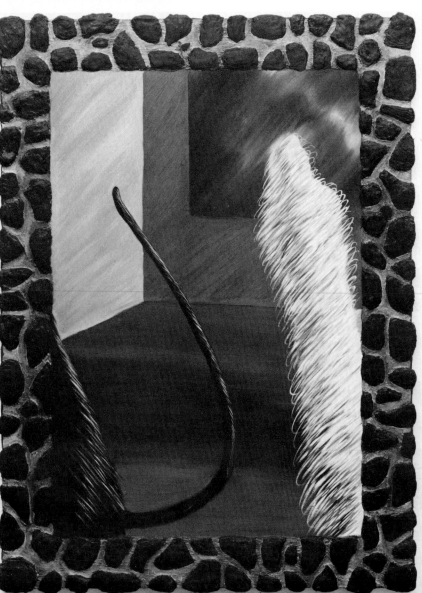

UNTITLED
1981. Oil on canvas,
49½ x 36¼ in
(125.7 x 92.1 cm).
Collection the artist

CHERYL LAEMMLE
Born Minneapolis, Minnesota, 1947,
lives in New York

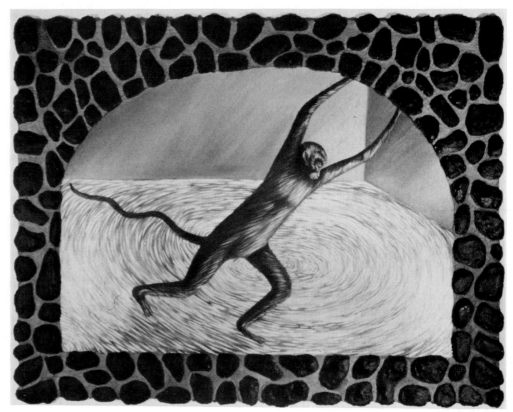

UNTITLED
1981. Oil on canvas,
36 x 48 in
(91.4 x 121.9 cm).
Collection the artist

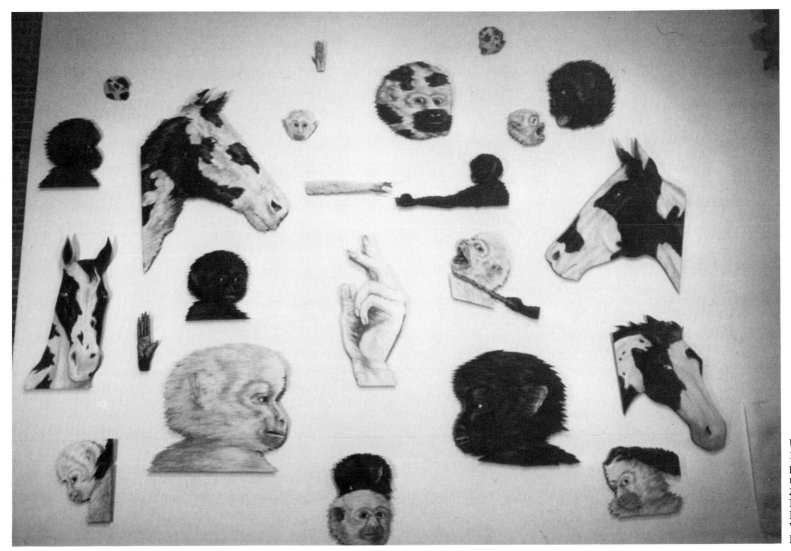

UNTITLED
1979. Oil and synthetic
polymer paint on
masonite, overall 20 x
26 ft (609.6 x 792.5 cm).
Installation at Wake
Forest University,
Winston-Salem,
North Carolina

197

Canon
1981. Synthetic polymer paint on camera,
3⅛ in x 6¾ x 5⅞ (8 x 17 x 15 cm).
Collection Roland Soriano, Neuchâtel, Switzerland

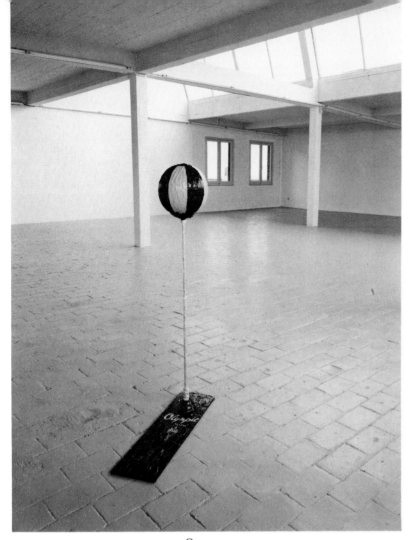

OLYMPIC
1982. Synthetic polymer paint on punching ball,
43⅜ x 17¾ x 11¾ in (110 x 45 x 30 cm).
Collection Ernest Delville, Brussels, Belgium

SICLI NC 2
1980. Synthetic polymer paint on fire extinguisher,
26⅜ x 6¾ x 4¾ in (67 x 17 x 12 cm).
Private collection

HYPERION
1982. Oil on canvas, 8 ft 2 in x
6 ft 11⅞ in (249 x 213 cm).
Swindon Art Gallery

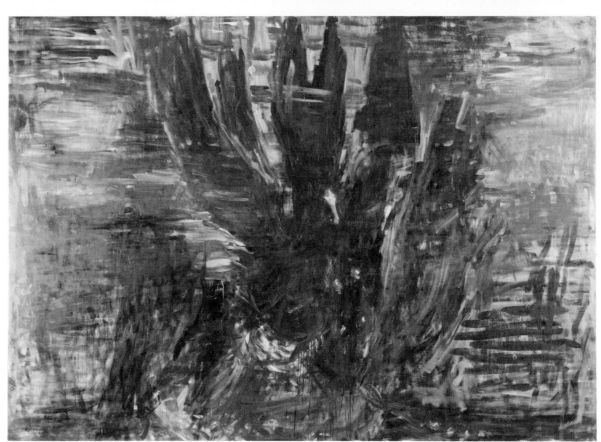

PILLAR, BANNER, FIRE
1982. Oil on canvas, 8 ft 4¼ in x
11 ft 11¾ in (256 x 365 cm).
Private collection, London

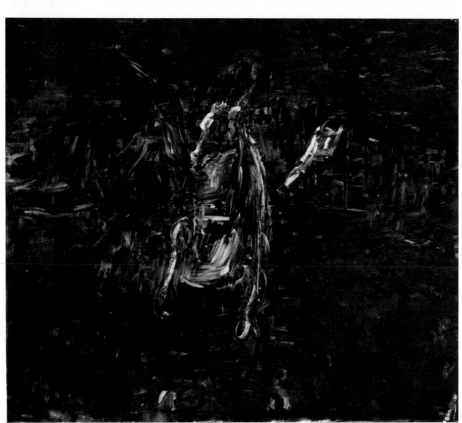

MARS IN THE AIR
1981. Oil on canvas, 8 ft 6 in x
9 ft 1⅛ in (259 x 300 cm).
The Chase Manhattan Bank, N.A.

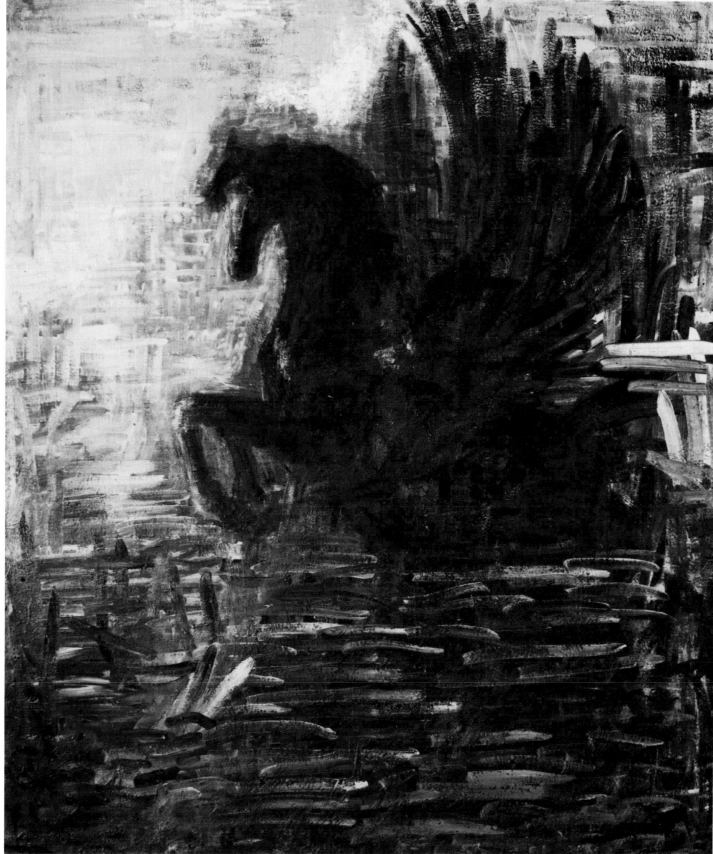

AMPHION
1980–81. Oil on canvas,
10 ft ½ in x 6 ft 11⅞ in
(305 x 213 cm). Collection
Frederik Roos

CHRISTOPHER LEBRUN · Born Portsmouth, England, 1951, lives in London

Jean Le Gac
Born Alès, France, 1936, lives in Paris

Le Délassement du peintre
(avec Touareg)
The Painter's Pastime
(with Tuareg)
1981. Photograph, drawing, and text,
6 ft 9⅛ in x 45¼ in (206 x 115 cm).
Galerie Daniel Templon, Paris

Le Délassement du peintre
(avec escalade)
The Painter's Pastime
(with Climbing)
1981. Photograph, drawing,
and text: photograph and
drawing, 6 ft 4⅜ in x 40¼ in
(194 x 102 cm); text, 11¾ x
15¾ in (30 x 40 cm).
Galerie Daniel Templon, Paris

Le Délassement du peintre
(avec tigre)
The Painter's Pastime
(with Tiger)
1981. Photograph, drawing,
and text, 45¼ in x
6 ft 9⅛ in (115 x 206 cm).
Collection Nicole Jullien

Le Délassement du peintre
(avec diseuse de bonne aventure)
The Painter's Pastime
(with Fortune Teller)
1981. Photograph, drawing, and
text, 45¼ in x 6 ft 9⅛ in (115 x
206 cm). Galerie Daniel Templon, Paris

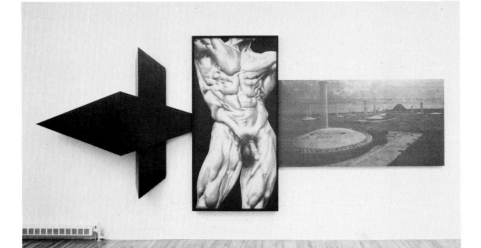

SWORD OF THE PIG
1983. Mixed mediums, 8 ft 1¼ in x
19 ft 1¼ in (248.3 x 582.3 cm).
The Trustees of the Tate Gallery, London

ROBERT LONGO
Born Brooklyn, New York, 1953,
lives in New York

NOW EVERYBODY
1982–83. Charcoal, graphite, and ink on paper,
overall 8 x 16 ft (243.8 x 487.7 cm);
figure: cast bronze bonding, 6 ft 6 in x 25 in x 45 in (198 x 63.5 x 114 cm).
Neue Galerie–Sammlung Ludwig, Aachen, West Germany

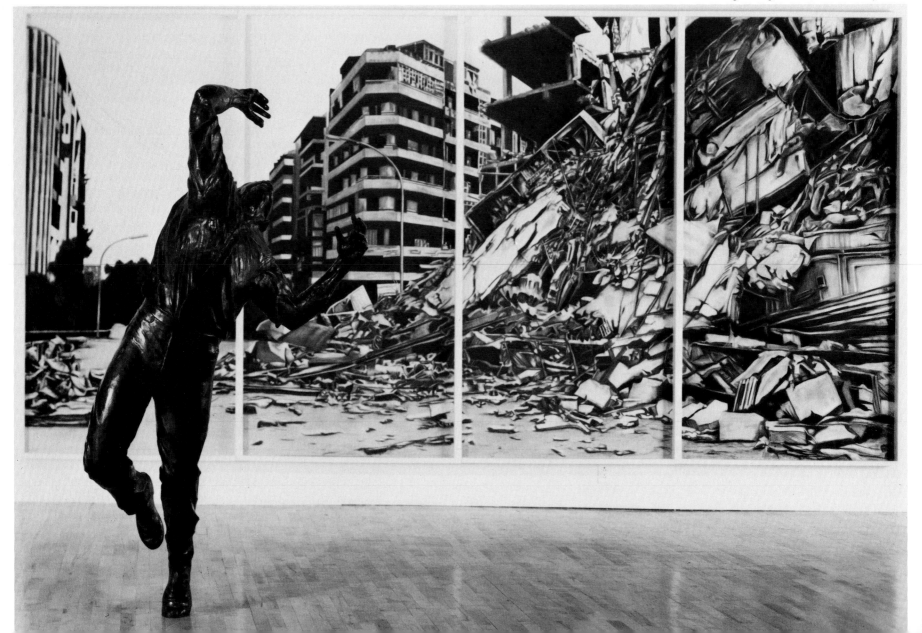

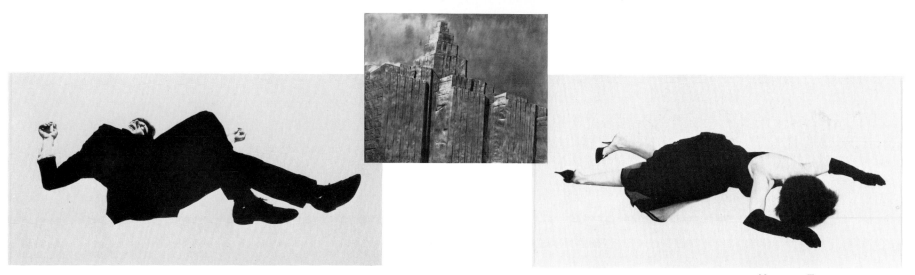

NATIONAL TRUST
1981. Charcoal and graphite on paper and
cast aluminum bonded relief, in three parts, overall
63 in x 19 ft 6 in (160 x 594.4 cm).
Walker Art Center, Minneapolis, Minnesota.
Art Center Acquisition Fund

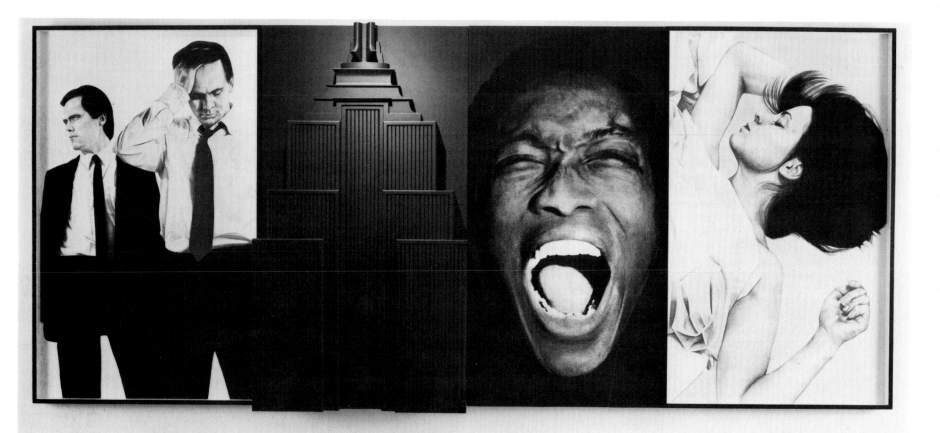

MISTER JAZZ
1982–83. Mixed mediums,
8 ft x 18 ft 9 in x 12 in (243.8 x 571.5 x 30.5 cm).
Private collection

NINO LONGOBARDI
Born Naples, Italy, 1953, lives in Naples

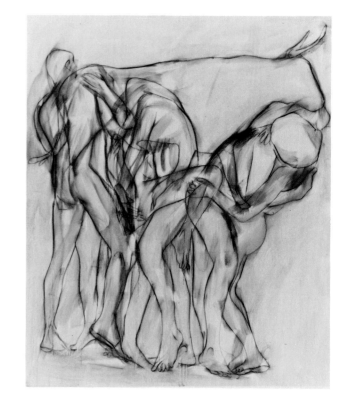

UNTITLED
1982. Oil and charcoal on canvas,
7 ft 10½ in x 6 ft 6¾ in (240 x 200 cm).
The Solomon R. Guggenheim
Museum, New York. Gift of Lucio Amelio

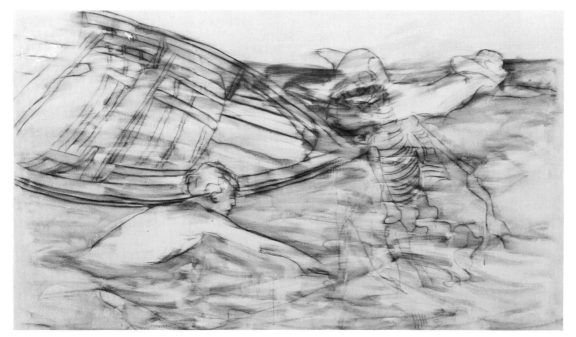

UNTITLED
1982. Oil and charcoal on canvas,
6 ft 6¾ in x 11 ft 5¾ in
(200 x 350 cm).
Collection the artist

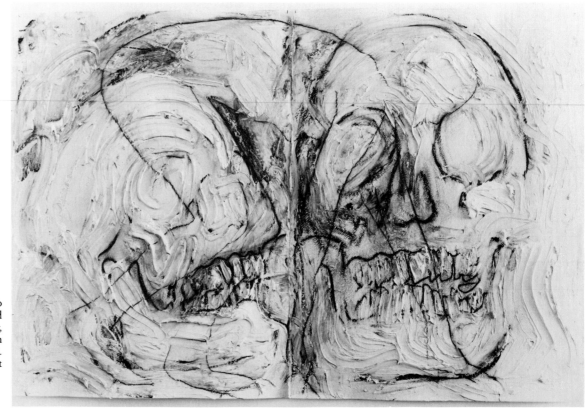

UNTITLED
1982. Tempera and
charcoal on paper,
29⅞ x 45¼ in
(76 x 115 cm).
Collection the artist

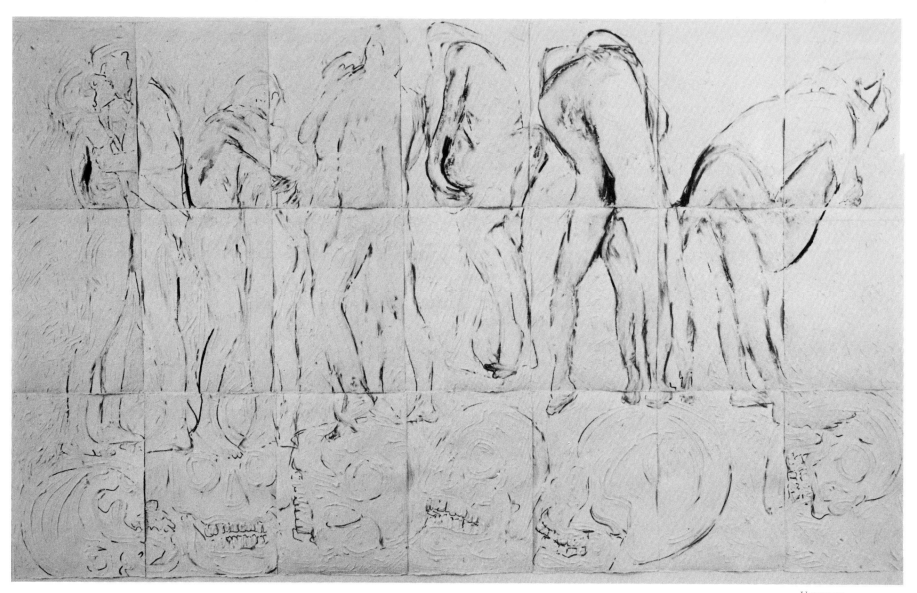

UNTITLED
1980. Tempera and charcoal on paper,
7 ft 7 in x 12 ft 10⅛ in
(231 x 392 cm).
Galleria Lucio Amelio, Naples, Italy

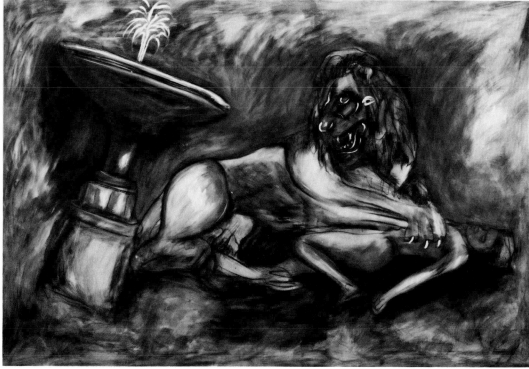

UNTITLED
1980. Oil and charcoal
on canvas, 6 ft 7⅛ in x
9 ft 10⅞ in (201 x 301.9 cm).
The Solomon R. Guggenheim
Museum, New York.
Exxon Corporation
Purchase Award

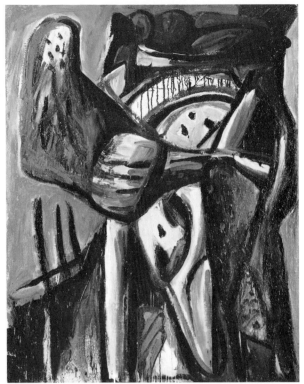

MARKUS LÜPERTZ
Born Reichenberg, Bohemia
(now Liberec, Czechoslovakia),
1941, lives in Berlin and
Karlsruhe, West Germany,
and Milan, Italy

BABYLON–DITHYRAMBISCH, XI
1975. Mixed mediums on canvas,
63¾ x 51¼ in
(162 x 130 cm). Galerie Michael Werner,
Cologne, West Germany

MÄRZHASE
MARCH HARE
1981. Oil on canvas, 39⅜ x 31⅞ in
(100 x 81 cm). Mary Boone Gallery, New York, and
Galerie Michael Werner, Cologne, West Germany

DER GROSSE LÖFFEL
THE BIG SPOON
1982. Oil on canvas, 6 ft 6¾ in x
9 ft 10¼ in (200 x 300 cm). Galerie Michael
Werner, Cologne, West Germany

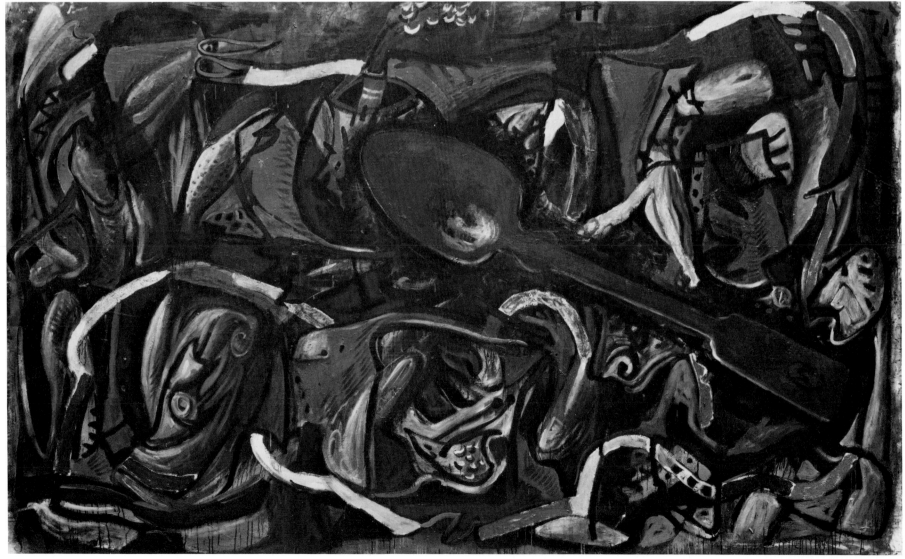

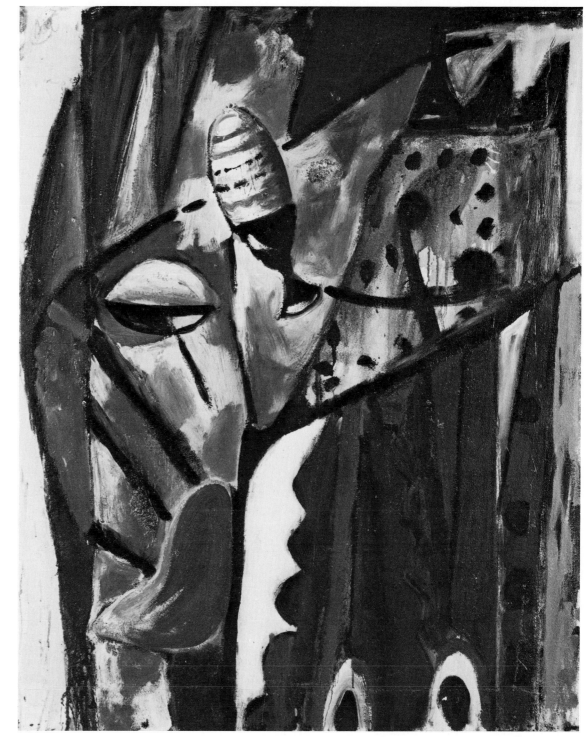

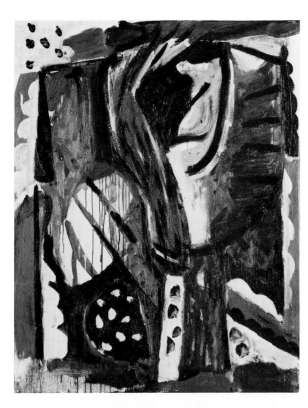

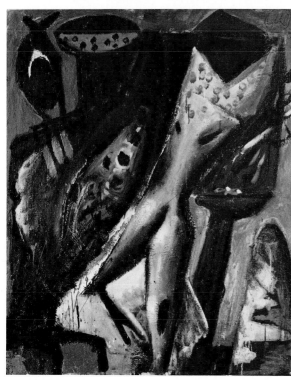

Es! versetzte die Maus ziemlich scharf
It! Replied the Mouse Rather Sharply
1981. Oil on canvas, 39⅜ x 31⅞ in
(100 x 81 cm). Art Gallery of New South
Wales, Sydney, Australia

Above left
Wenn Ich mal Herzogin werde
When I Shall Become Duchess, Sometime
1981. Oil on canvas, 39⅜ x 31⅞ in
(100 x 81 cm). Private collection. Courtesy
Mary Boone Gallery, New York, and
Galerie Michael Werner, Cologne, West Germany

Left
Das muss ein allerliebster Tanz sein
That Must Be the Loveliest Dance
1980–81. Oil on canvas, 39⅜ x 31⅞ in
(100 x 81 cm). Private collection. Courtesy
Mary Boone Gallery, New York, and
Galerie Michael Werner, Cologne, West Germany

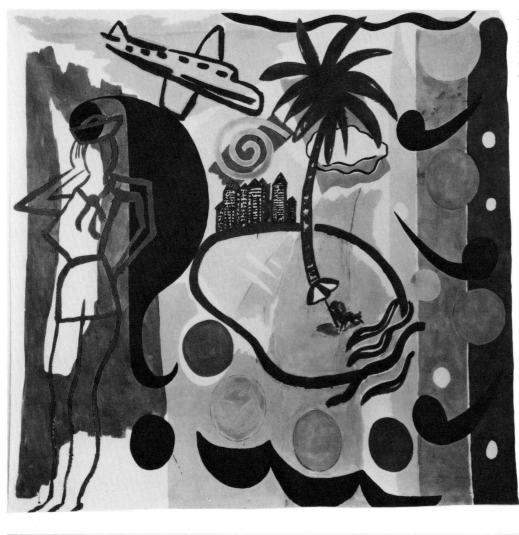

MARK OF SUCCESS
1983. Synthetic polymer paint on
cotton, 8 ft 6½ in x 9 ft
(256.2 x 270 cm). Collection
the artist. Courtesy Holly Solomon
Gallery, New York

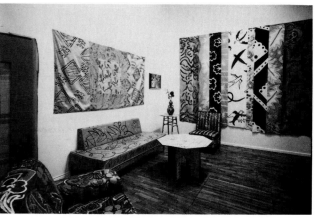

Installation at Holly Solomon Gallery, New York, 1977

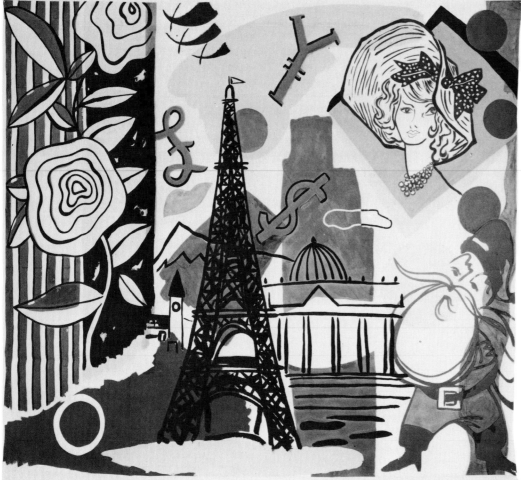

MOP 'N' GLO
1983. Synthetic polymer paint on
cotton, 8 x 9 ft (243.8 x 274.3 cm).
Albright-Knox Art Gallery,
Buffalo, New York

VICTROLA
1980. Synthetic polymer paint on cotton,
7 ft 9 in x 9 ft 9 in (236.2 x 297.2 cm).
Collection Carole and Beldon Katleman

KIM MACCONNEL
Born Oklahoma City, Oklahoma, 1946, lives in
Encinitas, California

KENSINGTON PARK
1980. Watercolor on calfskin vellum,
12½ x 11 in (31.6 x 28 cm).
Collection Phillip A. Bruno, New York

THE GREEN RIDE
1981. Watercolor on calfskin vellum,
8½ x 8 in (21.6 x 20.4 cm).
Staempfli Gallery, New York

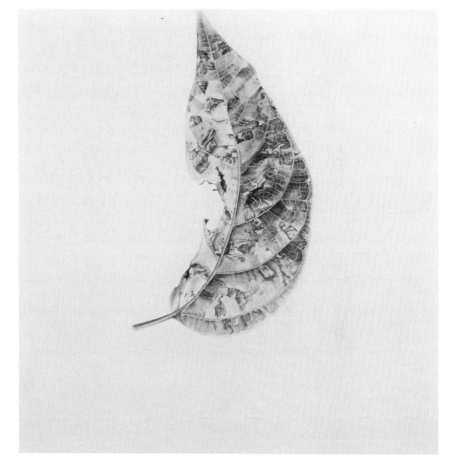

RORY MCEWEN
Born Marchmont, Berwickshire, Scotland, 1932,
died in London, 1982

Above
GRUB ISLAND,
ANDAMAN ISLANDS
1981. Watercolor
on calfskin vellum,
11½ x 11 in
(29 x 28 cm).
Staempfli Gallery,
New York

UNTITLED
1980. Watercolor on calfskin vellum,
5⅞ x 3⅞ in (14.9 x 9.8 cm).
Private collection

ROSS ISLAND, ANDAMAN ISLANDS
1981. Watercolor on calfskin vellum,
12 x 11½ in (30.4 x 29 cm).
Staempfli Gallery, New York

213

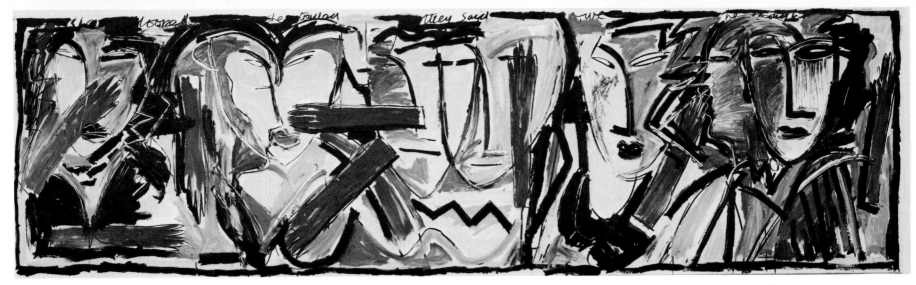

SHE LOOKED...THEY SAID...
1981. Synthetic polymer paint on photographic
paper, 54 in x 15 ft 7⅜ in
(137 x 476 cm). Art & Project,
Amsterdam, Netherlands

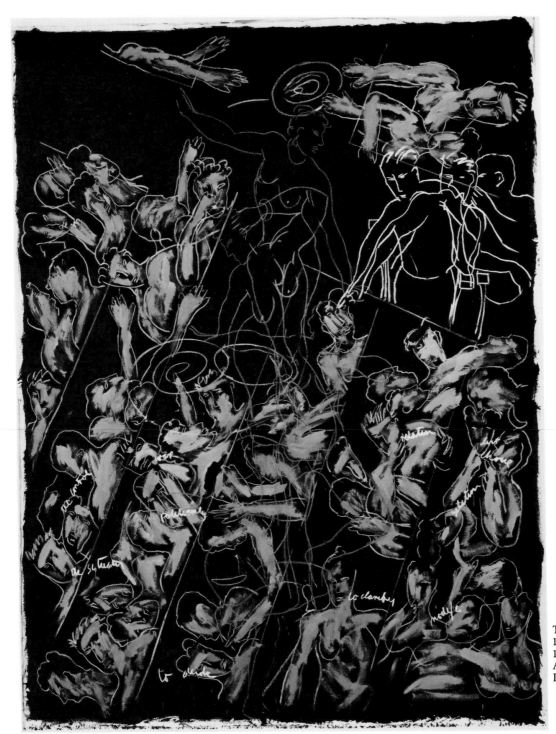

THE GENERAL MANEUVER
1982. Synthetic polymer paint on canvas,
13 ft 1½ in x 9 ft 10¼ in (400 x 300 cm).
Anthony d'Offay Gallery,
London, England

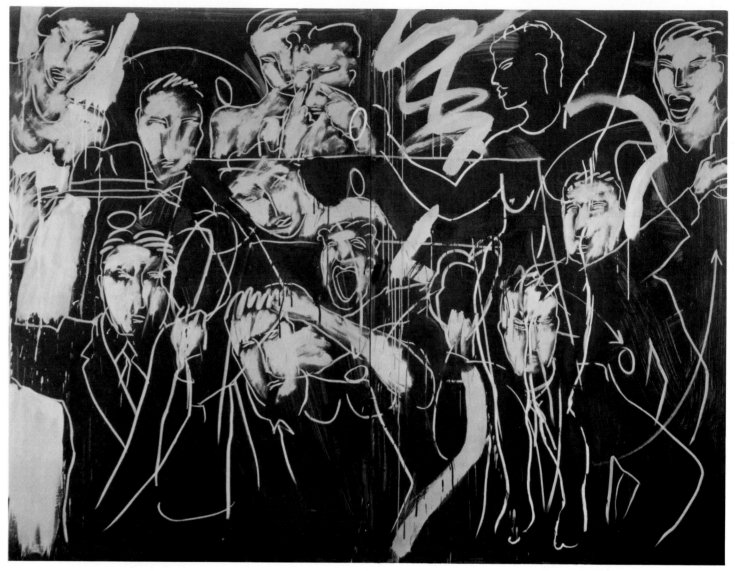

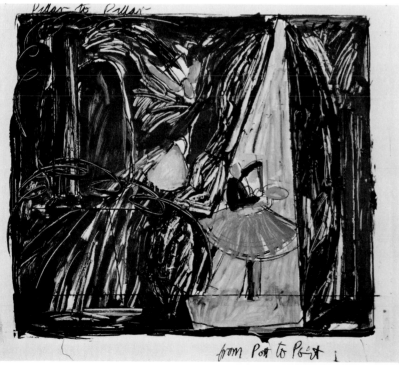

Pillar to Pillar from
Post to Post
1980. Synthetic polymer paint and
wax crayon on photographic paper,
54 x 67 in (137 x 170 cm).
Anthony d'Offay Gallery, London

Enter the Egg
1982. Synthetic polymer paint on canvas,
7 ft 1¼ in x 9 ft 10¼ in (218 x 300 cm).
Private collection

Bruce McLean
Born Glasgow, Scotland, 1942,
lives in London

215

Da Uno Studio del vero di A. R. Mengs
1975. Letter, color photograph,
and oil sketch on cardboard.
Private collection

Ganimede e l'acquila di Giove
Ganymede and Jove's Eagle
1978. Oil on canvas, 70⅞ x 53⅛ in
(180 x 135 cm). Private collection

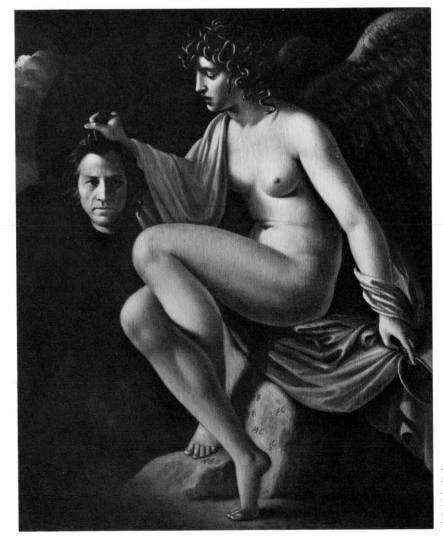

Carlo Maria Mariani
Born Rome, 1931,
lives in Rome

*Allegoria della critica
de l'arte*
Allegory of Art Criticism
1981. Oil on canvas, 19⅝ x 16⅛ in
(50 x 41.5 cm). Collection
William J. Hokin, Chicago, Illinois

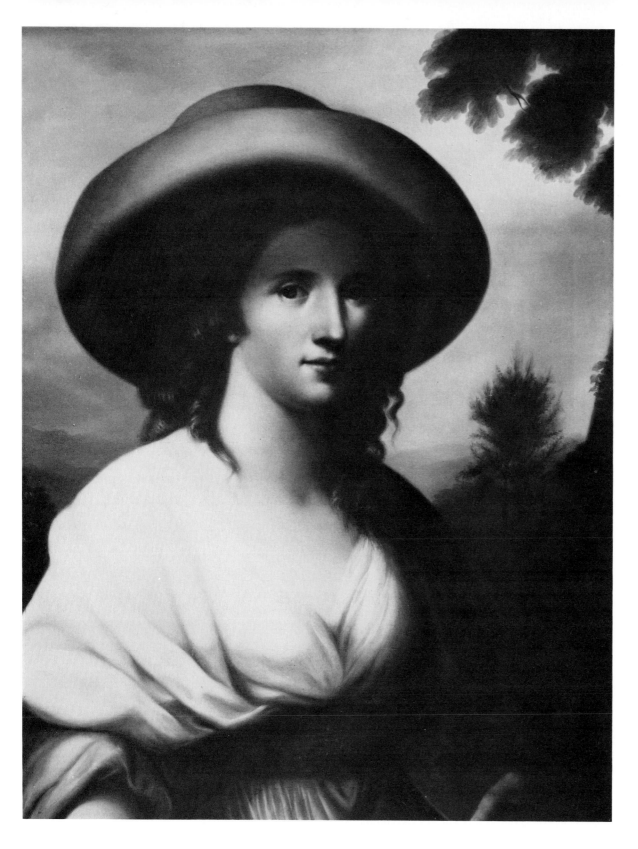

Il Ratto di Ganimede
The Kidnapping of Ganymede
1981. Oil on canvas, 24½ x 16½ in
(62.5 x 42 cm). Private collection

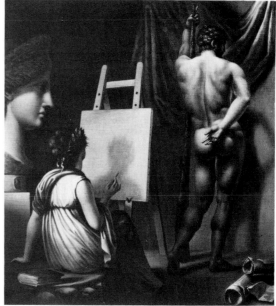

Ercole posa per
una pittrice neoclassica
Hercules Posing for
a Neoclassical Painter
1981. Oil on canvas,
15¾ x 17 in (40 x 43 cm).
Private collection

Autoritratto immaginario
di Angelica Kauffmann
Imaginary Self-Portrait
of Angelica Kauffmann
1976. Oil on canvas,
30 x 23¼ in (76 x 59 cm).
Galerie Paul Maenz,
Cologne, West Germany

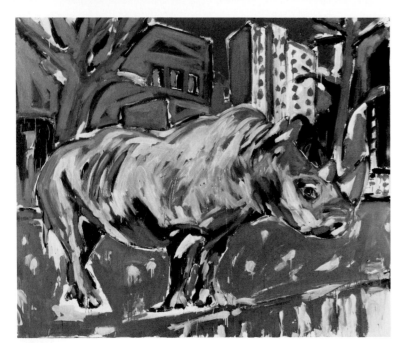

NASHORN, II
RHINOCEROS, II
1979. Synthetic polymer paint
on linen, 29½ x 35⅝ in
(75 x 90.5 cm). Collection
Triebold, Rheinfelden, Switzerland

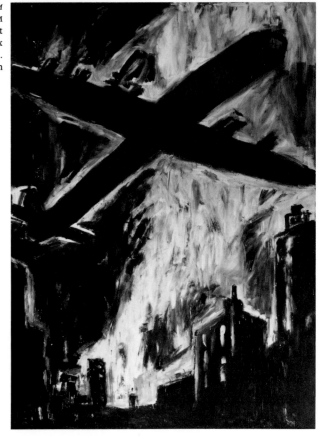

FLUGZEUGTRAUM
AIRPLANE DREAM
1982. Synthetic polymer paint
on canvas, 13 ft 1½ in x
9 ft 10¼ in (400 x 300 cm).
Private collection

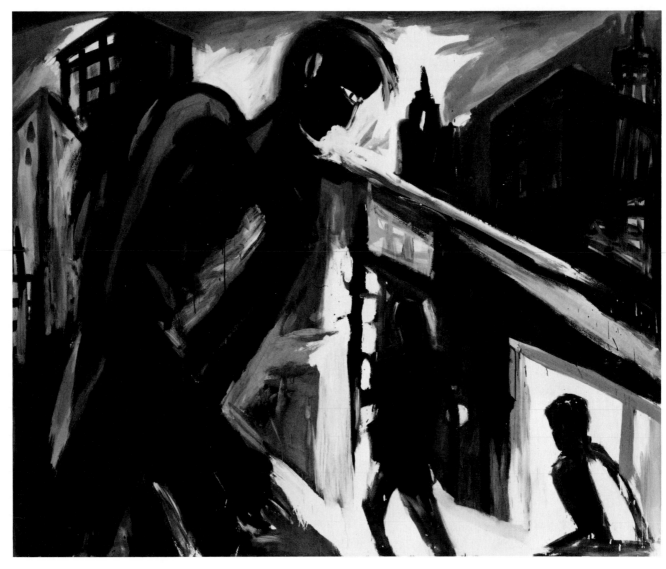

ROTER HIMMEL
RED SKY
1982. Synthetic polymer
paint on canvas, 70⅞ in x
7 ft 2⅝ in (180 x 220 cm).
Collection Frederik Roos

Im Malen
IN PAINTING
1982. Dispersion on canvas,
13 ft 1½ in x 9 ft 10¼ in
(400 x 300 cm).
Private collection

HELMUT MIDDENDORF
Born Dinklage, West Germany, 1953, lives in Berlin

Schwebender Rot
HOVERING RED
1980. Synthetic polymer paint
on canvas, 6 ft 2¾ in x
8 ft 2⅜ in (190 x 250 cm).
Metzger Collection, on extended
loan to Museum Folkwang, Essen,
West Germany

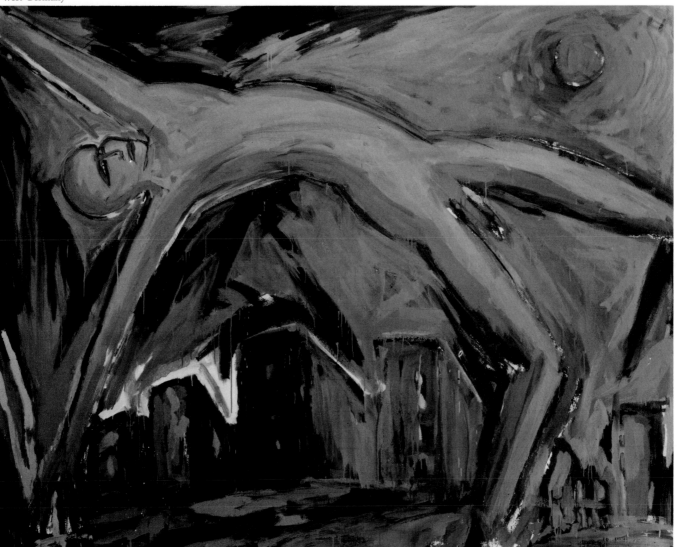

THE ULTIMATE ANXIETY
1978. Oil on canvas, 6 ft 7⅞ in x
8 ft 2¼ in (185 x 250 cm).
Collection Nancy Hoffman, New York

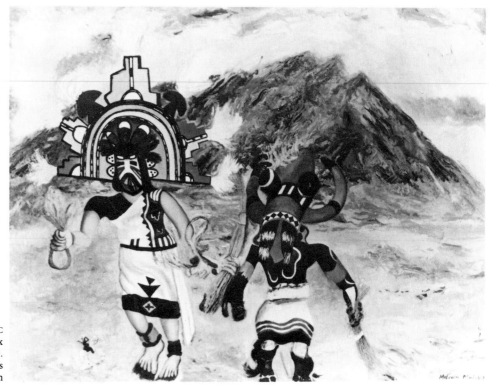

ARIZONAC
1981. Oil on canvas, 6 ft 8 in x
8 ft 9 in (203.2 x 266.7 cm).
Collection Doris and Charles
Saatchi, London

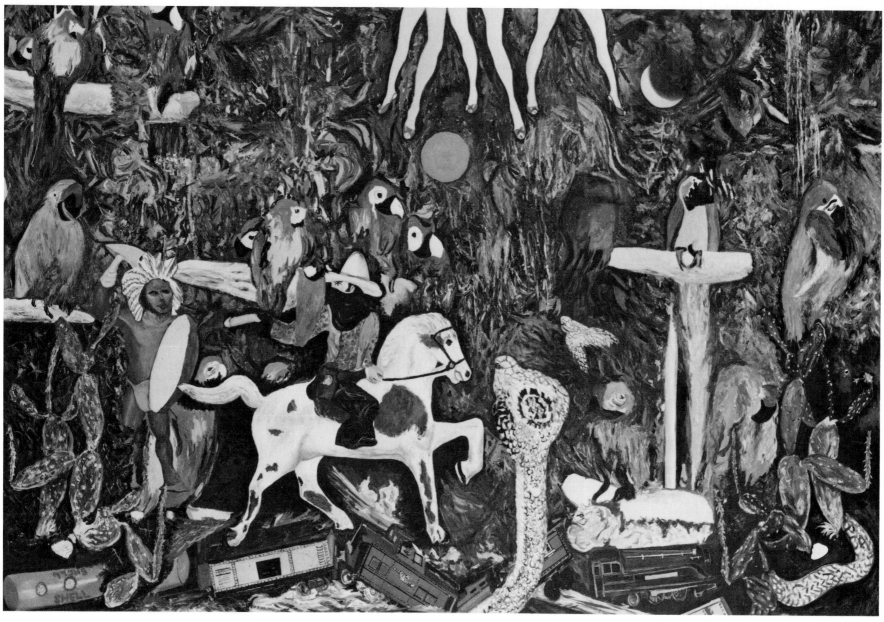

CHRISTMAS TREE–THE LONELY RANGER LOST
IN THE JUNGLE OF EROTIC DESIRES
1981. Oil on canvas, 6 ft x 9 ft (182.9 x 274.3 cm).
Private collection

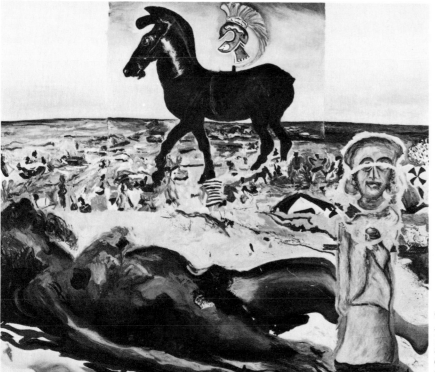

MALCOLM MORLEY
Born London, 1931, lives in New York

CRADLE OF CIVILIZATION WITH
AMERICAN WOMAN
1982. Oil on canvas, 6 ft 8 in x
8 ft 4 in (203.2 x 254 cm).
Collection Mr. and Mrs. David Workman,
Stamford, Connecticut

221

Robert Moskowitz
Born New York, 1935, lives in New York

The Mittens
1980–81. Oil on canvas,
39 in x 12 ft
(99 x 365.8 cm).
Collection Lewis
Zachary Cohen

'39 SANTA FE SUPERCHIEF
1975. Synthetic polymer paint
and latex on canvas,
7 ft 6 in x 6 ft 3 in
(228.6 x 190.5 cm).
Collection Miani Johnson,
New York

FLATIRON
(FOR LILY)
1979. Oil on canvas,
9 ft x 52 in
(274.3 x 132.1 cm).
Collection Ernie
and Lynn Mieger

COPPERHEAD
1981. Oil on canvas,
9 ft x 38 in
(274.3 x 96.5 cm).
Private collection

BEGINNER
1976. Oil on canvas,
9 ft 5 in x 9 ft 6 in
(287 x 289.6 cm).
Collection Doris and
Charles Saatchi,
London

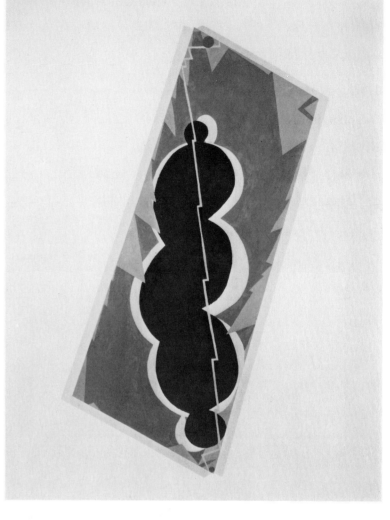

PARTING AND TOGETHER
1978. Oil on canvas,
10 ft 2 in x 52 in
(309.9 x 132.1 cm).
Collection Paul Anka

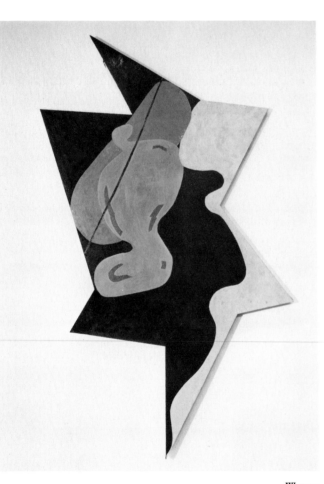

PAINTERS PROGRESS
1981. Oil on canvas, in
nineteen parts, overall
9 ft 8 in x 7 ft 10 in (294.5 x
236.2 cm) (irregular).
The Museum of Modern Art,
New York. Acquired through
the Bernhill and Agnes Gund
Saalfield Funds

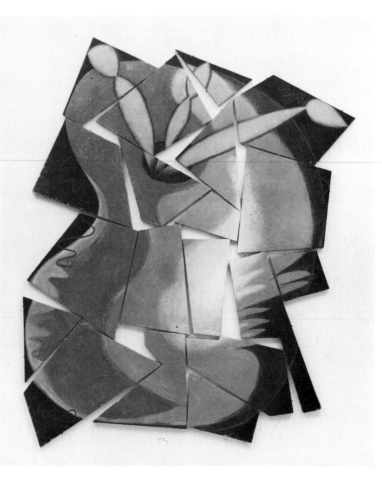

WRITER
1979. Oil on canvas,
11 ft 5 in x 6 ft 2 in (348 x
188). St. Louis Art
Museum, St. Louis,
Missouri

ELIZABETH MURRAY
Born Chicago, Illinois, 1940,
lives in New York

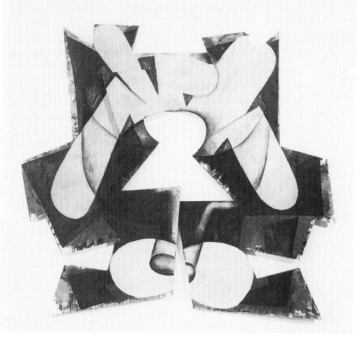

KEYHOLE
1982. Oil on canvas,
8 ft 3½ in x 9 ft 2½ in
(252.7 x 280.7 cm).
Private collection

SAIL BABY
1983. Oil on canvas,
in three parts, overall
10 ft 6 in x 11 ft 3 in
(320 x 342.9 cm).
Paula Cooper Gallery,
New York

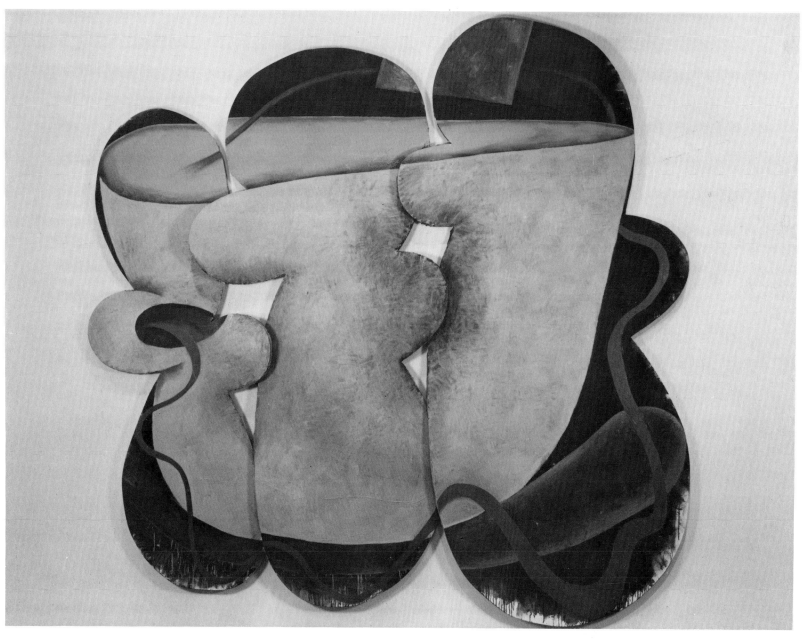

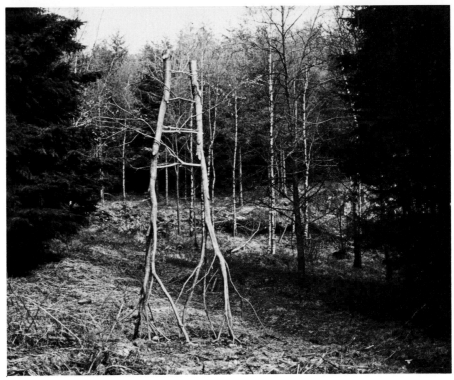

WILLOW LADDER, I:
GRIZEDALE FOREST
1978. Willow,
12 ft (365.7 cm) high.

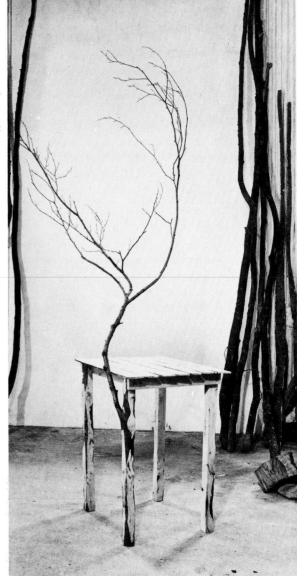

BRANCH TABLE
1977. Beech,
10 ft (304.8 cm) high.
Collection the artist

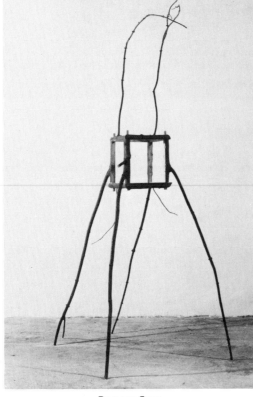

BRANCH CUBE
1982. Beech,
12 ft (365.8 cm) high.
Rijksmuseum
Kröller-Müller,
Otterlo, Netherlands

DAVID NASH
Born Esher, Surrey, England, 1945,
lives in Blaenau Ffestiniog, Wales

FLYING FRAME
1980. Oak,
7 ft 1 in x 11 ft 1 in x 44 in
(215.9 x 337.8 x 111.8 cm).
Private collection,
Great Britain

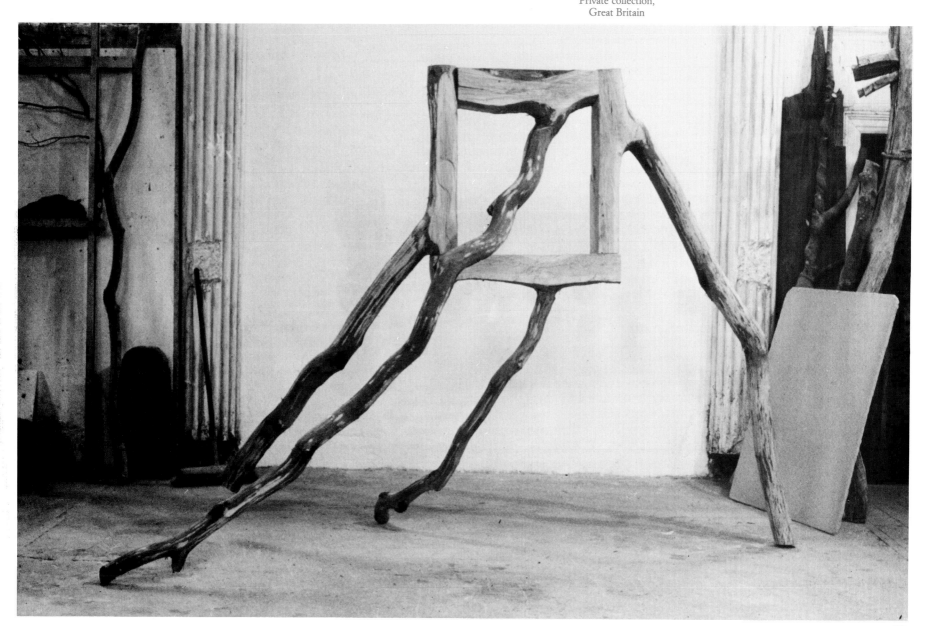

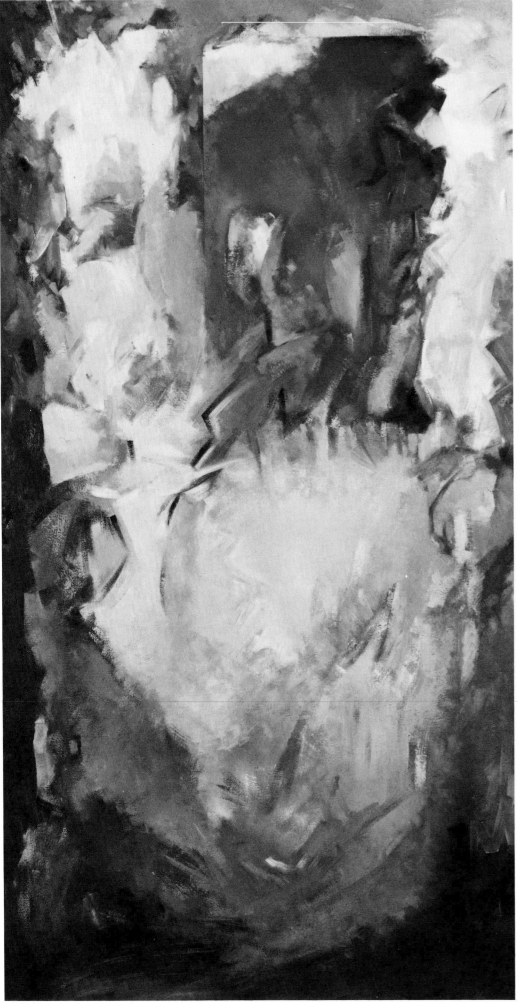

GEORGE NEGROPONTE
Born New York, 1953,
lives in New York

NOTES ON NATURE
1983. Oil on canvas, 7 ft x
45 in (213.4 x 114.3 cm).
Collection Hospital
Corporation of America

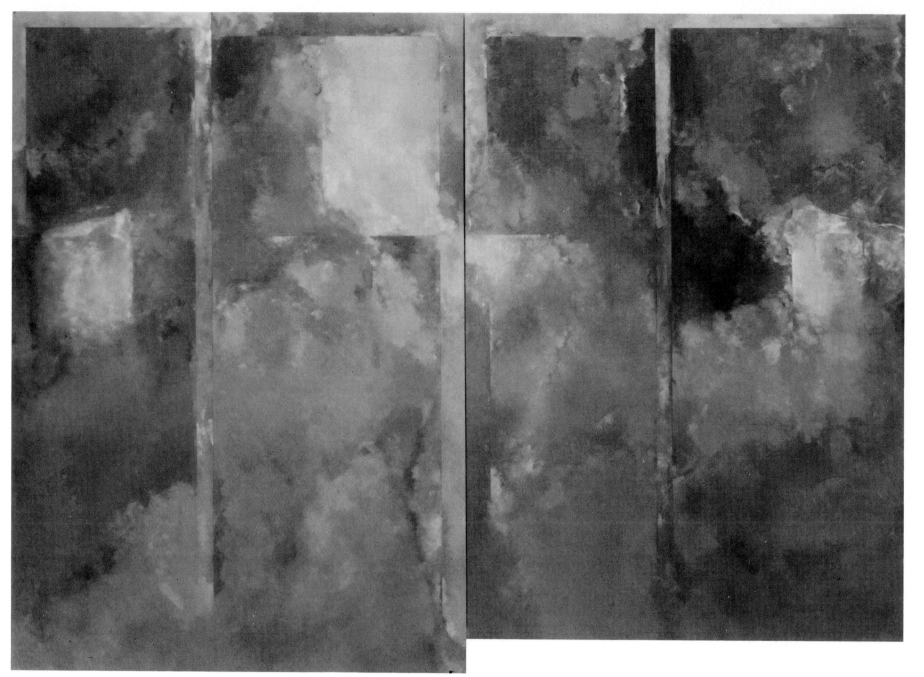

THE CLEARING
1981. Oil on canvas, in two parts,
overall 6 ft 6½ in x 9 ft 4 in
(199.4 x 284.5 cm). Private
collection, Houston, Texas

CORNER PAINTING
1982. Oil on canvas, in
two parts, overall 50 x
70 in (127 x 177.8 cm).
Collection the artist

PARK EVENING
1982. Oil on canvas, 48 x 60 in (121.9 x 152.4 cm).
Collection the artist.
Courtesy Tracey Garet Gallery, New York

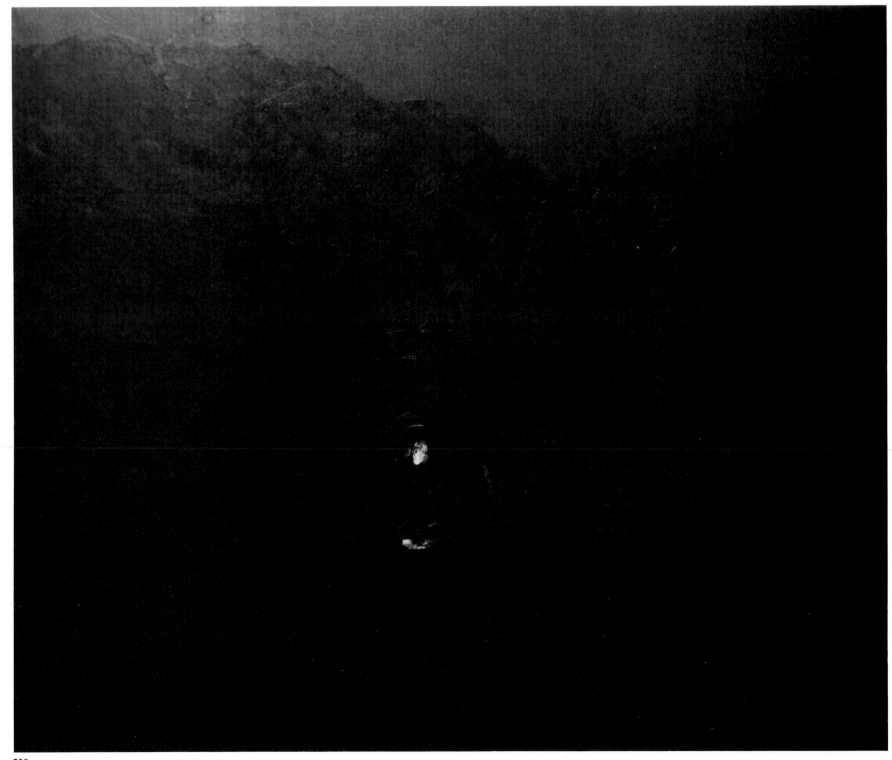

23 STREET HOT
1982. Oil on canvas, 60 x 48 in
(152.4 x 121.9 cm).
Collection José Pérez-Beola

WINTER SKY
1984. Oil on canvas, 40 x 62 in
(101.6 x 157.5 cm).
Collection the artist

GUSTAVO OJEDA
Born Havana, Cuba, 1958,
lives in New York

TOWERS
1984. Oil on canvas, 62 x 48 in
(157.5 x 121.9 cm).
Private collection

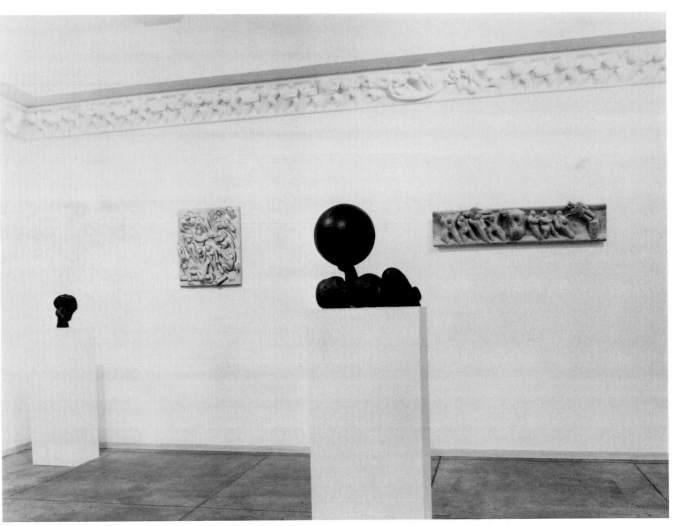

Installation at Brooke Alexander, Inc., New York, 1983

Installation at
Brooke Alexander, Inc.,
New York, 1983

TOM OTTERNESS
Born Wichita, Kansas, 1952,
lives in New York

SLEEP OF KINGS
1983. Oil stick on paper, 24½ x
19 in (62.2 x 48.3 cm).
Brooke Alexander, Inc., New York

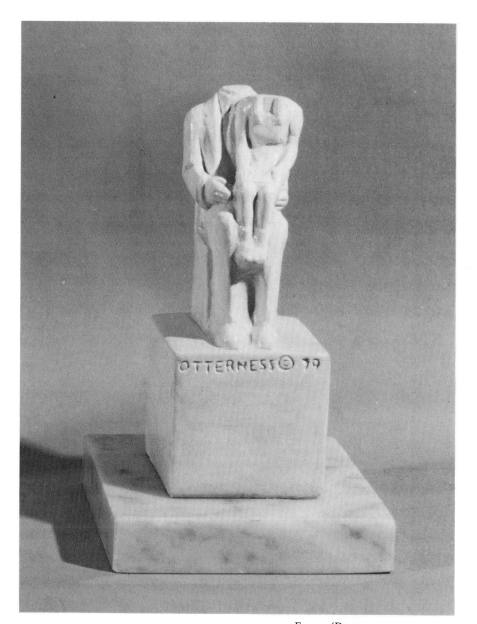

FATHER/DAUGHTER
1979. Cast hydrocal,
6 x 2¼ x 2¼ in
(15.2 x 5.7 x 5.7 cm).
Brooke Alexander, Inc.,
New York

FEMALE REVOLUTION AND FEMALE WORKERS
and FALL OF THE KING AND MALE WORKERS
1984. Photocopy and pen on paper, 8½ x 11 in
(21.6 x 27.9 cm). Sketch for frieze executed
for the exhibition

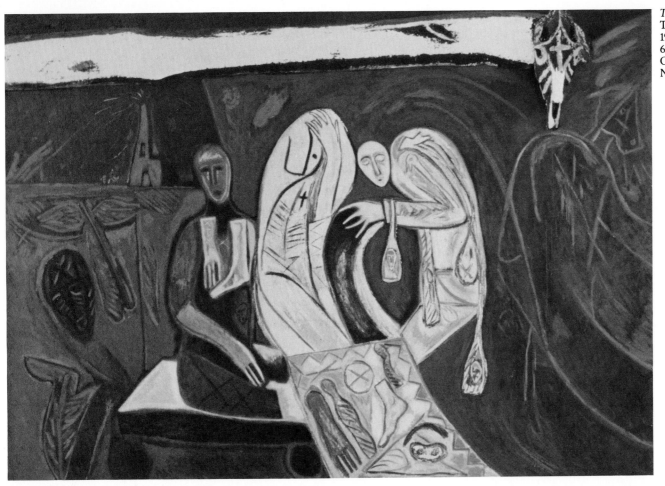

Tre Comete
Three Comets
1983. Oil on canvas with wood,
6 ft 9 in x 10 ft ½ in (205.7 x 306.1 cm).
Collection Paine Webber, Inc.,
New York

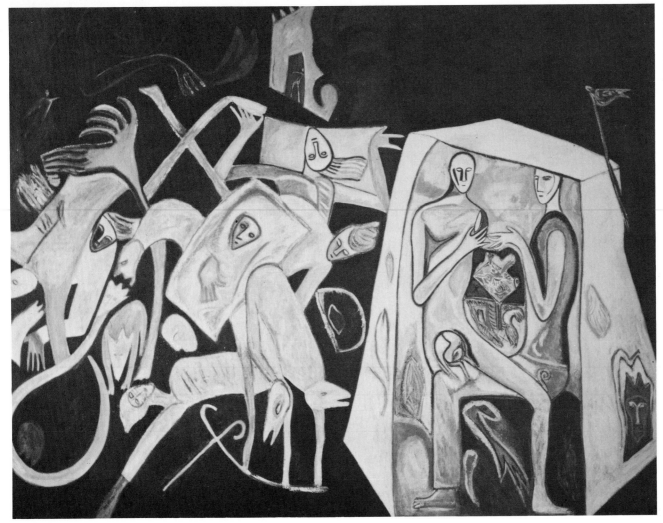

Nightwatch
1982. Oil on canvas,
9 ft 10¼ in x 13 ft 1½ in
(300.3 x 400 cm).
Galerie Schellmann & Klüser,
Munich, West Germany

VIANDANTE
1983. Oil on canvas on wood, with wood
elements, 10 ft 6 in (320 cm) diam.
Collection Gerald S. Elliott

MIMMO PALADINO · Born Paduli, near Benevento, Italy, 1948, lives in Paduli

TIMES OF THE DAY, I
1974–75. Synthetic polymer paint and
oil on aluminum, in four parts,
each 22⅛ x 20½ in (56.8 x 52.1 cm).
Dia Art Foundation, New York

BLINKY PALERMO
Born Leipzig, Germany, 1943, died in Sri Lanka, 1977

Left
CARIATIDE
1979. Pencil on paper and
plaster columns, 70⅞ x 47¼ in
(180 x 120 cm). Studio Marconi,
Milan, Italy

MIMESI
1975–76. Plaster, two pieces,
each 25½ x 19⅝ x 11¾ in (65 x 50 x 30 cm).
Studio Marconi, Milan, Italy

GIULIO PAOLINI
Born Genoa, Italy, 1940,
lives in Turin, Italy

A–Artaud (against the Light) Self-Portrait at Sixty-Five
Detail of installation at Art Gallery of Western Australia, Perth,
Australia, 1983

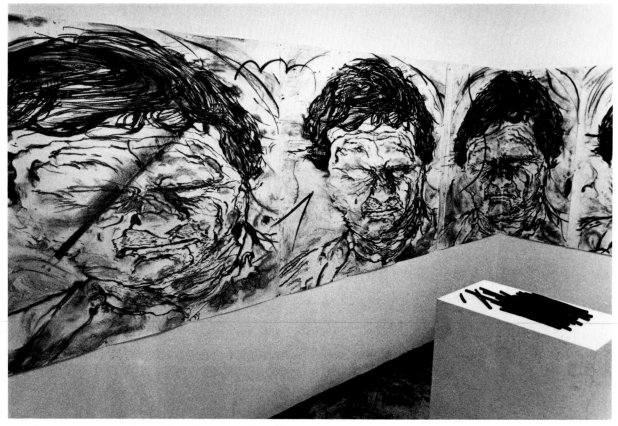

A–Artaud (against the Light) Self-Portrait at Sixty-Five
Detail of installation at Art Gallery of Western Australia, Perth,
Australia, 1983

CHEMICAL TRANSFICTION (ALLOYED SELF-PORTRAIT
AS A SLICE OF LIFE OR THE ATOMS OF POINT BY POINT)
1984. Charcoal and pastel on Stonehenge paper,
50 in x 12 ft (127 x 365.8 cm). Collection the artist

MIKE PARR
Born Sydney, Australia, 1945,
lives in Sydney

ABLAUT SELF-PORTRAIT
(Number 7 in the Braalagg Hoick series)
1984. Charcoal and pastel on Stonehenge paper, 50 in x 11 ft
(127 x 335.3 cm). Private collection

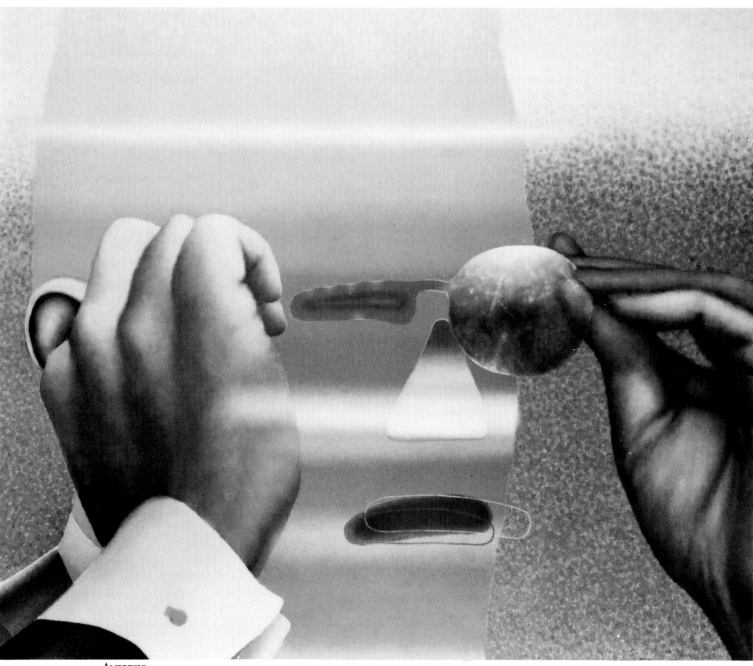

AMBRESIO
1981. Oil on canvas, 34 x 70 in
(86.4 x 177.8 cm). Private collection

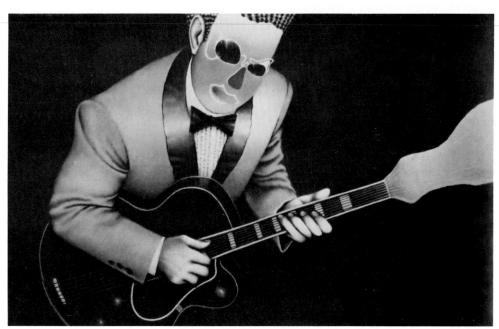

GUITAO
1978. Oil on canvas,
46 in x 6 ft 6 in (116.8 x 198.1 cm).
Private collection, Chicago

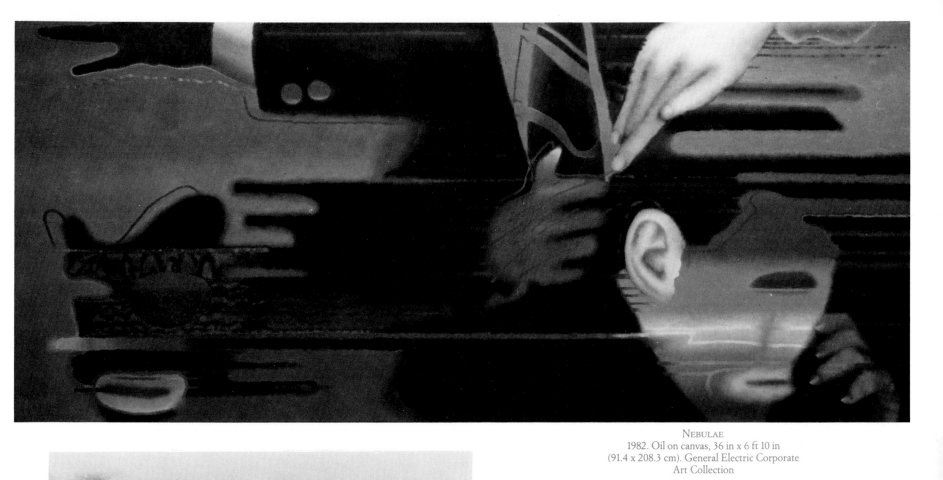

NEBULAE
1982. Oil on canvas, 36 in x 6 ft 10 in
(91.4 x 208.3 cm). General Electric Corporate
Art Collection

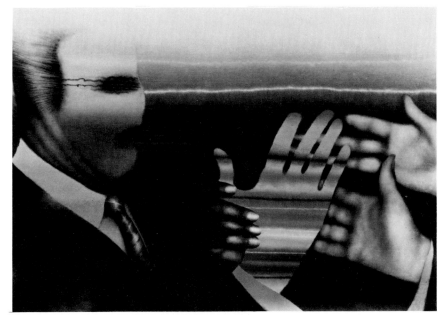

RIO-NEGRO
1980. Oil on canvas,
46 x 66 in (116.8 x 167.6 cm).
Private collection, New York

VIBREX
1982. Oil on canvas, 42 in x 6 ft 8 in
(106.7 x 203.2 cm). Phyllis Kind Gallery,
Chicago, Illinois

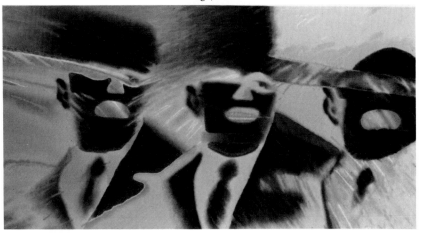

ED PASCHKE
Born Chicago, Illinois, 1939, lives in Chicago

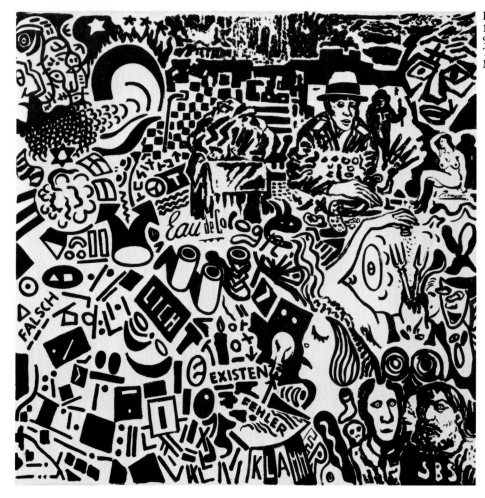

EAU DE COLOGNE
1975. Synthetic polymer paint on canvas,
9 ft 6¼ in x 9 ft 6¼ in (285 x 285 cm).
The Museum of Modern Art, New York.
Mr. and Mrs. Sid R. Bass Fund

KAMELSCHNAUZE IM UNIVERSUM
CAMEL SNOUT IN THE UNIVERSE
1975. Dispersion on canvas,
9 ft 3 in x 9 ft 3 in (281.9 x 281.9 cm).
Private collection. Courtesy Galerie
Michael Werner, Cologne, West Germany

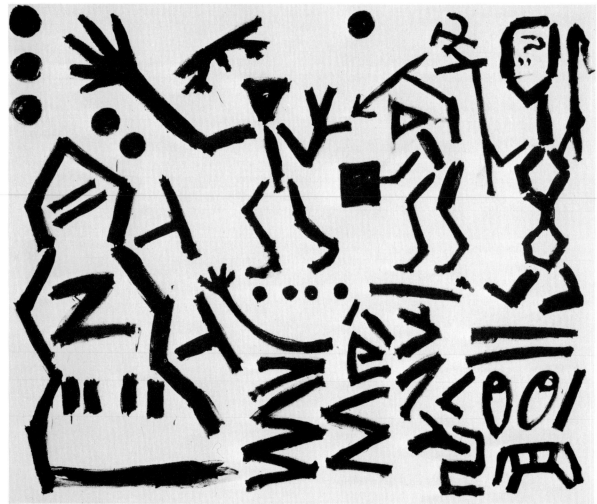

ÜBERGANG
CROSSING
1980. Dispersion on
canvas, 7 ft 6 in x 9 ft 2 in
(228.6 x 279.4 cm).
Galerie Michael Werner,
Cologne, West Germany

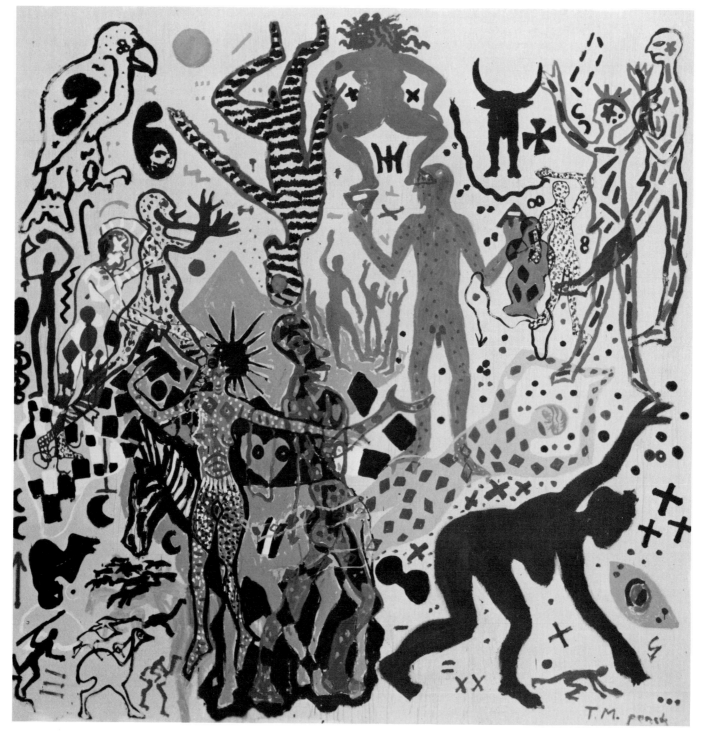

Metaphysicher Durchgang durch ein Zebra
Metaphysical Passage through a Zebra
1975. Synthetic polymer paint on canvas, 9 ft 4¼ in x
9 ft 4¼ in (285 x 285 cm). Neue Galerie–Sammlung
Ludwig, Aachen, West Germany

A. R. Penck
Born Dresden, Germany, 1939,
lives near London

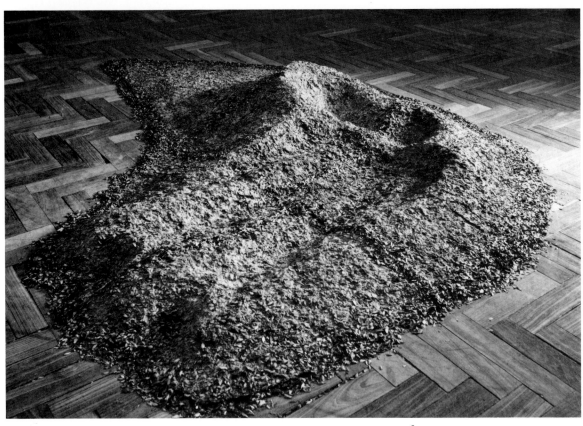

Soffio di foglie
Breath of Leaves
1979. Cast bronze, 13¾ in x
6 ft 6¾ in x 9 ft 10¼ in
(35 x 200 x 300 cm). Installation
at Stedelijk Museum, Amsterdam,
Netherlands

Zucche e nero assoluto d'Africa
Squash and Absolute Black of Africa
1978–79. Cast bronze and cast Atlas granite,
three pieces: squash, 11 x 31½ x 47¼ in
(28 x 80 x 120 cm), 8⅝ x 29½ x 23⅜ in
(22 x 60 x 75 cm); granite, 6 ft 6 in x 27¼ in x
17¾ in (69 x 198 x 45cm). Crex Collection.
Installation at Halle für Internationale Neue Kunst,
Zurich, Switzerland, 1979–80

Albero di 12 metri
Twelve-meter Tree
1981. Larch wood, 39 ft 4 in x
19⅝ in x 19⅝ in (1,200 x 50 x 50 cm).
Installation at The Solomon R.
Guggenheim Museum, New York, 1982

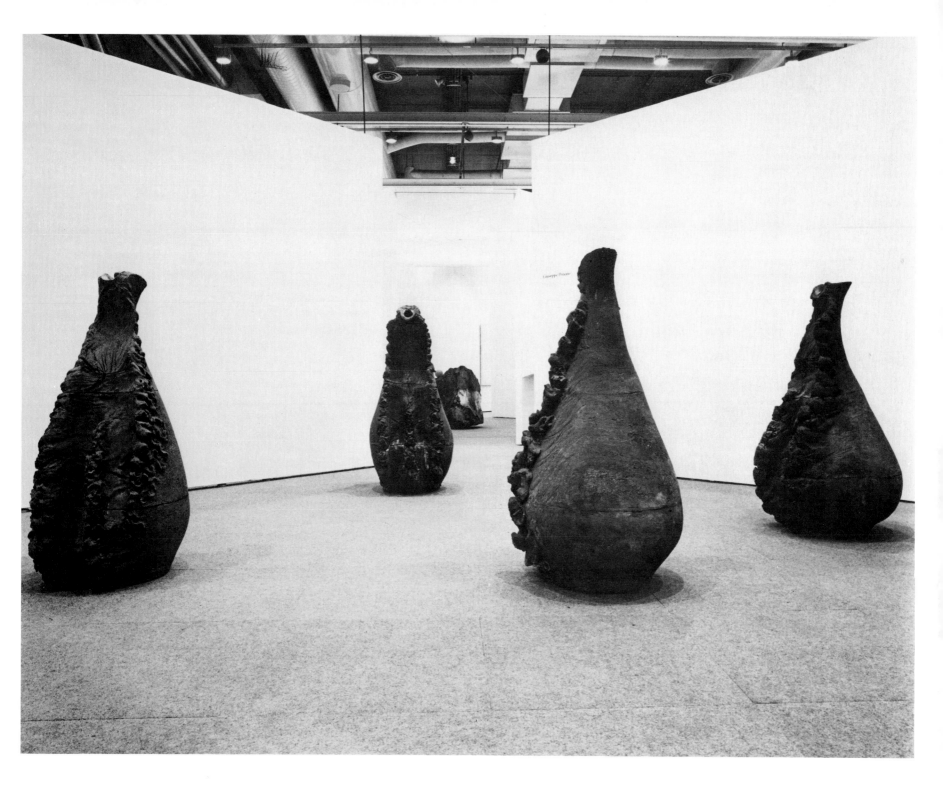

GIUSEPPE PENONE · Born Garessio Ponte, Italy, 1947, lives in Garessio Ponte and Turin, Italy

Soffio nos. 3, 4, 5, 6
BREATH NOS. 3, 4, 5, 6
1978. Terra cotta, each 60 in (152.4 cm) high.
No. 3: Collection Dr. Carlo de Stefani, Vittorio, Veneto, Italy;
No. 4: Galerie Rudolf Zwirner, Cologne, West Germany;
No. 5: The Trustees of the Tate Gallery, London;
No. 6: Musèe National d'Art Moderne, Centre Georges Pompidou, Paris.
Installation at Centre Georges Pompidou, Paris, 1981.
Breath No. 3 is in the exhibition

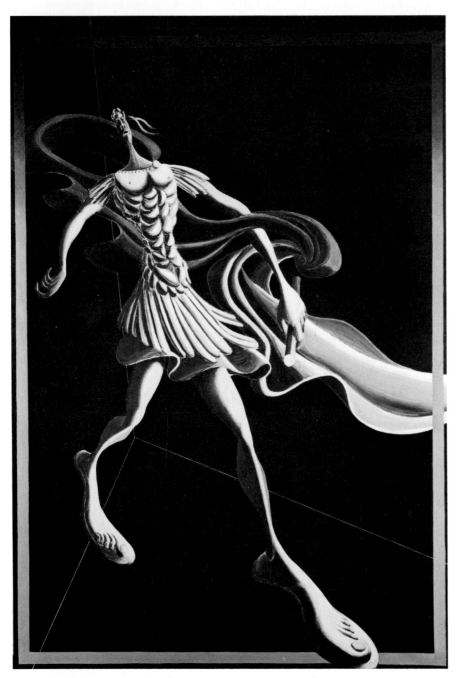

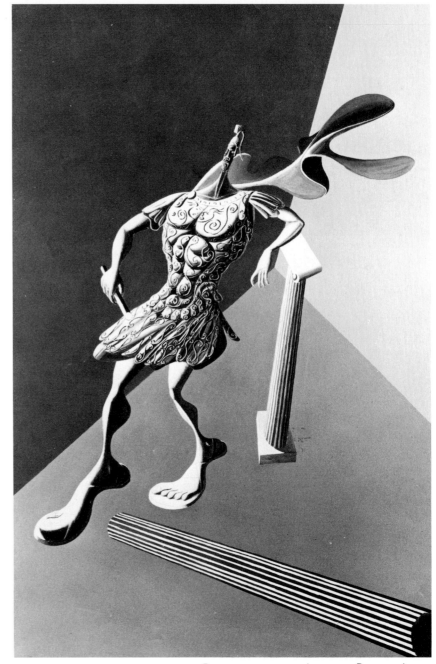

PORTRAIT OFFICIEL DE L'EMPEREUR OLYBRIUS SORTANT DU CADRE DE L'HISTOIRE
OFFICIAL PORTRAIT OF THE EMPEROR OLYBRIUS LEAVING THE FRAME OF HISTORY
1975–76. Oil on canvas, 6 ft 4¾ in x 51⅛ in (195 x 130 cm).
Collection M and Mme Gilles Fuchs

PORTRAIT OFFICIEL DE L'EMPEREUR PHILIPPE L'ARABE
OFFICIAL PORTRAIT OF THE EMPEROR PHILIPPE THE ARAB
1977. Oil on canvas, 6 ft 4¾ in x 51⅛ in (195 x 130 cm).
Collection Mrs. A. Mitchell, Paris

EMMANUEL PEREIRE
Born Paris, 1935, lives in Paris

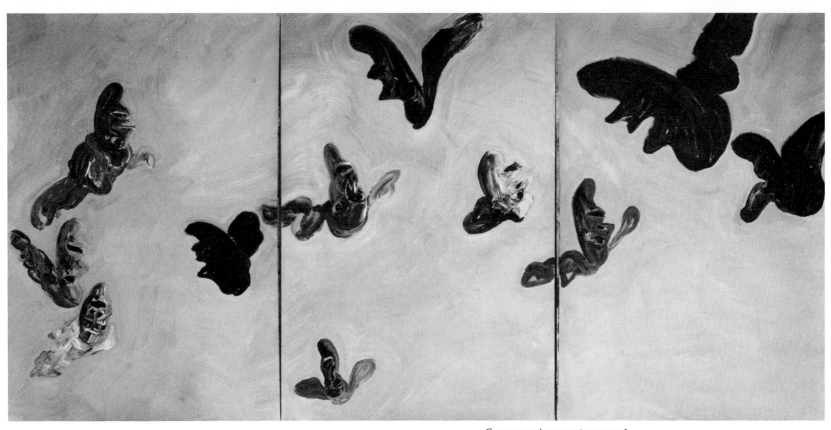

COHORTES D'ANGES DÉCHUS NO. 1
COHORTS OF FALLEN ANGELS NO. 1
1983. Oil on wood, triptych,
overall 55¼ in x 7 ft 10½ in (140 x 240 cm).
Collection the artist

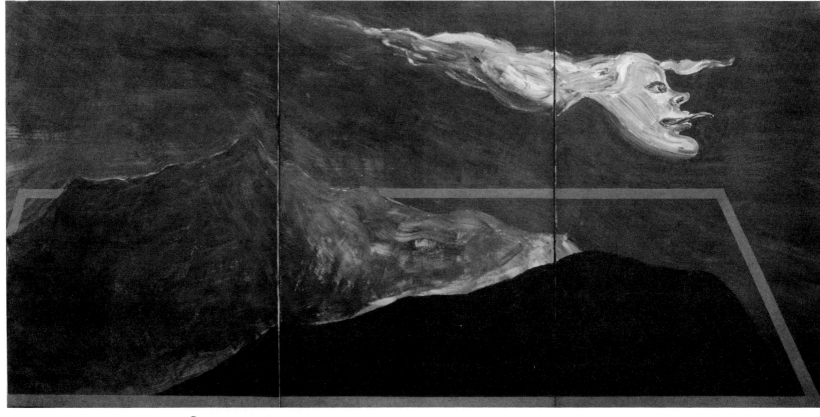

PAYSAGE TRAVERSÉ PAR ANGE RICANANT
LANDSCAPE CROSSED BY A GIGGLING ANGEL
1983. Oil on wood, triptych,
overall 43¼ in x 7 ft 10½ in (110 x 240 cm).
Collection the artist

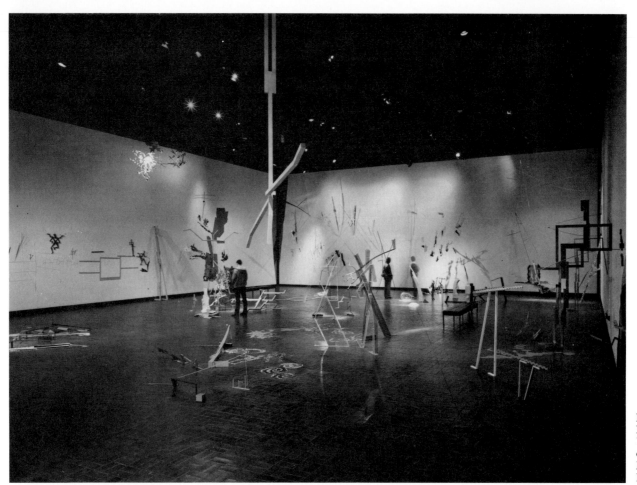

REINVENTING THE WHEEL
Detail of installation in
Ten Artists/Artists Space
exhibition at Neuberger
Museum, Purchase,
New York, 1979

BOA
Detail of installation at
University of Massachusetts,
Amherst, Massachusetts, 1982

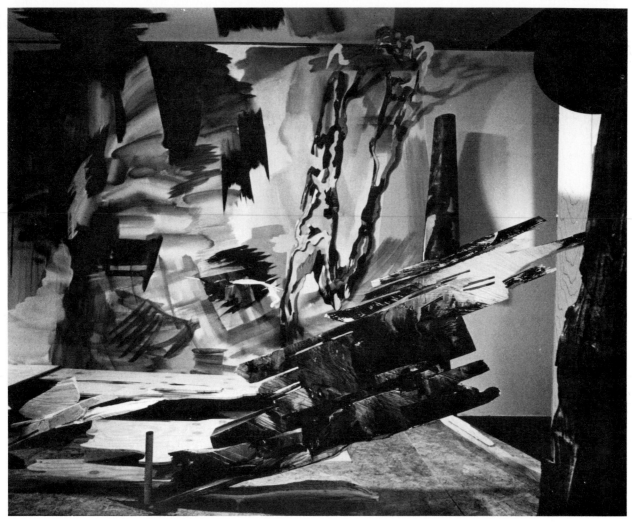

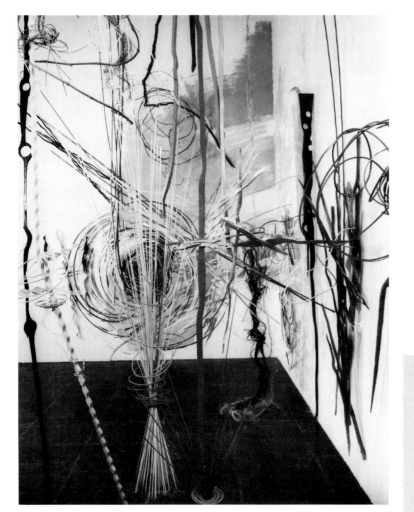

DRAGON
Installation in Biennial Exhibition
at Whitney Museum of American Art,
New York, 1981

JUDY PFAFF
Born London, 1946, lives in New York

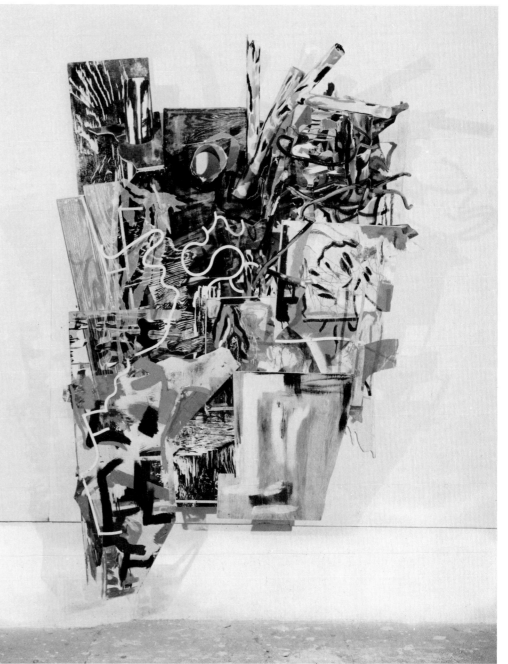

UNTITLED
1984. Mixed materials,
8 ft 3 in x 68 in x 35 in
(251.5 x 172.7 x 88.9 cm).
Collection the artist.
Courtesy Holly Solomon
Gallery, New York

CAMELEONARDO DA WILLICH
1979. Synthetic polymer paint
on cotton damask with metal rings,
43½ in x 6 ft 8¾ in (110.5 x 205 cm).
Musée National d'Art Moderne,
Centre Georges Pompidou, Paris

SUPERMARKETS
1976. Mixed mediums on paper,
6 ft 9½ in x 9 ft 8¼ in
(207 x 295 cm).
Crex Collection

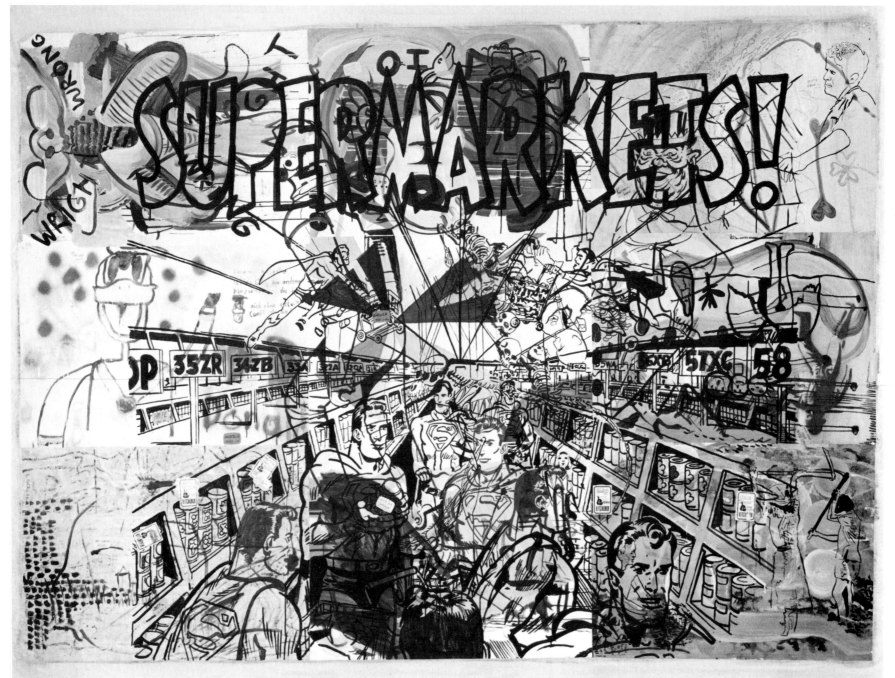

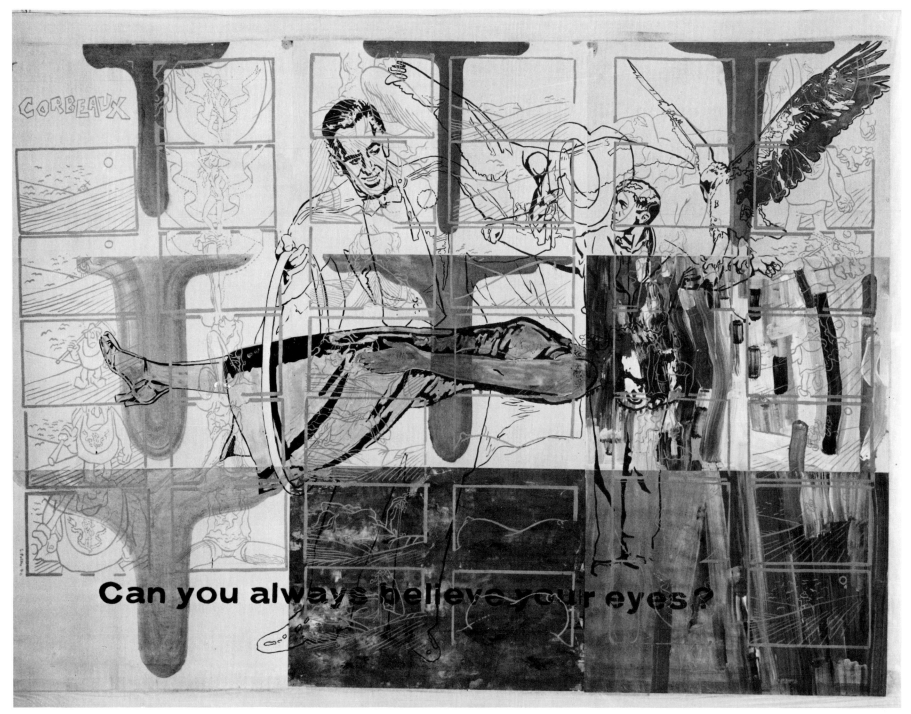

CAN YOU ALWAYS BELIEVE YOUR EYES?
1976. Mixed mediums on paper,
6 ft 8¾ in x 9 ft 8⅞ in
(205 x 297 cm). Crex Collection

SIGMAR POLKE
Born Oels, Germany (now Oleśnica, Poland), 1941, lives in Cologne and Hamburg, West Germany

ABANDONED CONVERSATIONS
1982. Oil on canvas, 6 ft 10 in x
8 ft 10 in (208.3 x 269.2 cm).
The Edward R. Broida Trust,
Los Angeles, California

THE CITY AT NIGHT
1983. Oil on canvas,
7 ft 2 in x 15 ft 6 in
(218.4 x 472.4 cm).
The Edward R. Broida
Trust, Los Angeles,
California

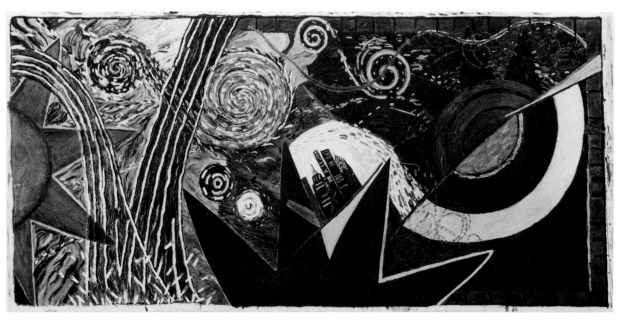

SAN SALVADOR
1980. Oil on canvas,
6 ft 7½ in x 11 ft 10¾ in
(201.9 x 362.6 cm).
David McKee Gallery,
New York

TRUTH RESCUED FROM ROMANCE
1980. Oil on canvas, 7 ft 4½ in x
7 ft 2¼ in (224.8 cm x 219.1 cm).
Philadelphia Museum of Art,
Philadelphia, Pennsylvania.
Purchase The Edward
and Althea Budd Fund

HUNK
1983. Painted ceramic,
3¼ x 6 x 4 in
(8.2 x 15.2 x 10.2 cm).
Private collection

FOUR CORNERS
1983. Painted ceramic,
4 x 4¼ x 4¼ in
(10.2 x 10.8 x 10.8 cm).
The Menil Foundation

DOBOS
1983. Painted ceramic,
3¼ x 4½ x 3½ in
(8.2 x 11.4 x 8.9 cm).
The Menil Foundation

TOWN UNIT 1
1972–77. Ceramic, painted
wood, and cabinet,
70 x 39 x 20 in
(177.8 x 99.1 x 50.8 cm).
Private collection

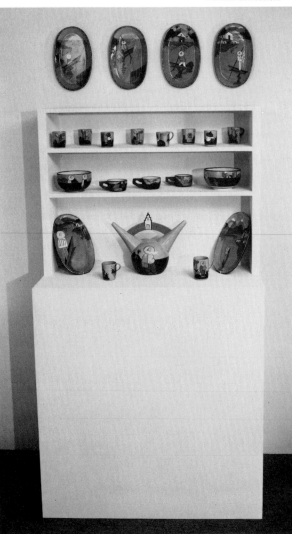

TOWN UNIT 2
1972–77. Ceramic, painted
wood, and cabinet,
70 x 39 x 20 in
(177.8 x 99.1 x 50.8 cm).
Private collection

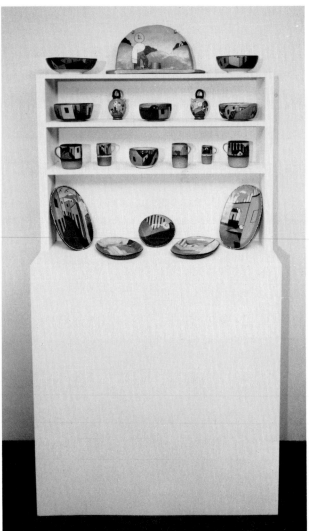

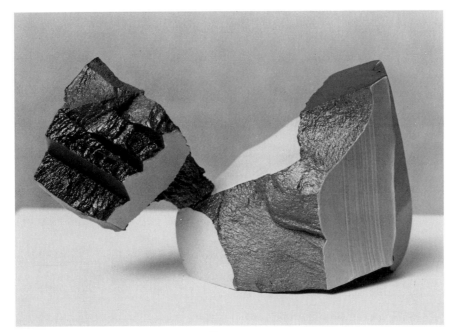

RELTNY
1983. Painted ceramic, 3 x 5 x 2¼ in
(7.6 x 12.7 x 7 cm). Collection Happy Price

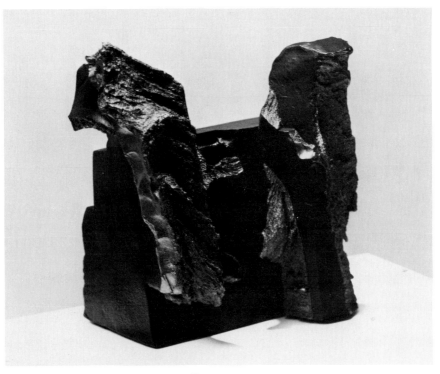

EGYPTIAN
1983. Painted ceramic, 7½ x 7 x 5¾ in (19 x 17.8 x 14.6 cm).
Collection Mr. and Mrs. Roy O'Connor, Houston, Texas

KENNETH PRICE
Born Los Angeles, California, 1935, lives in South Dartmouth, Massachusetts

SOME TALES
1975–77. Ash and yellow pine, five pieces,
overall 24 ft (731.5 cm) long. Collection
Torin Corporation, Torrington, Connecticut

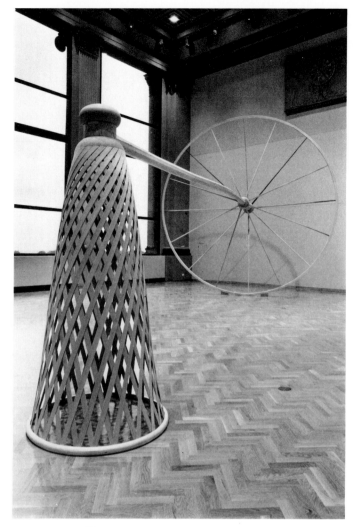

HER
1979. Red cedar and Douglas fir,
approx. 6 ft (182.9 cm) high.
Collection Linda and Harry Macklowe,
New York

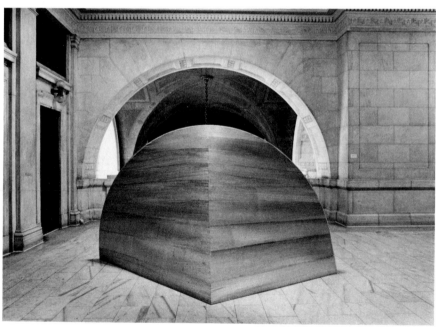

DESIRE
1981. Wood, 16 x 33 x 16 ft
(487 x 1,005 x 487 cm). Collection
the artist. Courtesy Donald
Young Gallery, Chicago, Illinois

WHERE THE HEART IS
1981. Mixed materials, 18 ft (548.6 cm) diam.
Collection the artist. Courtesy Donald
Young Gallery, Chicago, Illinois.
Installation at And/Or Gallery,
Seattle, Washington, 1981

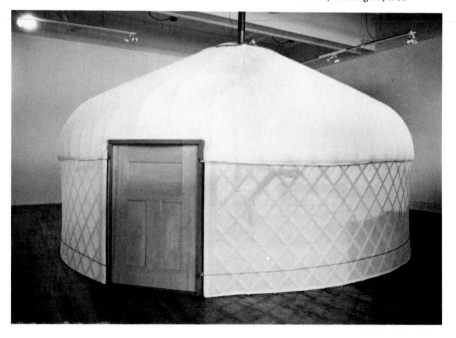

BELIEVER
1982. Poplar and pine,
24¼ x 23 x 17½ in
(61.6 x 58.5 x 44.4 cm).
Collection the artist.
Courtesy Donald Young
Gallery, Chicago, Illinois

SANCTUARY
1982. Pine, maple, and
cherry, 10 ft 6 in x 24 in x 18 in
(320 x 61 x 45.7 cm).
The Art Institute of Chicago,
Chicago, Illinois. Mr. and Mrs.
Frank G. Logan Prize Fund

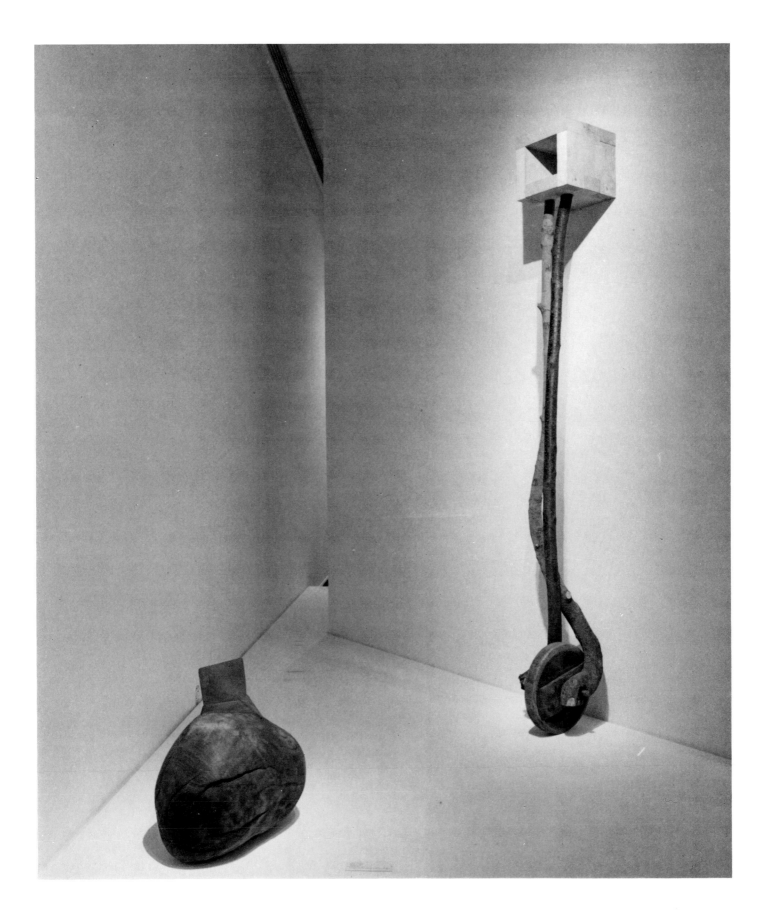

MARKUS RAETZ

Born Büren an der Aare, Switzerland, 1941,
lives in Bern, Switzerland

HANDS
1981. Forty-two pieces of
heather wood and ten
pieces of copper, approx.
6 ft 6¾ in x 6 ft 6¾ in
(200 x 200 cm). Musée
National d'Art Moderne,
Centre Georges Pompidou,
Paris

Studio installation, Bern, Switzerland, 1981

ELEVEN PROFILES
1981. Thirty-three pieces
of heather wood,
21⅞ in x 8 ft 2⅜ in
(55 x 250 cm).
Musée d'Art et d'Histoire,
Geneva, Switzerland

SLEEPING WOOD
1981. Heather wood,
in ninety-six parts,
approx. 70⅞ x 55⅛ in
(180 x 140 cm).
Musée de Toulon,
Toulon, France

CARL FREDRIK REUTERSWÄRD
Born Stockholm, Sweden, 1934, lives in
Bussigny, Switzerland

LE SYSTÈME BONBON
1976–77. Enamel on canvas,
6 ft 4¼ in x 51⅛ in
(195 x 130 cm). Collection
Jeanette Bonnier, New York

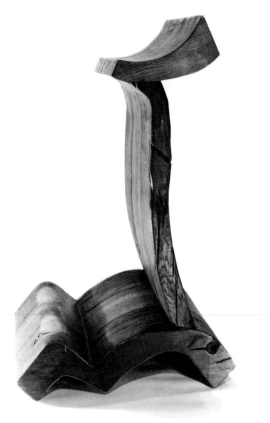

L AS IN LEONARDO:
PRAYER STOOL FOR ARTISTS
1975–76. Oak, 33 x 20 x 21¼ in
(84 x 51 x 54 cm). Collection
Jeanette Bonnier, New York

THE GREAT FETISH:
PICASSO, SLEEPING PARTNER
1974–77. Steel and bronze,
67¾ in x 15 ft 9¾ in x 35½ in
(172 x 482 x 90.2 cm).
Stadtische Kunsthalle,
Düsseldorf, West Germany

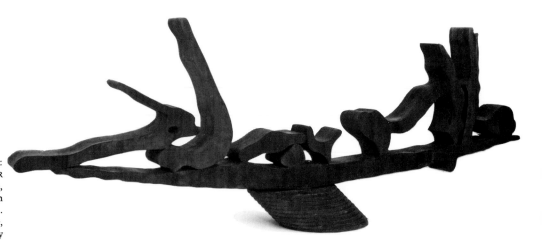

The artist kneeling
on wood and steel version of
L as in Leonardo, 1981

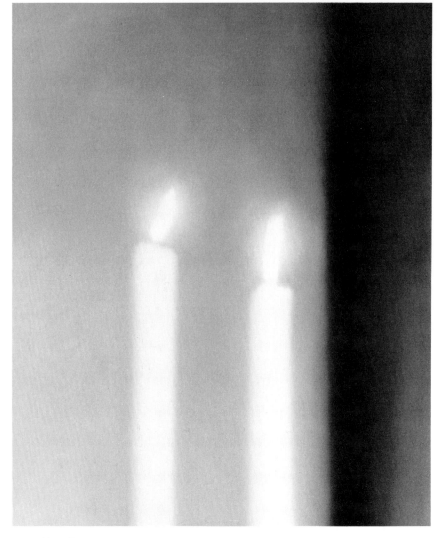

ZWEI KERZEN
TWO CANDLES
1982. Oil on canvas, 47¼ x
39⅛ in (120 x 100 cm).
The Art Institute of Chicago,
Chicago, Illinois. Twentieth-
Century Discretionary Fund

UNTITLED
1977. Oil on canvas, 9 ft 10⅛ in x 6 ft 6¾ in
(300 x 200 cm). Collection Gabriele Henkel

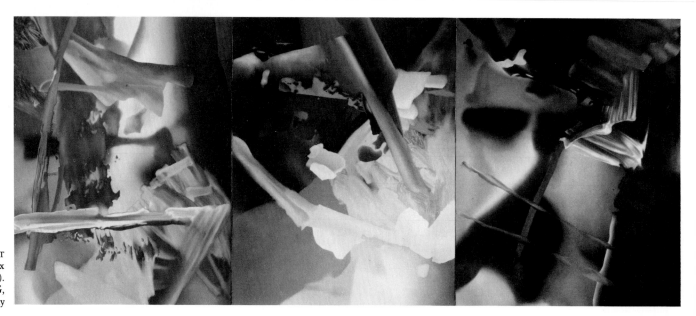

FAUST
1980. Oil on canvas, 9 ft 8¼ in x
22 ft 9 in (295 x 675 cm).
Collection Deutsche Bank AG,
Düsseldorf, West Germany

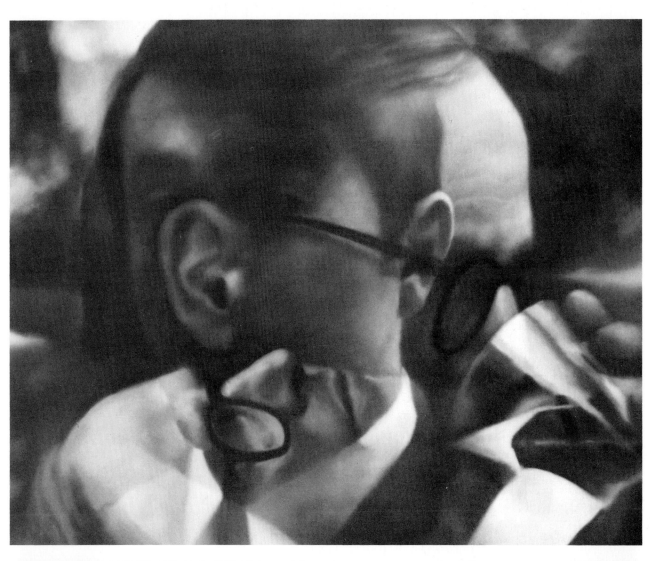

GILBERT AND GEORGE
1975. Oil on canvas,
31½ x 39⅜ in (80 x 100 cm).
Collection the artist

GERHARD RICHTER
Born Dresden, Germany, 1932,
lives in Cologne, West Germany

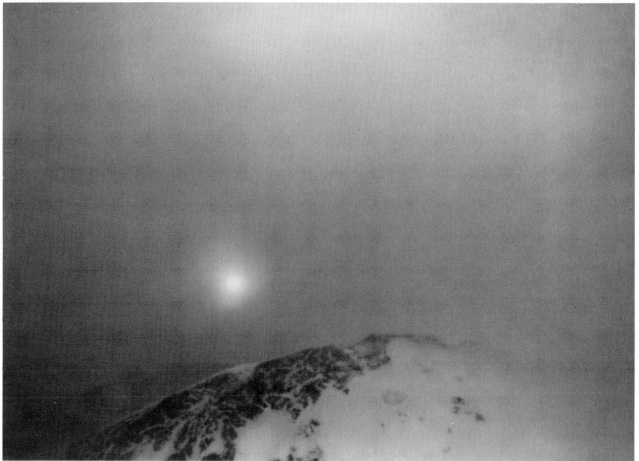

DAVOS S
1981. Oil on canvas,
33⅞ x 44 in (86 x 112 cm).
Collection the artist

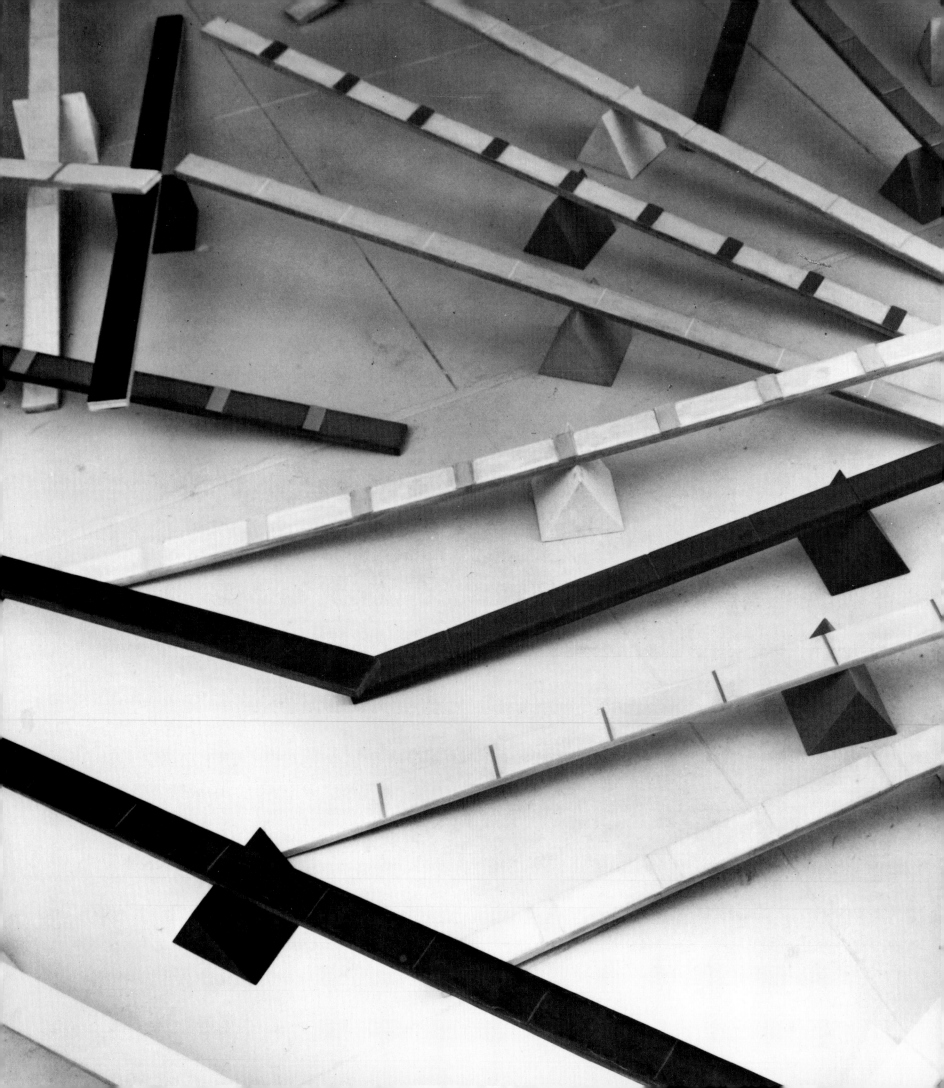

BRUCE ROBBINS

Born Philadelphia, Pennsylvania, 1948,
lives in New York

AXES
1976. Synthetic polymer paint
and gesso on canvas, 64⅝ in x
8 ft 8⅞ in (164.2 x 266.4 cm).
The Museum of Modern Art, New York.
Purchased with the aid of funds from
the National Endowment for the Arts

BEGGAR
1982. Oil on canvas, 39½ x 50½ in (99 x 128 cm). Private collection. Courtesy Willard Gallery, New York

THE HULK
1979. Flashe and synthetic polymer paint on canvas.
7 ft 5 in x 11 ft 6 in (226 x 350.5 cm).
Collection Barry Lowen, Los Angeles, California

WITHALL
1982. Oil on canvas, 65 in x 10 ft 2½ in (165.1 x 311.1 cm). Stedelijk Museum, Amsterdam, Netherlands

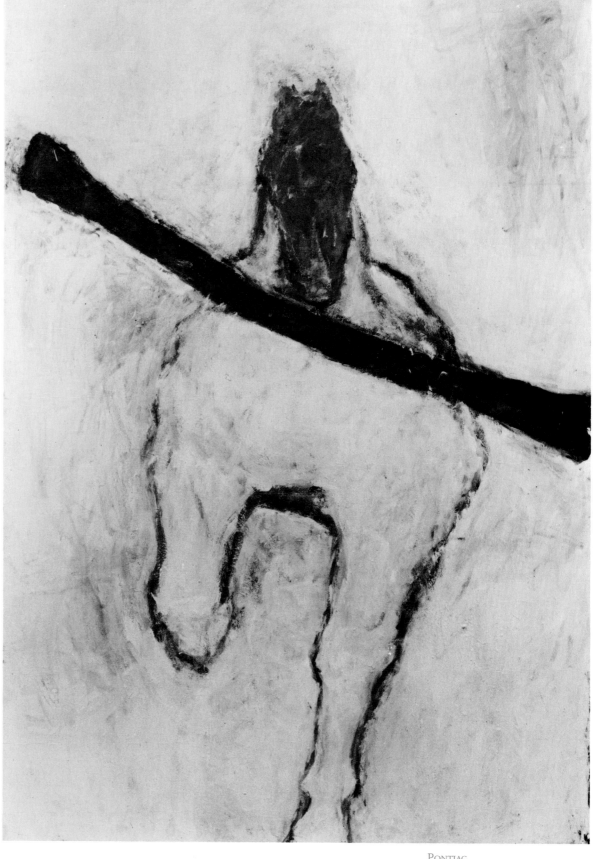

SUSAN ROTHENBERG
Born Buffalo, New York, 1945,
lives in New York

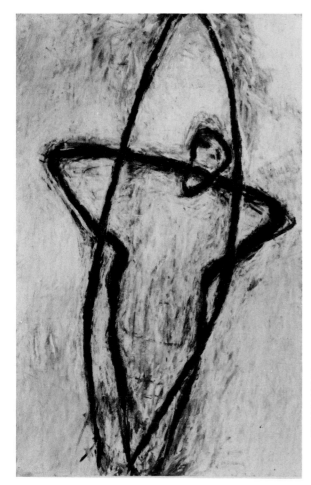

ENDLESS
1982. Oil on canvas,
7 ft 4 in x 57 in (217 x
142 cm). Private collection.
Courtesy Willard Gallery,
New York

PONTIAC
1979. Flashe and
synthetic polymer
paint on canvas,
7 ft 4 in x 61 in
(223.5 x 154.9 cm).
Private collection.
Courtesy Willard Gallery,
New York

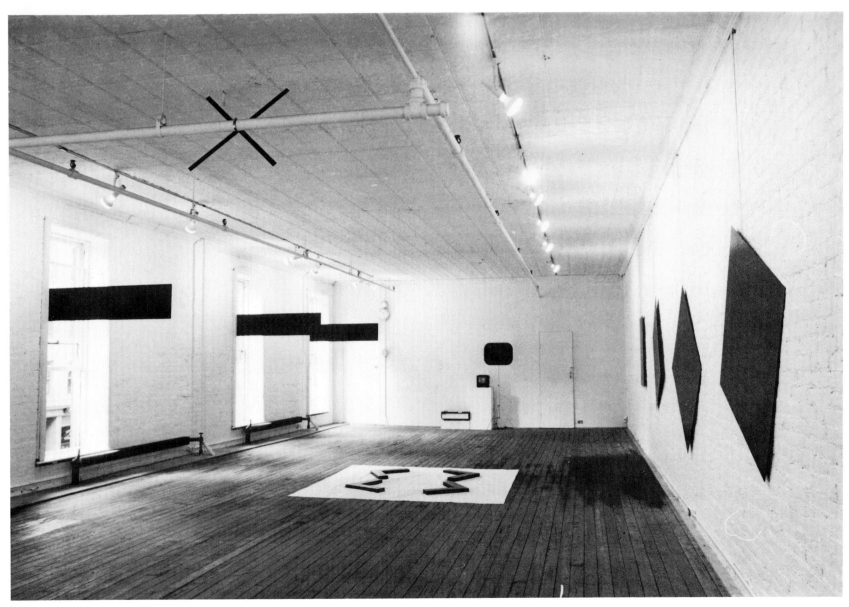

TRIPTYCHON
1975. Three aluminum window shades,
each 13¾ x 70⅞ in (35 x 180 cm).
Collection the artist

REINER RUTHENBECK
Born Velbert, Germany, 1937, lives in
Düsseldorf, West Germany

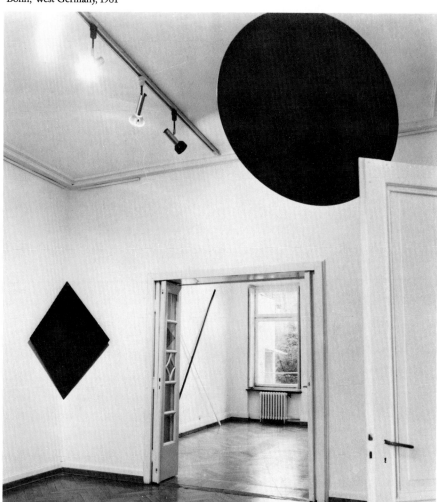

CROSS FOR A COLUMN
1977. Metal, approx. 26 ft 4 in x 26 ft 4 in
(800 x 800 cm). Installation at
Documenta 6, Kassel, West Germany, 1977

TISCH MIT KUGEL
TABLE WITH SPHERE
1982. Aluminum, wood, and
lacquer: sphere, 33½ in (85 cm)
diam.; table, 35¼ x 70⅞ x
45¼ in (89.5 x 180 x 115 cm).
Rijksmuseum Kröller-Müller,
Otterlo, Netherlands

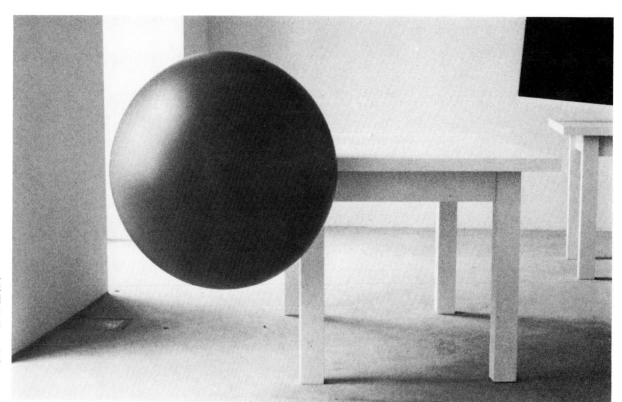

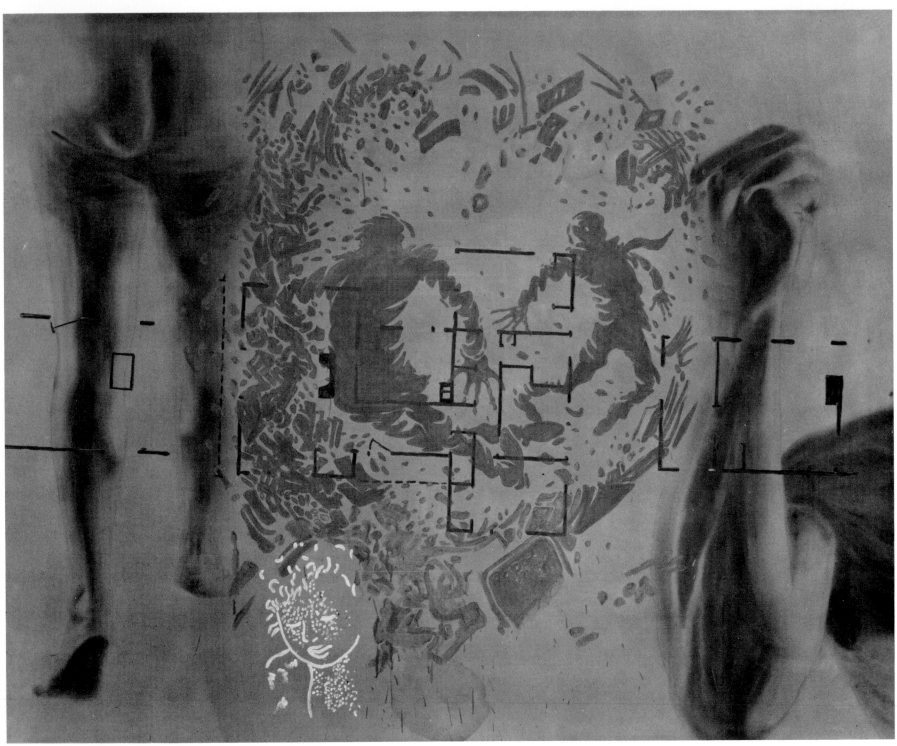

A LONG LIFE
1981. Synthetic polymer paint on canvas,
7 ft 2 in x 9 ft 4 in (218.4 x 284.5 cm).
Collection Barry Lowen, Los Angeles,
California

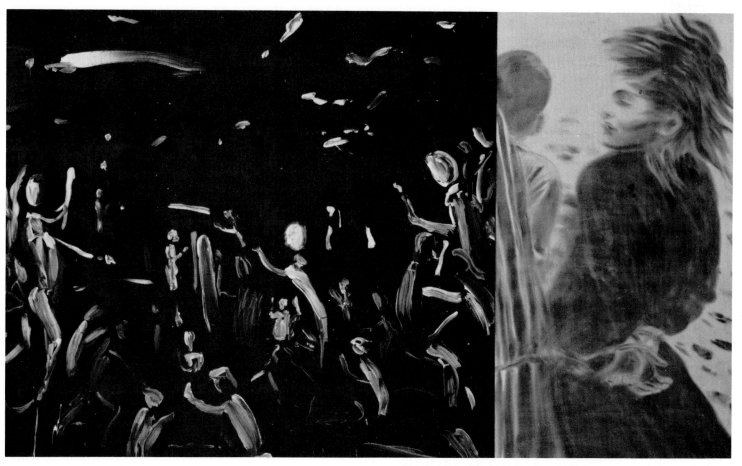

THE OLD, THE NEW, AND THE DIFFERENT
1981. Synthetic polymer paint on canvas,
8 ft x 12 ft 6 in (243.8 x 381 cm).
Collection Janet and Michael Green, London

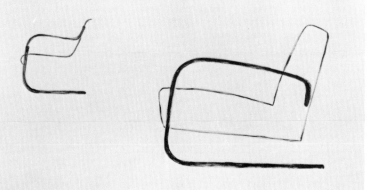

DAVID SALLE
Born Norman, Oklahoma, 1952,
lives in New York

STRENGTH LESS
1981. Synthetic polymer paint
on canvas, 8 x 6 ft (243.8 x 182.9 cm).
Collection M and Mme Gilles Fuchs

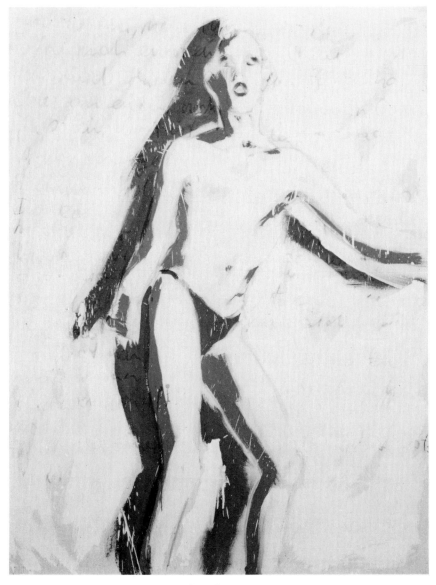

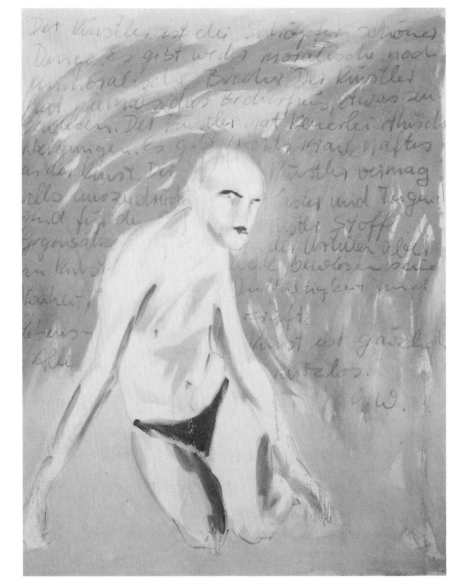

Brief Brecht
BRECHT LETTER
1979. Synthetic resin on nettle cloth,
67 x 51¼ in (170 x 130 cm). Collection
Thomas Ammann, Zurich, Switzerland

Brief Wilde
OSCAR WILDE LETTER
1979. Synthetic resin on nettle cloth,
67 x 51¼ in (170 x 130 cm). Collection
Thomas Ammann, Zurich, Switzerland

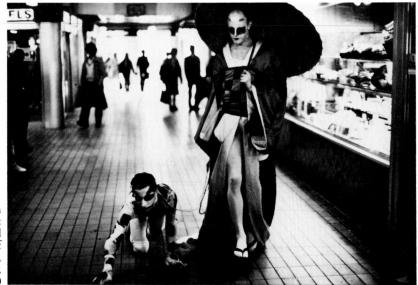

The artist in
performance at
Third International
Symposium of
Performance Art,
Lyons, France,
1980

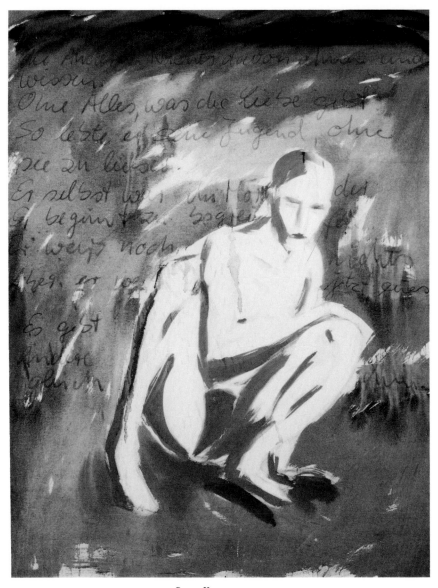

BRIEF KIRCHNER
KIRCHNER LETTER
1979. Synthetic resin on nettle cloth,
67 x 51¼ in (170 x 130 cm). Collection
Thomas Ammann, Zurich, Switzerland

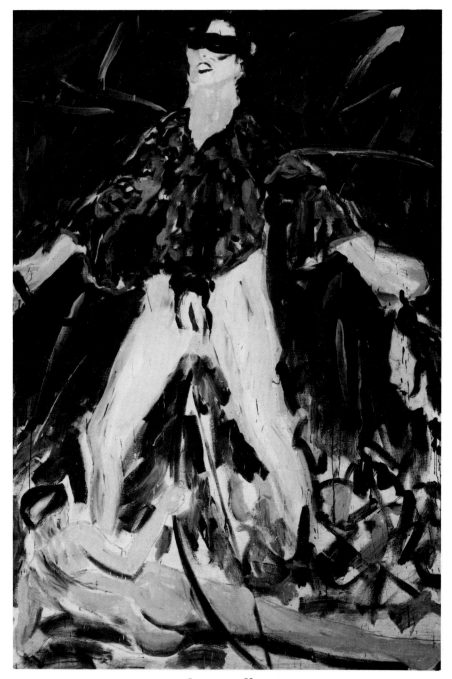

JUDITH AND HOLOFERNES
1981. Kaparol and pigment on cotton duck,
9 ft 6⅛ in x 6 ft 6¾ in (290 x 200 cm).
Private collection

SALOMÉ
Born Karlsruhe, West Germany, 1954,
lives in Berlin

HALL NO. 10
1982. Rubber, carpet, wood, plastic, and
electricity, approx. 16 ft 4⅞ in x 14 ft 9⅛ in
(500 x 450 cm). Collection the artist

UNTITLED
1980. Vinyl, synthetic silk, and tapestry,
63 x 39⅜ in (160 x 100 cm).
Collection the artist

PATRICK SAYTOUR
Born Nice, France, 1935, lives in
Aubais, France

RÉSORPTION DÉFINITIVE DE LA FATALITÉ
THE FINAL REABSORPTION OF FATE
1980. Tapestry, 59 x 59 in (150 x 150 cm).
Collection the artist

UNTITLED
1981. Charcoal on paper, with wood and glass, overall 7 ft 2⅛ in x 39⅛ in (220 x 100 cm). Collection the artist. Courtesy Delahunty Gallery, New York, and Dallas, Texas

ITALO SCANGA

Born Lago, Calabria, Italy, 1932, lives in La Jolla, California

POTATO FAMINE NO. 2
1979. Wood, linen, plaster, paint, and potatoes, in two parts, left 36½ x 13 x 11 in (92.7 x 33 x 27.9 cm); right 60 x 22 x 18 in (152.4 x 55.9 x 45.7 cm). Collection the artist

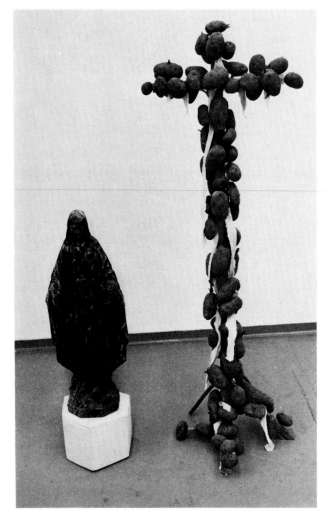

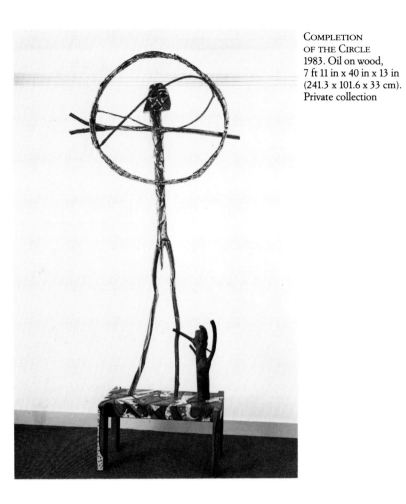

COMPLETION
OF THE CIRCLE
1983. Oil on wood,
7 ft 11 in x 40 in x 13 in
(241.3 x 101.6 x 33 cm).
Private collection

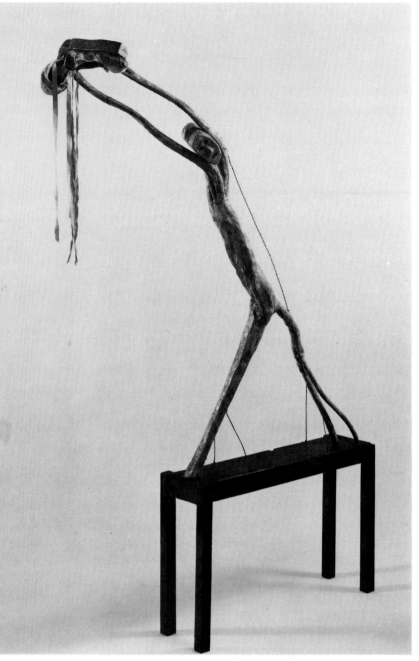

FEAR OF THE ARTS
1981. Oil on wood, wire,
and found objects,
6 ft 2 in x 50 in x 18 in
(188 x 127 x 45.7 cm).
Private collection

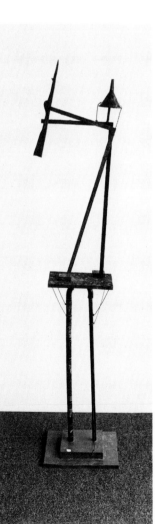

Far left
FEAR OF FIRE
1980. Oil on wood, and wire,
6 ft x 27 in x 16 in
(182.9 x 68.6 x 40.6 cm).
Collection Maurice Tuchman,
Los Angeles, California

Left
FEAR OF WAR
1980. Oil on wood, and wire,
6 ft x 16 in x 11 in
(182.9 x 40.6 x 27.9 cm).
Private collection

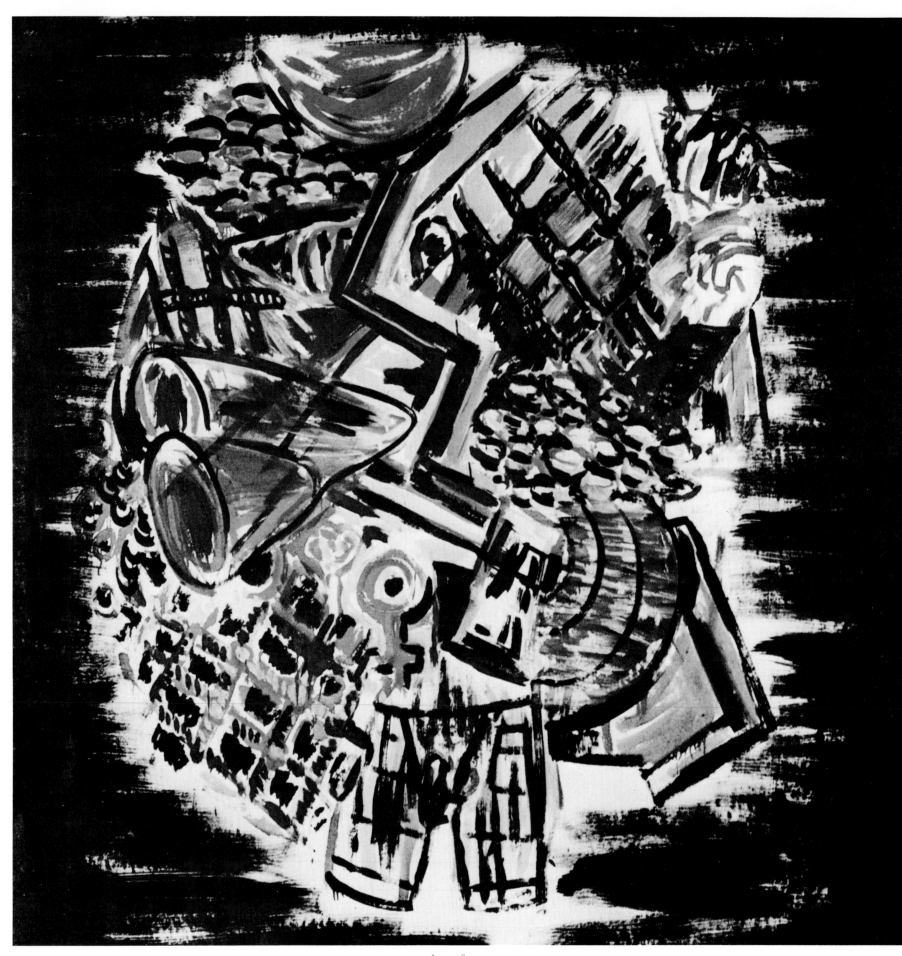

Laute Szene
Noisy Scene
1980. Oil on canvas, 6 ft 6¾ in x 6 ft 6¾ in (200 x 200 cm).
Galerie Max Hetzler, Cologne, West Germany

Zweiter Bericht
Second Report
1980. Oil on canvas,
6 ft 6¾ in x 6 ft 6¾ in
(200 x 200 cm).
Private collection,
Innsbruck, Austria

HUBERT SCHMALIX
Born Graz, Austria, 1952,
lives in Vienna, Austria, and Cologne,
West Germany

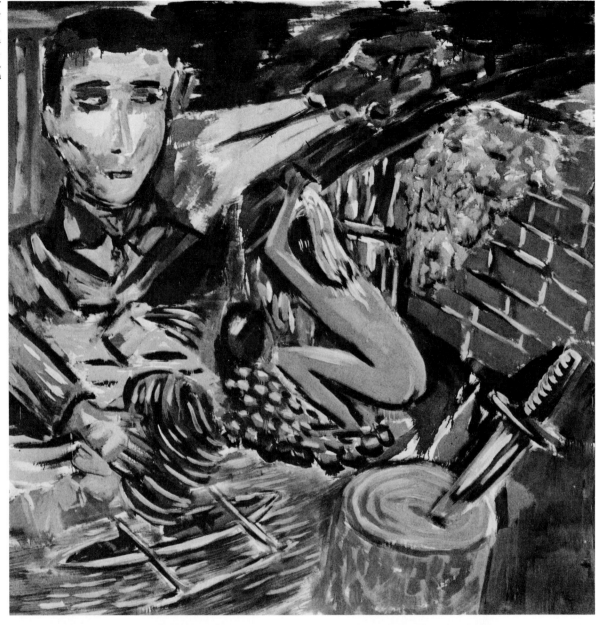

Stilleben
Still Life
1978. Oil on canvas,
51¼ x 59 in (130 x 150 cm).
Private collection

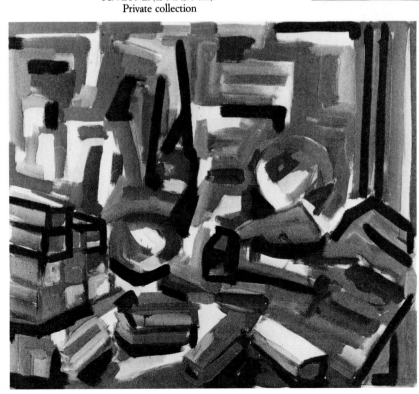

Die Botschaft
The Message
1980. Oil on canvas,
6 ft 6¾ in x 6 ft 6¾ in
(200 x 200 cm).
Galerie Krinzinger,
Innsbruck, Austria

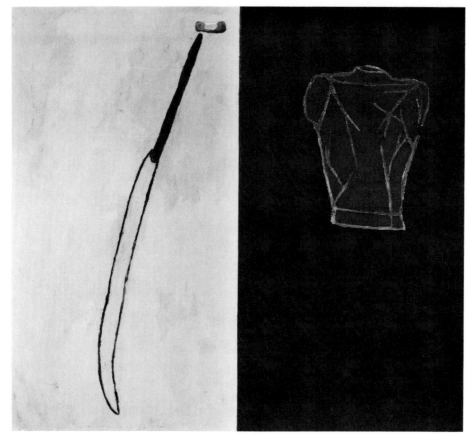

VALLANSASCA, ITALIAN HERO
1978–79. Oil on canvas, 8 x 8 ft (243.8 x 243.8 cm).
Collection Linda and Harry Macklowe, New York

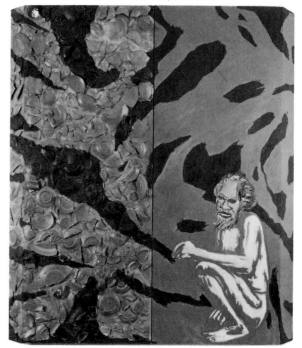

UNTITLED ABORIGINE PAINTING
1979. Oil and plates on wood,
8 x 7 ft (243.8 x 213.4 cm).
Private collection, New York

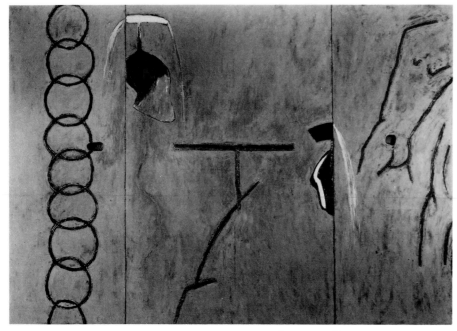

RAPED BY A ZOMBIE
1979. Oil, modeling paste,
and wax on canvas, 7 ft 6 in x
11 ft (228.6 x 335.2 cm).
The Morton G. Neumann
Family Collection, Chicago,
Illinois, and New York

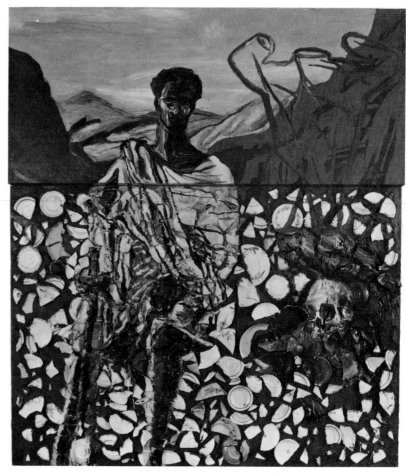

ST. FRANCIS IN ECSTASY
1980. Oil and plates on wood, 8 x 7 ft (243.8 x 213.4 cm).
Collection Mary Boone, New York

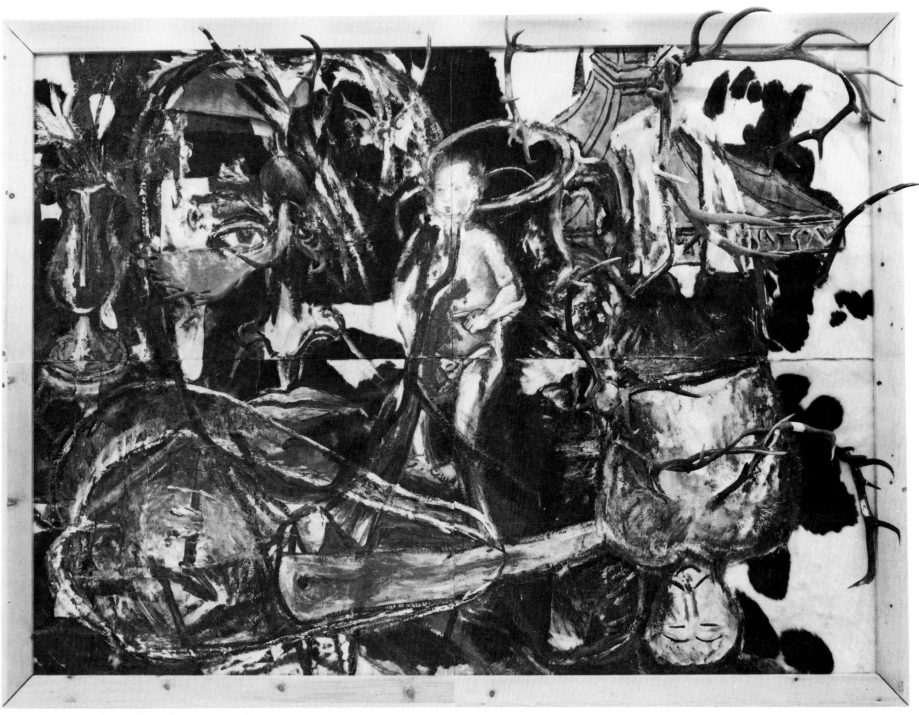

PREHISTORY: GLORY, HONOR, PRIVILEGE, AND POVERTY
1981. Oil and antlers on pony hide, 10 ft 8 in x 14 ft 9 in (325.1 x 449.6 cm).
Collection Doris and Charles Saatchi, London

JULIAN SCHNABEL
Born New York, 1951, lives in New York

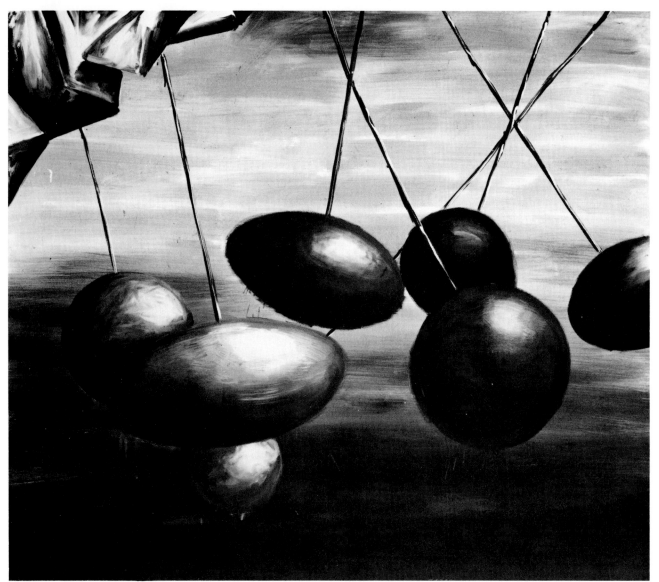

Hangende Kugeln
Hanging Balls
1981. Dispersion on nettle
cloth, 7 ft 8½ in x
8 ft 10¼ in (235 x 270 cm).
Private collection

Untitled
1982. Dispersion on nettle
cloth, 6 ft 6¾ in x
13 ft 1½ in (200 x 400 cm).
Galerie Six Friedrich,
Munich, West Germany

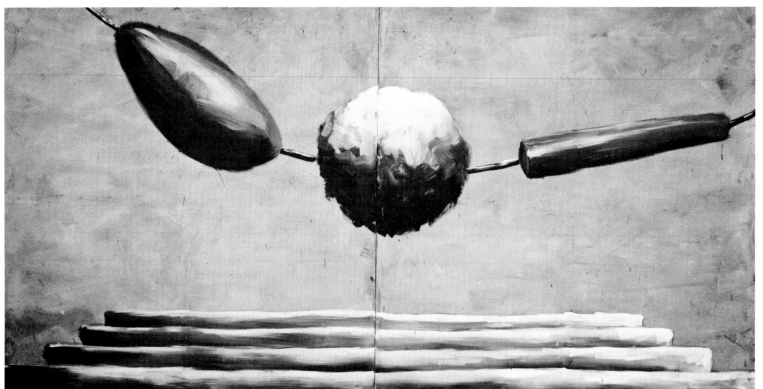

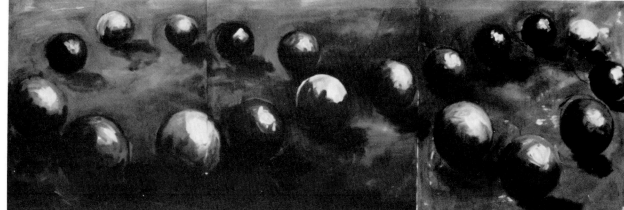

BLUE BALL PAINTING
1982. Dispersion on nettle
cloth, 6 ft 6¾ in x 19 ft 8¼ in
(200 x 600 cm). Private
collection, West Germany

ANDREAS SCHULZE
Born Hannover, West Germany, 1955, lives in Cologne, West Germany

HIDDEN DRAWING NO. 3
1975. Synthetic polymer paint
and tape on canvas,
7 x 7 ft (213.3 x 213.3 cm).
Juda Rowan Gallery, London

TIGER
1983. Oil on canvas, 6 ft 10 in x 6 ft 3 in (208.3 x 190.5 cm).
David McKee Gallery, New York

MOROCCAN
1982. Oil on canvas,
9 ft 4 in x 63 in
(284.5 x 160 cm).
Collection
William Beadleston,
New York

ADORATION
1982. Oil on canvas, 9 x 13 ft
(274.3 x 396.2 cm). David
McKee Gallery, New York

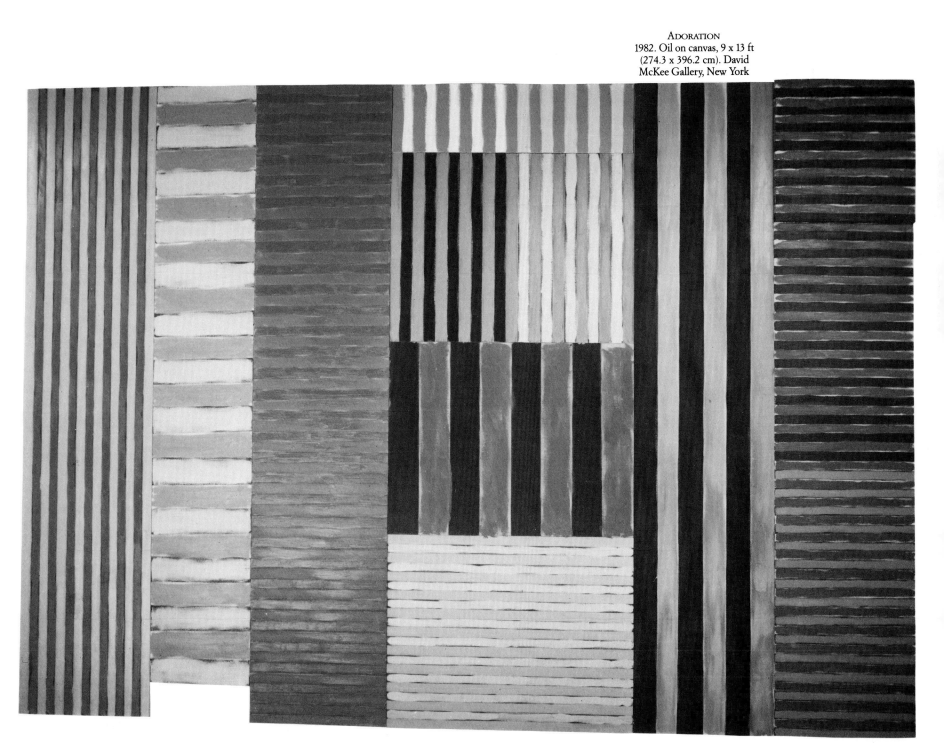

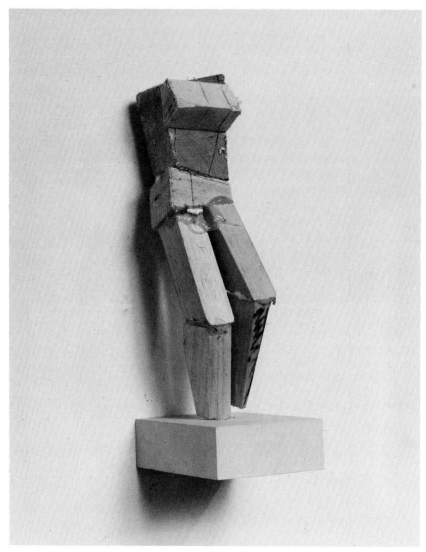

UNTITLED
1979. Wood, 8 x 4 x 3 in
(20.3 x 10.2 x 7.6 cm).
Private collection

JOEL SHAPIRO
Born New York, 1941, lives in New York

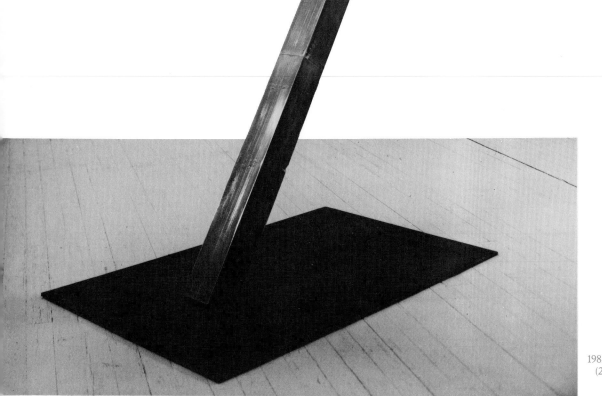

UNTITLED
1983. Bronze, 7 ft 1¾ in x 15 in x 42½ in
(217.8 x 38.1 x 107.9 cm). Collection
The Edward R. Broida Trust,
Los Angeles, California

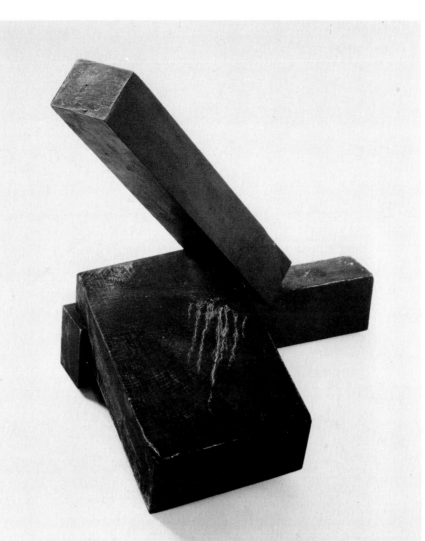

UNTITLED
1980. Oil and casein
on wood, 18¼ x
16½ x 12½ in (46.4 x
41.9 x 31.8 cm).
Private collection

UNTITLED
1975–76. Bronze on wood base:
bronze, 3½ x 28¾ x 21½ in
(8.9 x 73 x 54.6 cm); base, 17½ x
28¾ x 21½ in (44.5 x 73 x 54.6 cm).
Whitney Museum of American Art,
New York. Gift of Mrs. Oscar Kolin

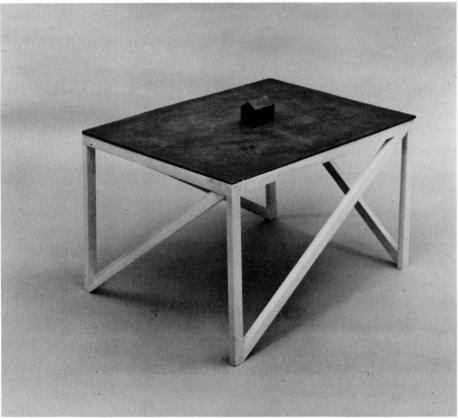

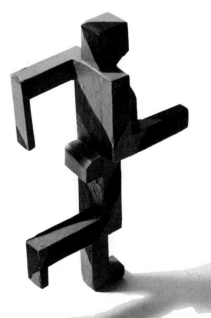

UNTITLED
1976–77. Oil on bronze,
9¾ x 2⅝ x 5 in
(24.8 x 6.7 x 12.7 cm).
Collection Mr. and Mrs.
Donald A. Petrie

ALEXIS SMITH
Born Los Angeles, California, 1949,
lives in Venice, California

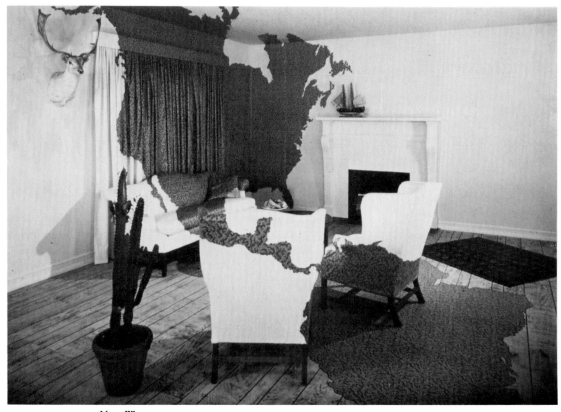

NEW WORLD
1980. Mixed mediums.
Installation commissioned by
House and Garden
for February 1981 issue

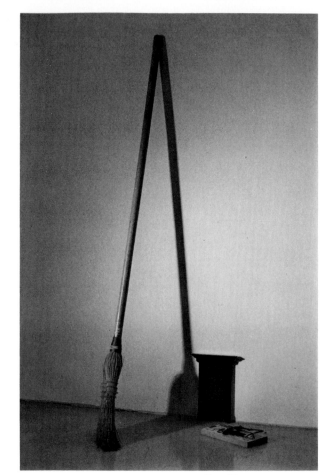

CITY MOUSE
1980. Mixed mediums,
60 x 36 in (152.4 x 91.4 cm).
Installation in *Tableau* exhibition
at Los Angeles Institute of
Contemporary Art,
Los Angeles, California

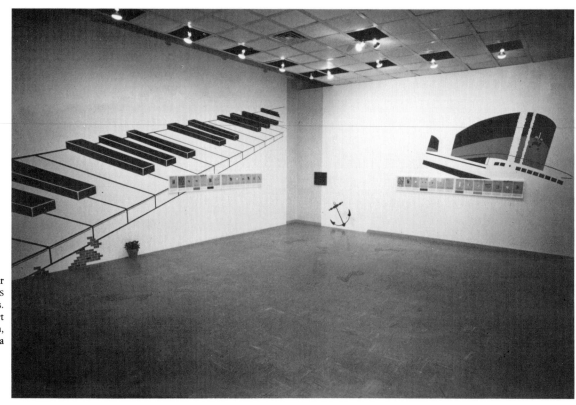

THE PROMISED LAND or
PORGY AND BESS
1981. Mixed mediums.
Installation at Newport
Harbor Art Museum,
Newport Beach, California

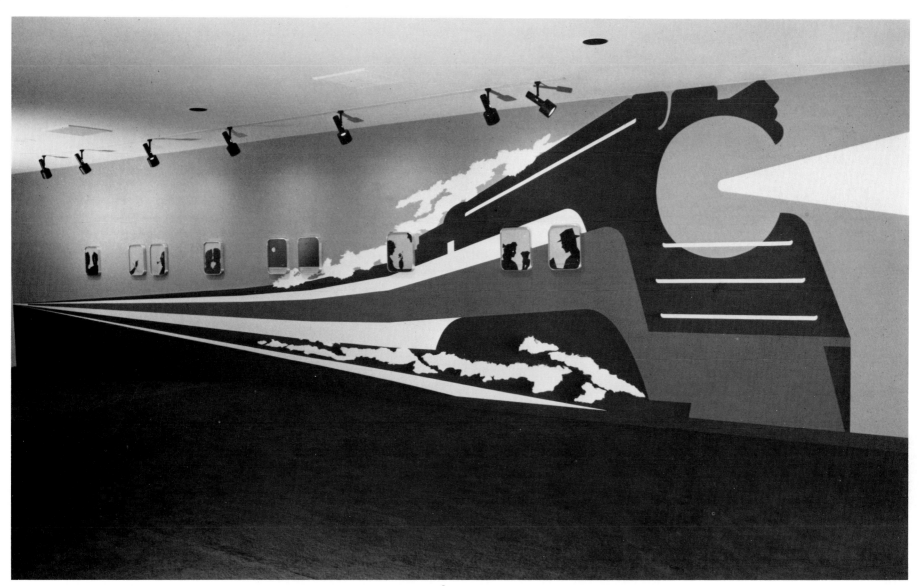

STARLIGHT
1982. Mixed mediums, size variable. Collection Unity Savings and Loan, West Hollywood, California.
Installation executed for the exhibition includes seven framed collages, each 15 x 12 x 1¼ in (38.1 x 30.5 x 3.2 cm), four of which are shown here.

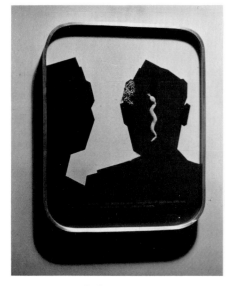

Berlin Express

Union Pacific

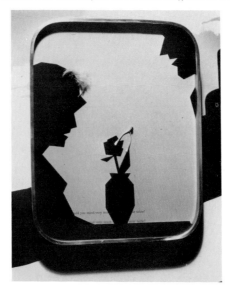

Brief Encounter

Sullivan's Travels

A PART OF THE WHOLE
1982. Detail of installation
at Prudential Insurance Company,
Thousand Oaks, California, 1982

STAHAHE SPHERE
1978. Cast concrete with pigment,
7 ft 6 in x 6 ft
(228.6 x 182.9 cm) diam.
Collection the artist.
Courtesy Holly Solomon
Gallery, New York

NED SMYTH
Born New York, 1948,
lives in New York

Detail of installation at Holly Solomon Gallery, New York, 1982

Right
THE LAST SUPPER
1975. Cast concrete. Installation
at P.S. 1 (Project Studios One),
Long Island City, New York, 1975

DREAMERS
1982. Cedar, poplar, paint, tar, and polyurethane,
7 ft 6 in x 68 in x 27 ft (228.6 x 172.7 x
823 cm). Installation at Neuberger Museum,
Purchase, New York, 1982

FROM THE DEEP
1982. Watercolor and charcoal on paper,
7 x 10 ft (213.4 x 304.8 cm).
Max Hutchinson Gallery,
New York

CHINA CLIPPER GETTING INTO THE AIR
March 16, 1980. Watercolor and charcoal on paper,
with suspended wood boat, 42 in x 15 ft 11 in
(106.7 x 485.1 cm). Private collection,
La Jolla, California

ROBERT STACKHOUSE
Born Bronxville, New York, 1942,
lives in New York

MOUNTAIN CLIMBER
1982. Painted oak and lath, overall
20 ft x 57 in (609.6 x 144.8 cm) (variable).
Max Hutchinson Gallery, New York

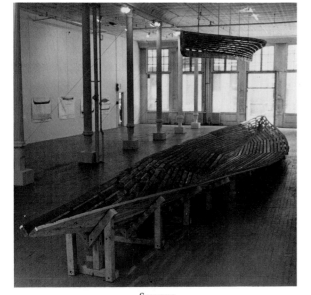

SAILORS
1979. Painted wood: ship's deck,
36 in x 12 ft x 72 ft (91.4 x 365.8 x 2,194.6 cm);
ship's hull, 18 in x 7 ft x 37 ft
(45.7 x 213.4 x 1,127.8 cm); overall
18 x 20 x 72 ft (548.6 x 609.6 x 2,194.6 cm).
Installation at Sculpture Now,
New York, 1979

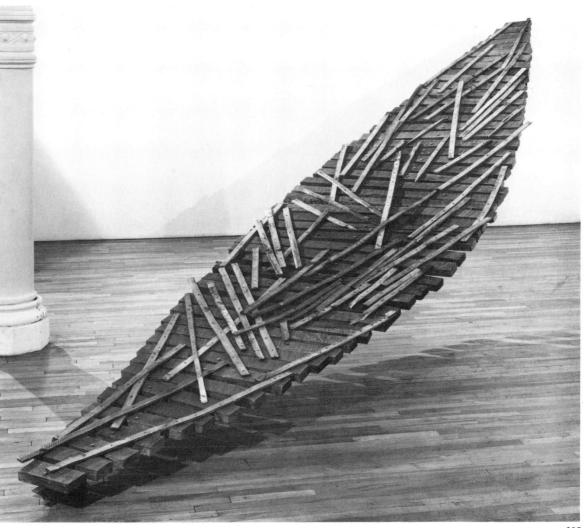

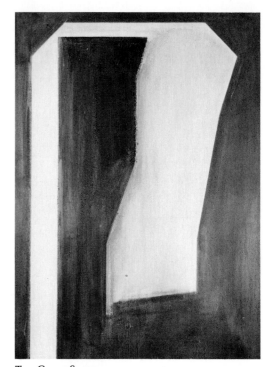

THE GREAT SLAVE
1978. Synthetic polymer
paint on canvas,
6 ft x 54 in
(182.9 x 137.2 cm).
Collection Steve and
Dorothy Weber,
Boston, Massachusetts

BEING IN THE WORLD and BINDING KNOWLEDGE
1981. Synthetic polymer paint on canvas, in two parts,
each 7 ft 6 in x 48 in (228.6 x 121.9 cm).
Collection Frederik Roos

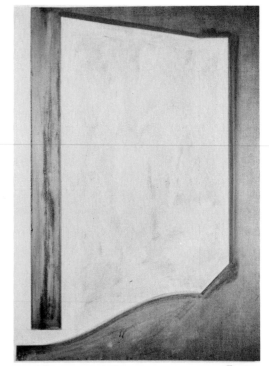

EASTER
1976–77. Synthetic
polymer paint on
canvas, 6 ft 8 in x 60 in
(203.2 x 152.4 cm).
Collection Bud Yorkin,
Los Angeles, California

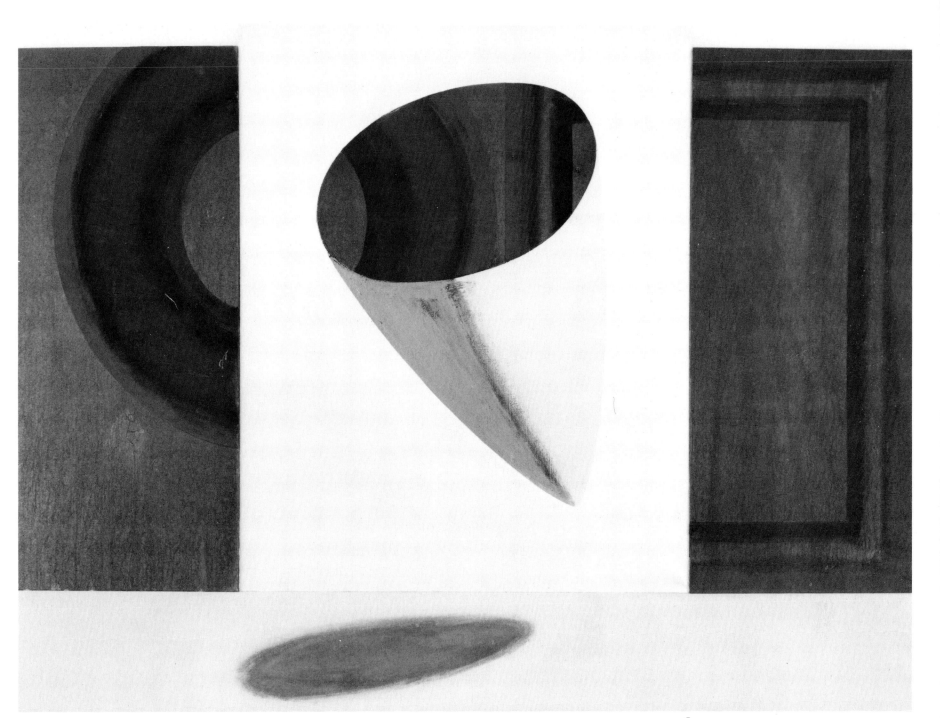

CENTURY
1983. Synthetic polymer paint on canvas,
8 ft 10 in x 12 ft (269.2 x 365.8 cm).
Collection Michael H. Schwartz,
Philadelphia, Pennsylvania

GARY STEPHAN
Born Brooklyn, New York, 1942, lives in New York

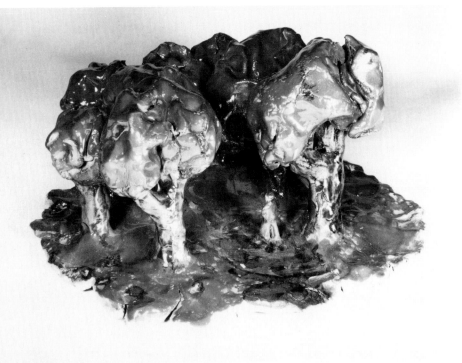

Spaziergänger im Wald
STROLLER IN THE WOODS
1982. Glazed ceramic, 6¼ x 9 x
11⅞ in (16 x 23 x 30 cm).
Galerie Krinzinger,
Innsbruck, Austria

THOMAS STIMM
Born Vienna, Austria, 1948,
lives in Vienna
and Waldviertel, Austria

Wohnung
APARTMENT
1983. Glazed ceramic,
11 x 12½ x 16½ in
(28 x 32 x 42 cm).
Museum Moderner Kunst,
Vienna, Austria

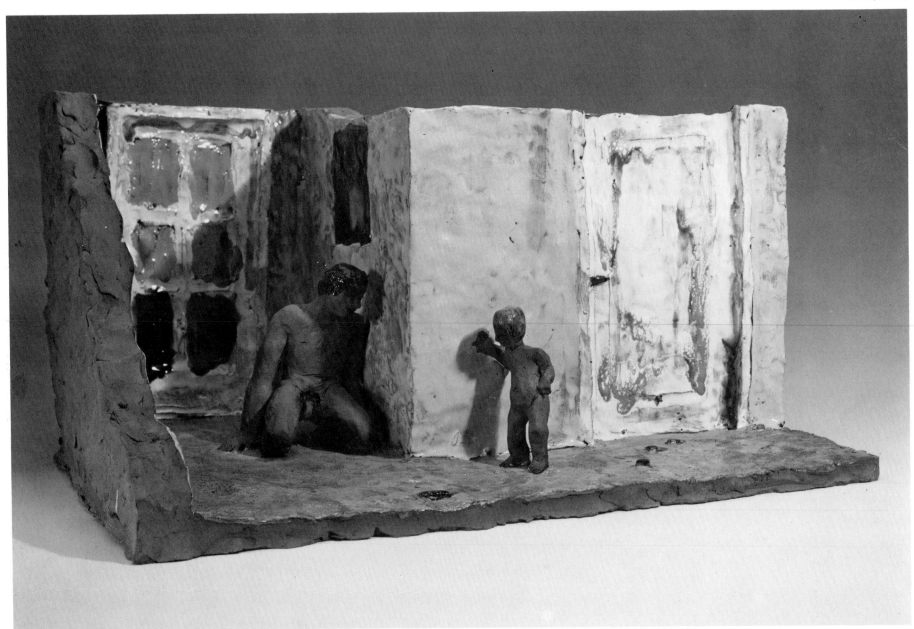

298

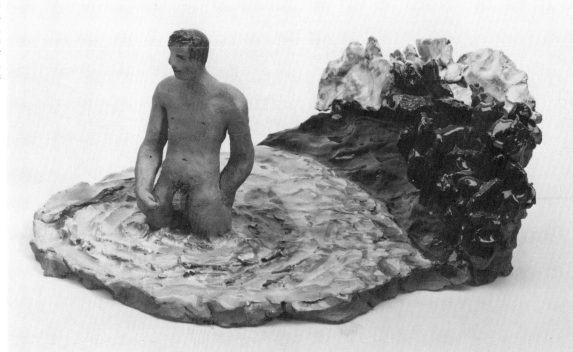

Der Schwimmer
THE SWIMMER
1982. Glazed ceramic,
6¼ x 9⅞ x 9½ in
(17 x 25 x 24 cm). Galerie
Nächst St. Stephan,
Vienna, Austria

SWIMMING POOL
1983. Glazed ceramic,
3¼ x 13⅜ x 18½ in
(8 x 34 x 47 cm).
Galerie Nächst St. Stephan,
Vienna, Austria

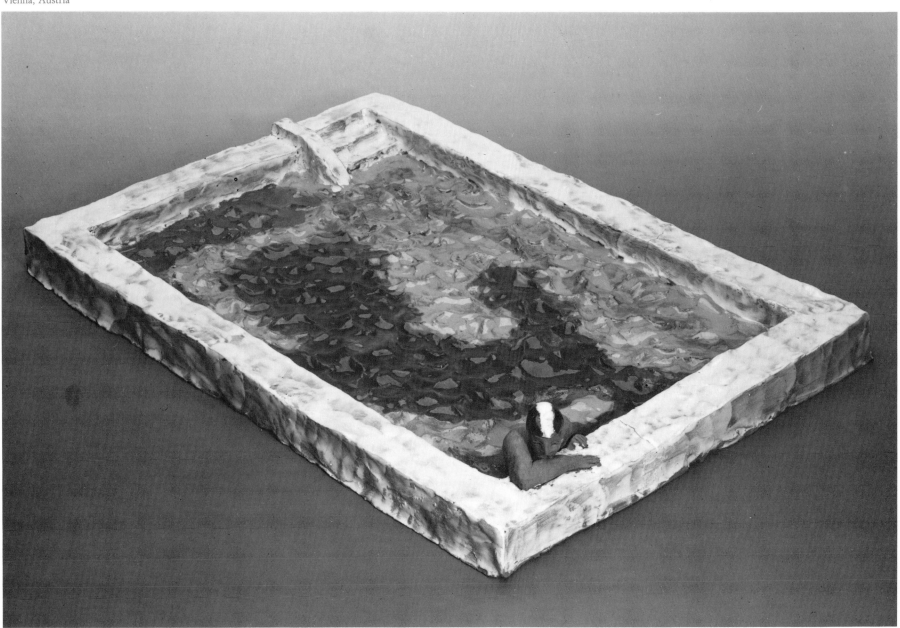

PUMPS, JANUARY 19, 1984
1984. Leaves, latex, and oil stick on
Cor-ten steel, 8 ft ⅛ in x
8 ft ¼ in (244.2 x 244.5 cm).
Collection Mr. and Mrs. Eli Broad

RAIN, JULY 8, 1982
1982. Oil, charcoal, and encaustic
on vinyl tile over wood,
8 ft x 48 in (243.8 x 121.9 cm).
Collection Gabriele Henkel

FOREST FIRE, JANUARY 5, 1984
1984. Latex, plaster, and tar on vinyl tile over masonite,
8 ft ¼ in x 8 ft ¾ in (244.5 x 245.7 cm).
Private collection, New York

DONALD SULTAN
Born Asheville, North Carolina, 1951, lives in New York

TRIUMPH OF
THE NEW YORK SCHOOL
1984. Oil on canvas,
6 ft 2 in x 10 ft
(188 x 304.8 cm).
Grace Borgenicht Gallery,
New York

INNOCENT EYE TEST
1981. Oil on canvas,
6 ft 6 in x 10 ft
(198.1 x 304.8 cm).
The Metropolitan
Museum of Art, New
York. Extended loan
and promised gift
of Charles Cowles

ACTION PAINTING
1981. Oil on canvas,
36 in x 6 ft 6 in (91.4 x
198.1 cm). Collection
Dr. Allen Logerquist,
New York

ICONOGRAPH, I
1984. Oil on canvas,
6 x 6 ft
(182.9 x 182.9 cm).
Grace Borgenicht
Gallery,
New York

SHORT HISTORY OF MODERN PAINTING
1982. Oil on canvas, 58 in x 10 ft (147.3 x 304.8 cm).
Collection Martin Sklar

MARK TANSEY
Born San Jose, California, 1949,
lives in New York

GOING OUT COMING IN
1982. Oil on canvas,
42 x 42 in (106.7 x 106.7 cm).
Collection the artist

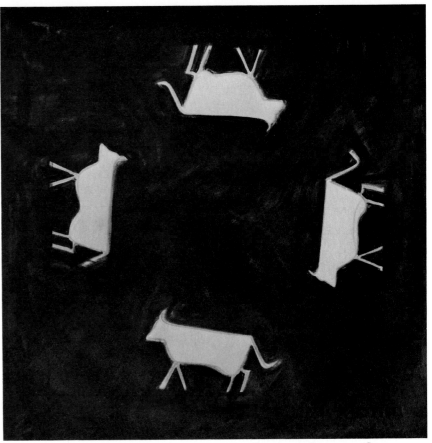

ROUND AND ROUND THE GARDEN
1983. Oil on canvas, 42 x 42 in
(106.7 x 106.7 cm). Collection
First Marathon Securities, Ltd.,
Toronto, Canada

THE PATH
1977. Oil on canvas,
35½ x 35½ in (90 x 90 cm).
Private collection

RIDUAN TOMKINS
Born Weymouth, England, 1941, lives in
Halifax, Nova Scotia, Canada

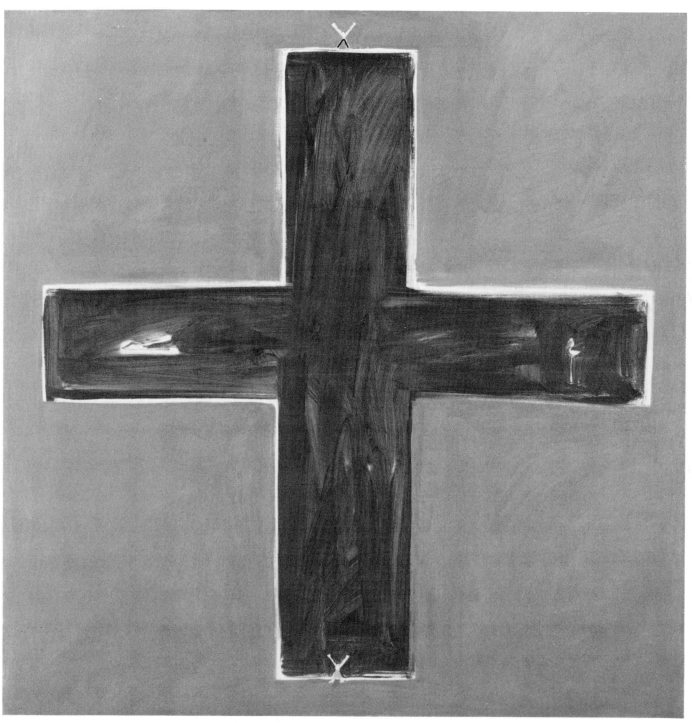

COME TOGETHER
1978. Oil on canvas,
47¼ x 47¼ in (120 x 120 cm).
Collection Hardwin Tibbs

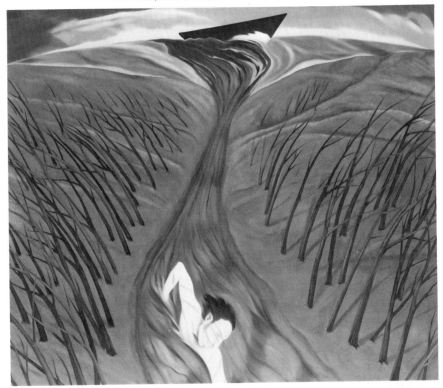

RECONCILIATION
1982. Oil on linen, 60 in x 6 ft (152.4 x 182.9 cm). Private collection

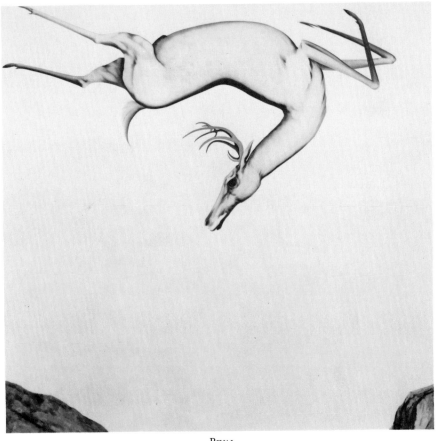

RIVAL
1981. Oil on canvas, 7 x 7 ft (213.4 x 213.4 cm). Private collection

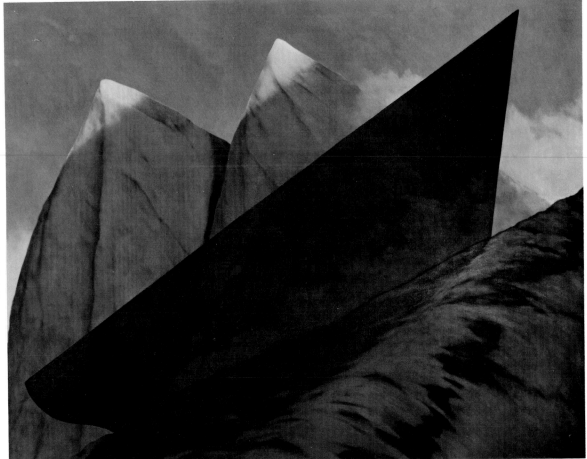

VEIL
1981. Oil on canvas,
66 in x 7 ft 4 in
(167.6 x 223.5 cm).
Private collection

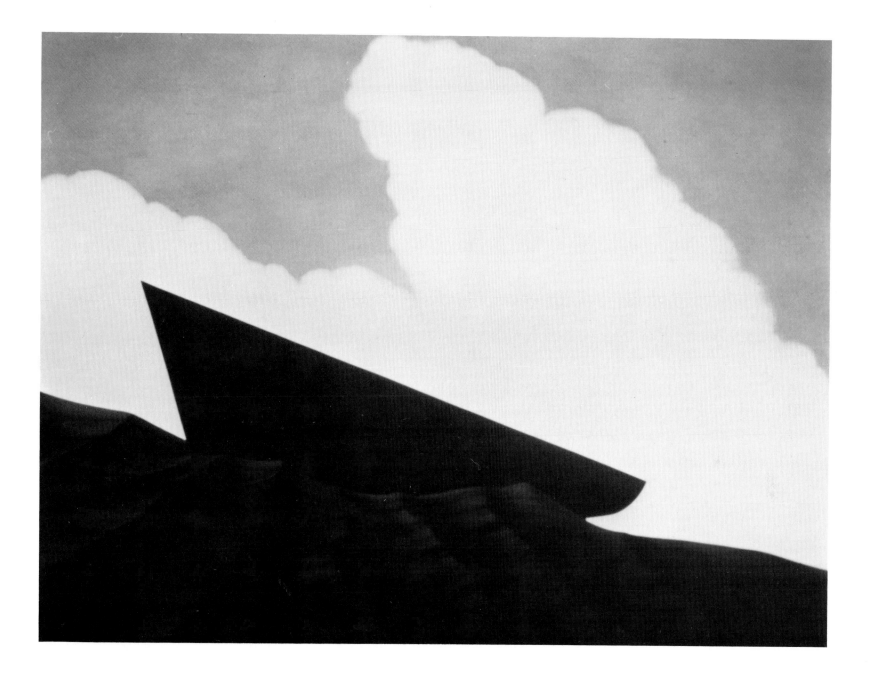

BLUE SEA
1976. Oil on canvas, 6 x 8 ft (182.9 x 243.8 cm). Private collection

DAVID TRUE
Born Marietta,
Ohio, 1942,
lives in New York

UNTITLED
1980–81. Oil on canvas,
55⅛ in x 12 ft 3⅝ in
(140 x 375 cm). Art & Project,
Amsterdam, Netherlands

UNTITLED
1979. Synthetic polymer
paint and oil on canvas,
9 ft 4⅝ in x 19¼ in
(286 x 49 cm). Haags
Gemeentemuseum,
The Hague, Netherlands

TOON VERHOEF
Born Voorburg, Netherlands, 1946,
lives in Edam, Netherlands

UNTITLED
1977. Oil on canvas,
8 ft 10 in x 31½ in (269 x
80 cm). Collection
Agnes and Frits Becht,
Naarden, Netherlands

UNTITLED
1980. Oil on linen,
9 ft 2¼ in x 19⅝ in (280 x
50 cm). Art & Project,
Amsterdam, Netherlands

EMO VERKERK
Born Amsterdam, Netherlands, 1955, lives in Amsterdam

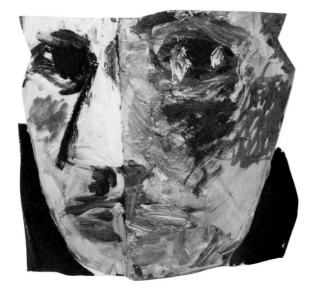

STUDY FOR PORTRAIT OF CHARLES BAUDELAIRE
1981. Oil on paper, 11⅜ x 12¼ x 4 in
(29 x 31 x 10 cm). Marian Goodman Gallery,
New York

STUDY FOR PORTRAIT OF CHARLIE PARKER
1982. Oil on paper, in two parts, overall
53⅛ x 28⅞ in (135 x 73.5 cm).
Art & Project, Amsterdam,
Netherlands

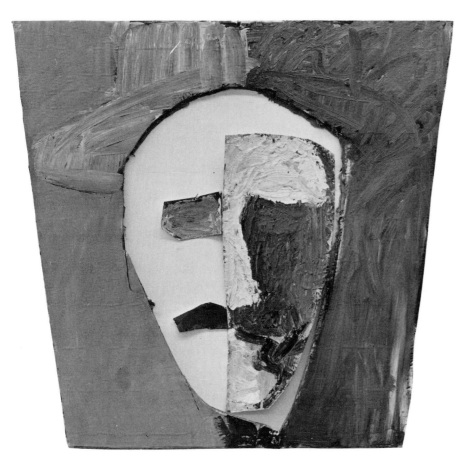

STUDY FOR PORTRAIT OF JAMES JOYCE
1982. Oil on paper and corrugated
cardboard, in four parts, overall
23⅝ x 24¼ x 1½ in (60 x 63 x 4 cm).
Stedelijk Museum, Amsterdam,
Netherlands

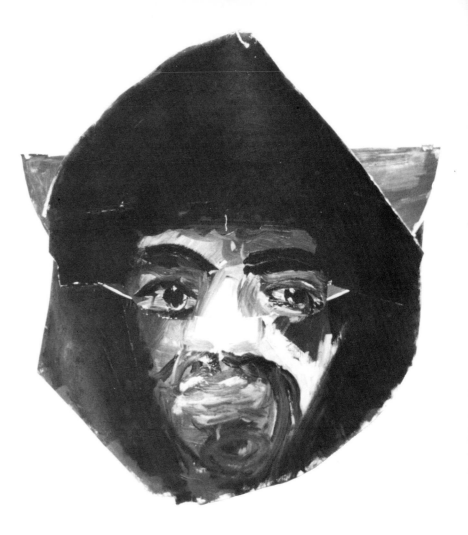

STUDY FOR PORTRAIT OF JIMI HENDRIX
1982. Oil on paper on brass, in three
parts, overall 25⅝ x 24¼ x 13⅜ in
(65 x 61.5 x 34 cm). Collection Agnes
and Frits Becht, Naarden, Netherlands

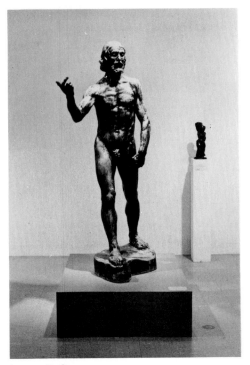

Auguste Rodin:
ST. JOHN THE BAPTIST PREACHING
1878–80. Bronze, 6 ft 6¾ in (200.1 cm) high.
The Museum of Modern Art, New York.
Mrs. Simon Guggenheim Fund.
Installation at The Museum of
Modern Art, 1978

SCULPTURE
1978. Painted wood, 14⅛ x 56⅞ x
42½ in (144.5 x 108 x 36 cm).
Installation at the artist's studio,
Brooklyn, New York, 1978

Left to right

SCULPTURE
1981. Plaster, 7 ft 4½ in x 23⅜ in x
23⅜ in (225 x 60 x 60 cm).
Collection André Goeminne,
Nazareth, Belgium

Installation at Galerie Micheline
Szwajcer, Antwerp, Belgium, 1982
In the exhibition, left: *Sculpture*
1982. Wood, 8 ft 3¼ in x 13¾ in x
13¾ in (252 x 35 x 35 cm).
Galerie Micheline Szwajcer

SCULPTURE
1981. Plaster. Collection the artist

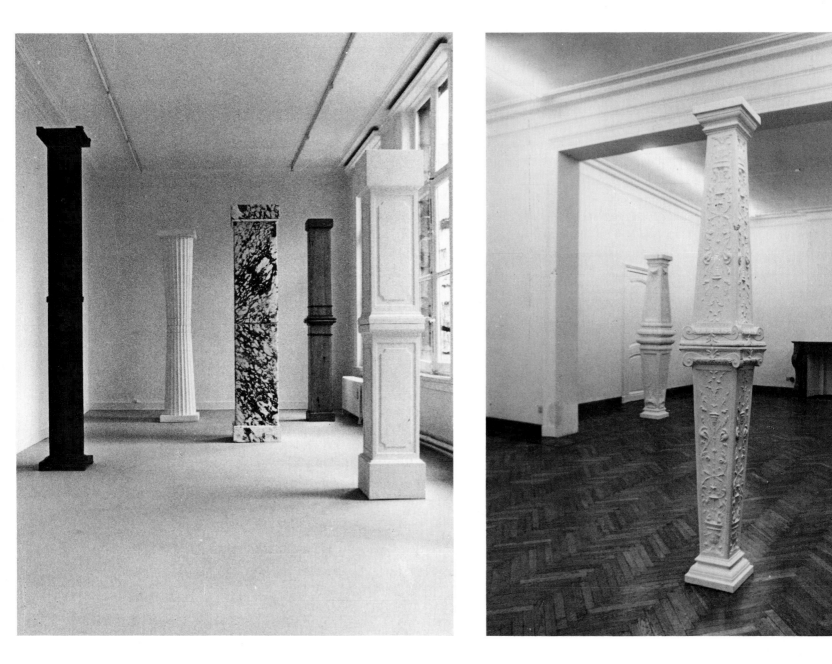

Installation at
Musée National d'Art Moderne,
Centre Georges Pompidou,
Paris 1982

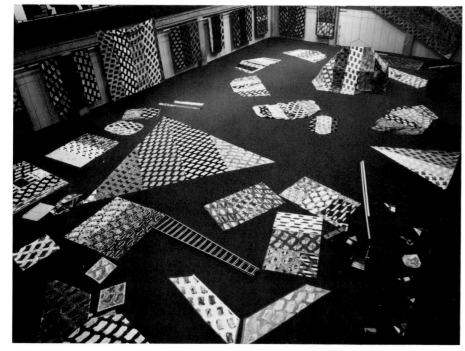

EMPREINTES SUR BÂCHE IRREGULIÈRE DE BATEAU
IMPRINTS ON IRREGULAR BOAT TARPAULIN
1979. Synthetic polymer paint on canvas, 10 ft 2 in x
6 ft 10⅝ in (310 x 210 cm). Musée Cantini,
Marseille, France

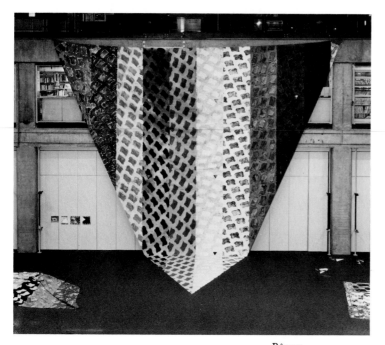

BÂCHE
TARPAULIN
1981. Synthetic polymer paint on canvas,
42 ft 7⅞ in x 36 ft 1 in (1,300 x 1,100 cm).
Galerie Jean Fournier, Paris

CLAUDE VIALLAT
Born Nîmes, France, 1936,
lives in Nîmes and Aigues-Vives,
France

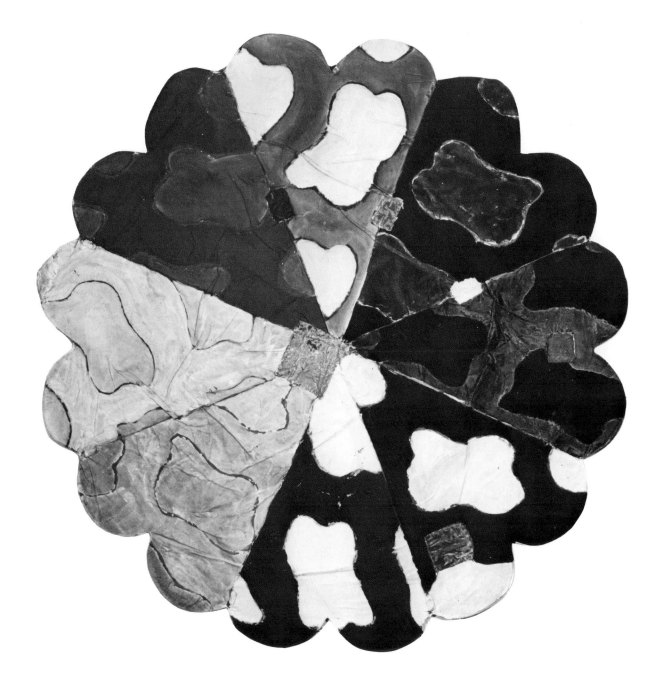

PARASOL
1978. Synthetic polymer paint on canvas, 6 ft ⅞ in (185 cm) diam. Collection Viallat Family

LÁGRIMA MARRÓN, I (SERIACIÓN I)
BROWN TEAR, I (SERIES I)
1983. Mixed mediums, 55⅛ x 67 in (140 x 170 cm).
Collection Placido Avango, Madrid, Spain

RETROCESO SIMPLE
SIMPLE REGRESSION
1980. Mixed mediums, triptych, overall 6 ft 6¾ in x
15 ft 9 in (200 x 480 cm). Collection the artist

Lágrima marrón, II (seriación I)
BROWN TEAR, II (SERIES I)
1983. Mixed mediums, 55⅛ x 67 in (140 x 170 cm).
Collection the artist.
Courtesy Charles Cowles Gallery, New York

Darío Villalba
Born San Sebastian, Spain, 1939, lives in Madrid, Spain

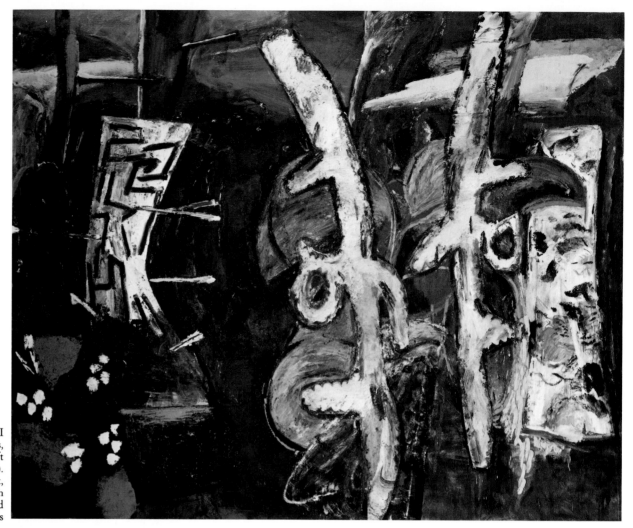

OCEANIA, I
1982. Oil on canvas,
7 ft 11⅞ in x 10 ft
(243.4 x 304.9 cm).
The Museum of Modern Art,
New York. Acquired through
the René d'Harnoncourt and
Blanchette Rockefeller Funds

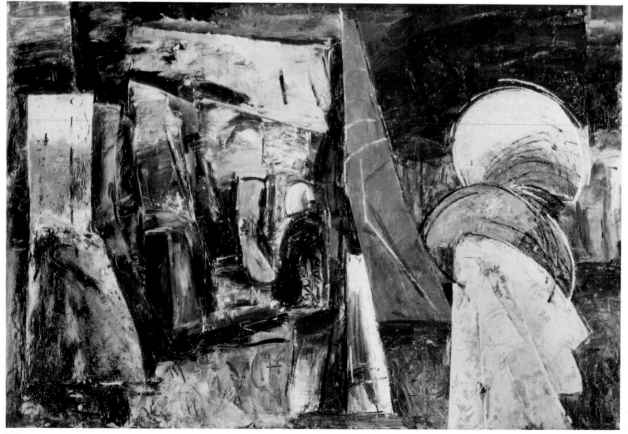

MELBOURNE LABYRINTH
1981. Oil on canvas,
7 ft 9½ in x 11 ft 9½ in
(237.5 x 359.4 cm).
Collection James Baker,
Brisbane, Australia

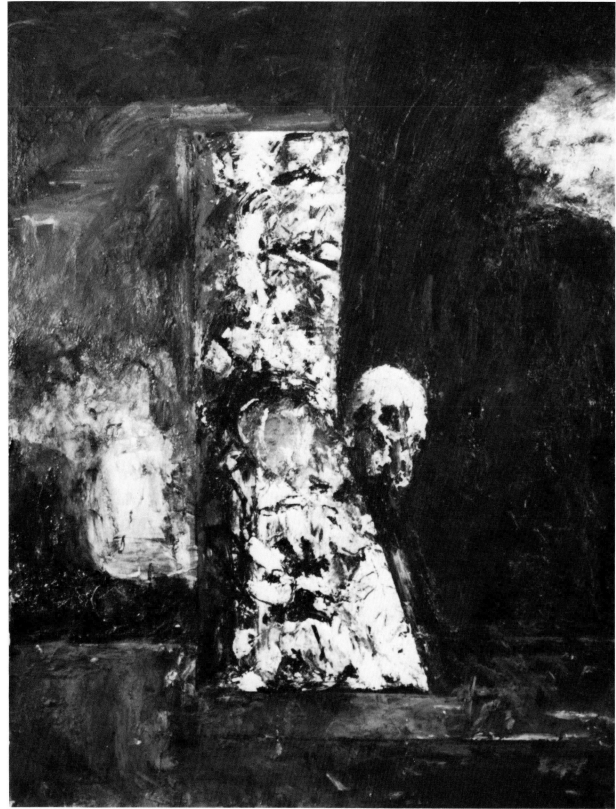

THE FORM, SKULL,
AND THE FALL
1982. Oil on canvas, 7 ft x
60 in (213.4 x 152.4 cm).
Collection The Edward R.
Broida Trust, Los Angeles,
California

WILLIAM T. WILEY

Born Bedford, Indiana, 1937,
lives in Forest Knolls,
California

ATTEMPTING TO MONITOR THE APE
1981. Watercolor, 22 x 30 in (55.9 x 76.2 cm).
Collection Mr. and Mrs. E. A. Bergman,
Chicago, Illinois

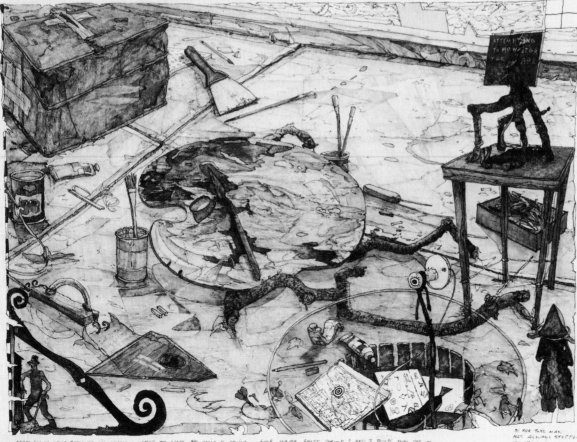

O.T.P.A.G. FOR E.T.S.
1982. Ceramic, steel, paint, and brass,
8 ft 9 in x 53 in x 25 in
(266.7 x 134.6 x 63.5 cm).
Allan Frumkin Gallery, New York

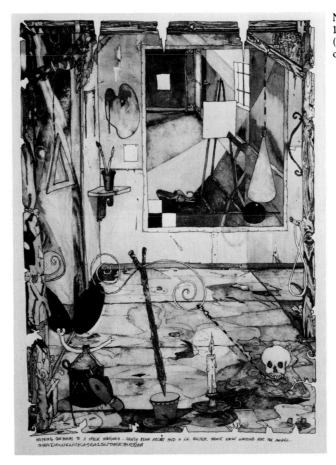

NOTHING CONFORMS
1978. Watercolor, 30 x 22 in
(76.2 x 55.9 cm). Whitney Museum
of American Art, New York

ACID RAIN
1981. Charcoal and synthetic polymer
paint on canvas, 8 ft x 13 ft 4½ in
(243.8 x 407.7 cm). Collection
Graham Gund

BLUE SAIL
1976. Oil stick on paper,
24 x 18 in (61 x 45.7 cm).
Private collection,
New York

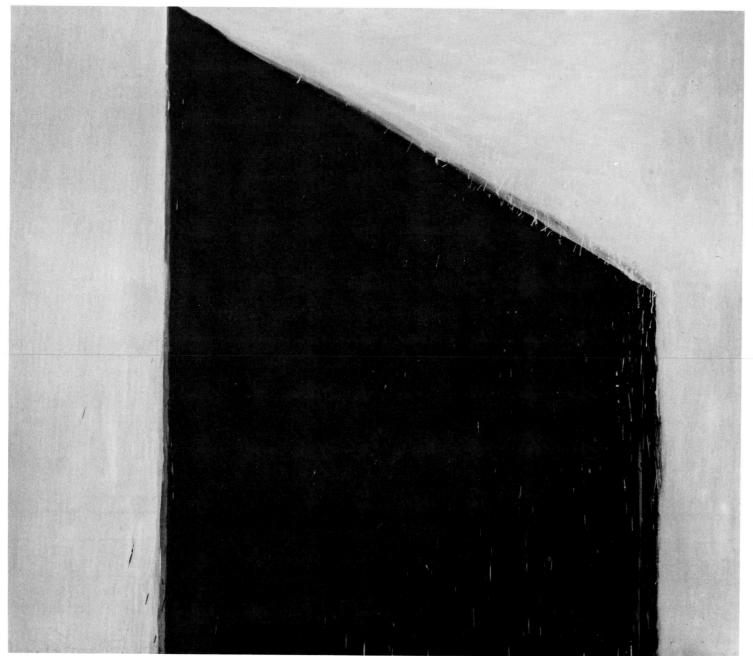

RED WARRIOR, II
1980. Synthetic polymer
paint on canvas, 7 ft x 8 ft 4 in
(213.4 x 254 cm). Collection
Neil Jenney

THORNTON WILLIS
Born Pensacola,
Florida, 1936,
lives in New York

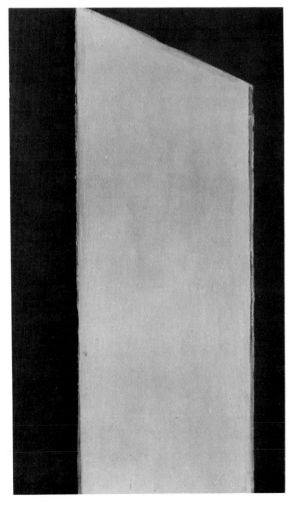

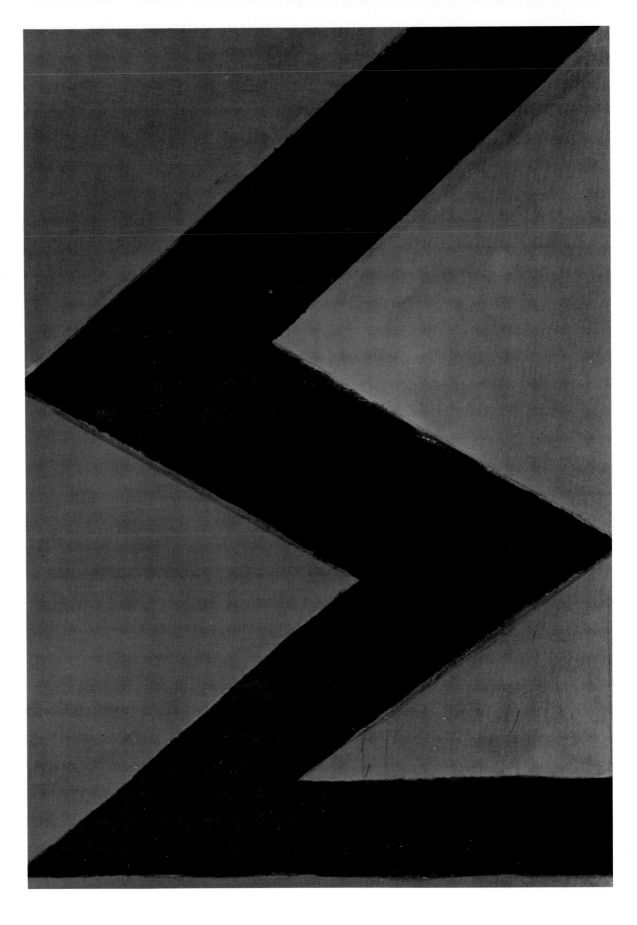

ALTARPIECE
1981. Synthetic polymer
paint on canvas,
7 ft x 48 in
(213.4 x 121.9 cm).
Private collection,
California

BLACK FLASH
1982. Synthetic polymer paint on
canvas, 6 ft 6 in x 54 in
(198.1 x 137.2 cm). The Power
Gallery of Contemporary
Art, University of Sydney,
Sydney, Australia

323

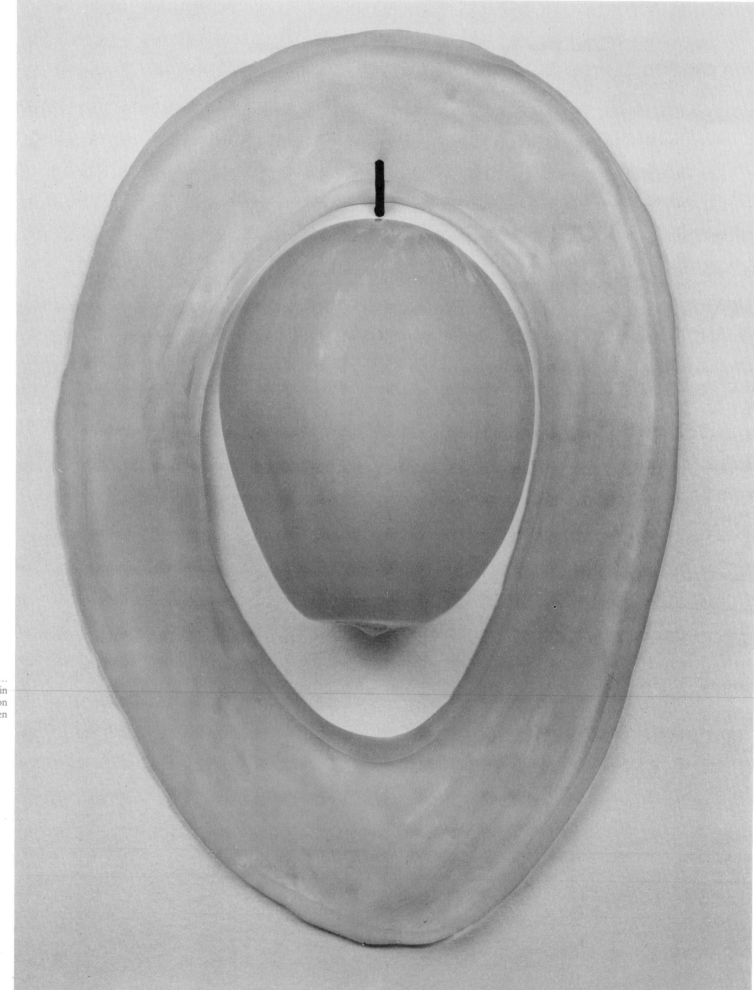

The Whole Soul Summed Up…
1979–80. Glass, 17 x 12 x 5¼ in
(43.2 x 30.5 x 13.3 cm). Collection
Marlene and Robert Baumgarten

324

INSERT MYSELF WITHIN YOUR STORY...
(from *Breath: Inspired by Seven Poems of
Stéphane Mallarmé Translated by Frederick Morgan*)
1980–81. Etching and aquatint, plate size 12¾ x 8½ in
(32.4 x 21.6 cm). Collection the artist

THE WHOLE SOUL SUMMED UP...
(from *Breath: Inspired by Seven Poems of
Stéphane Mallarmé Translated by Frederick Morgan*)
1980–81. Etching and aquatint, plate size 12¾ x 8½ in
(32.4 x 21.6 cm). Collection the artist

CHRISTOPHER WILMARTH
Born Sonoma, California, 1943,
lives in New York

INSERT MYSELF WITHIN YOUR STORY...
1979–81. Bronze and glass,
18⅛ x 14 x 5½ in
(46 x 35.6 x 14 cm). The Corning Museum
of Glass, Corning, New York.
Purchased in part with funds from
the National Endowment for the Arts

BAPTISTE (LONGING)
1981. Bronze and glass, 40 x 51 x 6 in
(101.6 x 129.5 x 15.2 cm). Collection
Mr. and Mrs. David Pincus,
Philadelphia, Pennsylvania

Robert Wilson
Born Waco, Texas, 1941,
lives in New York

THE CIVIL warS: A TREE IS BEST MEASURED WHEN IT IS DOWN, ACT I, SCENE B. Rotterdam, Netherlands, 1983

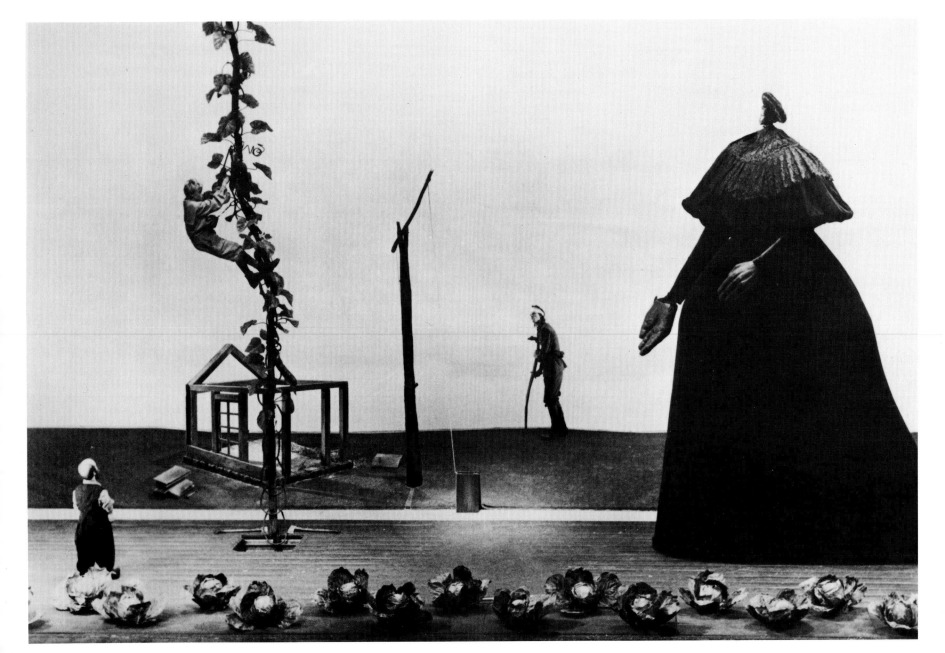

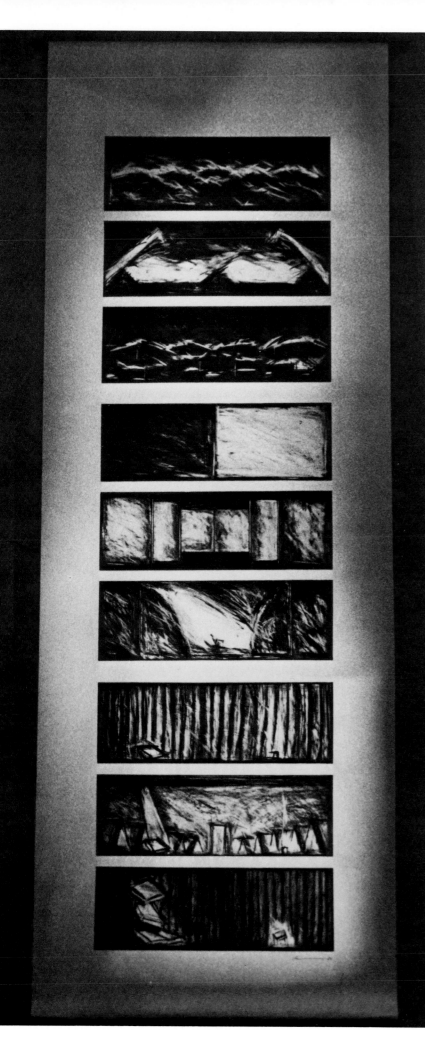

THE CIVIL warS:
ACT I, SCENE C;
ACT II, SCENE C;
ACT III, SCENE C
1983. Graphite on paper,
12 ft 4 in x 53¾ in
(375.9 x 136.5 cm).
Paula Cooper Gallery,
New York

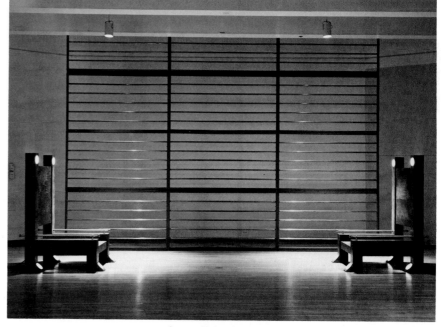

QUEEN VICTORIA CHAIRS
Installation at Contemporary Arts Center,
Cincinnati, Ohio, May 1980

THEOPHRASTUS' GARDEN 4
1982. Oil on linen, 7 ft 3 in x 70 in (221 x 177.8 cm).
Collection Dr. Jack E. Chachkes

TERRY WINTERS
Born New York, 1949, lives in
New York

BOTANICAL SUBJECT 5
1982. Oil on linen, 48 x 36 in (122 x 91.4 cm).
Collection Doris and Charles Saatchi, London

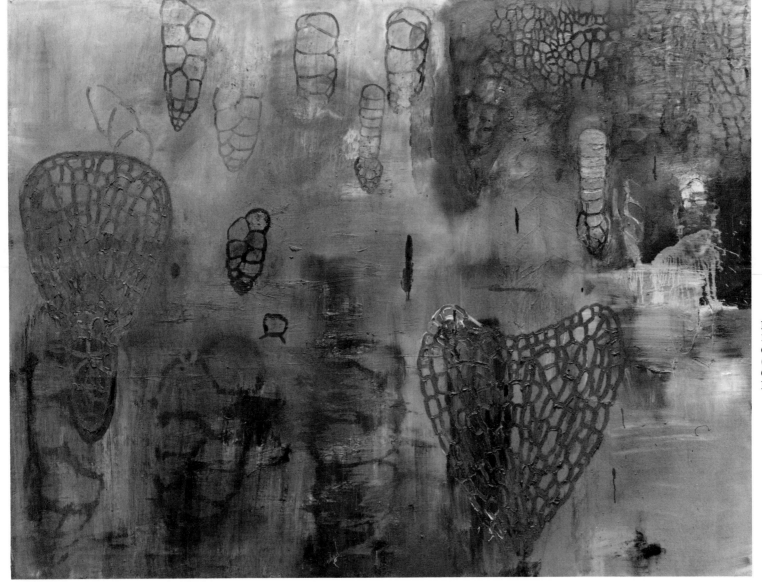

FREE UNION
1983. Oil on linen,
6 ft 7 in x 8 ft 8¼ in
(200.7 x 264.8 cm).
Collection Suzanne and
Howard Feldman

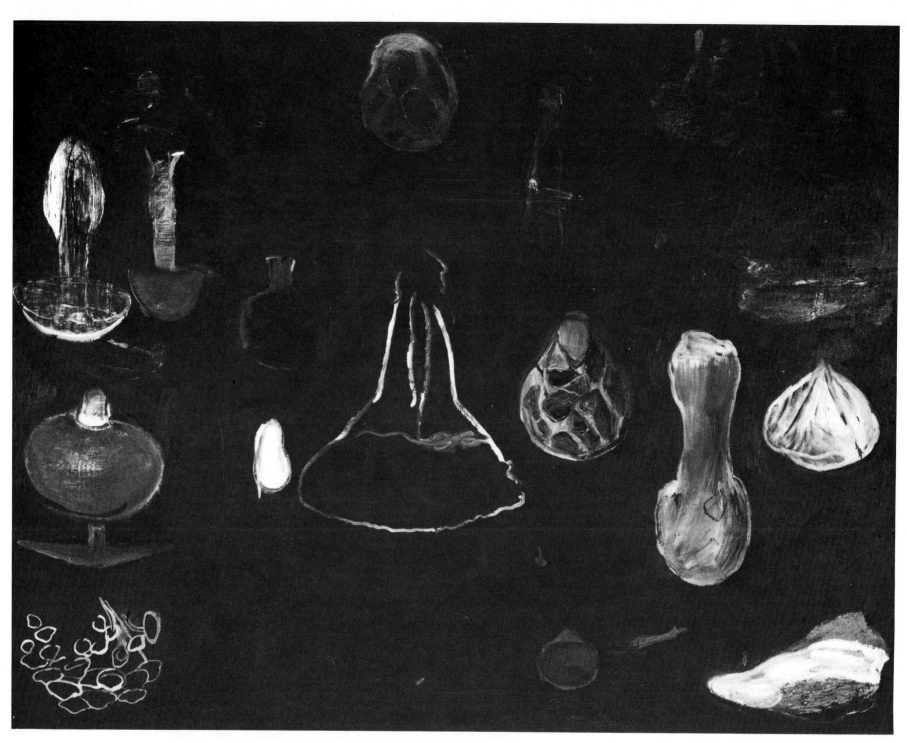

STRATA (TABLET)
1982. Oil on linen, 44 x 62 in
(111.8 x 157.5 cm).
Collection Paula Kassover

FUNGUS
1982. Oil on linen, 60 in x 6 ft 6 in
(152.4 x 198.1 cm). Collection Doris and
Charles Saatchi, London

CAR DOOR, IRONING BOARD, AND TWIN TUB,
WITH NORTH-AMERICAN INDIAN HEADDRESS
1981. Mixed materials, dimensions variable.
The Trustees of the Tate Gallery, London

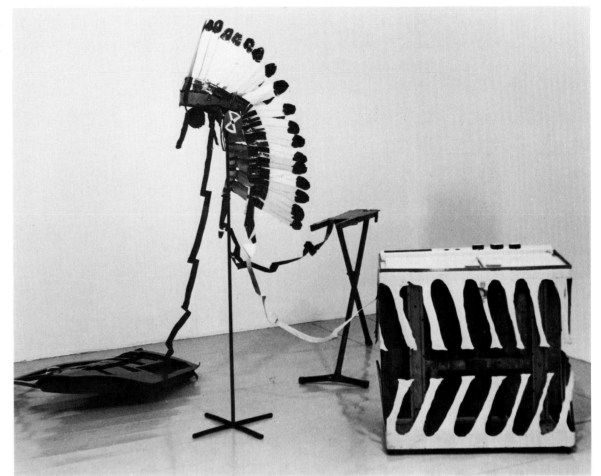

TATOO
1983. Mixed materials
(taxi fender, scrap metal, cloth),
approx. 40 in x 54 in x 7 ft
(101.6 x 137.2 x 213.4 cm).
Collection the artist

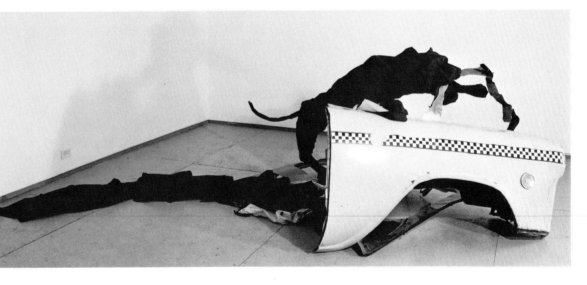

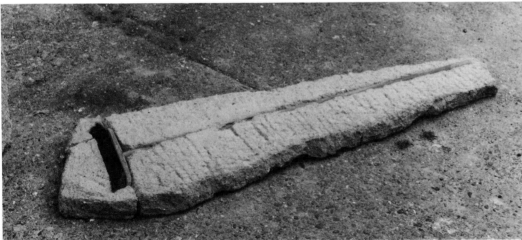

LAYING STONE
1979. Broom in cement,
59 x 19⅝ x 19⅝ in (150 x 50 x
50 cm). Collection the artist

330

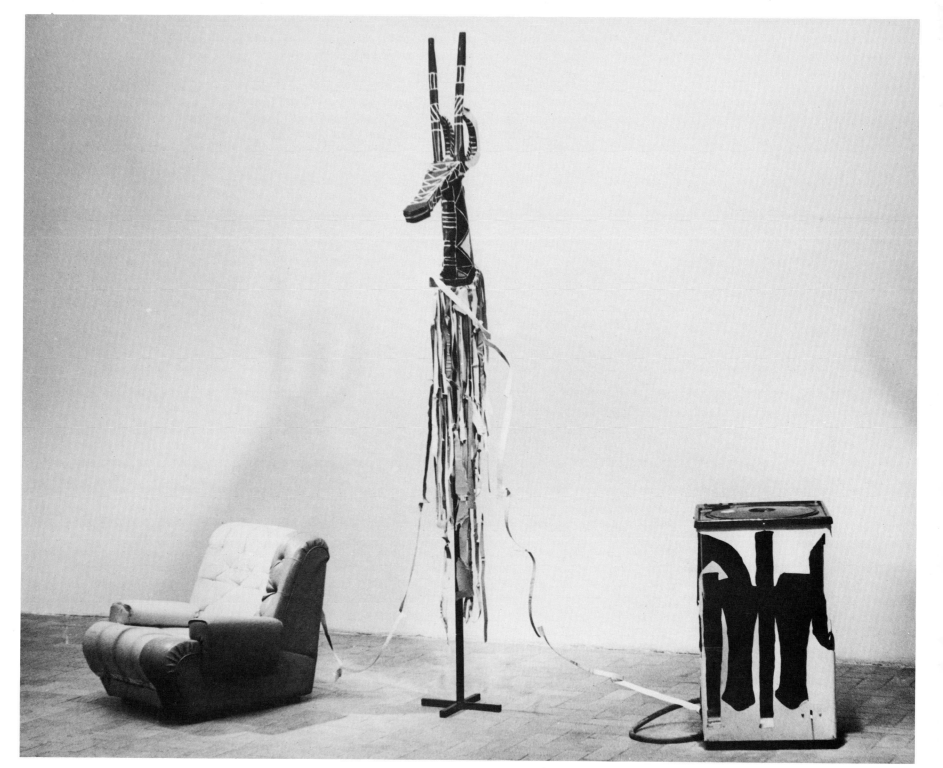

ARMCHAIR, WASHING MACHINE, AND KURUMBA MASK
1982. Mixed materials,
9 ft 10⅛ in x 11 ft 5¼ in x 6 ft 6¾ in
(300 x 350 x 200 cm).
Galerie Eric Fabre, Paris

BILL WOODROW
Born Henley, England, 1948, lives in London

ROYAL TRELLIS (from American Trellis series)
1979–80. Synthetic polymer paint on canvas,
7 ft 4 in x 11 ft (223.5 x 335.3 cm)
Private collection

DRAGON FIRE
1983. Synthetic polymer paint on canvas,
9 ft 1¾ in x 7 ft 1¾ in (278.8 x 217.8 cm).
Robert Miller Gallery, New York

RHINO
1979. Synthetic polymer paint
on canvas, triptych, overall
6 ft 6 in x 12 ft (198.1 x 365.8 cm).
Private collection, Geneva, Switzerland

MIDNIGHT MORNINGS OF GLORY
1980. Synthetic polymer paint on canvas,
66 x 54 in (167.6 x 137.2 cm).
Collection Marsha Fogel

JUNGLE TWIST
1980. Synthetic polymer paint
on canvas, 7 ft 4 in x 9 ft
(223.5 x 274.3 cm). Robert Miller
Gallery, New York

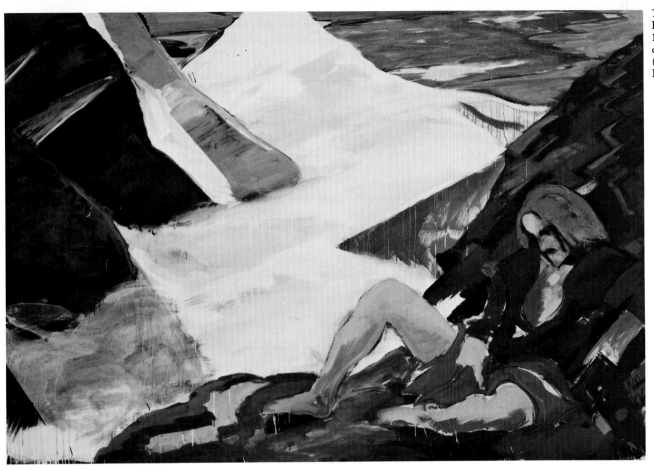

Traum von Similaun
Dream of Similaun
1981. Synthetic polymer paint
on canvas, 6 ft 8¾ in x 9 ft 10⅛ in
(205 x 300 cm). Collection Albert
Baronian, Brussels, Belgium

BERND ZIMMER
Born Planegg, West Germany, 1948,
lives in Berlin

PRAHU
1981. Synthetic polymer
paint on canvas,
6 ft 6¾ in x 8 ft 2⅜ in
(200 x 250 cm).
Collection the artist

Kuhschädel, IV
Cow Head, IV
1980. Synthetic polymer paint
on canvas, 6 ft 10 in x 10 ft
(208.3 x 304.8 cm). Collection
Mr. and Mrs. Aaron Katz

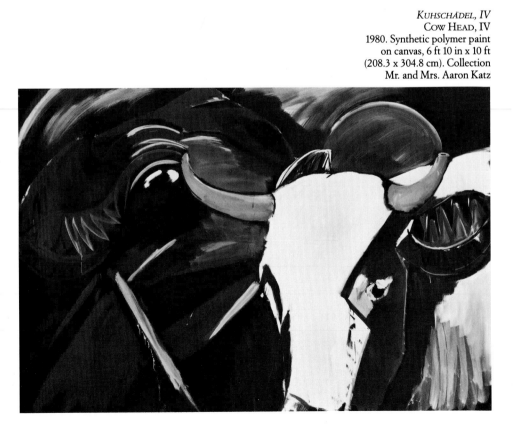

Brennende Fabrik
BURNING FACTORY
1981. Synthetic polymer paint
and oil on canvas, 6 ft 10⅝ in x
63 in (210 x 160 cm). Galerie
Gmyrek, Düsseldorf,
West Germany

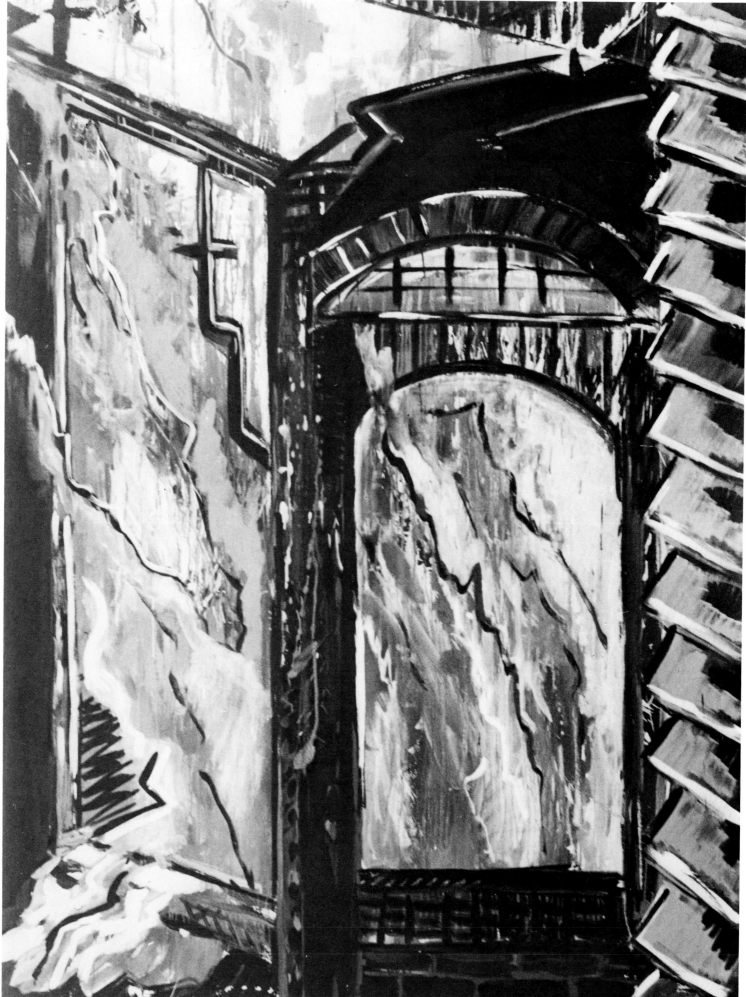

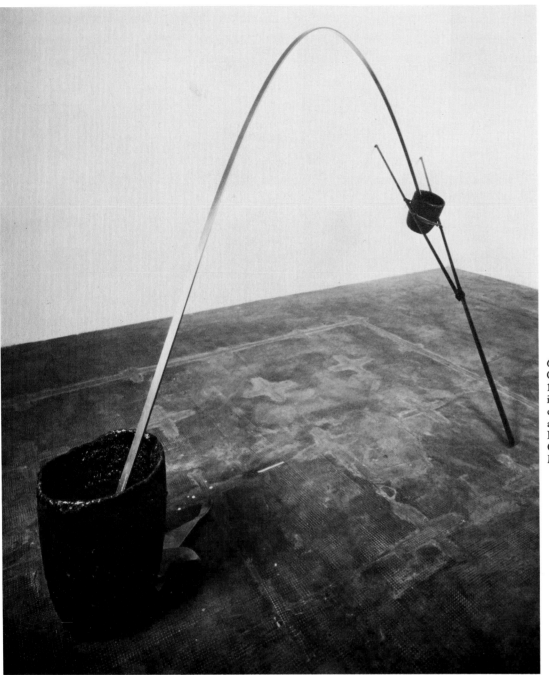

CROGIUOLI
CRUCIBLES
1980. Two crucibles,
iron tube, copper rod,
copper sulphate,
and hydrochloric acid.
Installation at
Galleria Salvatore Ala,
Milan, Italy, 1981

PER PURIFICARE LE PAROLE
TO PURIFY WORDS
1981. Terra cotta, wax, and
alcohol, 26 x 45 x 9 in
(66 x 114 x 22.8 cm).
Sonnabend Gallery,
New York

Stella per purificare la parola
STAR TO PURIFY THE WORD
1978. Leather star and javelin,
7 ft 4⅝ in x 7 ft 4½ in (220 x 225 cm).
Jean Bernier Gallery,
Athens, Greece

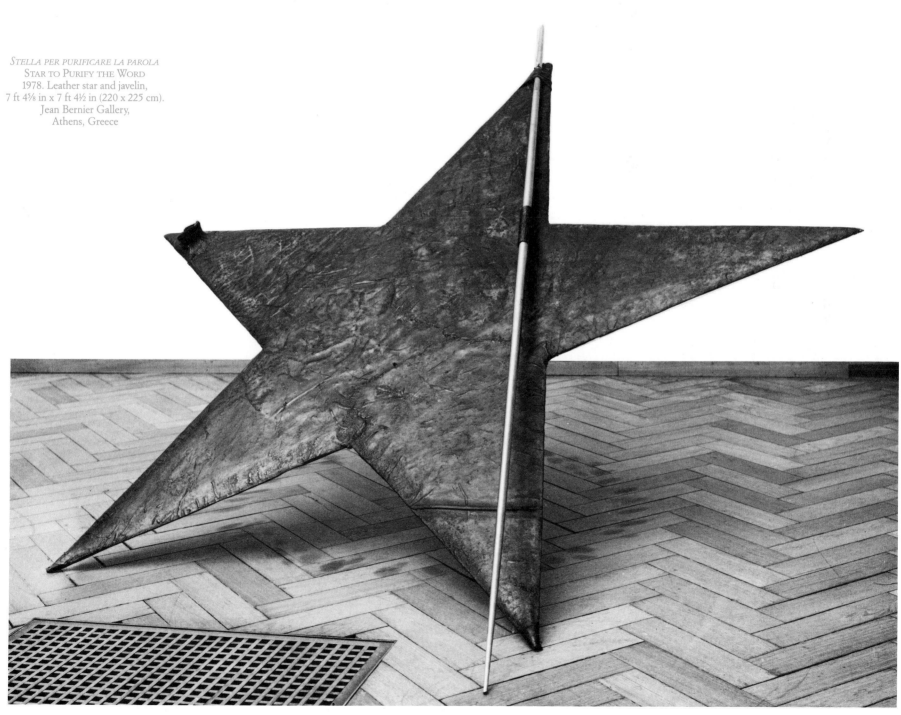

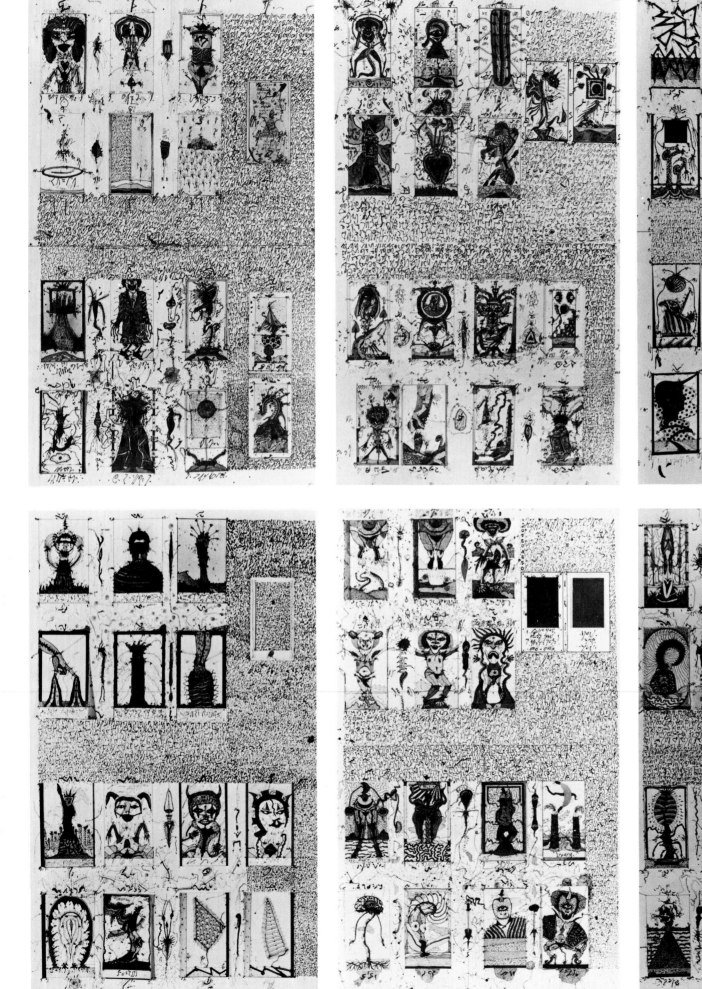

ZUSH

Born Barcelona, Spain, 1946, lives in
Barcelona and New York

THE TAROT CARDS
1976–79. Mixed mediums on paper,
in seven parts, each
29⅛ x 17⅛ in (74 x 43.5 cm).
Collection Vandrés

UNTITLED
1983. Raw pigment and oil on paper,
7 ft 6 in x 65 in
(228.6 x 165.1 cm).
Private collection

UNTITLED
1983. Raw pigment and oil on paper,
6 ft 8 in x 8 ft 7½ in
(203.2 x 262.9 cm).
Private collection

UNTITLED
1982. Raw pigment and oil on paper,
6 ft 8 in x 50 in (203.2 x 127 cm).
Collection The Chase Manhattan Bank, N.A.

UNTITLED
1982. Raw pigment and oil on paper,
6 ft 9 in x 56 in
(205.7 x 142.2 cm).
Private collection

MICHAEL ZWACK
Born Buffalo, New York, 1949,
lives in New York

341

Documentation

T HE bibliographic documentation that follows was compiled by Daniel Starr and is arranged in two sections: Individual Artists and Group Exhibitions. In the first section are to be found the principal individual exhibitions and publications for each artist represented in this book; the second consists of a selected list of international group exhibitions and catalogs in which many of the artists have appeared. Biographical sketches for each artist were compiled by Monique Beudert.

Individual documentation includes each artist's first exhibition, first trans-Atlantic show, major exhibitions (especially those with catalogs), and recent shows. Further information on the artists may be found in bibliographies and exhibitions lists in the publications given here; in the *Art Index, Artbibliographies Modern,* and *RILA* for references to articles and reviews of exhibitions in periodicals such as *Art in America, Artforum, Art News, Flash Art,* and *Kunstforum International;* and in the Group Exhibitions section of this book. The entries for individual exhibition catalogs give the title of the catalog and the author(s), if any; the publisher is given only if it differs from the first place of exhibition.

Documentation of group exhibitions provides a selection of some major, recent group exhibitions and catalogs. Shows in commercial galleries have been excluded, as have major recurring exhibitions such as *Documenta;* the Paris, São Paulo, Sydney, and Venice biennials; the Exxon national and international exhibitions at The Solomon R. Guggenheim Museum; the *Painting and Sculpture Today* exhibitions at the Indianapolis Museum of Art; the *Australian Perspecta* shows at the Art Gallery of New South Wales, Sydney; the Whitney biennials; and the *Directions* exhibitions at the Hirshhorn Museum and Sculpture Garden. The title of a group exhibition catalog is given only if it differs from that of the exhibition; the publisher of the catalog is given only if it differs from the first place of exhibition.

MAGDALENA ABAKANOWICZ

1930	Born Falenty, Poland
1950–55	Studied at School of Fine Arts, Warsaw, Poland
	Lives in Warsaw

EXHIBITIONS AND CATALOGS

1960	Galerie Kordegarda, Warsaw
1971	Pasadena Art Museum, Pasadena, California
1977	Konsthall, Malmö, Sweden. Catalog: *Abakanowicz: Organic Structures.*
1981	Galerie Alice Pauli, Lausanne
1982	Museum of Contemporary Art, Chicago, and the Chicago Public Library Cultural Center, Chicago, November 11–January 2, 1983, and tour. Catalog: *Magdalena Abakanowicz.* New York: Abbeville Press, 1982.
	Galerie Jeanne Bucher, Paris. Catalog: *Magdalena Abakanowicz: 21 Dessins au Fusain.*
1983	Galerie Alice Pauli, Lausanne
	National Academy of Sciences, Washington, D.C.

ALICE ADAMS

1930	Born New York
1953	B.F.A. Columbia University, New York
	Lives in New York

EXHIBITIONS

1964	Blumenfeld Gallery, New York
1970	55 Mercer, New York
1979	Hal Bromm Gallery, New York
1980	Artemesia Gallery, Chicago
1983	Hammarskjold Plaza Sculpture Garden, New York

MAC ADAMS

1943	Born South Wales, Great Britain
1961–67	Studied at Cardiff College of Art, Cardiff, Wales
1967–69	M.F.A. Rutgers University, New Brunswick, New Jersey
1967–77	Taught at various colleges including Douglass College, Rutgers University; Caldwell College, Caldwell, New Jersey; Fordham University, New York; and Montclair State College, Upper Montclair, New Jersey
1977	Taught at Nova Scotia College of Art and Design (summer session), Halifax, Nova Scotia
	Lives in New York

EXHIBITIONS AND CATALOGS

1969	Douglass College, Rutgers University, New Brunswick, New Jersey
1974	112 Greene Street, New York
1975	Arnolfini Gallery, Bristol, England
1979	Welsh Arts Council, Cardiff, Wales, touring exhibition. Catalog: *Mac Adams Mysteries.*
1980	Nigel Greenwood Inc. Ltd., London

1981	Neue Galerie–Sammlung Ludwig, Aachen, West Germany, September 12–October 6, and DAAD Galerie, Berlin. Catalog: Barbara Adams. *Mac Adams.*
1982	Musée de Toulon, Toulon, France, March 11–April 25. Catalog: *Mac Adams Mysteries.*

ROBERT ADRIAN X

1935	Born Toronto, Ontario, Canada
	Lives in Vienna, Austria

EXHIBITIONS AND CATALOG

1978	Galerie Dany Keller, Munich
	Galleria Fernando Pellegrino, Bologna
1982	Galleria Fernando Pellegrino, Bologna
	Frankfurter Kunstverein, Frankfurt am Main
	Galleria Cesare Manzo, Pescara, Italy
	Galerie Severina Teucher, Zurich
1984	Neue Galerie am Landesmuseum Joanneum, Graz, Austria, February 21–March 10. Catalog: *Robert Adrian X: Fünf Jahre, 1979–84.* Text by Wilfried Skreiner.

NICHOLAS AFRICANO

1948	Born Kankakee, Illinois
1970	B.A. (English literature) Illinois State University, Chicago, Illinois
1974	M.F.A. (painting) Illinois State University, Chicago
	Lives in Normal, Illinois

EXHIBITIONS AND CATALOG

1976	Nancy Lurie Gallery, Chicago
	University of Illinois, Urbana, Illinois
1977	Holly Solomon Gallery, New York
1979	Mayor Gallery, London
1982	Holly Solomon Gallery, New York
1983	Asher/Faure Gallery, Los Angeles
	North Carolina Museum of Art, Raleigh, North Carolina, November 5–January 29, 1984. Catalog: *Nicholas Africano: Paintings, 1976–1983.* Text by Mitchell Douglas Kahan.
	Middendorf Gallery, Washington, D.C.

JEAN MICHEL ALBEROLA

1953	Born Saïda, Algeria
	Lives in Le Havre, France

EXHIBITIONS

1982	Bonlow Gallery, New York
	Galerie Daniel Templon, Paris

PETER ALEXANDER

1939	Born Los Angeles, California
1957–60	Studied at University of Pennsylvania, Philadelphia, Pennsylvania
1960–62	Studied at Architectural Association, London
1962–68	Studied at University of California, Berkeley, California; University of Southern California, and University of California, Los Angeles (B.A., M.F.A.)
	Lives in Venice, California

EXHIBITIONS AND CATALOGS
1968 Robert Elkon Gallery, New York
1974 Art Gallery, University of California,
 Irvine, California, November 3–
 December 8. Catalog: *Peter Alexander:
 Sunsets.* Introduction by
 Hal Glicksman.
1982 Cirrus Editions, Los Angeles
 Charles Cowles Gallery, New York
1983 Arco Center for Visual Art, Los Angeles
 Municipal Art Gallery, Los Angeles,
 January 23–February 20. Catalog: *Peter
 Alexander: A Decade of Sunsets.* Text by
 Christopher Knight.

DAVIDA ALLEN
1951 Born Charleville, Queensland, Australia
1965–69 Studied at Stuartholme Convent,
 Brisbane, Australia, with Betty
 Churcher
1970–72 Studied at Central Technical College,
 Brisbane
 Lives at Purga Creek, near Brisbane
EXHIBITIONS
1973 Ray Hughes Gallery, Brisbane, Australia
1981 Ray Hughes Gallery, Brisbane
BOOK BY THE ARTIST
 Death of My Father: A Sketchbook.
 Brisbane: Ray Hughes Gallery, 1983.

GREGORY AMENOFF
1948 Born St. Charles, Illinois
1970 B.A. (history) Beloit College,
 Beloit, Wisconsin
 Lives in New York
EXHIBITIONS AND CATALOG
1972 Brockton Art Center, Brockton,
 Massachusetts
1976 Hayden Corridor Gallery,
 Massachusetts Institute of Technology,
 Cambridge, Massachusetts
1977 Nielsen Gallery, Boston
1981 Robert Miller Gallery, New York
1983 Fayerweather Gallery, University of
 Virginia, Charlottesville, Virginia
 Robert Miller Gallery, New York.
 Catalog: *Gregory Amenoff.* Text by
 Kenneth Baker.
 Stephen Wirtz Gallery, San Francisco

GIOVANNI ANSELMO
1934 Born Borgofranco d'Ivrea, Italy
 Lives in Turin, Italy
EXHIBITIONS AND CATALOGS
1968 Galleria Gian Enzo Sperone, Turin
1972 John Weber Gallery, New York
1973 Kunstmuseum, Lucerne,
 October 7–November 11. Catalog:
 Giovanni Anselmo. Edited by Jean-
 Christophe Ammann.
1979 Kunsthalle, Basel, March 18–April 22,
 and Van Abbemuseum, Eindhoven,
 Netherlands. Catalog: *Giovanni
 Anselmo.* Edited by Jean-Christophe
 Ammann, Giovanni Anselmo, and
 M. Suter.
1981 Salvatore Ala Gallery, New York
1982 Galerie Helen van der Meij, Amsterdam
 Galleria Christian Stein, Turin

IDA APPLEBROOG
1929 Born Bronx, New York
 Studied at School of The Art Institute
 of Chicago, Chicago, Illinois
 Lives in New York
EXHIBITIONS
1971 Dwight Boehm Gallery, Palomar
 College, San Marcos, California
1973 Max Hutchinson Gallery, New York
 Newport Harbor Art Museum,
 Newport Beach, California
1979 Franklin Furnace Archive, New York
1981 Nigel Greenwood Inc. Ltd., London
1982 Bowdoin College Museum of Art,
 Brunswick, Maine
 Ronald Feldman Fine Arts, New York
1983 Koplin Gallery, Los Angeles
BOOKS BY THE ARTIST
 Galileo Works (series of 10 books), 1977.
 Dyspepsia Works (series of 11 books),
 1979.
 Blue Books (series of 7 books), 1981.

SIAH ARMAJANI
1939 Born Teheran, Iran
1960 To United States
1963 B.A. Macalester College,
 St. Paul, Minnesota
 Lives in Minneapolis, Minnesota
EXHIBITIONS AND CATALOGS
1978 Philadelphia College of Art,
 Philadelphia, March 4–25. Catalog: *Siah
 Armajani: Red School House for Thomas
 Paine.* Essay by Janet Kardon.
1979 Max Protetch Gallery, New York
1980 Joslyn Art Museum, Omaha, Nebraska,
 June 14–September 7. Catalog: *Siah
 Armajani: Reading Garden #2.*
 Text by Holliday T. Day.
1981 Max Protetch Gallery, New York
 Hudson River Museum, Yonkers,
 New York, April 11–July 5. Catalog: *Siah
 Armajani: Office for Four.* Text by
 Julie Brown.
1982 Baxter Art Gallery, California Institute
 of Technology, Pasadena, California,
 March 3–April 25. *Siah Armajani: A
 Poetry Lounge.* Essay by David Antin.
1983 Max Protetch Gallery, New York

ARMANDO
1929 Born Amsterdam, Netherlands
 Studied art history at Gemeente
 Universiteit, Amsterdam
1958 Cofounder of Nederlandse informele
 groep
1979–80 DAAD Stipend to Berlin
 Lives in Berlin
EXHIBITIONS AND CATALOGS
1954 Galerie Le Canard, Amsterdam
1969 Galerie Krikhaar, Amsterdam
1974 Stedelijk Museum, Amsterdam,
 March 14–April 28. Catalog: *Armando.*
 Text by Carel Blotkamp.
1976 Centraal Museum, Utrecht,
 Netherlands, December 15–January 30,
 1977. Catalog: *Armando: Nieuwe
 Schilderijen en Tekeningen, Literair
 Werk, Herenleed.*
1979 Akademie der Künste, Berlin,
 June 4–July 4. Catalog: *Armando.*
 Berlin: Berliner Künstlerprogramm des
 DAAD, 1979.

1981 Stedelijk Museum, Amsterdam,
 October 30–January 3, 1982, and Van
 Abbemuseum, Eindhoven. Catalog:
 Armando. Text by Armando
 and R. H. Fuchs.
 Galerie Springer, Berlin, and Galleria
 Carlo Grossetti, Milan. Catalog: *Armando.*
1983 Galerie Springer, Berlin
 Nationalgalerie, Berlin

CHRISTIAN LUDWIG ATTERSEE
1940 Born Pressburg (now Bratislava,
 Czechoslovakia)
1957–63 Studied painting and graphics at
 Akademie für Angewandte Kunst,
 Vienna
 Involved with performances, stage sets,
 short films, and inventions
 Lives in Vienna
EXHIBITIONS AND CATALOGS
1966 Galerie Katz, Berlin
1972 Galerie Ariadne, Cologne, and Galerie
 Springer, Berlin. Catalog: *Attersee:
 Zyklus Segelsport, Bilder und
 Zeichnungen, Berlin 1971–72.*
1975 9th Paris Biennale, Musée National
 d'Art Moderne, Centre Georges
 Pompidou, Paris, and Galerie
 Grünangergasse, Vienna. Catalog:
 *Atternatters Tellerbluten
 (Ausstellungsbegleiter).*
1977 Internationale Kunstmesse, Basel,
 June 16–21. Catalog: *Attersee: Das
 Draufhausen.*
 Mannheimer Kunstverein, Mannheim,
 West Germany, April 17–May 5.
 Catalog: *Attersee: Aufschnitt 74–77.*
 Text by Peter Gorsen.
1979 Galerie Heike Curtze, Düsseldorf and
 Vienna, and Kulturhaus der Stadt, Graz,
 Austria. Catalog: *Attersee und Brus.*
 Galerie Stähli, Zurich. Catalog: *Attersee:
 Horizontmilch: Werkauswahl 1978/79.*
1980 Galerie Klewan, Munich, Catalog:
 *Attersee: Der Slawe ist die Herrlichste
 Farbe, Wekauswahl 1979/80.*
1982 Galerie Klewan, Munich: *Attersee: Das
 Traumzweit.*
 Museum Moderner Kunst/Museum des
 20. Jahrhunderts, Vienna, October 8–
 November 21, and tour. Catalog:
 Attersee: Werksquer. Introduction by
 Dieter Ronte. Salzburg: Residenz Verlag,
 1982.
1983 Galerie Stähli, Zurich. Catalog: *Attersee:
 Am Weg zur Braut, 1980-1983.*
 Reinhard Onnasch Ausstellungen,
 Berlin. Catalog: *Attersee: Der
 Wettergatte, Bilder 1979–1983.*
MONOGRAPH
 *Attersee: Das Graphische Werk,
 Originalgraphiken, limitierte und
 signierte Kunstdruck, Objektauflagen
 1965–1975.* Büren an der Aare,
 Switzerland: Galerie und Edition
 Herzog, 1975.
BOOK BY THE ARTIST
 *Österreichischer Sonnenschein: Austrian
 Sunshine.* Zurich: Galerie Bruno
 Bischofberger, 1968.

FRANK AUERBACH
1931 Born in Berlin
1939 To England
1948–52 Studied at St. Martin's School of Art,
 London
1948–53 Classes with David Bomberg
1952–55 Studied at Royal College of Art, London
1956–68 Taught at Camberwell School of Art,
 London, and Slade School of Art,
 London
 Lives in London
EXHIBITIONS AND CATALOGS
1956 Beaux-Arts Gallery, London
1969 Marlborough-Gerson Gallery,
 New York
1979 Bernard Jacobson, Ltd., New York
1982 Marlborough Gallery, New York.
 Catalog: *Frank Auerbach: Recent
 Paintings and Drawings.*
1983 Marlborough Fine Art, Ltd., London.
 Catalog: *Frank Auerbach: Recent Work.*

MIQUEL BARCELÓ
1957 Born Felanitx, Majorca, Spain
 Studied at Escola d'Arts Oficis, Majorca
 Lives in Paris
EXHIBITIONS
1982 Galería Trece, Barcelona
1983 Galerie Yvon Lambert, Paris

GEORG BASELITZ
1938 Born Georg Kern in Deutschbaselitz,
 Germany
1956–57 Studied at Hochschule der Künste, East
 Berlin, with Prof. Womacka
1956–64 Studied at Hochschule der Künste, West
 Berlin, with Hann Trier
1965 Stipend to Villa Romana, Florence, Italy
1977 Professor at Staatliche Kunstakademie,
 Karlsruhe, West Germany
1983 Professor at Hochschule der Künste,
 Berlin
 Lives in Derneburg, near Hildesheim,
 West Germany
EXHIBITIONS AND CATALOGS
1961 Schaperstrasse 22/Fasanenplatz, Berlin
 (with Eugen Schönebeck)
1963 Galerie Werner & Katz, Berlin
1973 Galerie Neuendorf, Hamburg. Catalog:
 *Georg Baselitz: Ein neuer Typ, Bilder
 1965/66.* Text by Günther Gercken.
1975 West German Pavilion, Bienal de São
 Paulo. Catalog: Evelyn Weiss. *Georg
 Baselitz.*
1976 Kunsthalle, Bern, January 24–March 7.
 Catalog: *Baselitz: Malerei,
 Handzeichnungen, Druckgraphik.*
 Edited by Johannes Gachnang.
1980 West German Pavilion, Venice Biennale.
 Catalog: *Georg Baselitz.* Edited by Klaus
 Gallwitz.
1981 Kunstverein, Braunschweig, West
 Germany, October 3–November 29.
 Catalog: *Georg Baselitz.* Edited by
 Jürgen Schilling.
 Xavier Fourcade, Inc., New York
1982 Anthony d'Offay Gallery and Helen van
 der Meij, London. Catalog: Rafael
 Jablonka. *Ruins: Strategies of
 Destruction in the Fracture Paintings of
 Georg Baselitz, 1966–1969.*
 Waddington Galleries, London.
 Catalog: *Baselitz.* Text by Richard
 Calvocoressi.

1983 Akron Art Museum, Akron, Ohio, June 18–August 28.

Galerie Folker Skulima, Berlin

Musée d'Art Contemporain, Bordeaux, France, March 18–April 23. Catalog: *Baselitz: Sculptures.*

Galerie Neuendorf, Hamburg

Whitechapel Art Gallery, London, September 7–October 30; Stedelijk Museum, Amsterdam; and Kunsthalle, Basel. Catalog: *Baselitz: Paintings, 1960–83.* Edited by Nicholas Serota and Mark Francis.

Studio d'Arte Cannaviello, Milan

The Museum of Modern Art, New York (with Rolf Iseli)

Sonnabend Gallery, New York

Xavier Fourcade, Inc., New York. Catalog: *Georg Baselitz: 6 Paintings, 1965–1969; 4 Paintings, 1982–1983.*

1984 Galerie Thomas Borgmann, Cologne

Mary Boone/Michael Werner Gallery, New York. Catalog: *Georg Baselitz.* Text by Norman Rosenthal and Klaus Kertess.

JEAN MICHEL BASQUIAT
1960 Born Brooklyn, New York

Lives in New York

EXHIBITIONS
1982 Annina Nosei Gallery, New York

Galleria Mario Diacono, Rome

1983 West Beach Café, Venice, California

JAKE BERTHOT
1939 Born Niagara Falls, New York

1960–61 Studied at New School for Social Research, New York

1960–62 Studied at Pratt Institute, Brooklyn, New York

Lives in New York

EXHIBITION
1983 David McKee Gallery, New York

JEAN CHARLES BLAIS
1956 Born Nantes, France

1974–79 Studied at École des Beaux-Arts, Rennes, France

Lives in Paris

EXHIBITIONS
1982 Galerie Karen & Jean Bernier, Athens

Galerie Baronian–Lambert, Ghent, Belgium

Galerie Yvon Lambert, Paris

Galleria Ugo Ferranti, Rome

1983 Galerie Max Marek, Berlin

Galleria Ugo Ferranti, Rome

Galerie Buchmann, St. Gallen, Switzerland

ERWIN BOHATSCH
1951 Born Murzzuschlag, Austria

1971–76 Studied with Prof. Eckert at Akademie der Bildenden Künste, Vienna, Austria

Lives in Fehring, Austria

EXHIBITIONS
1977 Galerie Brandstätter, Vienna

1981 Galerie Ariadne, Vienna

PETER BÖMMELS
1951 Born Frauenburg, West Germany

1970–76 University studies in sociology, politics, and education

Member of Mülheimer Freiheit (with Walter Dahn, Jiři Georg Dokoupil, and others)

Lives in Cologne, West Germany

EXHIBITIONS AND CATALOG
1982 Galerie Paul Maenz, Cologne

1983 Galerie Paul Maenz, Cologne

Museum am Ostwall, Dortmund, West Germany, October 16–December 4. Catalog: *Bilder, Die die Welt Bedeuten: Peter Bömmels.* Text by Bazon Brock.

PETER BOOTH
1940 Born Sheffield, England

1956–57 Studied at Sheffield College of Art, Sheffield

1958 Moved to Australia

1962–65 Studied at National Gallery School, Melbourne, Australia

Lives in Melbourne

EXHIBITIONS AND CATALOGS
1969 Pinacotheca, Melbourne

Central Street Gallery, Sydney

1980 Visual Arts Board, Sydney (with Mike Brown). Catalog: *In the Labyrinth: Drawings by Peter Booth and Mike Brown.*

1981 Pinacotheca, Melbourne

1982 Australian Pavilion, Venice Biennale (with Rosalie Gascoigne). Catalog: *Australia: Venice Biennale 1982.*

JONATHAN BOROFSKY
1942 Born Boston, Massachusetts

1964 B.F.A. Carnegie Mellon University, Pittsburgh, Pennsylvania

Summer, studied at École de Fontainebleau, France

1966 M.F.A. Yale University, New Haven, Connecticut

1969–77 Taught at School of Visual Arts, New York

1977–80 Taught at California Institute of the Arts, Valencia, California

Lives in Venice, California

EXHIBITIONS AND CATALOG
1975 Paula Cooper Gallery, New York

1976 Wadsworth Atheneum, Hartford, Connecticut

1979 The Museum of Modern Art, New York, August 17–October 29.

1981 Kunsthalle, Basel, July 12–September 13, and Institute of Contemporary Arts, London. Catalog: *Jonathan Borofsky: Dreams, 1973–81.* Text by Sandy Nairne, Jean-Christophe Ammann, and Joan Simon.

1982 Galerie Erika & Otto Friedrich, Bern

1983 Gemini G.E.L., Los Angeles

Galleri Wallner, Malmö, Sweden

Paula Cooper Gallery, New York

RICHARD BOSMAN
1944 Born Madras, India

1964–69 Studied at Byam Shaw School of Painting and Drawing, London

1969–71 Studied at New York Studio School, New York

1972 Taught at New York Studio School

1982 Visiting artist, Skowhegan School of Painting and Sculpture, Skowhegan, Maine

Lives in New York

EXHIBITIONS
1980 Brooke Alexander, Inc., New York

1982 Thomas Segal Gallery, Boston

Dart Gallery, Chicago

Fort Worth Art Museum, Fort Worth, Texas, March 6–April 18

Brooke Alexander, Inc., New York

1983 Mayor Gallery, London

Brooke Alexander, Inc., New York

1984 Brooke Alexander, Inc., New York

BOOK BY THE ARTIST
Exit the Face. New York: The Museum of Modern Art, 1982. Text by Ted Greenwald.

PAUL BOSTON
1952 Born Fitzroy, Victoria, Australia

1969–73 Studied at Preston Institute of Technology, Melbourne, Australia

1973–76 Lived in Japan and Southeast Asia

1980 Lived in United States and Germany

Lives in Melbourne

EXHIBITION
1983 Reconnaissance Gallery, Melbourne

1954 Born Jersey City, New Jersey

1973 B.F.A. California Institute of the Arts, Valencia, California

Lives in New York

EXHIBITIONS
1981 Metro Pictures, New York

1982 Mary Boone Gallery, New York (with Matt Mullican)

1983 Galerie Schellmann & Klüser, Munich

Mary Boone Gallery, New York

ROGER BROWN
1941 Born Hamilton, Alabama

1962–64 Studied at American Academy of Art

1968 B.F.A. School of The Art Institute of Chicago, Chicago, Illinois

1970 M.F.A. School of The Art Institute of Chicago

Lives in Chicago

EXHIBITIONS AND CATALOG
1971 Phyllis Kind Gallery, Chicago

1974 Galerie Darthea Speyer, Paris

1975 Phyllis Kind Gallery, New York

1980 Montgomery Museum of Fine Arts, Montgomery, Alabama, October 5–November 23, and tour. Catalog: Mitchell Douglas Kahan. *Roger Brown.*

1983 Asher/Faure Gallery, Los Angeles

1984 Phyllis Kind Gallery, New York

CHRIS BURDEN
1946 Born Boston, Massachusetts

1969 B.F.A. Pomona College, Claremont, California

1971 M.F.A. University of California, Irvine, California

Lives in Venice, California

EXHIBITIONS
1974 Riko Mizuno Gallery, Los Angeles

Ronald Feldman Fine Arts, New York

1975 Galleria A. Castelli, Milan

1977 Ronald Feldman Fine Arts, New York

1983 Ronald Feldman Fine Arts, New York

BOOKS BY THE ARTIST
Chris Burden 71–73. Los Angeles: Chris Burden, 1974.

B-Car: The Story of Chris Burden's Bicycle Car. Los Angeles: Choke Publications, 1977 (with Alexis Smith)

Chris Burden 74–77. Los Angeles: Chris Burden, 1978.

SCOTT BURTON
1939 Born Greensboro, Alabama

1957–59 Studied painting with Leon Berkowitz, Washington, D.C., and with Hans Hoffman, Provincetown, Massachusetts

1962 B.A. (literature) Columbia University, New York

1963 M.A. (literature) New York University, New York

Lives in New York

EXHIBITIONS AND CATALOG
1975 Artists Space, New York

1976 The Solomon R. Guggenheim Museum, New York, February 24–April 4

1981 Hammarskjold Plaza Sculpture Garden, New York

1982 Max Protetch Gallery, New York

1983 Contemporary Arts Center, Cincinnati, Ohio, March 11–April 20, and tour. Catalog: *Scott Burton Chairs.* Text by Charles F. Stuckey.

ELIZABETH BUTTERWORTH
1949 Born Rochdale, England

1968–71 Studied at Maidstone School of Art, Maidstone, England

1971–74 Studied at Royal College of Art, London

Lives in London

EXHIBITIONS
1975 Angela Flowers Gallery, London

1982 Fischer Fine Art, Ltd., London

1983 Artis Group, New York

MICHAEL BYRON
1954 Born Providence, Rhode Island

1976 B.F.A. Kansas City Art Institute, Kansas City, Missouri

1981 M.F.A. Nova Scotia College of Art and Design, Halifax, Nova Scotia, Canada

Lives in New York

EXHIBITIONS
1980 Anna Leonowens Gallery, Halifax, Nova Scotia

1982 Artists Space, New York

1983 Nature Morte Gallery, New York

Lawrence Oliver Gallery, Philadelphia

MIRIAM CAHN
1949 Born Basel, Switzerland

1968–73 Studied graphic design

Lives in Basel

EXHIBITIONS AND CATALOG
1977 Galerie Stampa, Basel

1982 Galerie Stampa, Basel

Galerie Konrad Fischer, Zurich

Kunsthaus, Zurich

1983 Kunsthalle, Basel, March 13–April 17. Catalog: *Miriam Cahn: Arbeiten 1979–1983.* Text by Theodora Vischer.

LUCIANO CASTELLI

1951 Born Lucerne, Switzerland

Apprenticed as a letterer; studied at Kunstgewerbeschule, Lucerne

1974 Traveled to United States

1977–78 Lived in Rome

1978 Moved to Berlin

Lives in Berlin

EXHIBITIONS AND CATALOG

1971 Galerie Toni Gerber, Bern

1981 Galerie Farideh Cadot, Paris

Annina Nosei Gallery, New York (with Salomé)

1982 Musée Cantonal des Beaux-Arts, Lausanne, September 29–November 12. Catalog: *Luciano Castelli: Tableaux Peints à Berlin, 1980–82.* Edited by Erika Billeter.

Annina Nosei Gallery, New York

MARC CAMILLE CHAIMOWICZ

1947 Born Paris; moved to London as a child

1963–65 Studied at Ealing College of Art, London

1965–68 Studied at Camberwell School of Art, London

1968–70 Studied at Slade School of Art, London

Lives in London

EXHIBITIONS AND CATALOG

1970 Camden Art Centre, London (with Peter Carey)

1979 Nigel Greenwood Inc. Ltd., London

1982 Galerie H. Air, Vienna

Galleria del Cavallino, Venice

1983 Galerie J. L. J. Bertin, Lyons

Bluecoat Gallery, Liverpool, England; Orchard Gallery, Londonderry, Northern Ireland; and John Hansard Gallery, Southampton, England. Catalog: *Past Imperfect: Marc Camille Chaimowicz, 1972–1982.* Text by Jean Fisher; essay by Stuart Morgan.

BOOK BY THE ARTIST

Dream, An Anecdote: Dreamt in the Winter and Remembered in the Spring of 1977. London: Nigel Greenwood Inc. Books, 1977.

LOUISA CHASE

1951 Born Panama City, Panama

1973 B.F.A. Syracuse University, Syracuse, New York

1975 M.F.A. Yale University, New Haven, Connecticut

Lives in New York

EXHIBITIONS AND CATALOGS

1975 Artists Space, New York

1978 Edward Thorp Gallery, New York

1981 Robert Miller Gallery, New York

1982 Harcus Krakow Gallery, Boston

Robert Miller Gallery, New York. Catalog: *Louisa Chase.*

1984 Robert Miller Gallery, New York. Catalog: *Louisa Chase.*

SANDRO CHIA

1946 Born Florence, Italy

Studied at Accademia di Belle Arti, Florence

1969 Traveled in Europe and India

1970 Lived in Rome

1980 Lived in New York

1980–81 Stipend from City of Mönchengladbach, West Germany

Lives in Rome and Ronciglione, Italy, and New York

EXHIBITIONS AND CATALOGS

1971 Galleria La Salita, Rome

1980 Kunsthalle, Basel, May 11–June 22; Museum Folkwang, Essen; and Stedelijk Museum, Amsterdam. Catalog: *Sandro Chia.*

Sperone Westwater Fischer Gallery, New York

1981 Anthony d'Offay Gallery, London. Catalog: Anne Seymour. *The Draught of Dr. Jekyll: An Essay on the Work of Sandro Chia.*

1982 Leo Castelli Gallery, New York

1983 Stedelijk Museum, Amsterdam, April 7–May 29. Catalog: *Sandro Chia.*

Galerie Silvia Menzel, Berlin

Städtisches Museum Abteiberg, Mönchengladbach, West Germany, August 14–September 18. Catalog: *Sandro Chia: Mönchengladbach Journal.*

Leo Castelli Gallery, New York

Galleria Mario Diacono, Rome

BOOKS BY THE ARTIST

Intorno a Se. Rome: Giuliana De Crescenzo, 1978. Essay by Achille Bonito Oliva.

Scultura Andata, Scultura Storna. Modena: Emilio Mazzoli, 1982 (with Enzo Cucchi).

FRANCESCO CLEMENTE

1952 Born Naples, Italy

Lives in Rome; Madras, India; and New York

EXHIBITIONS AND CATALOG

1971 Galleria Valle Giulia, Rome

1980 Sperone Westwater Fischer Gallery, New York

1982 Wadsworth Atheneum, Hartford, Connecticut

1983 Anthony d'Offay Gallery and Gian Enzo Sperone, London

Whitechapel Art Gallery, London, January 7–February 20, and tour. Catalog: *Francesco Clemente: The Fourteen Stations.* Edited by Mark Francis.

Mary Boone Gallery, New York

Sperone Westwater Gallery, New York

MONOGRAPH

Paul Maenz, editor. *Francesco Clemente, "Il Viaggiatore Napoletano."* Cologne: Verlag Gerd de Vries, 1982.

TONY COLEING

1942 Born Warrnambool, Victoria, Australia

1958–59 Studied at National Art School, Sydney, Australia

1963–68 Traveled in Europe

Lives in Sydney

EXHIBITIONS

1969 Gallery A, Melbourne and Sydney

1981 Institute of Modern Art, Brisbane, Australia

1982 Ray Hughes Gallery Downtown, Brisbane

JAN COMMANDEUR

1954 Born Avenhorn, Netherlands

1975–77 Studied at Gerrit Rietveld Academy, Amsterdam, Netherlands

1977–79 Studied at Ateliers '63, Haarlem, Netherlands

Lives in Amsterdam

EXHIBITIONS

1980 Art & Project, Amsterdam

1982 Stedelijk Museum, Amsterdam, February 12–March 28

STEPHEN COX

1946 Born Bristol, England

1964–65 Studied at West of England College of Art, Bristol

1966–68 Studied at Central School of Art and Design, London

1968–77 Taught at Coventry College of Art, Coventry, England; Stourbridge College of Art, Stourbridge, England; Newport College of Art, Wales; Birmingham Polytechnic, Birmingham, England; and Brighton Polytechnic, Brighton, England

Lives in London and Italy

EXHIBITIONS

1976 Lisson Gallery, London

1977 Julian Pretto Gallery, New York

1982 Galleria La Salita, Rome

1983 Nigel Greenwood Inc. Ltd., London

TONY CRAGG

1949 Born Liverpool, England

1969–70 Studied at Gloucestershire College of Art and Design, Cheltenham, England

1970–73 Studied at Wimbledon School of Art, London

1973–77 Studied at Royal College of Art, London

1977 Taught at École des Beaux-Arts, Metz, France, and Hornsea School of Art, London

1978–79 Taught at Kunstakademie, Düsseldorf, West Germany

1980 Taught at Chelsea School of Art, London, and Jan van Eyck Akademie, Maastricht, Netherlands

Lives in Wuppertal, West Germany

EXHIBITIONS AND CATALOGS

1979 Lisson Gallery, London

1981 Whitechapel Art Gallery, London

1982 Badischer Kunstverein, Karlsruhe, West Germany, January 12–February 28. Catalog: Michael Schwarz. *Tony Cragg: Skulpturen.*

1983 Kunsthalle, Bern, April 30–June 5. Catalog: *Tony Cragg.* Edited by Jean-Hubert Martin.

Galleria Franco Toselli, Milan

Marian Goodman Gallery, New York

ENZO CUCCHI

1950 Born Morro d'Alba, Italy

Lives in Ancona, Italy

EXHIBITIONS AND CATALOGS

1977 Incontri Internazionali d'Arte, Rome

Galleria Luigi De Ambrogi, Milan

1981 Sperone Westwater Fischer Gallery, New York

1980 Kunsthalle, Basel, May 11–June 22; Museum Folkwang, Essen; and Stedelijk Museum, Amsterdam. Catalog: *Enzo Cucchi.*

1982 Museum Folkwang, Essen, December 17–January 23, 1983. Catalog: Zdenek Felix. *Enzo Cucchi: Un'Immagine Oscura.* Essen: Richard Bacht, 1982.

Kunsthaus, Zurich, May 11–August 8, and Groninger Museum, Groningen, Netherlands. Catalog: Ursula Perucchi. *Enzo Cucchi: Zeichnungen.*

1983 Stedelijk Museum, Amsterdam, November 10–January 8, 1984, and Kunsthalle, Basel. Catalog: *Enzo Cucchi: Giulio Cesare Roma.*

Galerie Schellmann & Klüser, Munich

Sperone Westwater Gallery, New York

Galerie Buchmann, St. Gallen, Switzerland. Catalog: *Cucchi.* Text by Armin Wildermuth.

WALTER DAHN

1954 Born Krefeld, West Germany

Member of Mülheimer Freiheit (with Peter Bömmels, Jiři Georg Dokoupil, and others)

Lives in Cologne, West Germany

EXHIBITIONS

1982 Galerie Helen van der Meij, Amsterdam

Galerie Philomene Magers, Bonn (with Jiři Georg Dokoupil)

Galerie Paul Maenz, Cologne

Galerie 't Venster, Rotterdam (with Jiři Georg Dokoupil)

1983 Galerie Paul Maenz, Cologne

Mary Boone Gallery, New York

Galerie Chantal Crousel, Paris

RICHARD DEACON

1949 Born Wales, Great Britain

1968–69 Studied at Somerset College of Art, Taunton, England

1969–72 Studied at St. Martin's School of Art, London

1974–77 Studied at Royal College of Art, London

1977–78 Studied at Chelsea School of Art, London

Lives in London

EXHIBITIONS

1983 Lisson Gallery, London

Orchard Gallery, Londonderry, Northern Ireland

NICOLA DE MARIA

1954 Born Foglianese, Italy

Lives in Turin and Foglianese, Italy

EXHIBITIONS AND CATALOGS

1975 Galleriaforma, Genoa, Italy

1980 Kunsthalle, Basel, May 11–June 22; Museum Folkwang, Essen; and Stedelijk Museum, Amsterdam. Catalog: *Nicola De Maria: Musica-Occhi.*

1981 Lisson Gallery, London

Galerie Annemarie Verna, Zurich

1982 Galleria Mario Diacono, Rome

Galleria Marilena Bonomo, Spoleto, Italy

1983 Kunsthalle, Basel, October 2–November 6. Catalog: *Nicola De Maria: Libertà, Segreta, Segreta.* Text by Jean-Christophe Ammann.

Galerie Karsten Greve, Cologne

Museum Haus Lange, Krefeld, West Germany, February 27–April 24. Catalog: *Nicola De Maria: EE AA Stop Campane.* Krefeld: Kunstmuseum der Stadt, 1983.

Galleria Franco Toselli, Milan

GIANNI DESSÌ

1955 Born Rome

 Lives in Rome

EXHIBITIONS

1980 Galerie Swart, Amsterdam

1982 Galerie Folker Skulima, Berlin

 Galerie Nicole Gonet, Lausanne

 Galleria Ugo Ferranti, Rome

1983 Salvatore Ala Gallery, New York

DAVID DEUTSCH

1943 Born Los Angeles, California

1966 B.A. University of California, Los Angeles

1968 Studied at California Institute of the Arts, Chouinard, California

 Lives in New York

EXHIBITIONS AND CATALOG

1972 Michael Walls Gallery, Los Angeles

1980 Gagosian Nosei-Weber Gallery, New York

1982 Annina Nosei Gallery, New York

1983 Hayden Gallery, Massachusetts Institute of Technology, Cambridge, Massachusetts, October 8–November 13 (with Peter Campus). Catalog: *Peter Campus, Photographs, and David Deutsch, Paintings and Drawings.*

ANTONIO DIAS

1944 Born Paraiba, Brazil

 Lives in Milan, Italy

EXHIBITIONS AND CATALOGS

1962 Galeria Sobradinho, Rio de Janeiro

1965 Galerie Houston-Brown, Paris

1969 Brazilian Government Trade Bureau, New York. Catalog: *Antonio Dias.*

1971 Galleria Breton, Milan. Catalog: *The Tripper.* Text by Ernesto L. Francalanci.

1974 Museu de Arte Moderna, Rio de Janeiro. Catalog: *Antonio Dias.* Text by Ronaldo Brito.

1979 Núcleo de Arte Contemporânea, João Pessoa, Brazil. Catalog: *Antonio Dias.*

1981 Galerie Walter Storms, Villingen, West Germany

1983 Galerie Albert Baronian, Brussels

MONOGRAPHS

 Paulo Sérgio Duarte. *Antonio Dias.* Rio de Janeiro: FUNARTE, 1979.

 Catherine Millet. *Antonio Dias.* Brescia, Italy: Piero Cavellini, 1983.

BOOK BY THE ARTIST

 Some Artists Do, Some Not. Brescia, Italy: Edizioni Nuovi Strumenti, 1974.

MARTIN DISLER

1949 Born Seewen, Switzerland

1973 Traveled to Paris, and Bologna, Italy

1974-75 Traveled to Capri, Italy

1976-77 Traveled in United States with Rolf Winnewisser

1980 Traveled in Italy

 Lives in Zurich, Switzerland; New York; and Harlingen, Netherlands

EXHIBITIONS AND CATALOGS

1971 Kunstzone, Munich

1980 Kunsthalle, Basel, March 16–April 20. Catalog: *Martin Disler: Invasion durch eine Falsche Sprache.* Text by Jean-Christophe Ammann, Martin Disler, and M. Suter.

1981 Württembergischer Kunstverein, Stuttgart. Catalog: *Martin Disler: Die Umgebung der Liebe.* Text by Tilman Osterwold and Dieter Hall.

1982 Galerie Eric Franck, Geneva. Catalog: *Martin Disler: Drawings.*

 Marian Goodman Gallery, New York

 Galerie Chantal Crousel, Paris

 Galerie Konrad Fischer, Zurich

1983 Galerie Van Krimpen, Amsterdam

 Museum für Gegenwartskunst, Basel, and tour. Catalog: *Martin Disler: Zeichnungen 1968–1983, Bücher, und das grosse Bild "Öffnung eines Massengrabs" von 1982.* Text by Marie Hélène Cornips, Bice Curiger, Martin Disler, and Dieter Koepplin.

 Galerie Rolf Ricke, Cologne

 Marian Goodman Gallery, New York

BOOKS BY THE ARTIST

 Bilder vom Maler. Dudweiler, West Germany: AQ-Verlag, 1980.

 Der Zungenkuss. Biel, Switzerland: Galerie Seevorstadt, 1980.

 Schwarzweisse Novelle. Zurich: Edition Elisabeth Kaufmann, 1983.

JIŘI GEORG DOKOUPIL

1954 Born Krnov, Czechoslovakia

 Member of Mülheimer Freiheit (with Peter Bömmels, Walter Dahn, and others)

 Lives in Cologne, West Germany

EXHIBITIONS AND CATALOG

1982 Galerie Philomene Magers, Bonn (with Walter Dahn)

 Galerie Paul Maenz, Cologne

 Galerie 't Venster, Rotterdam (with Walter Dahn)

1983 Produzentengalerie, Hamburg, and tour (with Walter Dahn). Catalog: *Die Duschbilder.*

 Mary Boone Gallery, New York

 Galerie Crousel-Hussenot, Paris

GER VAN ELK

1941 Born Amsterdam, Netherlands

1959–61 Studied at Institut voor Kunstnijverheidsonderwijs, Amsterdam

1961–63 Studied art history at Immaculate Heart College, Los Angeles, California

1965–66 Studied art history at University of Groningen, Groningen, Netherlands

1972 Began teaching at Ateliers '63, Haarlem, Netherlands

 Lives in Amsterdam

EXHIBITIONS AND CATALOGS

1962 Museum Fodor, Amsterdam (with Wim T. Schippers)

 Dilexi Gallery, Los Angeles

1974 Stedelijk Museum, Amsterdam, November 15–January 8, 1975. Catalog: *Ger van Elk.*

1975 The Museum of Modern Art, New York, April 3–May 4.

1977 Badischer Kunstverein, Karlsruhe, West Germany; Rheinisches Landesmuseum, Bonn; and Kunstverein, Braunschweig, West Germany. Catalog: *Ger van Elk: Arbeiten von 1969–1977.* Edited by Michael Schwarz.

1980 Kunsthalle, Basel, October 7–November 9; ARC, Musée d'Art Moderne de la Ville de Paris; and Museum Boymans–van Beuningen, Rotterdam. Catalog: *Ger van Elk.* Edited by Geert van Beijeren.

1981 Marian Goodman Gallery, New York

1982 Galerie Karen & Jean Bernier, Athens

1983 Wadsworth Atheneum, Hartford, Connecticut, November 19–February 12, 1984.

1984 Marian Goodman Gallery, New York

DONALD EVANS

1945 Born Morristown, New Jersey

1965–69 Studied architecture at Cornell University, Ithaca, New York

1972 Traveled to Netherlands

1973 Moved to Netherlands

1977 Died in a fire in Amsterdam, Netherlands

EXHIBITIONS

1972 Galerij Asselijn, Amsterdam

1975 Fischbach Gallery, New York

1980 Neuberger Museum, Purchase, New York, November 9–December 9, and tour.

MONOGRAPH

 Willy Eisenhart. *The World of Donald Evans.* New York: Harlin Quist, 1980.

LUCIANO FABRO

1936 Born Turin, Italy

 Lives in Milan, Italy

EXHIBITIONS AND CATALOGS

1965 Galleria Vismara Arte Contemporanea, Milan

1980 Galleria Christian Stein, Turin

 Salvatore Ala Gallery, New York

1981 Museum Folkwang, Essen, March 27–May 5, and Museum Boymans–van Beuningen, Rotterdam. Catalog: *Luciano Fabro.* Edited by Zdenek Felix.

1983 Loggetta Lombardesca, Ravenna, Italy. Catalog: Jole De Sanna. *Fabro.* Ravenna: Essegi, 1983.

RAFAEL FERRER

1933 Born San Juan, Puerto Rico

1951–52 Studied at Syracuse University, Syracuse, New York

1952–54 Studied at University of Puerto Rico, Mayagüez, Puerto Rico

1967 Taught at Philadelphia College of Art, Philadelphia, Pennsylvania

1977–79 Taught at School of Visual Arts, New York

 Lives in Philadelphia

EXHIBITIONS AND CATALOGS

1964 University of Puerto Rico, Museum of Art, Mayagüez, Puerto Rico

1969 Galerie M. E. Thelen, Cologne

 Castelli Gallery, New York

1971 Institute of Contemporary Art, University of Pennsylvania, Philadelphia, September 25–October 30. Catalog: *Rafael Ferrer: Enclosures.*

1973 Contemporary Arts Center, Cincinnati, Ohio. Catalog: *Deseo: An Adventure.* Essay by Carter Ratcliff.

1974 The Museum of Modern Art, New York, April 22–May 27.

1978 Institute of Contemporary Art, Boston, September 13–October 29. Catalog: *Rafael Ferrer: Recent Work and an Installation.*

1982 Frumkin & Struve Gallery, Chicago

 Nancy Hoffman Gallery, New York

1984 Nancy Hoffman Gallery, New York

RAINER FETTING

1949 Born Wilhelmshaven, West Germany

1969–72 Worked as apprentice carpenter and volunteer set designer

1972–78 Studied at Hochschule der Künste, Berlin, with Hans Jaenisch

1975 Began making films

1977 Cofounder of Galerie am Moritzplatz, Berlin (with Helmut Middendorf, Salomé, and Bernd Zimmer)

1978–79 DAAD Stipend to New York

 Lives in New York

EXHIBITIONS AND CATALOG

1977 Galerie am Moritzplatz, Berlin

1981 Anthony d'Offay Gallery, London

 Mary Boone Gallery, New York

1982 Anthony d'Offay Gallery, London. Catalog: Anne Seymour. *Rainer Fetting.*

1983 Galerie Maier-Hahn, Düsseldorf

R. M. FISCHER

1947 Born New York

1971 B.A. Long Island University, Brookville, New York

1973 M.F.A. San Francisco Art Institute, San Francisco, California

 Lives in New York

EXHIBITIONS AND CATALOG

1979 Artists Space, New York

1980 Art et Industrie Gallery, New York

1981 Contemporary Arts Center, Cincinnati, Ohio, July 31–September 4. Catalog: *R. M. Fischer: Lampworks.*

1982 Texas Gallery, Houston, Texas

 Stefannotti Gallery, New York

1983 Baskerville & Watson Gallery, New York

ERIC FISCHL

1948 Born New York

1972 B.F.A. California Institute of the Arts, Valencia, California

 Lives in New York

EXHIBITIONS AND CATALOGS

1975 Dalhousie Art Gallery, Halifax, Nova Scotia

1980 Edward Thorp Gallery, New York

1981 Emily H. Davis Art Gallery, University of Akron, Akron, Ohio, September 29–October 17, and tour. Catalog: *Eric Fischl: Paintings & Drawings.*

 Sable-Castelli Gallery, Toronto

1982 Edward Thorp Gallery, New York

1983 Sir George Williams Art Galleries, Concordia University, Montreal, March 16–April 9. Catalog: *Eric Fischl: Paintings.* Text by Sandra Paikowsky.

 Multiples, Inc., New York

FISCHLI AND WEISS

PETER FISCHLI
1952	Born Zurich, Switzerland
1975–76	Studied at Accademia di Belle Arti, Urbino, Italy
1976–77	Studied at Accademia di Belle Arti, Bologna, Italy
1979	Began collaboration with David Weiss
	Lives in Zurich

DAVID WEISS
1946	Born Zurich, Switzerland
1963–65	Studied decorative arts in Zurich and Basel, Switzerland
1979	Began collaboration with Peter Fischli
	Lives in Zurich

EXHIBITION
1981	Galerie Stähli, Zurich

BOOK BY THE ARTISTS
Plötzlich diese Übersicht. Zurich: Edition Stähli, 1982.

JOEL FISHER
1947	Born Salem, Ohio
1969	B.A. Kenyon College, Gambier, Ohio
1973–74	DAAD Stipend to Berlin
1979	Taught at Goldsmith's College, University of London, London
1980–82	Taught at Bath Academy of Art, Bath, England
	Lives in New York

EXHIBITIONS AND CATALOGS
1968	Robert Bowen Brown Gallery, Chalmers Library, Gambier, Ohio
1970	Whitney Art Resources Center, New York
1971	Nigel Greenwood Inc. Ltd., London
1976	Max Protetch Gallery, New York
1977	Museum of Modern Art, Oxford, England. Catalog: *Joel Fisher.*
1978	Stedelijk Museum, Amsterdam, April 14–May 28. Catalog: *Joel Fisher.*
1980	New 57 Gallery, Edinburgh. Catalog: *Joel Fisher.*
1982	Nigel Greenwood Inc. Ltd., London (with Alan Saret)

BOOK BY THE ARTIST
[Untitled]. Berlin: Berliner Künstlerprogramm des Deutschen Akademischen Austauschdienstes (DAAD), 1974.

BARRY FLANAGAN
1941	Born Prestatyn, Wales
1964–66	Studied at St. Martin's School of Art, London
1967–71	Taught at St. Martin's School of Art and Central School of Art and Design, London
	Lives in London

EXHIBITIONS AND CATALOGS
1966	Rowan Gallery, London
1969	Museum Haus Lange, Krefeld, West Germany, September 7–October 12. Catalog: *Barry Flanagan: Object Sculptures.* Text by Paul Wember.
	Fischbach Gallery, New York
1974	The Museum of Modern Art, New York, January 18–March 3
1977	Van Abbemuseum, Eindhoven, Netherlands, June 10–July 10, and tour. Catalog: *Barry Flanagan: Sculpture 1966–1976.* Text by Catharine Lampert.

1980	Waddington Galleries, London. Catalog: *Barry Flanagan: Sculptures in Stone, 1973–1979.*
1981	Waddington Galleries, London. Catalog: *Barry Flanagan: Sculptures in Bronze, 1980–1981.*
1982	British Pavilion, Venice Biennale, June 13–September 12; Museum Haus Lange, Krefeld, West Germany; and Whitechapel Art Gallery, London. Catalog: *Barry Flanagan: Sculpture.* London: British Council, 1983. Text by Tim Hilton and Michael Compton.
1983	The Pace Gallery, New York. Catalog: *Barry Flanagan: Recent Sculpture.* Text by Michael Compton.
	Musée National d'Art Moderne, Centre Georges Pompidou, Paris, March 16–May 9. Catalog: *Barry Flanagan: Sculptures.*

ALPHONS FREIJMUTH
1940	Born Haarlem, Netherlands
1963–64	Studied at Rijksakademie, Amsterdam, Netherlands
1974	Began teaching at Akademie voor Kunst en Industrie, Enschede, Netherlands
	Lives in Amsterdam

EXHIBITIONS AND CATALOGS
1965	Galerie 845, Amsterdam
1977	Stedelijk Museum, Amsterdam. Catalog: *Alphons Freijmuth.* Text by Rini Dippel.
1982	Gem. van Reekummuseum, Apeldoorn, Netherlands, January 17–February 14, and tour. Catalog: *Alphons Freijmuth.* Edited by Jerven Ober.

WILLIAM GARBE
1948	Born New York
1964–65	Studied at Art Students League, New York
1970	B.F.A. Pratt Institute, Brooklyn, New York
	Lives in New York

EXHIBITION
1977	Wolfe Street Gallery, Washington, D.C.

JEDD GARET
1955	Born Los Angeles, California
1975–76	Studied at Rhode Island School of Design, Providence, Rhode Island
1977	Studied at School of Visual Arts, New York
	Lives in New York

EXHIBITIONS AND CATALOG
1979	Felicity Samuel Gallery, London
	Robert Miller Gallery, New York
1981	Robert Miller Gallery, New York. Catalog: *Jedd Garet.*
1982	John Berggruen Gallery, San Francisco
1983	Robert Miller Gallery, New York
1984	Stephen Wirtz Gallery, San Francisco

DANA GARRETT
1953	Born Los Angeles, California
	Lives in New York

EXHIBITIONS AND CATALOG
1980	Robert Miller Gallery, New York
1982	Robert Miller Gallery, New York
	San Jose Institute of Contemporary Art, San Jose, California

1983	Nature Morte Gallery, New York (with David Carrino)
	Tracey Garet/Michael Kohn Gallery, New York. Catalog: *Arch Connelly, Dana Garrett, Gustavo Ojeda, Ricardo Regazzoni.* New York: Robert Kohn, 1983.

GENERAL IDEA
1968	Formed by A. A. Bronson, Felix Partz, and Jorge Zontal

A. A. BRONSON
1946	Born Michael Tims in Vancouver, British Columbia, Canada
1964–67	Studied at School of Architecture, University of Manitoba, Winnipeg, Manitoba, Canada
	Lives in Toronto, Ontario, Canada

FELIX PARTZ
1945	Born Ron Gabe in Winnipeg, Ontario, Canada
1963–67	Studied at School of Fine Arts, University of Manitoba
	Lives in Toronto

JORGE ZONTAL
1944	Born Jorge Saia in Parma, Italy
1968	B.Arch. Dalhousie University, Halifax, Nova Scotia, Canada
	Lives in Toronto

EXHIBITIONS
1971	Art Gallery of Ontario, Toronto
	A Space Gallery, Toronto
1976	Galerie Gaetan, Geneva
1981	49th Parallel Gallery, New York
1983	Galerie Stampa, Basel
	Carmen Lamanna Gallery, Toronto

BOOKS BY THE ARTISTS
Luxon V.B.: the 1984 Miss General Idea Pavillion, no. 101, 1973.

S/he: the 1984 Miss General Idea Pageant, no. 102. Toronto: Art Metropole, 1976.

The Getting into the Spirits Cocktail Book: From the 1984 Miss General Idea Pavillion. Toronto: General Idea, 1980.

STEVE GIANAKOS
1938	Born New York
1964	B.I.D. Pratt Institute, Brooklyn, New York
	Lives in New York

EXHIBITIONS
1974	The Clocktower, Institute for Art and Urban Resources, New York
1979	Contemporary Arts Museum, Houston, Texas
	Droll/Kolbert Gallery, New York
1983	Barbara Gladstone Gallery, New York

BOOK BY THE ARTIST
Steve Gianakos. Calais, Vermont: Z Press, 1981.

PATRICE GIORDA
1952	Born Lyons, France
1973–78	Studied at École des Beaux-Arts, Lyons
	Lives in Florence, Italy, and Lyons

EXHIBITIONS
1980	Galerie L'Oeil Écoute, Lyons
1983	Galerie Jean-Yves Noblet, Grenoble, France

JACK GOLDSTEIN
1945	Born Montreal, Quebec, Canada
1970	B.F.A. Chouinard Art Institute, Los Angeles, California
1972	M.F.A. California Institute of the Arts, Valencia, California
	Lives in New York

EXHIBITIONS
1971	Nigel Greenwood Inc. Ltd., London
1980	The Kitchen, New York
	Metro Pictures, New York
1982	Galerie Albert Baronian, Brussels
1983	Lisson Gallery, London
	Galerie Schellmann & Klüser, Munich
	Metro Pictures, New York

BOOK BY THE ARTIST
The Mystic Lamb. Geneva: Centre d'Art Contemporain, 1982. Text by Fulvio Salvadori.

ANTONY GORMLEY
1950	Born London
1968–70	Studied at Trinity College, Cambridge, England
1973–74	Studied at Central College of Art and Design, London
1975–77	Studied at Goldsmith's College, University of London, London
1977–79	Studied at Slade School of Art, London
	Lives in London

EXHIBITIONS AND CATALOG
1981	Whitechapel Art Gallery, London, March 26–April 12. Catalog: Jenni Lomax. *Antony Gormley: Sculpture.*
1983	Coracle Press, London

TONI GRAND
1935	Born Gallargues, France
	Lives in Mouriès, France

EXHIBITIONS AND CATALOGS
1974	Galerie Eric Fabre, Paris
1976	Galerie Eric Fabre, Paris. Catalog: *Toni Grand.* Paris: Edition Eric Fabre, 1976.
1979	Musée Savoisien, Chambéry, France, December–February 1980. Catalog: *Toni Grand: Sculptures 1976–1979.* Text by Bernard Ceysson and Yves Michaud.
1981	Salles Romanes du Cloître St. Trophime, Arles, France, July–September. Catalog: *Toni Grand.*
1982	French Pavilion, Venice Biennale, June 13–September 12. Catalog: *Toni Grand.* Paris: Association Française d'Action Artistique, 1982. Text by Didier Semin.
1983	ARCA, Marseille, France
	Musée Sainte-Croix, Poitiers, France, June–August. Catalog: *Toni Grand: Sculptures 1982–1983.*

JENE HIGHSTEIN
1942	Born Baltimore, Maryland
1969	B.A. (aesthetic philosophy) University of Maryland, College Park, Maryland
1963–65	Studied at The University of Chicago, Chicago, Illinois
1965–66	Studied at New York Studio School, New York
1970	Studied at Royal Academy Schools, London, received postgraduate degree in art
1973	Taught at University of Illinois, Chicago, Illinois

1974 Taught at School of Visual Arts, New York

Lives in New York

EXHIBITIONS AND CATALOG
1970 Lisson Gallery, London
1973 City College Graduate Center, New York
1978 Musée d'Art et d'Industrie, St.-Étienne, France. Catalog: *Jene Highstein.*
1981 Ace Gallery, Venice, California
1982 Oscarsson Hood Gallery, New York
1983 Fort Worth Art Museum, Fort Worth, Texas

South Campus Art Gallery, Miami-Dade Community College, Miami, Florida

Oscarsson Hood Gallery, New York

MONOGRAPH
Corinna Ferrari. *Jene Highstein: Five Black Cement Sculptures.* Milan: Salvatore Ala Editions, 1977.

HOWARD HODGKIN
1932 Born London
1949–50 Studied at Camberwell School of Art, London
1950–54 Studied at Bath Academy of Art, Bath, England
1954–72 Taught at Bath Academy of Art, and Chelsea School of Art, London
1976 Artist-in-residence, Brasenose College, Oxford, England

Lives in London and Wiltshire, England

EXHIBITIONS AND CATALOGS
1962 Arthur Tooth & Sons Gallery, London
1973 Kornblee Gallery, New York
1976 Museum of Modern Art, Oxford, England, March 14–April 18, and tour. Catalog: *Howard Hodgkin: Forty-five Paintings, 1949–1975.* London: Arts Council of Great Britain, 1976. Text by Richard Morphet.
1981 M. Knoedler & Co., New York. Catalog: *Howard Hodgkin.* Text by Lawrence Gowing.
1982 The Tate Gallery, London, September 22–November 7. Catalog: Michael Compton. *Howard Hodgkin's Indian Leaves.*

Jacobson Hochman Gallery, New York

M. Knoedler & Co., New York

Petersburg Press, New York

BOOK BY THE ARTIST
Indian Leaves. London and New York: Petersburg Press, 1982. With text by Bruce Chatwin.

K. H. HÖDICKE
1938 Born Nürnberg, Germany
1959 Studied at Hochschule der Künste, Berlin
1966 Traveled to New York
1968 Villa Massimo Prize, Rome
1974 Professor at Hochschule der Künste

Lives in Berlin

EXHIBITIONS AND CATALOG
1964 Galerie Grossgörschen 35, Berlin
1965 Galerie René Block, Berlin
1976 René Block Gallery, New York
1977 Badischer Kunstverein, Karlsruhe, West Germany, January 19–February 27. Catalog: *K. H. Hödicke.* Edited by René Block and Michael Schwarz.
1982 L.A. Louver Gallery, Venice, California

1983 Galerie Folker Skulima, Berlin

Annina Nosei Gallery, New York

MONOGRAPH
K. H. Hödicke: Standbilder, 1980–1982. Berlin: Galerie Folker Skulima, 1982. Text by Ulrich Krempel.

BOOK BY THE ARTIST
Kalenderblätter: Aufzeichnungen, 1969–79. Berlin: Rainer Verlag, 1980.

HANS VAN HOEK
1947 Born Deurne, Netherlands
1960–62 Trained as housepainter
1962–69 Studied at Koninklijke Academie voor Kunst en Vormgeving, s'-Hertogenbosch, Netherlands
1969–71 Studied at Ateliers '63, Haarlem, Netherlands
1971–77 Lived in Montreal, Quebec, Canada

Lives in Liessel, Netherlands

EXHIBITIONS AND CATALOG
1974 Galerie Véhicule, Montreal (with Jan Andriesse)
1977 Stedelijk Museum, Amsterdam, September 23–November 6. Catalog: *Hans van Hoek: Schilderijen 1974–1976, Paintings, 1974–1976.*
1982 Galerij Wild & Hardebeck, Amsterdam

BRYAN HUNT
1947 Born Terre Haute, Indiana
1971 B.F.A. Otis Art Institute, Los Angeles, California
1972 Independent Study Program, Whitney Museum of American Art, New York

Lives in New York

EXHIBITIONS AND CATALOGS
1974 Jack Glenn Gallery, Corona del Mar, California

The Clocktower, Institute for Art and Urban Resources, New York
1975 Palais des Beaux-Arts, Brussels
1981 Blum Helman Gallery, New York
1982 Daniel Weinberg Gallery, San Francisco
1983 Amerika Haus, Berlin. Catalog: *Bryan Hunt.* Text by Barbara Haskell.

University Art Museum, California State University, Long Beach, California, November 15–December 11. Catalog: *Bryan Hunt: A Decade of Drawings.* Edited by Constance W. Glenn and Jane K. Bledsoe.

Blum Helman Gallery, New York, and tour. Catalog: *Bryan Hunt.* Text by Carter Ratcliff.

BOOK BY THE ARTIST
Conversations with Nature. New York: The Museum of Modern Art, 1982.

JÖRG IMMENDORFF
1945 Born Bleckede, near Lüneburg, Germany
1963–64 Studied stage-set design at Kunstakademie, Düsseldorf, West Germany, with Theo Otto
1964 Attended class of Joseph Beuys at Kunstakademie, Düsseldorf
1977 May 1, met Ralf Winkler (A. R. Penck) in East Berlin
1981 Guest professor at Konsthogskolan, Stockholm

Lives in Düsseldorf

EXHIBITIONS AND CATALOGS
1961 New-Orleans-Club, Bonn
1973 Westfälischer Kunstverein, Münster, West Germany
1980 Kunsthalle, Bern, August 15–September 21. Catalog: *Jörg Immendorff: Malermut Rundum.* Edited by Marianne Schmidt and Johannes Gachnang.
1981 Galerie Neuendorf, Hamburg. Catalog: *Jörg Immendorff: Teilbau.*
1982 Galerie Michael Werner, Cologne. Catalog: *Jörg Immendorff: Kein Licht für Wen?*

Galerie Hans Strelow, Düsseldorf

Galerie Fred Jahn, Munich. Catalog: *Jörg Immendorff: Grüsse von der Nordfront: Bilder und Gouachen 1981.*

Kunsthalle, Düsseldorf, March 27–May 9. Catalog: *Jörg Immendorff: Café Deutschland, Adlerhälfte.* Edited by Ulrich Krempel.

Sonnabend Gallery, New York

Galerie Daniel Templon, Paris
1983 Van Abbemuseum, Eindhoven, Netherlands

Nigel Greenwood Inc. Ltd., London

Galerie Daniel Templon, Paris

Galerie Gillespie-Laage-Salomon, Paris

Kunsthaus, Zurich, November 19–January 22, 1984. Catalog: *Immendorff.* Text by Johannes Gachnang, Toni Stooss, and Harald Szeemann.
1984 Mary Boone Gallery, New York

Galerie Ascan Crone, Hamburg. Catalog: *Immendorff: Neue Bilder und Skulpturen.* Text by Erich Fried and Peter Schneider.

BOOKS BY THE ARTIST
Hier und Jetzt: Das Tun, Was zu Tun Ist. Cologne: Verlag Gebr. König, 1973.

Immendorff besucht Y. Munich: Rogner & Bernhard, 1979 (with A. R. Penck).

LIDL, 1966–1970. Eindhoven, Netherlands: Van Abbemuseum, 1981.

Brandenburger Tor, Weltfrage (Brandenburg Gate Universal Question). New York: The Museum of Modern Art, 1982. With a poem by A. R. Penck.

MARK INNERST
1957 Born York, Pennsylvania
1980 B.F.A. Kutztown State College, Kutztown, Pennsylvania
1981 Worked on fabrication of sculpture by Walter De Maria
1981–83 Assistant to Robert Longo

Lives in New York

EXHIBITION
1982 The Kitchen, New York

OLIVER JACKSON
1935 Born St. Louis, Missouri
1958 B.F.A. Illinois Wesleyan University, Bloomington, Illinois
1963 M.F.A. University of Iowa, Iowa City, Iowa
1964–67 Taught at St. Louis Community College, St. Louis
1967–69 Taught at Washington University, St. Louis
1969–70 Taught at Oberlin College, Oberlin, Ohio
1971 Taught at California State College, Sacramento, California

1979 Visiting artist, School of The Art Institute of Chicago, Chicago, Illinois

Lives in Oakland, California

EXHIBITIONS AND CATALOGS
1964 Downstairs Gallery, St. Louis, Missouri
1980 Allan Stone Gallery, New York

Southeastern Center for Contemporary Art, Winston-Salem, North Carolina, October 18–November 23. Catalog: *Oliver Lee Jackson.* Text by Regina Hackett.
1982 Kirk deGooyer Gallery, Los Angeles

Seattle Art Museum, Seattle, Washington. Catalog: *Oliver Jackson.* Text by Thomas Albright.

YVONNE JACQUETTE
1934 Born Pittsburgh, Pennsylvania
1952–56 Studied at Rhode Island School of Design, Providence, Rhode Island
1972 Taught at Moore College of Art, Philadelphia, Pennsylvania
1972–75 Taught at Graduate School of Fine Arts, University of Pennsylvania, Philadelphia
1974 Taught at Tyler School of Art, Philadelphia, and Brooklyn Museum School, Brooklyn, New York
1974–78 Taught at Parsons School of Design, New York
1979–82 Taught at Graduate School of Fine Arts, University of Pennsylvania

Lives in New York and Maine

EXHIBITIONS AND CATALOG
1965 Swarthmore College, Swarthmore, Pennsylvania
1971 Fischbach Gallery, New York
1976 Brooke Alexander, Inc., New York. Catalog: *Yvonne Jacquette: Paintings Monotypes & Drawings.* Text by Carter Ratcliff.
1983 Brooke Alexander, Inc., New York

NEIL JENNEY
1945 Born Torrington, Connecticut
1964–66 Studied at Massachusetts College of Art, Boston, Massachusetts

Lives in New York

EXHIBITIONS AND CATALOG
1968 Galerie Rudolf Zwirner, Cologne
1970 David Whitney Gallery, New York

Noah Goldowsky Gallery, New York
1981 University Art Museum, University of California, Berkeley, California, April 15–May 31, and tour. Catalog: *Neil Jenney: Paintings and Sculpture, 1967–1980.* Text by Mark Rosenthal.

BILL JENSEN
1945 Born Minneapolis, Minnesota
1968 B.F.A. University of Minnesota, Minneapolis
1970 M.F.A. University of Minnesota

Lives in New York

EXHIBITIONS
1973 Fischbach Gallery, New York
1982 Washburn Gallery, New York

ROBERTO JUAREZ

1952 Born Chicago, Illinois

B.F.A. San Francisco Art Institute, San Francisco, California

1978–79 Graduate studies at University of California, Los Angeles, California

Lives in New York

EXHIBITIONS AND CATALOG

1977 San Francisco Art Institute, San Francisco

1981 Robert Miller Gallery, New York

1983 Robert Miller Gallery, New York. Catalog: Duncan Smith. *Roberto Juarez: Spirit and Form.*

Mira Godard Gallery, Toronto

1984 Betsy Rosenfield Gallery, Chicago

ANISH KAPOOR

1954 Born Bombay, India

1973–77 Studied at Hornsea School of Art, London

1977–78 Studied at Chelsea School of Art, London

1979–82 Taught at The Polytechnic, Wolverhampton, England

1982 Artist-in-residence, Walker Art Gallery, Liverpool, England

Lives in London

EXHIBITIONS AND CATALOG

1980 Galerie Patrice Alexandre, Paris

1982 Lisson Gallery, London

1983 Walker Art Gallery, Liverpool, England, and Le Nouveau Musée, Lyons. Catalog: Marco Livingstone. *Anish Kapoor: Feeling into Form, Le Sentiment de la Forme, La Forme du Sentiment.*

Lisson Gallery, London

Galerie 't Venster, Rotterdam

MEL KENDRICK

1949 Born Boston, Massachusetts

1971 B.A. Trinity College, Hartford, Connecticut

1973 M.A. Hunter College, New York

Lives in New York

EXHIBITIONS

1974 Artists Space, New York

1979 P.S. 1 (Project Studios One), Long Island City, New York

1980 John Weber Gallery, New York

1982 Carol Taylor Art, Dallas, Texas

1983 John Weber Gallery, New York

JON KESSLER

1957 Born Yonkers, New York

1980 B.F.A. State University of New York, Purchase, New York; participated in Independent Study Program, Whitney Museum of American Art, New York

Lives in New York

EXHIBITIONS

1983 Artists Space, New York

White Columns Gallery, New York

ANSELM KIEFER

1945 Born Donaueschingen, Germany

1965 Began studies in law and French

1966–68 Studied at Akademie der Bildenden Künste, Freiburg, West Germany, with Peter Dreher

1969 Studied at Akademie der Bildenden Künste, Karlsruhe, West Germany, with Horst Antes

1970–72 Studied at Kunstakademie, Düsseldorf, West Germany, with Joseph Beuys

Lives in Hornbach, Odenwald, West Germany

EXHIBITIONS AND CATALOGS

1969 Galerie am Kaiserplatz, Karlsruhe, West Germany

1978 Kunsthalle, Bern, October 7– November 19. *Anselm Kiefer: Bilder und Bücher.* Edited by Marianne Schmidt-Miescher and Johannes Gachnang.

1979 Van Abbemuseum, Eindhoven, Netherlands, November 19–December 10. Catalog: *Anselm Kiefer.* Text by R. H. Fuchs.

1980 Württembergischer Kunstverein, Stuttgart, September 18–October 26. Catalog: *Anselm Kiefer.* Text by Tilman Osterwold.

West German Pavilion, Venice Biennale (with Georg Baselitz). Catalog: *Anselm Kiefer: Verbrennen-Verholzen-Versenken-Versanden.* Text by R. H. Fuchs.

1981 Museum Folkwang, Essen, October 30–December 6, and Whitechapel Art Gallery, London. Catalog: *Anselm Kiefer.* Edited by Zdenek Felix.

Kunstverein, Freiburg, West Germany, September 18–October 18. Catalog: *Anselm Kiefer: Aquarelle 1970–1980.* Text by R. H. Fuchs.

Marian Goodman Gallery, New York

1982 Marian Goodman Gallery, New York

Mary Boone Gallery, New York

1983 Anthony d'Offay Gallery and Helen van der Meij, London

Maximilian Verlag, Munich

1984 Kunsthalle, Düsseldorf, March 24– May 5, and tour. Catalog: *Anselm Kiefer.* Text by Suzanne Pagé and Jürgen Harten.

BOOK BY THE ARTIST

Hoffmann von Fallersleben auf Helgoland. Groningen, Netherlands: Groninger Museum, 1980.

PER KIRKEBY

1938 Born Copenhagen, Denmark

1957 Began study of natural history at University of Copenhagen, Copenhagen

1964 Finished study of natural history, with concentration in arctic quaternary geology

1982 DAAD Stipend to Berlin

Lives in Copenhagen and Laesø, Denmark, and Karlsruhe, West Germany

EXHIBITIONS AND CATALOGS

1974 Hoved-Bibliotek, Copenhagen

1977 Museum Folkwang, Essen, August 26– October 2. Catalog: *Per Kirkeby: Fliegende Blätter.* Text by Zdenek Felix and Troels Andersen.

1979 Kunsthalle, Bern, April 27–June 4. Catalog: *Per Kirkeby.* Edited by Marianne Schmidt-Miescher and Johannes Gachnang.

1981 Museum Ordrupgaardsamlingen, Copenhagen, April 10–May 10. Catalog: *Per Kirkeby.*

1982 Galerie Michael Werner, Cologne

Van Abbemuseum, Eindhoven, Netherlands, October 29–December 6. Catalog: *Per Kirkeby.* Text by R. H. Fuchs, Johannes Gachnang, and Per Kirkeby.

Galerie Ascan Crone, Hamburg

Nigel Greenwood Inc. Ltd., London

Galerie Fred Jahn, Munich

1983 DAAD Galerie, Berlin. Catalog: *Per Kirkeby: Zeichnungen 1964–1982.* Text by Johannes Gachnang.

Galerie Springer, Berlin. Catalog: *Per Kirkeby: Bilder aus der Berliner Zeit 1982.*

Galerie Rudolf Zwirner, Cologne

Galerie Ascan Crone, Hamburg

Galerie Gillespie-Laage-Salomon, Paris

BOOK BY THE ARTIST

Selected Essays from Bravura. Eindhoven, Netherlands: Van Abbemuseum, 1982.

BERND KOBERLING

1938 Born Berlin

1955–68 Worked as a cook

1958–60 Studied at Hochschule der Künste, Berlin

1961–63 Lived in England

1969–70 Villa Massimo Prize, Rome

1970–74 Lived in Cologne, West Germany

1976–81 Guest lecturer at Hamburg, Düsseldorf, and Berlin

1981 Professor at Hochschule für Bildende Künste, Hamburg, West Germany

Lives in Berlin

EXHIBITIONS AND CATALOGS

1965 Galerie Grossgörschen 35, Berlin

1966 Galerie René Block, Berlin

1978 Haus am Waldsee, Berlin, February 17– April 9, and Städtisches Museum, Leverkusen, West Germany. Catalog: *Bernd Koberling: Malerei 1962–77.* Edited by Thomas Kempas.

1981 Nigel Greenwood Inc. Ltd., London

1982 Reinhard Onnasch Ausstellungen, Berlin. Catalog: *Bernd Koberling: Inseln.* Text by Ilona Lindenberg.

Annina Nosei Gallery, New York

1983 Galerie Gmyrek, Düsseldorf. Catalog: *Bernd Koberling: Moderne Peripherie.* Text by Jeannot Simmen.

Galleria Chisel, Genoa, Italy

Galerie Ascan Crone, Hamburg. Catalog: *Bernd Koberling: Bilder 1980–1983.* Text by Armin Wildermuth.

KOMAR AND MELAMID

VITALY KOMAR

1943 Born Moscow, Soviet Union

1956–58 Art school

1967 Graduated from Stroganov Institute for Art and Design

1977 Moved to Tel-Aviv, Israel

Lives in New York

ALEXANDER MELAMID

1945 Born Moscow, Soviet Union

1958–60 Art school

1967 Graduated from Stroganov Institute for Art and Design

1977 Moved to Tel-Aviv, Israel

Lives in New York

EXHIBITIONS

1976 Ronald Feldman Fine Arts, New York

1978 Wadsworth Atheneum, Hartford, Connecticut

1980 Edwin A. Ulrich Museum of Art, Wichita, Kansas

1982 Ronald Feldman Fine Arts, New York

1983 Portland Center for Visual Arts, Portland, Oregon

Anderson Gallery, Virginia Commonwealth University, Richmond, Virginia

1984 Ronald Feldman Fine Arts, New York

MONOGRAPH

Komar/Melamid: Two Soviet Dissident Artists. Carbondale, Illinois: Southern Illinois University Press, 1979. Edited by Melvyn Nathanson.

ROBERT KUSHNER

1949 Born Pasadena, California

B.A. University of California, San Diego, California

Lives in New York

EXHIBITIONS AND CATALOG

1971 Art Gallery, University of California, San Diego, California

1975 Rasdall Gallery, University of Kentucky, Lexington, Kentucky

Holly Solomon Gallery, New York

1978 Mayor Gallery, London

1979 Holly Solomon Gallery, New York (2 shows)

1981 Holly Solomon Gallery, New York. Catalog: *Dreams and Visions.* Essay by Richard Armstrong.

1982 University of Colorado Art Galleries, Boulder, Colorado

Holly Solomon Gallery, New York

1983 Holly Solomon Gallery, New York

BOOKS BY THE ARTIST

The New York Hat Line. New York: Bozeaux of London Press, 1979. Text by Ed Friedman; photography and design by Katherine Landman.

The Persian Poems. New York, Bozeaux of London Press, 1980. With Kathy Acker.

CHERYL LAEMMLE

1947 Born Minneapolis, Minnesota

1974 B.A. Humboldt State University, Arcata, California

1978 M.F.A. Washington State University, Pullman, Washington

Lives in New York

EXHIBITIONS

1977 Manolides Gallery, Seattle, Washington

1980 P.S. 1 (Project Studios One), Long Island City, New York

1982 Texas Gallery, Houston, Texas

1983 Barbara Toll Fine Arts, New York

BERTRAND LAVIER

1949 Born Châtillion-sur-Seine, France

1968–72 Studied at École Nationale Superieure d'Horticulture, Versailles, France

Lives in Paris and Aignay-le-Duc, France

EXHIBITIONS AND CATALOG

1973 Galerie Lara Vincy, Paris

1977 Fine Arts Building, New York

1982 Galerie Média, Neuchâtel, Switzerland

1983 Galerie Michèle Lachowsky, Antwerp, Belgium

Au Fond de la Cour à Droite, Chagny, France

Lisson Gallery, London

Galleria Massimo Minini, Milan

Galerie Liliane et Michel Durand-Dessert, Paris

Le Nouveau Musée, Villeurbanne/Lyons, France, September 29–November 27, and Kunsthalle, Bern. Catalog: *Bertrand Lavier.* Text by Xavier Douroux and Franck Gautherot.

CHRISTOPHER LeBRUN
1951 Born Portsmouth, England
1970–74 Studied at Slade School of Art, London
1974–75 Studied at Chelsea School of Art, London
1975 Lecturer at Brighton Polytechnic, Brighton, England

Lives in London

EXHIBITIONS
1980 Nigel Greenwood Inc. Ltd., London
1981 Galerie Gillespie-Laage-Salomon, Paris
1982 Nigel Greenwood Inc. Ltd., London
1983 Sperone Westwater Gallery, New York

JEAN LE GAC
1936 Born Alès, France
1954–58 Studied art in Paris; certified as professor of drawing
1958 Began teaching; taught in several art schools in Paris

Lives in Paris

EXHIBITIONS AND CATALOGS
1970 Galerie Daniel Templon, Paris
1973 Museum of Modern Art, Oxford, England, June 2–July 1.
1974 John Gibson Gallery, New York
1978 Musée National d'Art Moderne, Centre Georges Pompidou, Paris, January 11–February 27. Catalog: *Jean Le Gac: Le Peintre, Exposition Romancée.* Text by Günter Metken.
1982 Hal Bromm Gallery, New York (with John Mendelsohn)

Galerie Catherine Issert, St. Paul de Vence, France

Musée de Toulon, Toulon, France, December 2–January 9, 1983. Catalog: Marie-Claude Beaud, Brigitte Burgard, and Jean Le Gac. *Le Déclassement du Peinture, Jean Le Gac.*
1983 Galerie Daniel Templon, Paris
BOOK BY THE ARTIST
Imitation of Jean Le Gac. Oxford, England: Museum of Modern Art, 1973.

ROBERT LONGO
1953 Born Brooklyn, New York
1972 B.F.A. State University of New York, Buffalo, New York

Lives in New York

EXHIBITIONS
1979 Kitchen Center, New York
1983 Galerie Schellmann & Klüser, Munich

Brooke Alexander, Inc., New York

Leo Castelli Gallery, New York

Metro Pictures, New York

NINO LONGOBARDI
1953 Born Naples, Italy

Lives in Naples

EXHIBITIONS AND CATALOGS
1978 Studio Gianni Pisani, Naples
1982 Galleria Lucio Amelio, Naples

Galerie Fernando Vijande, Madrid. Catalog: *Nino Longobardi.* Text by Achille Bonito Oliva.

Galerie Art in Progress, Munich

Galleria Il Ponte, Rome. Catalog: *Nino Longobardi: Opere su Carta.*
1983 Institute of Contemporary Art, Boston

Galleriet, Lund, Sweden

Kunstmuseum, Lucerne, February 20–April 24. Catalog: *Nino Longobardi.* Edited by Martin Kunz.

Charles Cowles Gallery, New York

MARKUS LÜPERTZ
1941 Born Reichenberg, Bohemia (now Liberec, Czechoslovakia)
1956–61 Studied at Werkkunstschule, Krefeld, West Germany, with Laurens Goosens. Spent one year at Maria Laach Monastery; worked in coal fields and for the department of roads. Additional studies at Krefeld and the Kunstakademie, Düsseldorf, West Germany
1963 Moved to Berlin
1970 Stipend to Villa Romana, Florence, Italy
1974 Began teaching at Akademie der Bildenden Künste, Karlsruhe, West Germany

Lives in Berlin, Karlsruhe, and Milan, Italy

EXHIBITIONS AND CATALOGS
1964 Galerie Grossgörschen 35, Berlin
1973 Staatliche Kunsthalle, Baden-Baden, West Germany. Catalog: *Markus Lüpertz: Bilder, Gouachen und Zeichnungen, 1967–1973; Eine Festschrift.* Text by Klaus Gallwitz and George Tabori.
1976 Galerie Rudolf Zwirner, Cologne. Catalog: *Markus Lüpertz: Bilder 1972–1976.* Text by Reiner Speck.
1977 Kunsthalle, Bern, August 20–September 25. Catalog: *Markus Lüpertz: Dithyrambische und Stil-Malerei.* Text by Theo Kneubühler.

Van Abbemuseum, Eindhoven, Netherlands, November. Catalog: *Markus Lüpertz.* Text by R. H. Fuchs.

Kunsthalle, Hamburg. Catalog: *Markus Lüpertz.* Text by Werner Hofmann and Siegmar Holsten.
1979 Josef-Haubrich-Kunsthalle, Cologne. Catalog: *Markus Lüpertz: Gemälde und Handzeichnungen, 1964 bis 1979.* Text by Siegfried Gohr.

Whitechapel Art Gallery, London, September 21–October 28. Catalog: *Markus Lüpertz: 'Stil' Paintings, 1977–79.* Text by Siegfried Gohr.
1981 Waddington Galleries, London. Catalog: *Markus Lüpertz.* Text by Tony Godfrey.

Galerie Fred Jahn, Munich

Marian Goodman Gallery, New York
1982 Richard Onnasch Ausstellungen, Berlin. Catalog: *Markus Lüpertz: Grüne Bilder.* Edited by Rosewith Braig.

Galerie Michael Werner, Cologne. Catalog: *Markus Lüpertz: Acht Plastiken.* Text by Jiri Svestka.

Marian Goodman Gallery, New York

Galerie Gillespie-Laage-Salomon, Paris
1983 Van Abbemuseum, Eindhoven, Netherlands, January 21–March 6. Catalog: *Markus Lüpertz: Hölderlin.* Text by R. H. Fuchs, Johannes Gachnang, and Siegfried Gohr.

Kestner-Gesellschaft, Hannover. Catalog: *Markus Lüpertz: Bilder 1970–1983.* Edited by Carl Haenlein.

Waddington Galleries, London

Marian Goodman Gallery, New York

Galerie Maeght, Zurich
1984 Waddington Galleries, London. Catalog: *Markus Lüpertz: Sculptures in Bronze.*

KIM MacCONNEL
1946 Born Oklahoma City, Oklahoma
1969 B.A. University of California, San Diego, California
1972 M.F.A. University of California, San Diego

Lives in Encinitas, California

EXHIBITIONS AND CATALOG
1975 Holly Solomon Gallery, New York
1976 La Jolla Museum of Contemporary Art, La Jolla, California, March 19–May 2. Catalog: *Kim MacConnel.* Text by Richard Armstrong.
1978 Galerie Bruno Bischofberger, Zurich
1980 Holly Solomon Gallery, New York (2 shows)
1981 Mayor Gallery, London
1982 Texas Gallery, Houston, Texas

Holly Solomon Gallery, New York, and James Corcoran Gallery, Los Angeles

RORY McEWEN
1932 Born Marchmont, Berwickshire, Scotland
1952–55 Studied at Trinity College, Cambridge, England
1982 Died in London
EXHIBITIONS
1966 Douglas & Foulis Gallery, Edinburgh
1967 Byron Gallery, New York
1982 Staempfli Gallery, New York

BRUCE McLEAN
1942 Born Glasgow, Scotland
1961–63 Studied at Glasgow School of Art, Glasgow
1963–66 Studied at St. Martin's School of Art, London
1981 DAAD Stipend to Berlin

Lives in London

EXHIBITIONS AND CATALOGS
1969 Galerie Konrad Fischer, Düsseldorf
1970 Gallery, Nova Scotia College of Art, Halifax, Nova Scotia
1972 The Tate Gallery, London. Catalog: *Bruce McLean: Retrospective.* London: Situation Publications, 1972.
1978 The Kitchen, New York (with Rosy McLean)
1981 Kunsthalle, Basel; Whitechapel Art Gallery, London; and Van Abbemuseum, Eindhoven, Netherlands. Catalog: Nena Dimitrijević. *Bruce McLean.*

Anthony d'Offay Gallery, London

Musée d'Art et d'Industrie, St.-Étienne, France, January 23–March 8. Catalog: *Bruce McLean.*
1982 Mary Boone Gallery, New York
1983 Galerie Maier-Hahn, Düsseldorf

Whitechapel Art Gallery, London, and DAAD Galerie, Berlin. Catalog: *Bruce McLean: Berlin/London.* Edited by Mark Francis.

Galerie Dany Keller, Munich. Catalog: *Bruce McLean.*

Galerie Chantal Crousel, Paris

CARLO MARIA MARIANI
1931 Born Rome
1951 Finished studies at Accademia di Belle Arti, Rome
1958–60 Lived in Copenhagen, Denmark

Lives in Rome

EXHIBITIONS AND CATALOGS
1975 Studio d'Arte Cannaviello, Rome
1977 Galleria Gian Enzo Sperone, Rome. Catalog: *Carlo M. Mariani: "Io non Sono un Pittore, Io non Sono l'Artista, Io Sono l'Opus."* Rome: Bulzoni Editore, 1977.
1980 Galleria Gian Enzo Sperone, Turin. Catalog: *Carlo Maria Mariani.*
1981 Sperone Westwater Fischer Gallery, New York
1982 Galleria Mario Diacono, Rome
1983 Galleria Mario Diacono, Rome
1984 Sperone Westwater Gallery, New York
MONOGRAPH
Italo Musso. *Carlo Maria Mariani, Pictor Philosophus.* Rome: De Luca Editore, 1980.

HELMUT MIDDENDORF
1953 Born Dinklage, West Germany
1971–79 Studied at the Hochschule der Künste, Berlin, with K. H. Hödicke; involved with experimental film
1977 Cofounder of Galerie am Moritzplatz (with Rainer Fetting, Salomé, and Bernd Zimmer)
1980 DAAD Stipend to New York

Lives in Berlin

EXHIBITIONS AND CATALOGS
1977 Galerie am Moritzplatz, Berlin
1981 Mary Boone Gallery, New York (with Rainer Fetting)
1983 Staatliche Kunsthalle, Baden-Baden, West Germany. Catalog: *Helmut Middendorf: Die Umarmung der Nacht, Wandmalerei.* Text by Katharina Schmidt.

Galerie Folker Skulima, Berlin

Galerie Gmyrek, Düsseldorf

Groninger Museum, Groningen, Netherlands, and Kunsthalle, Düsseldorf. Catalog: *Helmut Middendorf.* St. Gallen, Switzerland: Galerie & Edition Buchmann, 1982.

Galerie Munro, Hamburg

Bonlow Gallery, New York
1984 Kunstverein, Braunschweig, West Germany, February 10–April 15. Catalog: *Helmut Middendorf.* Text by Heinrich Klotz. Düsseldorf: Galerie Gmyrek, 1984.

MALCOLM MORLEY

1931 Born London

1952–56 Studied at Camberwell School of Art, London

1954–57 Studied at Royal College of Art, London

1958 Began living in New York

1965–66 Instructor at Ohio State University, Columbus, Ohio

1967–74 Instructor at School of Visual Arts, New York, and State University of New York, Stonybrook, New York

1977–79 Lived in Florida

1977 DAAD Stipend to Berlin

Lives in New York

EXHIBITIONS AND CATALOG

1957 Kornblee Gallery, New York

1972 Galleri Östergren, Malmö, Sweden

1976 The Clocktower, Institute for Art and Urban Resources, New York

1979 Nancy Hoffman Gallery, New York

1981 Xavier Fourcade, Inc., New York

1982 Xavier Fourcade, Inc., New York

1983 Whitechapel Art Gallery, London, June 22–August 21, and tour. Catalog: *Malcolm Morley: Paintings, 1965–82*. Text by Michael Compton.

1984 Xavier Fourcade, Inc., New York

ROBERT MOSKOWITZ

1935 Born New York, New York

1957 Studied at Pratt Institute, Brooklyn, New York, with Adolph Gottlieb and Robert Richenburg

Lives in New York

EXHIBITIONS AND CATALOGS

1962 Leo Castelli Gallery, New York

1971 Hayden Gallery, Massachusetts Institute of Technology, Cambridge, Massachusetts, March 13–April 10. Catalog: *Robert Moskowitz: Recent Paintings*. Text by Judith Wechsler.

1977 The Clocktower, Institute for Art and Urban Resources, New York

1981 Kunsthalle, Basel, October 3–November 15, and Frankfurter Kunstverein, Frankfurt am Main. Catalog: *Robert Moskowitz*. Essays by Peter Blum and Michael Hurson.

1981 Walker Art Center, Minneapolis, Minnesota, March 22–May 10, and Hudson River Museum, Yonkers, New York

1983 Blum Helman Gallery, New York. Catalog: *Robert Moskowitz*. Text by Robert Rosenblum.

ELIZABETH MURRAY

1940 Born Chicago, Illinois

1962 B.F.A. The Art Institute of Chicago, Chicago

1964 M.F.A. Mills College, Oakland, California

1974, '76 Taught at Bard College, Annandale-on-Hudson, New York

1977 Taught at Princeton University, Princeton, New Jersey

1978–79 Taught at Yale University, New Haven, Connecticut

Lives in New York

EXHIBITIONS

1974 Jacob's Ladder Gallery, Washington, D.C. (with Joseph Zucker)

1975 Paula Cooper Gallery, New York (with James Dearing)

1981 Paula Cooper Gallery, New York

1982 Smith College Art Gallery, Northampton, Massachusetts

1983 Paula Cooper Gallery, New York

BOOK BY THE ARTIST

Notes for Fire and Rain. New York: Lapp Princess Press, 1981.

DAVID NASH

1945 Born Esher, Surrey, England

1963–67 Studied at Kingston College of Art, Kingston upon Thames, England

1968–70 Studied at Chelsea School of Art, London

1967 Began teaching at art colleges and universities, including Newcastle Polytechnic, Newcastle upon Tyne, England; Royal College of Art, London; Newport College of Art, Wales; and Dublin College of Art, Ireland. Established studio in Blaenau Ffestiniog, Wales

1971 Traveled in France

1978 Resident sculptor, Grizedale Forest; traveled in Yugoslavia

1979–80 Traveled in United States

1981 Traveled in Wales, England, and Scotland; Yorkshire Sculpture Park Fellowship

Lives in Blaenau Ffestiniog

EXHIBITIONS AND CATALOGS

1973 York Festival, York, England

1980 Elise Meyer, Inc., New York

1981 Yorkshire Sculpture Park, Wakefield, England. Catalog: *Fellowship '81–'82: David Nash*.

1982 Kilkenny Art Gallery Society, Kilkenny Castle, Ireland

Welsh Arts Council's Gallery, Cardiff, Wales. Catalog: *David Nash: Ash Dome and other Works on Paper*. Text by William Varley.

12 Duke Street Gallery, London

Elise Meyer, Inc., New York

Rijksmuseum Kröller-Müller, Otterlo, Netherlands. Catalog: *Wood Quarry, David Nash*.

1983 Third Eye Center, Glasgow, Scotland, and tour. Catalog: *Sixty Seasons, David Nash*. Text by Hugh Adams.

BOOKS BY THE ARTIST

Loosely Held Grain. Bristol, England: Arnolfini Gallery, 1976 (with Sue Wells).

Fletched over Ash. 1978 (with Sue Wells).

GEORGE NEGROPONTE

1953 Born New York

1971–75 B.A. (art) Yale University, New Haven, Connecticut

1973 Attended Skowhegan School of Painting and Sculpture, Skowhegan, Maine

Lives in New York

EXHIBITIONS

1981 Brooke Alexander, Inc., New York (with Frank Moore)

1983 Brooke Alexander, Inc., New York

GUSTAVO OJEDA

1958 Born Havana, Cuba

1975–79 Studied at Parsons School of Design, New York

1981–82 Studio at P.S. 1 (Project Studios One), Long Island City, New York

Lives in New York

EXHIBITIONS AND CATALOG

1981 Seventeenth Street Gallery, New York

1982 P.S. 1 (Project Studios One), Long Island City, New York

Pan American Health Organization Rotunda, Washington, D.C.

1983 Tracey Garet Gallery, New York. Catalog: *Arch Connelly, Dana Garrett, Gustavo Ojeda, Ricardo Regazzoni*. New York: Robert Kohn, 1983.

TOM OTTERNESS

1952 Born Wichita, Kansas

1970 Studied at Art Students League, New York

1973 Participated in Independent Study Program, Whitney Museum of American Art, New York

1977 Founding member of Collaborative Projects, Inc., New York

1981 Taught at School of Visual Arts, New York

1984 Works in Pietrasanta, Italy

Lives in New York

EXHIBITION AND CATALOG

1983 Brooke Alexander, Inc., New York. Catalog: *Tom Otterness: Objects, 1978–1982*.

MIMMO PALADINO

1948 Born Paduli, near Benevento, Italy

1964–68 Attended art school in Benevento

Lives in Paduli

EXHIBITIONS AND CATALOGS

1976 Nuovi Strumenti, Brescia, Italy

1980 Kunsthalle, Basel, May 11–June 22; Museum Folkwang, Essen; and Stedelijk Museum, Amsterdam. Catalog: *Mimmo Paladino*.

Badischer Kunstverein, Karlsruhe, West Germany, October 7–November 23. Catalog: *Mimmo Paladino*. Text by Andreas Franzke and interview by Wolfgang Max Faust.

Annina Nosei Gallery, New York

Marian Goodman Gallery, New York

1981 Kunstmuseum, Basel, July 11–August 2, and tour. Catalog: *Mimmo Paladino: Zeichnungen, 1976–1981*. Text by Dieter Koepplin.

1982 Waddington Galleries, London

Marian Goodman Gallery, New York

Galerie Buchmann, St. Gallen, Switzerland. Catalog: Achille Bonita Oliva and Armin Wildermuth. *Mimmo Paladino*.

Middendorf/Lane Gallery, Washington, D.C.

Kunst- und Museumsverein Wuppertal in the Von der Heydt-Museum, Wuppertal, West Germany, May 4–June 6, and Städtische Galerie, Erlangen, West Germany. Catalog: *Mimmo Paladino: Bilder und Zeichnungen, 1981–1982*. Text by Annelie Pohlen. Munich: Verlag Schellmann & Klüser, 1982.

1983 Galleria d'Arte Emilio Mazzoli, Modena, Italy

Sperone Westwater Gallery, New York. Catalog: *Mimmo Paladino*.

Galleria Gian Enzo Sperone, Rome

Galerie Buchmann, St. Gallen, Switzerland (with A. R. Penck)

BOOK BY THE ARTIST

En De Re. Modena, Italy: Emilio Mazzoli Editore, 1980.

BLINKY PALERMO

1943 Born Peter Schwarze in Leipzig, Germany; adopted by Heisterkamp family

1962 Began studies at Kunstakademie Düsseldorf, West Germany, with Bruno Goller; transferred to Joseph Beuys's class

1964 Assumed name Blinky Palermo, after American gangster and fight promoter

1967 Finished studies at Kunstakademie, Düsseldorf

1969 Moved to Mönchengladbach, West Germany; shared studio with Ulrich Rückriem

1970 Traveled to New York with Gerhard Richter

1973 Traveled in United States; moved to New York

1976 Returned to Düsseldorf

1977 Died in Sri Lanka

EXHIBITIONS AND CATALOGS

1966 Galerie Friedrich und Dahlem, Munich

1974 Kunstraum, Munich, November 13–December 21; Institut für Moderne Kunst, Nürnberg; and Kunstmuseum, Bonn. Catalog: *Palermo: Zeichnungen, 1963–73*. Text by Ludwig Binn.

1975 Heiner Friedrich, Inc., New York

1977 Museum Haus Lange, Krefeld, West Germany, November 13–January 1, 1978. Catalog: *Palermo: Stoffbilder, 1966–1972*. Text by Gerhard Storck.

1980 Haus der Kunst, Munich, July 30–September 21. Catalog: *Blinky Palermo, 1964–1976*. Text by Franz Dahlem, Laszlo Glozer, and Fred Jahn. Munich: Galerie-Verein, 1980.

1981 Kunstmuseum, Bonn

1983 Städtisches Museum Abteiberg, Mönchengladbach, West Germany, March 13–April 17; Rijksmuseum Kröller-Müller, Otterlo, Netherlands; and Ostdeutsche Galerie, Regensburg, West Germany. Catalog: *Palermo: Das gesamte Grafik und alle Auflagenobjekte 1966 bis 1975, Sammlung J. W. Froehlich*. Edited by Fred Jahn.

GIULIO PAOLINI

1940 Born Genoa, Italy

Lives in Turin, Italy

EXHIBITIONS AND CATALOGS

1964 Galleria La Salita, Rome

1968 Galleria de Nieubourg, Milan. Catalog: *Giulio Paolini: 2121969*.

1972 Sonnabend Gallery, New York

1973 Studio Marconi, Milan. Catalog: *Paolini: Opere 1961/73*. Interview by Achille Bonito Oliva.

1974 The Museum of Modern Art, New York, March 13–April 14.

1978 ARC, Musée d'Art Moderne de la Ville de Paris. Catalog: *Giulio Paolini: Del Bello Intelligibile*.

1980 Stedelijk Museum, Amsterdam, April 10–May 26, and Museum of Modern Art, Oxford, England. Catalog: *Giulio Paolini*. Text by Harald Szeemann, David Elliott, and Patrick Frey.

1981 Kunstmuseum, Lucerne, March 29–May 3. Catalogs: *Giulio Paolini: Werke und Schriften, 1960–1980*. Includes text by Max Wechsler. *Giulio Paolini: Hortus Clausus*. Text by Martin Kunz.

1982 Galleria Marilena Bonomo, Bari, Italy

Kunsthalle, Bielefeld, West Germany, March 7–April 25; Von der Heydt-Museum, Wuppertal, West Germany; Neuer Berliner Kunstverein, Berlin. Catalog: *Giulio Paolini: Del Bello Intelligibile*.

Galerie Baronian/Lambert, Brussels

Galleria Françoise Lambert, Milan

1983 Galerie Paul Maenz, Cologne

Galleria Christian Stein, Turin

MONOGRAPHS

Germano Celant. *Giulio Paolini*. New York: Sonnabend Press, 1972.

Maurizio Fagiolo and Arturo Carlo Quintavalle. *Giulio Paolini*. Parma, Italy: Università di Parma, 1980.

Giulio Paolini, Premio Bolaffi 1980. Giulio Bolaffi Editore, 1980.

BOOKS BY THE ARTIST

IDEM. Turin: Giulio Einaudi, 1975. Text by Italo Calvino.

Atto Unico in Tre Quadri. Milan: Gabriele Mazzotta, 1979. Text by Carlo Bertelli and Gianni Vattimo.

MIKE PARR

1945 Born Sydney, Australia

1965–66 Studied arts-law at University of Queensland, Brisbane, Australia

1968 Studied at National Art School, Darlinghurst, Australia

1970 Cofounder (with Peter Kennedy) of Inhibodress, an artists' cooperative

1972 Traveled in Europe

1974–78 Lecturer in art, Sydney University Art Workshop, Sydney, Australia

1979 Began teaching at Sydney College of Arts, Sydney

Lives in Sydney

EXHIBITIONS

1970 Reid Gallery, Brisbane, Australia

1973 Galerie Impact, Lausanne, and Galerie Média, Neuchâtel, Switzerland

1982 Art Projects, Melbourne

1983 Institute of Modern Art, Brisbane

Art Projects, Melbourne

ED PASCHKE

1939 Born Chicago, Illinois

1961 B.F.A. School of The Art Institute of Chicago, Chicago, Illinois

1970 M.F.A. School of The Art Institute of Chicago

1970–71 Taught at Meramec College, St. Louis, Missouri

1973 Taught at School of The Art Institute of Chicago

Lives in Chicago

EXHIBITIONS

1970 Deson Zaks Gallery, Chicago

1974 Galerie Darthea Speyer, Paris

1978 Phyllis Kind Gallery, New York

1983 Phyllis Kind Gallery, Chicago

Phyllis Kind Gallery, New York

Hewlett Gallery, Carnegie Mellon University, Pittsburgh, Pennsylvania

A. R. PENCK

1939 Born Ralf Winkler in Dresden, Germany. Penck pseudonym is taken from the nineteenth-century scientist Albrecht Penck, who studied the geomorphology of the glacial epoch (also uses following names: Mike Hammer, Y., T.M., ∝. Y.).

Trained as a draughtsman; worked as a design instructor

1977 May 1, met Jörg Immendorff in East Berlin

1980 Moved to Cologne, West Germany

Lives near London

EXHIBITIONS AND CATALOGS

1969 Galerie Michael Werner, Cologne

1973 Nova Scotia College of Art and Design, Halifax, Nova Scotia

1975 Kunsthalle, Bern, February 22–April 6. Catalog: *A. R. Penck*. Edited by Marianne Schmidt, Michael Werner, and Johannes Gachnang.

Galerie Neuendorf, Hamburg. Catalog: *A. R. Penck*. Text by Günther Gercken.

1978 Kunstmuseum, Basel, May 13–June 25. Catalog: *A. R. Penck: Zeichnungen bis 1975*. Text by Dieter Koepplin.

Galerie Fred Jahn, Munich. Catalog: *Y. (A. R. Penck): Vierzehnteilige Arbeit 1977*.

1979 Museum Boymans–van Beuningen, Rotterdam, October 6–November 18. Catalog: *A. R. Penck: Concept Conceptruimte*.

1980 Galerie Fred Jahn, Munich. *Catalog: A. R. Penck: Bilder, 1967–1977*.

1981 Josef-Haubrich-Kunsthalle, Cologne, April 15–May 17. Catalog: *A. R. Penck: Gemälde, Handzeichnungen*. Text by Siegfried Gohr.

Kunsthalle, Bern, August 15–September 27. Catalog: *A. R. Penck*. Edited by Johannes Gachnang and Marianne Schmidt-Miescher.

Galerie Neuendorf, Hamburg. Catalog: *A. R. Penck: 38 neue Bilder*. Text by Günther Gercken.

Sonnabend Gallery, New York (2 shows)

1982 Waddington Galleries, London. Catalog: *A. R. Penck*. Text by Richard Calvocoressi.

Galleria Franco Toselli, Milan

Sonnabend Gallery, New York

Galerie Gillespie-Laage-Salomon, Paris, Catalog: *A. R. Penck à Paris*.

1983 Galerie Springer, Berlin

Galerie Rudolf Zwirner, Cologne

Galerie Fred Jahn, Munich

Galerie Gillespie-Laage-Salomon, Paris

Galerie Buchmann, St. Gallen, Switzerland (with Mimmo Paladino)

1984 Mary Boone/Michael Werner Gallery, New York

BOOKS BY THE ARTIST

Standart Making. Cologne: Galerie Michael Werner, 1970

Was ist Standart? Cologne and New York: Gebr. König, 1970

"*Europäische Sonette*." Antwerp, Belgium: Galerie Wide White Space, 1973

Standart: Deskriptive Einführung. Milan: L'Uomo e l'Arte Editore, 1973

Der Begriff Modell: Erinnerungen an 1973. Cologne: Galerie Michael Werner, 1978

Immendorff besucht Y. Munich: Rogner & Bernhard, 1979 (with Jörg Immendorff)

Sanfte Theorie über Arsch, Asche und Vegetation. Groningen, Netherlands: Groninger Museum, 1979.

Ende im Osten. Berlin: Rainer Verlag, 1981

GIUSEPPE PENONE

1947 Born Garessio Ponte, Italy

1966–68 Studied at Accademia di Belle Arti, Turin, Italy

1970 Began teaching at Liceo Artistico, Turin

Lives in Garessio Ponte and Turin

EXHIBITIONS AND CATALOGS

1968 Galleria Deposito d'Arte Presente, Turin

1975 Sperone Gallery, New York

1977 Kunstmuseum, Lucerne, May 22–June 26. Catalog: *Giuseppe Penone: Bäume, Augen, Haare, Wände, Tongefäss*. Edited by Jean-Christophe Ammann and Giuseppe Penone.

1978 Staatliche Kunsthalle, Baden-Baden, West Germany, January 28–February 26. Catalog: *Giuseppe Penone*. Edited by Hans Albert Peters.

Museum Folkwang, Essen, September 1–October 1. Catalog: *Giuseppe Penone*. Text by Germano Celant.

1980 Stedelijk Museum, Amsterdam, February 15–March 30, 1980. Catalog: *Giuseppe Penone*. Text by Germano Celant.

1981 Salvatore Ala Gallery, New York

1982 Städtisches Museum Abteiberg, Mönchengladbach, West Germany, June 23–August 15. Catalog: *Giuseppe Penone*. Cologne: Walther König, 1982. Text by Penone.

Salvatore Ala Gallery, New York

1983 National Gallery of Canada, Ottawa, Ontario, October 7–December 4, and tour. Catalog: Jessica Bradley. *Giuseppe Penone*.

EMMANUEL PEREIRE

1935 Born Paris

Lives in Paris

EXHIBITIONS AND CATALOG

1965 Galerie Knoedler, Paris. Catalog: *Emmanuel Pereire: Peintures 1963–1965*. Text by Roland Barthes.

1972 The Museum of Modern Art, New York, April 25–May 28.

1982 Galerie Texbraun, Paris

JUDY PFAFF

1946 Born London

1965–66 Studied at Wayne State University, Detroit, Michigan

1968–69 Studied at Southern Illinois University, Edwardsville, Illinois

1969–71 B.F.A. Washington University, St. Louis, Missouri

1973 M.F.A. Yale University, New Haven, Connecticut

Lives in New York

EXHIBITIONS AND CATALOG

1974 Artists Space, New York

1980 Holly Solomon Gallery, New York

1981 John & Mable Ringling Museum of Art, Sarasota, Florida, July 16–August 30, and tour. Catalog: *Judy Pfaff: Installations, Collages and Drawings*. Text by Michael Auping.

1982 University Gallery, University of Massachusetts, Amherst, Massachusetts

Albright-Knox Art Gallery, Buffalo, New York

Hallwalls Gallery, Buffalo, New York

1983 Holly Solomon Gallery, New York

SIGMAR POLKE

1941 Born Oels, Germany (now Oleśnica, Poland)

1953 To West Germany

1959–60 Studied glass painting, Düsseldorf, West Germany

1961–67 Studied painting at Kunstakademie, Düsseldorf, with Gerhard Hoehme and K. O. Goetz

1963 Cofounded Kapitalistischer Realismus (with Konrad Fischer-Lueg and Gerhard Richter)

1970–71 Visiting professor, Hochschule für Bildende Künste, Hamburg, West Germany

1977 Appointed professor

Lives in Cologne and Hamburg, West Germany

EXHIBITIONS AND CATALOGS

1966 Galerie René Block, Berlin. Catalog: *Sigmar Polke*.

Galerie Alfred Schmela, Düsseldorf

Galerie H, Hannover, West Germany

1975 Kunsthalle, Kiel, West Germany, April 13–July 9 (with Achim Duchow). Catalog: *Mu Nieltnam Netdrruprup*. Edited by Eberhard Freitag.

1976 Kunsthalle, Tübingen, West Germany, February 14–March 14; Kunsthalle, Düsseldorf; and Van Abbemuseum, Eindhoven, Netherlands. Catalog: *Sigmar Polke: Bilder, Tücher, Objekte; Werkauswahl, 1962–1971*. Text by B. H. D. Buchloh.

1977 Kunstverein, Kassel, West Germany, March 12–April 13 (with Achim Duchow). Catalog: *Sigmar Polke; Achim Duchow: Projektionen*. Text by Peter Breslaw.

1982 Holly Solomon Gallery, New York

Galerie Banna, Paris

1983 Galerie Thomas Borgmann, Cologne

Museum Boymans–van Beuningen, Rotterdam, December 18–January 29, 1984, and Kunstmuseum, Bonn. Catalog: *Sigmar Polke*. Edited by Elbrig de Groot.

KATHERINE PORTER

1941 Born Cedar Rapids, Iowa

1962 Studied at Boston University, Boston, Massachusetts

1963 B.A. Colorado College, Colorado Springs, Colorado

Lives in Lincolnville, Maine

EXHIBITIONS AND CATALOGS

1971 Parker 470 Gallery, Boston

University of Rhode Island, Kingston, Rhode Island

1974 Hayden Gallery, Massachusetts Institute of Technology, Cambridge, Massachusetts, November 22–December 21. Catalog: *Katherine Porter*. Essay by Wayne Andersen.

1975 David McKee Gallery, New York

1980 Hopkins Center, Dartmouth College, Hanover, New Hampshire

1982 David McKee Gallery, New York. Catalog: *Katherine Porter: Paintings, 1981–1982.* Essay by Jonathan Fineberg.

1983 Arts Club of Chicago, Chicago, November 16–December 31. Catalog: *Katherine Porter.* Text by Stephen Westfall.

KENNETH PRICE

1935 Born Los Angeles, California

1953–54 Studied at Chouinard Art Institute, Los Angeles

1956 B.F.A. University of Southern California, Los Angeles

1957–58 Studied with Peter Voulkos at Otis Art Institute, Los Angeles

1959 M.F.A. State University of New York, Alfred, New York

1962 Traveled in Japan

1968 Lived in London

Lives in South Dartmouth, Massachusetts

EXHIBITIONS AND CATALOG

1960 Ferus Gallery, Los Angeles

1968 Kasmin Gallery, London

1969 Whitney Museum of American Art, New York

1978 Los Angeles County Museum of Art, Los Angeles, April 2–July 2. Catalog: Maurice Tuchman. *Ken Price, Happy's Curios.*

1980 Visual Arts Museum, School of Visual Arts, New York

1981 James Corcoran Gallery, Los Angeles

1982 Willard Gallery, New York

1983 Leo Castelli Gallery, New York

1984 Texas Gallery, Houston, Texas

MARTIN PURYEAR

1941 Born Washington, D.C.

1963 Studied at Catholic University of America, Washington, D.C.

1966–68 Studied at Swedish Royal Academy of Art, Stockholm, Sweden

1969–71 M.F.A. (sculpture) Yale University, New Haven, Connecticut

Lives in Chicago, Illinois

EXHIBITIONS AND CATALOG

1968 Galleri Grona Palletten, Stockholm

1972 Fisk University, Nashville, Tennessee

Henri Gallery, Washington, D.C.

1980 Museum of Contemporary Art, Chicago, February 1–March 11.

Young-Hoffman Gallery, Chicago

Joslyn Art Museum, Omaha, Nebraska, August 2–September 14. Catalog: *I-80 Series: Martin Puryear.* Text by Holliday T. Day.

1982 Young-Hoffman Gallery, Chicago

McIntosh/Drysdale Gallery, Washington, D.C.

MARKUS RAETZ

1941 Born Büren an der Aare, Switzerland

1956–61 Educated as a teacher

1961–63 Worked as a teacher

1965 Traveled to Poland

1969–73 Lived in Amsterdam, Netherlands

1971 Traveled to Morocco and Spain

1973–76 Lived in Carona, Ticino, Switzerland

1981–82 DAAD Stipend to Berlin

Lives in Bern, Switzerland

EXHIBITIONS AND CATALOGS

1966 Galerie Toni Gerber, Bern

1972 Kunstmuseum, Basel, March 4–April 16. Catalog: *Markus Raetz: Zeichnungen, Objekte.* Text by Dieter Koepplin.

1975 Neue Galerie am Landesmuseum Joanneum, Graz, Austria, October 24–November 30. Catalog: *Markus Raetz: Zeichnungen, Aquarelle, "Die Bücher."*

Kunsthaus, Zurich, October 4–November 2. Catalog: *Notizbuch, Ergänzung zur Ausstellung: Amsterdam Frühjahr 1973: Arbeiten aus einem Monat und einer Nacht von Markus Raetz.* Introduction by Erika Gysling-Billeter.

1979 Stedelijk Museum, Amsterdam, April 6–May 20, and Galerie Nouvelles Images, The Hague, Netherlands. Catalog: *Markus Raetz.* Introduction by Ad Petersen.

1981 Kunsthaus, Aarau, Switzerland; Galerie Krinzinger, Innsbruck; and Galerie Nächst St. Stephan, Vienna. Catalog: *MIMI.*

1982 DAAD Galerie, Berlin

Kunsthalle, Basel, and tour. Catalog: *Markus Raetz: Arbeiten/Travaux/Works 1971–1981.* Text by Jean-Christophe Ammann.

BOOK BY THE ARTIST
Notizen 1981–82. Berlin: Berliner Künstlerprogramm des Deutschen Akademischer Austauschdienstes, 1982.

CARL FREDRIK REUTERSWÄRD

1934 Born Stockholm, Sweden

1952 Studied at School of Fernand Léger, Paris

1952–55 Studied at College of Art, Stockholm

1965–69 Professor at College of Art, Stockholm

Lives in Bussigny, Switzerland

EXHIBITIONS AND CATALOGS

1955 Galleri Samlaren, Stockholm

Institute of Contemporary Arts, London

1961 Galerie Lucien Durand and Galerie La Roue, Paris. Catalog: *Carl Fredrik Reuterswärd.*

1971 Euginia Butler Gallery, Los Angeles

1972 Centre National d'Art Contemporain, Paris, November 24–January 15, 1973. Catalog: *Reuterswärd.* Text by Ulf Linde.

1976 Galerie Maeght, Zurich. Catalog: *Reuterswärd.* Text by Ulf Linde.

1977 Moderna Museet, Stockholm, September 10–October 30. Catalog: *Carl Fredrik Reuterswärd: 25 Är i Branschen.* Text by Ulf Linde.

1978 Museum of Holography, New York, September. Catalog: *Carl Fredrik Reuterswärd: 25 Years in the Branch.* Rome: Benteli, 1978. Text by Dore Ashton and Ulf Linde.

1982 Malmö Museum, Malmö, Sweden. Catalog: *Reuterswärd Samlingen-The Reuterswärd Collection.* Edited by Göran Christenson and Mona Möller-Nielsen.

Bonlow Gallery, New York

Ulmer Museum, Ulm, West Germany, May 16–June 20.

1983 Otis Art Institute and Koplin Gallery, Los Angeles. Catalog: *Caviart: The Ultimate Selection from the Pratt-Muller Empire.* Text by Dore Ashton.

Kommunes Kunstsamlinger, Oslo, Norway

BOOK BY THE ARTIST
Laser. Stockholm: Wahlström & Widstrand, 1969.

GERHARD RICHTER

1932 Born Dresden, Germany

1949–52 Worked in a photography laboratory and as a set and advertisement painter

1952–57 Studied at the Hochschule für Bildende Kunst, Dresden

1960 Moved to Düsseldorf, West Germany

1961–64 Studied at Kunstakademie, Düsseldorf, with K. O. Goetz

1963 Cofounded Kapitalistischer Realismus (with Konrad Fischer-Lueg and Sigmar Polke)

1971 Began teaching at Kunstakademie, Düsseldorf

Lives in Cologne, West Germany

EXHIBITIONS AND CATALOGS

1963 Möbelhaus Berges, Düsseldorf (with Konrad Fischer-Lueg)

1964 Galerie René Block, Berlin. Catalog: *Gerhard Richter: Bilder des Kapitalistischen Realismus.* Text by Manfred de la Motte.

1972 West German Pavilion, Venice Biennale, June 6–October 1. Catalog: *Gerhard Richter.* Essen: Museum Folkwang, 1972. Introduction by Dieter Honisch.

1973 Städtische Galerie im Lenbachhaus, Munich, May 23–July 1. Catalog: *Gerhard Richter.* Edited by Michael Petzet and Armin Zweite.

Onnasch Gallery, New York

1975 Kunsthalle, Bremen, West Germany, November 30–January 18, 1976. Catalog: *Gerhard Richter: Bilder aus den Jahren 1962–1974.* Edited by Marlis Grüterich and Bernhard Schnackenburg.

1977 Musée National d'Art Moderne, Centre Georges Pompidou, Paris, February 1–March 21. Catalog: *Gerhard Richter.* Text by B. H. D. Buchloh.

1978 Van Abbemuseum, Eindhoven, Netherlands, and Whitechapel Art Gallery, London. Catalog: *Gerhard Richter: Abstract Paintings.* Text by B. H. D. Buchloh.

Sperone Westwater Fischer Gallery, New York

Midland Group, Nottingham, England, September 16–October 21. Catalog: *Gerhard Richter: 48 Portraits.*

1980 Museum Folkwang, Essen, June 8–August 3. Catalog: *Gerhard Richter: Zwei gelbe Striche.* Text by Zdenek Felix.

1982 Kunsthalle, Bielefeld, West Germany, January 10–February 21, and Mannheimer Kunstverein, Mannheim, West Germany. Catalog: *Gerhard Richter: Abstrakte Bilder, 1976 bis 1981.* Text by R. H. Fuchs and Heribert Heere.

Padiglione d'Arte Contemporanea, Milan (with Giulio Paolini)

Galerie Fred Jahn, Munich

Galerie Konrad Fischer, Zurich

1983 Sperone Westwater Fischer Gallery, New York

1984 Galerie Thomas Borgmann, Cologne

BOOK BY THE ARTIST
128 Details from a Picture (Halifax 1978). Halifax, Nova Scotia: Press of the Nova Scotia College of Art and Design, 1980.

BRUCE ROBBINS

1948 Born Philadelphia, Pennsylvania

1968–69 Studied at Hebrew University, Jerusalem, Israel

1970 B.A. Temple University, Philadelphia, Pennsylvania

1973 B.F.A. The Cooper Union, New York

Lives in New York

EXHIBITIONS

1977 Truman Gallery, New York

1980 Galerie Rudolf Zwirner, Cologne

1981 Blum Helman Gallery, New York

1983 Galerie Rudolf Zwirner, Cologne

John Berggruen Gallery, San Francisco

1984 Blum Helman Gallery, New York

SUSAN ROTHENBERG

1945 Born Buffalo, New York

1966 B.F.A. Cornell University, Ithaca, New York

1967 Studied at George Washington University, Washington, D.C., and Corcoran Museum School, Washington, D.C.

Lives in New York

EXHIBITIONS AND CATALOGS

1975 112 Greene Street, New York

1978 University Art Museum, University of California, Berkeley, California, January 20–April 20.

1981 Kunsthalle, Basel, October 3–November 15, and Frankfurter Kunstverein, Frankfurt am Main. Catalog: *Susan Rothenberg.* Text by Peter Blum.

Willard Gallery, New York

Akron Art Museum, Akron, Ohio, November 21–January 10, 1982.

1982 Stedelijk Museum, Amsterdam, October 14–November 28. Catalog: *Susan Rothenberg: Recente Schilderijen/ Recent Paintings.* Text by Alexander van Grevenstein.

1983 Willard Gallery, New York

REINER RUTHENBECK

1937 Born Velbert, Germany

Worked as a photographer in Velbert and Düsseldorf, West Germany, and Berlin

1962–69 Studied at the Kunstakademie, Düsseldorf, with Joseph Beuys

1972 Began transcendental meditation

1980 Began teaching at Kunstakademie, Düsseldorf (Münster branch)

Lives in Düsseldorf

EXHIBITIONS AND CATALOGS

1967 Galleri Charlottenburg, Copenhagen

1971 Westfälischer Kunstverein, Münster, West Germany, November 27–December 26. Catalog: *Reiner Ruthenbeck.* Text by Klaus Honnef and Johannes Cladders.

1974 Kunsthalle, Düsseldorf, February 1–March 3. Catalog: *Reiner Ruthenbeck, Objekte.* Text by Jürgen Harten.

1975	René Block Gallery, New York
1978	Museum Haus Lange, Krefeld, West Germany, June 4–July 30. Catalog: *Reiner Ruthenbeck: Handzeichnungen 1963–1977.*
1983	Kunstverein, Braunschweig, West Germany, April 22–June 26. Catalog: Dieter Blume. *Reiner Ruthenbeck: Arbeiten, 1965–1983.*

DAVID SALLE

1952 Born Norman, Oklahoma

1973 B.F.A. California Institute of the Arts, Valencia, California

1975 M.F.A. California Institute of the Arts

Lives in New York

EXHIBITIONS AND CATALOGS

1975 Project, Inc., Cambridge, Massachusetts

Claire S. Copley Gallery, Los Angeles

1976 Fondation Corps de Garde, Groningen, Netherlands

Artists Space, New York

1981 Galleria Lucio Amelio, Naples

Mary Boone Gallery, New York

1982 Anthony d'Offay Gallery, London

Leo Castelli Gallery, New York

Mary Boone Gallery, New York

Galleria Mario Diacono, Rome

1983 Addison Gallery of American Art, Phillips Academy, Andover, Massachusetts

Galerie Ascan Crone, Hamburg. Catalog: *David Salle: Neue Bilder und Aquarelle.* Essay by Michael Krüger.

Castelli Graphics, New York

Mary Boone Gallery, New York

Museum Boymans–van Beuningen, Rotterdam, February 26–April 17. Catalog: *David Salle.* Text by W. A. L. Beeren.

B. R. Kornblatt Gallery, Washington, D.C.

Galerie Schellmann & Klüser, Munich (with Francis Picabia). Catalog: *David Salle, Francis Picabia.* Text by Ingrid Rein.

SALOMÉ

1954 Born Wolfgang Cilarz in Karlsruhe, West Germany

1973 To Berlin

1974–80 Studied at Hochschule der Künste, Berlin, with K. H. Hödicke

1977 Cofounder of Galerie am Moritzplatz, Berlin (with Rainer Fetting, Helmut Middendorf, and Bernd Zimmer)

1981 DAAD Stipend to New York

Lives in Berlin

EXHIBITIONS AND CATALOG

1977 Galerie am Moritzplatz, Berlin

1981 Galerie Lietzow, Berlin. Catalog: *Salomé: Malerei.*

Annina Nosei Gallery, New York

1982 Galerie Rudolf Zwirner, Cologne

Galerie Bruno Bischofberger, Zurich

PATRICK SAYTOUR

1935 Born Nice, France

Taught at École des Beaux-Arts, Nîmes, France

Lives in Aubais, France

EXHIBITIONS AND CATALOGS

1975 Galerie Eric Fabre, Paris

1981 Musée Savoisien, Chambéry, France, December 5–February 28, 1982. Catalog: *Patrick Saytour.* Chambéry: Musée Chambéry, 1981.

Galerie Eric Fabre, Paris

1982 Musée d'Art et d'Industrie, St.-Étienne, France, December 6–January 22, 1983. Catalog: *Patrick Saytour: 1967, 1974, 1980.*

ITALO SCANGA

1932 Born Lago, Calabria, Italy

1947 Moved to United States

1953–55 Served in Austria with U.S. Army

1961 B.F.A., M.A. Michigan State University, Lansing, Michigan

Lives in La Jolla, California

EXHIBITIONS AND CATALOGS

1969 Baylor Art Gallery, Baylor University, Waco, Texas

1972 Whitney Museum of American Art, New York

1975 Alessandra Gallery, New York. Catalog: *Italo Scanga: Restoration Pieces.* Text by Alan Moore.

1979 Gallery One, San Jose State University, San Jose, California. Catalog: *Italo Scanga.* Text by R. J. Onorato.

1982 Susanne Hilberry Gallery, Birmingham, Michigan

Charles Cowles Gallery, New York

1983 La Jolla Museum of Contemporary Art, La Jolla, California, June 4–August 3. Catalog: *Archimedes' Troubles: Sculptures and Drawings by Italo Scanga.* Essay by William Zimmer.

Los Angeles County Museum of Art, Los Angeles, July 14–August 14.

Delahunty Gallery, New York

HUBERT SCHMALIX

1952 Born Graz, Austria

1971–76 Studied at Akademie der Bildenden Künste, Vienna, Austria

Lives in Vienna, Austria, and Cologne, West Germany

EXHIBITIONS AND CATALOGS

1978 Neue Galerie am Landesmuseum Joanneum, Graz, Austria, October 8–29. Catalog: Christa Steinle. *Hubert Schmalix: Stilleben.*

Galerie Ariadne, Vienna. Catalog: *Schmalix.*

1981 Galerie Krinzinger, Innsbruck, Austria. Catalog: *Schmalix.* Text by Dieter Ronte.

1982 Galerie Six Friedrich, Munich. Catalog: *Schmalix.* Text by Wilfried Skreiner.

1983 Fischer Fine Art, Ltd., London. Catalog: *Hubert Schmalix: Thirteen Paintings 1983; Gouaches on Paper 1982.* Text by Wilfried Skreiner.

1984 Holly Solomon Gallery, New York (with Siegfried Anzinger). Catalog: *Siegfried Anzinger, Hubert Schmalix.* Text by Peter Weiermair.

JULIAN SCHNABEL

1951 Born New York

1972 B.F.A. University of Houston, Houston, Texas

1973–74 Participated in Independent Study Program, Whitney Museum of American Art, New York

Lives in New York

EXHIBITIONS AND CATALOGS

1976 Contemporary Art Museum, Houston, Texas

1978 Galerie December, Düsseldorf

1979 Mary Boone Gallery, New York

1981 Kunsthalle, Basel, October 3–November 15, and Frankfurter Kunstverein, Frankfurt am Main. Catalog: *Julian Schnabel.* Edited by Jean-Christophe Ammann and Margrit Suter.

1982 Stedelijk Museum, Amsterdam, January 28–March 14. Catalog: *Julian Schnabel.* Text by René Ricard and Alexander van Grevenstein.

University Art Museum, University of California, Berkeley, California, May 19–July 25.

The Tate Gallery, London, June 30–September 5. Catalog: *Julian Schnabel.* Text by Richard Francis.

Los Angeles County Museum of Art, Los Angeles

Mary Boone Gallery, New York

1983 Akron Art Museum, Akron, Ohio, June 18–August 28.

Waddington Galleries, London. Catalog: *Julian Schnabel.* Text by David Robbins.

Akira Ikeda Gallery, Nagoya, Japan. Catalog: *Julian Schnabel: Drawings.*

Leo Castelli Gallery, New York

Galerie Daniel Templon, Paris

Galleria Mario Diacono, Rome

ANDREAS SCHULZE

1955 Born Hannover, West Germany

1976–78 Studied painting at Gesamthochschule, Kassel, West Germany

1978–83 Studied at Kunstakademie, Düsseldorf, West Germany, with Prof. Dieter Krieg

Lives in Cologne, West Germany

EXHIBITIONS

1982 Galerie Six Friedrich, Munich

1983 Monika Sprüth Galerie, Cologne

Galerie Max-Ulrich Hetzler, Stuttgart

1984 Monika Sprüth Galerie, Cologne

Galerie Ascan Crone, Hamburg

SEAN SCULLY

1945 Born Dublin, Ireland

1965–68 Studied at Croyden College of Art, London

1968–71 Studied at Newcastle University, Newcastle, England

1972–73 Studied at Harvard University, Cambridge, Massachusetts

1977–83 Taught at Princeton University, Princeton, New Jersey

Lives in New York

EXHIBITIONS AND CATALOG

1973 Rowan Gallery, London

1975 La Tortue Galerie, Santa Monica, California. Catalog: *Sean Scully: Paintings, 1974.*

1977 Duffy/Gibbs Gallery, New York

1979 The Clocktower, Institute for Art and Urban Resources, New York

1981 Rowan Gallery, London

Susan Caldwell, Inc., New York

McIntosh/Drysdale Gallery, Washington, D.C.

| 1982 | Arts Council of Northern Ireland, Belfast, Northern Ireland |

Warwick Arts Trust, London

William Beadleston, Inc., New York

1983 David McKee Gallery, New York

JOEL SHAPIRO

1941 Born New York

1964 B.A. New York University, New York

1969 M.A. New York University

1974–76 Taught at Princeton University, Princeton, New Jersey

1977 Began teaching at School of Visual Arts, New York

Lives in New York

EXHIBITIONS AND CATALOGS

1970 Paula Cooper Gallery, New York

1973 The Clocktower, Institute for Art and Urban Resources, New York

1974 Galleria Salvatore Ala, Milan

1976 Museum of Contemporary Art, Chicago, September 11–November 7. Catalog: *Joel Shapiro.* Text by Rosalind Krauss.

1980 Whitechapel Art Gallery, London, January 18–February 24; Museum Haus Lange, Krefeld, West Germany; and Moderna Museet, Stockholm. Catalog: *Joel Shapiro: Sculpture and Drawing.* Text by Roberta Smith.

Bell Gallery, Brown University, Providence, Rhode Island, November 22–December 17; Georgia State University Art Gallery, Atlanta, Georgia; and Contemporary Arts Center, Cincinnati, Ohio; Catalog: *Joel Shapiro.* Text by William H. Jordy.

1981 Israel Museum, Jerusalem, Israel, September–October. Catalog: *Joel Shapiro.* Text by Stephanie Rachum.

1982 Susanne Hilberry Gallery, Birmingham, Michigan

Paula Cooper Gallery, New York

Whitney Museum of American Art, New York, October 21–January 2, 1983. Catalog: *Joel Shapiro.* Essay by Roberta Smith.

Portland Center for Visual Arts, Portland, Oregon

Yarlow/Salzman Gallery, Toronto

1983 Asher/Faure Gallery, Los Angeles

Paula Cooper Gallery, New York

ALEXIS SMITH

1949 Born Patricia Anne Smith in Los Angeles, California

1966–70 B.A. (art) University of California, Irvine, California

Lives in Venice, California

EXHIBITIONS

1974 Riko Mizuno Gallery, Los Angeles

1975 Whitney Museum of American Art, New York, November 15–December 14.

Art Galleries, University of California, Santa Barbara, California

1977 Holly Solomon Gallery, New York

1979 Galerij De Appel, Amsterdam

1981 Holly Solomon Gallery, New York

1982 Margo Leavin Gallery, Los Angeles

Rosamund Felsen Gallery, Los Angeles

The Clocktower, Institute for Art and Urban Resources, New York

1983 Holly Solomon Gallery, New York

West Beach Café, Venice, California

NED SMYTH

1948 Born New York
1970 B.A. (art) Kenyon College, Gambier, Ohio

Lives in New York

EXHIBITIONS
1974 112 Greene Street, New York
1978 Hammarskjold Plaza Sculpture Garden, New York
1980 Galerie Bruno Bischofberger, Zurich
1982 Holly Solomon Gallery, New York

Holly Solomon Gallery, New York (with Brad Davis)

ROBERT STACKHOUSE

1942 Born Bronxville, New York
1965 B.A. University of South Florida, Tampa, Florida
1967 M.A. University of Maryland, College Park, Maryland; began teaching at Corcoran Museum School, Washington, D.C.

Lives in New York

EXHIBITIONS
1972 Henri Gallery, Washington, D.C.
1973 Corcoran Gallery of Art, Washington, D.C.
1976 Sculpture Now, Inc., New York
1980 Max Hutchinson Gallery, New York
1982 Middendorf/Lane Gallery, Washington, D.C.
1983 Max Hutchinson Gallery, New York

P.S. 1 (Project Studios One), Long Island City, New York (with Mary Beth Edelson)

GARY STEPHAN

1942 Born Brooklyn, New York
1960–61 Studied at Parsons School of Design, New York
1961 Studied at Art Students League, New York
1961–64 Studied at Pratt Institute, Brooklyn
1964–67 Studied at San Francisco Art Institute, San Francisco, California

Lives in New York

EXHIBITIONS
1979 Mary Boone Gallery, New York
1982 Mary Boone Gallery, New York
1983 Texas Gallery, Houston, Texas

Mary Boone Gallery, New York

BOOK BY THE ARTIST
Book of Nine. New York: The Museum of Modern Art, 1983.

THOMAS STIMM

1948 Born Vienna, Austria
1969–74 Studied at Akademie der Bildenden Künste, Vienna, with Max Weiler
1972 Studied in Hamburg, West Germany

Lives in Vienna and Waldviertel, Austria

EXHIBITIONS AND CATALOG
1978 Theseustempel, Vienna
1980 Galerie Ariadne, Vienna
1983 Galerie Nächst St. Stephan, Vienna. Catalog: Thomas Stimm: Arbeiten in Ton, 1982–1983.

DONALD SULTAN

1951 Born Asheville, North Carolina
1973 B.F.A. University of North Carolina, Chapel Hill, North Carolina
1975 M.F.A. School of The Art Institute of Chicago, Chicago, Illinois

Lives in New York

EXHIBITIONS AND CATALOG
1976 N.A.M.E. Gallery, Chicago
1977 P.S. 1 (Project Studios One), Long Island City, New York

Artists Space, New York
1980 Willard Gallery, New York
1981 Daniel Weinberg Gallery, San Francisco
1982 Galerie Hans Strelow, Düsseldorf

Blum Helman Gallery, New York
1983 Akira Ikeda Gallery, Tokyo, Japan. Catalog: Donald Sultan. Text by Maki Kuwayama.
1984 Blum Helman Gallery, New York

MARK TANSEY

1949 Born San Jose, California
1969 B.F.A. Art Center College of Design, Los Angeles, California
1975–78 Graduate studies (painting) at Hunter College, New York

Lives in New York

EXHIBITION AND CATALOG
1982 Grace Borgenicht Gallery, New York. Catalog: Mark Tansey: Paintings. Text by Peter Frank.

RIDUAN TOMKINS

1941 Born Weymouth, England
1958–68 Studied at Poole School of Art, Dorset, England; West of England College of Art, Bristol, England; Wimbledon School of Art, London; and Royal College of Art, London
1981 Moved to Canada, began teaching at University of Guelph, Guelph, Ontario, Canada
1983 Began teaching at Nova Scotia College of Art and Design, Halifax, Nova Scotia, Canada

Lives in Halifax

EXHIBITIONS AND CATALOG
1972 Greenwich Theatre Gallery, London
1977 Betty Parsons Gallery, New York
1979 Whitechapel Art Gallery, London, May 4–June 17. Catalog: Riduan Tomkins: Recent Paintings. Interview by David Coxhead.
1983 Betty Parsons Gallery, New York

Sable-Castelli Gallery, Toronto

DAVID TRUE

1942 Born Marietta, Ohio
1967 B.F.A., M.F.A. Ohio State University, Columbus, Ohio

Lives in New York

EXHIBITIONS
1974 Michael Walls Gallery, New York
1982 Edward Thorp Gallery, New York

TOON VERHOEF

1946 Born Voorburg, Netherlands
1965 Studied at Rijksakademie, Amsterdam, Netherlands
1968–70 Studied at Ateliers '63, Haarlem, Netherlands
1983 Teaches at Ateliers '63, and Akademie Minerva, Groningen, Netherlands

Lives in Edam, Netherlands

EXHIBITIONS AND CATALOG
1970 Galerij Asselijn, Amsterdam
1974 Stedelijk Museum De Lakenhal, Leiden, Netherlands (with Carel Visser)
1977 P.S. 1 (Project Studios One), Long Island City, New York
1981 Art & Project, Amsterdam
1983 Stedelijk Museum, Amsterdam, September 30–November 6. Catalog: Toon Verhoef: Schilderijen en Tekeningen, 1975–1983.

Galerij Wild & Hardebeck, Amsterdam

EMO VERKERK

1955 Born Amsterdam, Netherlands
1974–76 Studied philosophy at Vrije Universiteit, Amsterdam, and Universiteit van Amsterdam
1978–80 Studied at Ateliers '63, Haarlem, Netherlands
1983 Studio at P.S. 1 (Project Studios One), Long Island City, New York

Lives in Amsterdam

EXHIBITIONS
1982 Art & Project, Amsterdam

Marian Goodman Gallery, New York

DIDIER VERMEIREN

1951 Born Brussels, Belgium

Lives in Paris

EXHIBITIONS
1974 Galerie Delta, Brussels
1978 351 Jay Street, New York
1983 Galerie Eric Fabre, Paris
1984 Artists Space, New York

CLAUDE VIALLAT

1936 Born Nîmes, France
1955–59 Studied at École des Beaux-Arts, Montpellier, France
1962–63 Studied at École des Beaux-Arts, Paris, in the studio of Raymond Legueult
1964–67 Taught at École des Arts Décoratifs, Nice, France
1967 Named professor at École des Beaux-Arts, Limoges, France
1973 Taught at École des Beaux-Arts, Luming, France
1979 Named director of École des Beaux-Arts, Nîmes

Lives in Nîmes and Aigues-Vives, France

EXHIBITIONS AND CATALOGS
1966 Galerie A, Nice, France
1968 Musée d'Art Moderne, Céret, France
1976 Pierre Matisse Gallery, New York
1980 Centre d'Arts Plastiques Contemporains, Bordeaux, France, February 25–April 19. Catalog: Claude Viallat. Text by Jean-Louis Froment and Jean-Marc Poinsot.
1981 Ace Gallery, Venice, California

Flow Ace Gallery, Vancouver, British Columbia
1982 Leo Castelli Gallery, New York

Musée National d'Art Moderne, Centre Georges Pompidou, Paris, June 24–September 20. Catalog: Viallat. Edited by Alfred Pacquement.
1983 Galerie Wentzel, Cologne

DARÍO VILLALBA

1939 Born San Sebastian, Spain
1950–54 Lived in Boston, Massachusetts
1958 Studied with André Lhote in Paris
1958–62 Studied at Harvard University, Cambridge, Massachusetts
1962–64 Studied at Escuela Supérior de Bellas Artes de San Fernando, Madrid, Spain
1964 Studied philosophy and letters, at University of Madrid

Lives in Madrid

EXHIBITIONS AND CATALOGS
1957 Sala Alfil, Madrid
1964 Weeden Gallery, Boston
1970 Spanish Pavilion, Venice Biennale. Catalog: Darío Villalba.
1973 Spanish Pavilion, Bienal de São Paulo. Catalog: Darío Villalba, España, Spain. Text by Giancarlo Politi. Madrid: Galería Vandrés, 1973.
1974 Galería Vandrés, Madrid. Catalog: Darío Villalba. Text by Giancarlo Politi.
1975 Museum, Bochum, West Germany, September 12–October 19, and Heidelberger Kunstverein, Heidelberg, West Germany. Catalog: Darío Villalba.
1976 Palais des Beaux-Arts, Brussels, April 1–30. Catalog: Darío Villalba: Retrospective, 1972–1976. Brussels: Société des Expositions du Palais des Beaux-Arts, 1976.
1977 Künstlerhaus, Vienna. Catalog: Darío Villalba. Text by Hans Mayr.
1982 Charles Cowles Gallery, New York
1983 Salas Pablo Ruiz Picasso, Biblioteca Nacional, Madrid, and tour. Catalog: Darío Villalba: Obra Reciente, 1980–1983. Text by Eugenio de Vicente and Francisco Calvo Serraller.

JOHN WALKER

1939 Born Birmingham, England
1956–60 Studied at Birmingham College of Art, Birmingham
1961–63 Studied at Académie de la Grande Chaumière, Paris
1969–71 Lived in New York (Harkness Fellowship)
1974–80 Taught at The Cooper Union, New York; Yale University, New Haven, Connecticut; Columbia University, New York; and Royal College of Art, London
1977–78 Artist-in-residence, St. Catherine's College, Oxford, England
1979 Artist-in-residence, Monash University, Melbourne, Australia
1981 Visiting artist, Prahran College of Advanced Education, Melbourne
1982 Appointed Dean, Victoria College of the Arts, Melbourne

Lives in Melbourne

EXHIBITIONS AND CATALOGS
1967 Axiom Gallery, London
1968 Hayward Gallery, London
1971 Reese Palley Gallery, New York
1972 British Pavilion, Venice Biennale. Catalog: John Walker. Text by John Elderfield.
1974 The Museum of Modern Art, New York, December 17–February 2, 1975.
1978 Nigel Greenwood Inc. Ltd., London. Catalog: John Walker: Drawings 1972.

Phillips Collection, Washington. D.C., May 20–June 18. Catalog: John Walker. Text by Andrew Forge.
1979 University Gallery, University of Massachusetts, Amherst, Massachusetts, March 28–April 22, and tour. Catalog: John Walker. Text by Hugh Davies and Nancy Versacil.

1981 Nigel Greenwood Inc. Ltd., London
1982 Betty Cuningham Gallery, New York

Phillips Collection, Washington, D.C., February 13–April 11, and J. B. Speed Art Museum, Louisville, Kentucky. Catalog: *John Walker*. Text by Jack B. Flam.
1983 M. Knoedler & Co., New York

WILLIAM T. WILEY

1937 Born Bedford, Indiana
1961 B.F.A. San Francisco Art Institute, San Francisco, California
1962 M.F.A. San Francisco Art Institute
1962–68 Taught at University of California, Davis, California; San Francisco Art Institute; University of Nevada, Reno, Nevada; University of California, Berkeley, California; School of Visual Arts, New York; and University of Colorado, Boulder, Colorado

Lives in Forest Knolls, California

EXHIBITIONS AND CATALOGS
1960 Staempfli Gallery, New York

San Francisco Museum of Art, San Francisco
1971 University Art Museum, University of California, Berkeley, California, September 15–October 24, and tour. Catalog: *Wizdumb*. Catalog by Brenda Richardson.

Studio Marconi, Milan
1973 Van Abbemuseum, Eindhoven, Netherlands, April 13–May 27.
1976 The Museum of Modern Art, New York, April 9–May 16.
1979 Walker Art Center, Minneapolis, Minnesota, December 9–January 27, 1980, and tour. Catalog: Graham W. J. Beal and John Perreault. *Wiley Territory*.
1981 University Fine Arts Galleries, Florida State University, Tallahassee, Florida. Catalog: *William T. Wiley*. Text by Beth Coffelt et al.

Charles H. Scott Gallery, Emily Carr College of Art, Vancouver, British Columbia, and Allan Frumkin Gallery, New York. Catalog: *William T. Wiley*. Text by Ted Lindberg.
1982 Santa Barbara Contemporary Arts Forum, Santa Barbara, California, and tour. Catalog: *William T. Wiley, 1982*.
1983 Allan Frumkin Gallery, New York
BOOK BY THE ARTIST
Ships Log. San Francisco: Zephyrus Image, n.d.

THORNTON WILLIS

1936 Born Pensacola, Florida
1962 B.S. University of Southern Mississippi, Hattiesburg, Mississippi
1966 M.F.A. University of Alabama, Tuscaloosa, Alabama

Lives in New York

EXHIBITIONS AND CATALOG
1966 Stillman College Art Gallery, Tuscaloosa, Alabama
1968 Henri Gallery, Washington, D.C.
1970 Paley and Lowe Gallery, New York
1972 New Orleans Museum of Art, New Orleans, Louisiana
1979 55 Mercer, New York
1982 Oscarsson Hood Gallery, New York
1983 Galerie Nordenhake, Malmö, Sweden. Catalog: *Thornton Willis, Drawings*.

1984 Oscarsson Hood Gallery, New York

Warehouse Gallery, Orlando, Florida

CHRISTOPHER WILMARTH

1943 Born Sonoma, California
1965 B.F.A. The Cooper Union, New York
1969 Began teaching at The Cooper Union

Lives in New York

EXHIBITIONS AND CATALOGS
1968 Graham Gallery, New York
1973 Galleria dell'Ariete, Milan
1974 Wadsworth Atheneum, Hartford, Connecticut, November 13–January 12, 1975, and St. Louis Art Museum, St. Louis, Missouri. Catalog: *Christopher Wilmarth: Nine Clearings for a Standing Man*. Text by Joseph Masheck.
1978 Grey Art Gallery & Study Center, New York University, New York. Catalog: *Christopher Wilmarth: Sculpture and Drawings*. Text by Henry Geldzahler and Christopher Scott.
1979 Seattle Art Museum, Seattle, Washington, January 25–March 25
1982 Studio for the First Amendment, New York
BOOK BY THE ARTIST
Breath: Inspired by Seven Poems of Stéphane Mallarmé Translated by Frederick Morgan. New York: Studio for the First Amendment, 1982. Essay by Dore Ashton.

ROBERT WILSON

1941 Born Waco, Texas
1959–65 Studied at University of Texas, Austin, Texas
1962 Studied painting with George McNeil, Paris
1965 B.F.A. Architecture, Pratt Institute, Brooklyn, New York
1966 Assistant to Paolo Soleri, Arcosanti Community, Arizona

Lives in New York

EXHIBITIONS AND CATALOGS
1971 Willard Gallery, New York
1972 Musée Galliera, Paris
1977 Multiples, Inc./Marian Goodman Gallery, New York
1980 Contemporary Arts Center, Cincinnati, Ohio, May 16–June 29, and Neuberger Museum, Purchase, New York. Catalog: *Robert Wilson: From a Theater of Images*. Text by John Rockwell and Robert Stearns.
1982 Städtische Galerie im Lenbachhaus, Munich, May 18–June 13; Galerie Annemarie Verna, Zurich; and Multiples, Inc./Marian Goodman Gallery, New York. Catalog: *Robert Wilson: The Golden Windows, Die Goldenen Fenster*. Edited by Fred Jahn.
1983 Galerie Dany Keller, Munich

Castelli Feigen Corcoran Gallery, New York

Museum of Art, Rhode Island School of Design, Providence, Rhode Island
BOOK BY THE ARTIST
Première Partie de The Civil warS: A Tree is Best Measured when it is Down. Paris: Editions Herscher, 1983; published in conjunction with a series of performances of the opera and an exhibition of drawings at the Théâtre de la Ville, Paris, September 17–24, 1983, and at the Pavillon des Arts, Paris.

TERRY WINTERS

1949 Born New York
1971 B.F.A. Pratt Institute, Brooklyn, New York

Lives in New York

EXHIBITIONS
1982 Sonnabend Gallery, New York
1983 Galerie Karen & Jean Bernier, Athens (with Carroll Dunham)

Vollum College Center Gallery, Reed College, Portland, Oregon
1984 Sonnabend Gallery, New York

BILL WOODROW

1948 Born Henley, England
1967–68 Studied at Winchester School of Art, Winchester, England
1968–71 Studied at St. Martin's School of Art, London
1971–72 Studied at Chelsea School of Art, London

Lives in London

EXHIBITIONS
1972 Whitechapel Art Gallery, London
1981 Lisson Gallery, London
1983 Museum van Hedendaagse Kunst, Ghent, Belgium

Lisson Gallery, London

Galleria Franco Toselli, Milan

Museum of Modern Art, Oxford, England
1984 Art & Project, Amsterdam

ROBERT ZAKANITCH

1935 Born Elizabeth, New Jersey
1954–57 Studied commercial art at Newark School of Fine and Industrial Arts, Newark, New Jersey
1974 Visiting artist/lecturer, University of California, San Diego, California
1976 Visiting artist/lecturer, School of The Art Institute of Chicago, Chicago, Illinois

Lives in New York

EXHIBITIONS AND CATALOGS
1965 Henri Gallery, Alexandria, Virginia
1968 Stable Gallery, New York
1978 Galerie Liatowitsch, Basel
1981 Robert Miller Gallery, New York

Institute of Contemporary Art, University of Pennsylvania, Philadelphia, June 12–August 9. Catalog: *Robert S. Zakanitch*. Text by Janet Kardon and Paula Marincola.
1982 Harcus Krakow Gallery, Boston

Asher/Faure Gallery, Los Angeles

Galerie Daniel Templon, Paris
1983 McIntosh/Drysdale Gallery, Houston, Texas

Fondation du Château du Jau, Perpignan, France. Catalog: *Robert Zakanitch*. Text by Catherine Millet.
1984 Robert Miller Gallery, New York. Catalog: *Robert S. Zakanitch*.

BERND ZIMMER

1948 Born Planegg, West Germany
1968 Apprenticed in business and publishing
1973–79 Studied philosophy and religion at Freie Universität, Berlin
1977 Cofounder of Galerie am Moritzplatz, Berlin (with Rainer Fetting, Helmut Middendorf, and Salomé)

1982–83 Villa Massimo Prize, Rome

Lives in Berlin

EXHIBITIONS AND CATALOGS
1977 Galerie am Moritzplatz, Berlin
1981 Ausstellungshallen Mathildenhöhe, Darmstadt, West Germany, January 11–February 8. Catalog: Klaus Heinrich Kohrs. *Bernd Zimmer: Bilder*. Berlin: Karl Schmidt-Rottluff Förderungsstiftung, 1981.

Galerie Heiner Hepper "art in progress," Düsseldorf

Kunstverein, Freiburg, West Germany, August 15–September 13. Catalog: *Bernd Zimmer: 28 Tage in Freiburg*.

Barbara Gladstone Gallery, New York
1982 Groninger Museum, Groningen, Netherlands, February 28–April 4.

Galerie Buchmann, St. Gallen, Switzerland. Catalog: Armin Wildermuth. *Helmut Middendorf, Bernd Zimmer*.
1983 Galerie Gmyrek, Düsseldorf. Catalog: *Bernd Zimmer: Abgründe, Ihr Berge, Tanzt!* Text by Jürgen Schilling and Michael Krüger.

Galleria Chisel, Genoa, Italy
BOOK BY THE ARTIST
Lombok, Zwieselstein, Berlin: Zeichnungen, Bilder, Graphik, &c. Berlin: Rainer Verlag, 1981.

GILBERTO ZORIO

1944 Born Andorno Micca, Italy
1963–70 Studied painting at Accademia di Belle Arte, Turin, Italy

Lives in Milan, Italy
EXHIBITIONS AND CATALOGS
1967 Galleria Gian Enzo Sperone, Turin
1976 Kunstmuseum, Lucerne, May 9–June 20. Catalog: *Gilberto Zorio*.
1979 Stedelijk Museum, Amsterdam, March 29–May 13. Catalog: *Gilberto Zorio*. Text by Jean-Christophe Ammann.
1981 Galerie Appel und Fertsch, Frankfurt am Main. Catalog: *Gilberto Zorio*.

Galleria Salvatore Ala, Milan

Sonnabend Gallery, New York
1982 Galleria Christian Stein, Turin
1983 Galerie Walter Storms, Munich

ZUSH

1946 Born Alberto Porta in Barcelona, Spain
1968 Changed name to Zush; moved to Ibiza, Spain

Lives in Barcelona and New York
EXHIBITIONS AND CATALOGS
1968 Galería René Métras, Barcelona
1976 Marlborough Galleria d'Arte, Rome. Catalog: *Zush*.
1980 Galería Joan Prats, Barcelona. Catalog: *Zush*.

Galería Vandrés, Madrid

MICHAEL ZWACK

1949 Born Buffalo, New York
1970 B.A. State University of New York, Buffalo

Lives in New York
EXHIBITIONS
1974 Gallery 219, Buffalo, New York
1979 Artists Space, New York
1980 Studio d'Arte Cannaviello, Milan
1982 Metro Pictures, New York

1977

Ink, Zurich, and tour. *Works from the Crex Collection, Zurich.* Catalog edited by Christel Sauer and Urs Raussmüller. Artists included: Baselitz, Lüpertz, Palermo, Penck, Polke, and Richter.

1978

Galerie am Moritzplatz, Berlin. *Rolf v. Bergmann, Rainer Fetting, Ep. Hebeisen, Anne Jud, Thomas Müller, Helmut Middendorf, Salomé, Berthold Schepers, Bernd Zimmer.* Catalog introduction by Ernst Busche.

November 10–December 22, Whitechapel Art Gallery, London. *13° E: Eleven Artists Working in Berlin;* organized by Nicholas Serota. Catalog. Artists included: Hödicke, Koberling, and Lüpertz.

1979

January 19–March 12, ARC, Musée d'Art Moderne de la Ville de Paris. *Un Certain Art Anglais…: Sélection d'Artistes Britanniques, 1970–1979.* Artists included: Chaimowicz and McLean.

September 5–October 13, Grey Art Gallery & Study Center, New York University, New York. *American Painting: The Eighties, A Critical Interpretation.* Catalog by Barbara Rose; New York: Vista Press, 1979. Artists included: Chase, Jensen, Moskowitz, Murray, Rothenberg, Stephan, and Willis.

November 4–December 15, Palazzo di Città, Acireale, Italy. *Opere Fatte ad Arte.* Catalog edited by Achille Bonito Oliva. Florence: Centro Di, 1979. Artists included: Chia, Clemente, Cucchi, De Maria, and Paladino.

November 11–February 9, 1980, Castello Colonna, Genazzano, Italy. *Le Stanze.* Catalog edited by Achille Bonito Oliva; Florence: Centro Di, 1979. Artists included: Anselmo, Chia, Clemente, Cucchi, De Maria, Paladino, Paolini, Penone, and Zorio.

1980

January 13–February 10, Mannheimer Kunstverein, Mannheim, West Germany, and tour. *Dekor;* organized by Raman Schlemmer. Artists included: Kushner, MacConnel, Smyth, and Zakanitch.

March 31–May 11, The Solomon R. Guggenheim Museum, New York. *New Images from Spain.* Catalog by Margit Rowell; New York: Solomon R. Guggenheim Foundation, 1980. Artists included: Villalba and Zush.

June, New York. *Times Square Show;* organized by Tom Otterness et al. Artists included: Bosman and Otterness.

June 21–August 31, Museum van Hedendaagse Kunst and Centrum voor Kunst in Cultuur, Ghent, Belgium. *Kunst in Europa na '68.* Catalog. Artists included: Cragg, van Elk, Flanagan, Paolini, and Zorio.

November 15–December 31, Palazzo di Città, Acireale, Italy, and Palazzo dei Diamanti, Ferrara, Italy. *Genius Loci.* Catalog edited by Achille Bonito Oliva; Florence: Centro Di, 1980. Artists included: Adrian X, Borofsky, Chia, Clemente, Cucchi, Disler, and Zwack.

November 21–January 10, 1981, Musée d'Art et d'Industrie and Maison de la Culture, St.-Étienne, France. *Après le Classicisme;* organized by Jacques Beauffet, Bernard Ceysson, Anne Dary-Bossut, and Didier Semin. Artists included: Baselitz, Castelli, Chia, Clemente, De Maria, Fetting, Flanagan, Garet, Grand, Highstein, Immendorff, Kiefer, Kirkeby, Kushner, Lüpertz, MacConnel, Middendorf, Paladino, Penck, Rothenberg, Salle, Salomé, Saytour, Schnabel, Viallat, Zakanitch, and Zimmer.

1981

January 15–March 18, Royal Academy of Arts, London. *A New Spirit in Painting;* organized by Christos M. Joachimides, Norman Rosenthal, and Nicholas Serota. Catalog. Artists included: Auerbach, Baselitz, Chia, Fetting, Hodgkin, Hödicke, Kiefer, Kirkeby, Koberling, Lüpertz, McLean, Morley, Paladino, Penck, Polke, Richter, and Schnabel.

January 17–March 8, ARC, Musée d'Art Moderne de la Ville, Paris. *Art Allemagne Aujourd'hui: Différents Aspects de l'Art Actuel en République Fédérale d'Allemagne;* organized by Suzanne Pagé. Catalog. Artists included: Baselitz, Hödicke, Kiefer, Lüpertz, Middendorf, Palermo, Penck, Polke, Richter, and Ruthenbeck.

May 23–August 9, Arnolfini Gallery, Bristol, England, and Institute of Contemporary Arts, London. *Objects & Sculpture.* Catalog. Artists included: Deacon, Gormley, Kapoor, and Woodrow.

May 27–July 12, Palais des Beaux-Arts, Brussels. *Schilderkunst in Duitsland, 1981;* organized by Johannes Gachnang. Catalog: Brussels: Société des Expositions du Palais des Beaux-Arts, 1981. Artists included: Baselitz, Immendorff, Kiefer, Kirkeby, Lüpertz, and Penck.

May 30–August 16, Rheinhallen, Museen der Stadt Köln, Cologne. *Heute (Westkunst).* Catalog. Artists included: Borofsky, Brauntuch, Castelli, Chia, Clemente, Cucchi, De Maria, Goldstein, Kiefer, Kushner, Longo, MacConnel, Paladino, Pfaff, Salle, Salomé, Schmalix, and Schnabel.

June 14–July 1, Akademie der Künste, Berlin. *Bildwechsel: Neue Malerei aus Deutschland;* organized by Ernst Busche. Catalog by Hanspeter Heidrich; Berlin: Frölich & Kaufmann, 1981. Artists included: Bömmels, Dahn, Dokoupil, Fetting, Middendorf, Schulze, and Zimmer.

June 25–September 7, Musée National d'Art Moderne, Centre Georges Pompidou, Paris. *Identité Italienne: L'Art en Italie depuis 1959.* Catalog by Germano Celant. Artists included: Anselmo, De Maria, Fabro, Paolini, Penone, and Zorio.

July, Galerie d'Art Contemporain des Musées de Nice, Nice, France. *Situation Berlin.* Catalog: Berlin: D.A.A.D., 1981. Artists included: Castelli, Fetting, Middendorf, Salomé, and Zimmer.

September 21–October 9, California Institute of the Arts, Valencia, California. *Exhibition: An Exhibition of Current Works by Artists Who Are Alumni of the School of Art and Design of California Institute of the Arts;* art section organized by Helene Winer. Catalog. Artists included: Brauntuch, Fischl, Goldstein, and Salle.

October 1–November 15, Musée d'Art Moderne de la Ville de Paris. *Baroques 81;* organized by Suzanne Pagé. Catalog. Artists included: Borofsky, Castelli, Clemente, Paladino, Polke, Salomé, Schnabel, Viallat, Walker, and Zakanitch.

October 2–December 24, Hayden Gallery, Massachusetts Institute of Technology, Cambridge, Massachusetts, and tour. *Body Language: Figurative Aspects of Recent Art;* organized by Roberta Smith. Catalog: Cambridge, Massachusetts: Committee on the Visual Arts, 1981. Artists included: Armajani, Borofsky, Bosman, Brauntuch, Burton, Fischer, Longo, Pfaff, Salle, Schnabel, and Shapiro.

October 11–November 15, Kunstmuseum, Lucerne, and tour. *Im Westen Nichts Neues: (Wir Malen Weiter);* organized by Martin Kunz. Catalog. Artists included: Castelli, Fetting, Middendorf, Salomé, and Zimmer.

1982

Power Gallery, University of Sydney, Sydney, and University Art Museum, University of Queensland, Brisbane, Australia. *Spelt from Sibyl's Leaves: Explorations in Italian Art.* Catalog by Luigi Ballerini; Milan: Electa International, 1982. Artists included: Paolini and Zorio.

February 27–April 11, Tokyo Metropolitan Art Museum, Tokyo, and tour. *Aspects of British Art Today;* selected by David Brown and organized by Ian Barker. Catalog: Tokyo: Asahi Shimbun, 1982. Artists included: Auerbach, Cragg, Flanagan, McLean, and Walker.

March 13–April 25, Serpentine Gallery and Institute of Contemporary Arts, London. *Eureka: Artists from Australia;* organized by Sue Grayson. Catalog: London: Institute of Contemporary Arts and Arts Council of Great Britain, 1982. Artists included: Booth and Parr.

March 14–June 21, Kunsthalle, Basel, and Museum Boymans–van Beuningen, Rotterdam. *12 Künstler aus Deutschland;* organized by Jean-Christophe Ammann. Catalog edited by Jean-Christophe Ammann and Margrit Suter. Artists included: Bömmels, Castelli, Dahn, Dokoupil, Fetting, and Salomé.

March 17–April 17, University Fine Arts Galleries, Florida State University, Tallahassee, Florida, and Metropolitan Museum and Art Centers, Coral Gables, Florida. *New New York;* organized by Albert Stewart. Catalog by Albert Stewart. Artists included: Amenoff, Basquiat, Deutsch, Fischl, Laemmle, and Longo.

March 21–May 2, Galleria Civica, Modena, Italy. *Transavanguardia: Italia/America;* organized by Achille Bonito Oliva. Catalog. Artists included: Chia, Clemente, Cucchi, De Maria, Paladino, Basquiat, Deutsch, Salle, Schnabel, and Zakanitch.

March 26–June 6, Museum of Contemporary Art, Chicago, and tour. *Contemporary Art from The Netherlands;* organized by John Hallmark Neff. Catalog: Amsterdam: Visual Arts Office for Abroad of the Netherlands Ministry for Cultural Affairs, Recreation and Social Welfare, 1982. Artists included: Commandeur and Freijmuth.

April–July, Mura Aureliane da Porta Metronia a Porta Latina, Rome. *Avanguardia/Transavanguardia;* organized by Achille Bonito Oliva. Catalog: Milan: Electa, 1982. Artists included: Baselitz, Basquiat, Borofsky, Chia, Clemente, Cucchi, De Maria, Disler, van Elk, Fabro, Kiefer, Kirkeby, Immendorff, Longobardi, Lüpertz, Paladino, Paolini, Penck, Polke, Richter, Salle, and Schnabel.

April 2–June 20, The Solomon R. Guggenheim Museum, New York. *Italian Art Now: An American Perspective;* organized by Diane Waldman. Catalog by Diane Waldman; New York: Solomon R. Guggenheim Foundation, 1982. Artists included: Chia, Cucchi, Longobardi, Penone, and Zorio.

April 9–July 11, Stedelijk Museum, Amsterdam. *'60–'80: Attitudes/Concepts/Images;* organized by Edy de Wilde and Ad Petersen. Catalog: Amsterdam: Van Gennep, 1982. Artists included: Armando, Chia, Cucchi, van Elk, Fabro, Jenney, Kiefer, Paolini, Penone, Raetz, Richter, Schnabel, and Verkerk.

April 25–June 13, Walker Art Center, Minneapolis, Minnesota. *Eight Artists: The Anxious Edge;* organized by Lisa Lyons. Catalog by Lisa Lyons. Artists included: Borofsky, Burden, Longo, Salle, and Scanga.

Summer, Musée d'Art et d'Industrie, St.-Étienne, France. *Mythe, Drame, Tragédie;* organized by Jacques Beauffet and Bernard Ceysson. Catalog. Artists included: Alberola, Baselitz, Chia, Cucchi, Kiefer, LeBrun, Lüpertz, and Penck.

June 4–July 17, Galerie Nächst St. Stephan, Vienna. *Neue Skulptur;* organized by Rosemarie Schwarzwaelder. Catalog. Artists included: Adrian X, Bömmels, Chaimowicz, Cragg, Dokoupil, Fischli, Immendorff, Lavier, Paladino, Schmalix, Stimm, and Woodrow.

June 9–July 25, Kunsthalle, Bern, and Musée Savoisien, Chambéry, France. *Leçons de Choses: Sachkunde;* organized by Jean-Hubert Martin. Catalog edited by Jean-Hubert Martin. Artists included: Cragg, Lavier, Saytour, and Woodrow.

July 11–September 12, Kunstmuseum, Lucerne. *Englische Plastik Heute, British Sculpture Now;* organized by Martin Kunz. Catalog edited by Martin Kunz. Artists included: Cragg, Cox, Deacon, Kapoor, and Woodrow.

September 29–November 12, Musée Cantonal des Beaux-Arts, Lausanne. *Berlin, La Rage de Peindre.* Catalog by Erika Billeter. Artists included: Fetting, Hödicke, Koberling, Lüpertz, Middendorf, and Salomé.

October 7–December 5, Nationalgalerie, Berlin. *Kunst wird Material;* organized by Dieter Honisch, Michael Pauseback, and Britta Schmitz. Catalog. Artists included: Abakanowicz, Cragg, and Ruthenbeck.

October 8–November 14, Kunstverein, Munich, and tour. *Gefühl & Härte: Neue Kunst aus Berlin;* organized by Ursula Prinz. Catalog edited by Ursula Prinz and Wolfgang Jean Stock; Berlin: Frölich & Kaufmann, 1982. Artists included: Fetting, Middendorf, Salomé, and Zimmer.

October 12–January 9, 1983, Hayward Gallery and Institute for Contemporary Arts, London. *Arte Italiana, 1960–1982;* organized by the Comune di Milano. Catalog: London: Arts Council of Great Britain, 1982. Artists included: Clemente, Paladino, Paolini, and Zorio.

October 14–December 28, Institute of Contemporary Arts, London, *ICA:NY, A Season of New Work from New York at the ICA.* Catalog: *Brand New York: A Literary Review Special Issue.* London: Namara Press, 1982. Artists included: Longo.

October 15–January 15, 1983, Martin-Gropius-Bau, Berlin, *Zeitgeist;* organized by Christos M. Joachimides and Norman Rosenthal. Catalog: Berlin: Frölich & Kaufmann, 1982. Artists included: Baselitz, Bömmels, Bohatsch, Borofsky, Chia, Clemente, Cucchi, Dahn, Dokoupil, Fetting, Flanagan, Hödicke, Immendorff, Kiefer, Kirkeby, Koberling, LeBrun, Lüpertz, McLean, Morley, Paladino, Penck, Polke, Rothenberg, Salle, Salomé, and Schnabel.

October 31–December 12, ASART, Galleria Nazionale d'Arte Moderna, San Marino. *La Giovane Transavanguardia Tedesca;* organized by Achille Bonito Oliva. Catalog. Artists included: Bömmels, Dahn, Dokoupil, Fetting, Middendorf, Salomé, and Zimmer.

November 26–January 23, 1983, Kestner-Gesellschaft, Hannover, West Germany. *New York Now.* Catalog edited by Carl Haenlein. Artists included: Africano, Basquiat, Borofsky, Bosman, Brauntuch, Chase, Garet, Kushner, MacConnel, Pfaff, Salle, Schnabel, and Smyth.

December 3–January 23, 1983, Milwaukee Art Museum, Milwaukee, Wisconsin. *New Figuration in America;* organized by Russell Bowman. Catalog text by Russell Bowman and Peter Schjeldahl. Artists included: Africano, Borofsky, Bosman, Brauntuch, Fischl, Garet, Longo, Morley, Salle, and Schnabel.

December 8–January 30, 1983, Institute of Contemporary Art, University of Pennsylvania, Philadelphia. *Image Scavengers: Painting;* organized by Janet Kardon. Catalog by Janet Kardon. Artists included: Bosman, Goldstein, Longo, and Salle.

1983

Ateneumin Taidemuseo, Helsinki, Finland. *Ars 83 Helsinki;* organized by Leena Peltola and Tuula Arkio. Catalog. Artists included: Abakanowicz, Anselmo, Baselitz, Berthot, Borofsky, Chia, Clemente, Cragg, De Maria, van Elk, Flanagan, Hunt, Kiefer, Kirkeby, Le Gac, Lüpertz, Paladino, Penck, Rothenberg, Shapiro, and Willis.

National Gallery of Victoria, Melbourne. *Vox Pop: Into the Eighties.* Catalog by Robert Lindsay. Artists included: Booth and Boston.

January 22–March 30, Museo Civico d'Arte Contemporanea, Gibellina, Italy. *Tema Celeste;* organized by Demetrio Paparoni. Catalog. Artists included: Chia, Cragg, Cucchi, De Maria, Flanagan, Kapoor, Kiefer, Koberling, Lavier, LeBrun, Middendorf, Paladino, Penck, Schmalix, Woodrow, Zimmer, and Zorio.

March 15–May 14, Tel-Aviv Museum, Tel-Aviv, Israel. *New Painting from Germany;* organized by Nehama Guralnik. Catalog. Artists included: Baselitz, Fetting, Hödicke, Immendorff, Koberling, Lüpertz, Middendorf, Penck, Polke, Salomé, and Zimmer.

May 13–June 22, Rotterdam. *Beelden 1983; Sculpture 1983;* organized by Cees van der Geer. Catalog: Rotterdam: Rotterdamse Kunststichting, 1983. Artists included: Cragg, Kapoor, Lavier, Saytour, Vermeiren, and Woodrow.

May 29–July 31, Kunstmuseum, Lucerne, and tour. *Back to the USA: Amerikanische Kunst der Siebziger und Achtziger;* organized by Klaus Honnef and Barbara Kückels. Catalog by Klaus Honnef; Cologne: Rheinland-Verlag, 1983. Artists included: Africano, Basquiat, Borofsky, Bosman, Brauntuch, Chase, Fischl, Garet, Goldstein, Jenney, Juarez, Kushner, Longo, MacConnel, Otterness, Pfaff, Rothenberg, Salle, Schnabel, Shapiro, Smyth, and Zakanitch.

August 13–October 9, Hayward Gallery and Serpentine Gallery, London. *The Sculpture Show: Fifty Sculptors at the Serpentine and the South Bank;* selected by Paul de Monchaux, Fenella Crichton, and Kate Blacker. Catalog: London: Arts Council of Great Britain, 1983. Artists included: Cox, Cragg, Fisher, Gormley, Kapoor, Nash, and Woodrow.

September 14–October 23, The Tate Gallery, London. *New Art at the Tate Gallery, 1983.* Catalog by Michael Compton. Artists included: Armajani, Baselitz, Basquiat, Borofsky, Brauntuch, Chia, Clemente, Cox, Cragg, Cucchi, Dahn, Deacon, Disler, Dokoupil, Fabro, Fetting, Flanagan, Goldstein, Gormley, Immendorff, Jenney, Kapoor, Kiefer, Lavier, LeBrun, Longo, Lüpertz, McLean, Morley, Otterness, Paladino, Paolini, Penck, Penone, Pfaff, Polke, Salle, Schmalix, Schnabel, Walker, Winter, and Woodrow.

September 21–November 20, Städtische Galerie im Lenbachhaus, Munich. *Aktuell '83: Kunst aus Mailand, München, Wien und Zürich.* Catalog edited by Armin Zweite. Artists included: Disler, Fischli/Weiss, Paladino, Schmalix, and Stimm.

October 11–December 1, Palacio de Velázquez, Madrid. *Tendencias en Nueva York;* organized by Carmen Giménez. Catalog: Madrid: Ministerio de Cultura, 1983. Artists included: Fischl, Hunt, Jensen, Moskowitz, Rothenberg, Salle, Schnabel, and Sultan.

October 14–December 18, Bienal de São Paulo, and tour. *Transformations: New Sculpture from Britain;* organized by Teresa Gleadowe. Catalog: London: British Council, 1983. Artists included: Cragg, Deacon, Gormley, Kapoor, and Woodrow.

December 9–January 22, 1984, Museum Folkwang, Essen. *Werke aus der Sammlung FER.* Catalog by Christel Sauer: *Die Sammlung FER–The FER Collection;* Cologne: Gerd de Vries, 1983. Artists included: Anselmo, Bömmels, Chia, Clemente, Cucchi, Dahn, De Maria, Disler, Dokoupil, Fabro, Kiefer, and Paolini.

1984

January 19–March 15, Hôtel-de-Ville, Paris. *France: Une Nouvelle Génération.* Catalog introduction by Catherine Millet. Artists included: Alberola, Blais, and Giorda.

March 21–June 17, Whitney Museum of American Art, New York. *Five Painters in New York.* Catalog by Richard Armstrong and Richard Marshall. Artists included: Jensen, Murray, and Stephan.

April 15–June 10, P.S. 1 (Project Studios One), Long Island City, New York, and tour. *An Australian Accent: Three Artists;* organized by John Kaldor. Catalog. Artist included: Parr.

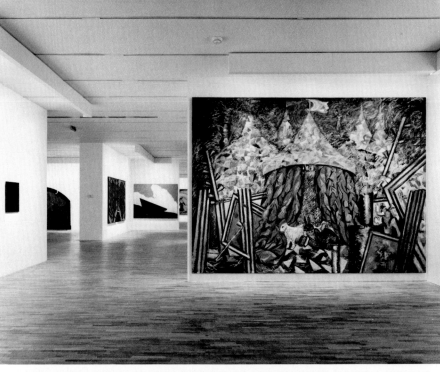

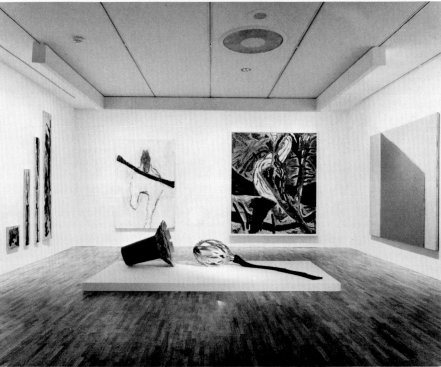

Installation views of
An International Survey of Recent Painting and Sculpture
in the Museum's new
International Council Galleries

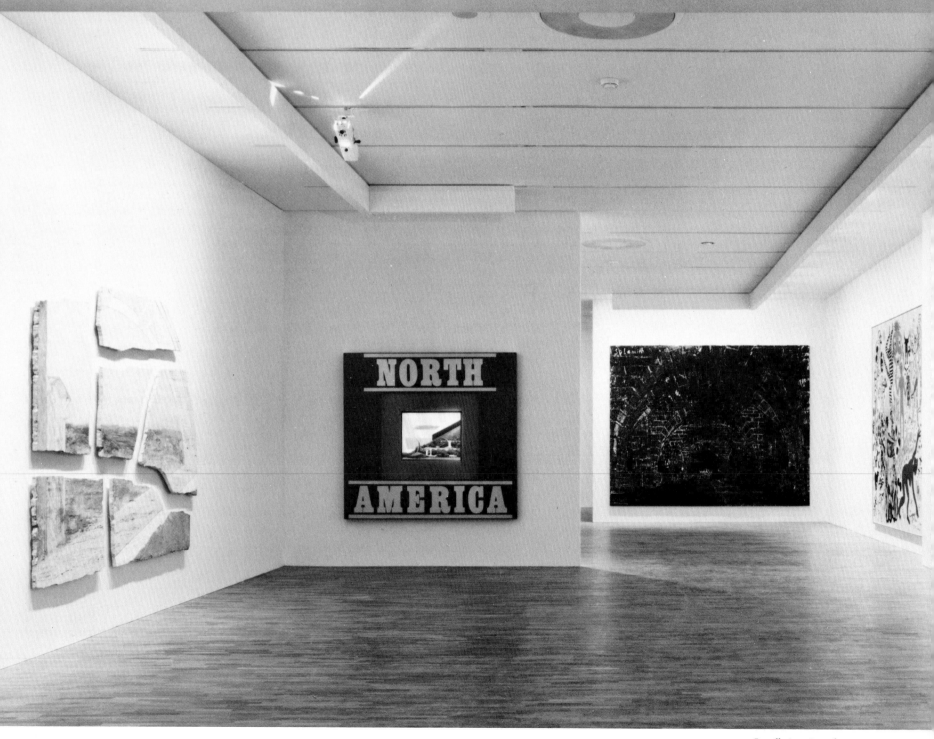

NORTH

AMERICA

Installation view of
An International Survey of Recent Painting and Sculpture
continued in the Museum's
René d'Harnoncourt Galleries

ACKNOWLEDGMENTS

The exhibition and its accompanying publication could not have been realized without the support, enthusiasm, and generosity of a great many people. On behalf of the trustees of The Museum of Modern Art I wish to express gratitude to all who have participated in their preparation. The greatest contribution is that of the artists, without whom there would be neither exhibition nor book. Particular thanks are due them, as well as the lenders to the exhibition, who graciously consented to share their works with us on this occasion. ◆ *An International Survey of Recent Painting and Sculpture* is, appropriately, the first exhibition to occupy the Museum's new International Council Galleries. Since its inception, The International Council of The Museum of Modern Art has been a major force in the circulation of exhibitions outside the United States and in furthering other international activities of the Museum. I would like to thank Prinz Franz von Bayern, Chairman, Mrs. Alfred R. Stern, President, and the other members of The International Council for their cooperation and assistance in organizing this exhibition.

The support of AT&T has been most generous. My personal thanks go to Charles L. Brown, Chairman of the Board and Chief Executive Officer, along with Edward M. Block, Vice President for Public Relations, and James L. Brunson, Corporate Vice President for Public Relations. Mary Delle Stelzer and Jacquelyn R. Byrne of AT&T have been particularly helpful. I also gratefully acknowledge the contribution of the National Endowment for the Arts, which has given strong support to contemporary artists and to exhibitions of contemporary art over the years.

Many colleagues at The Museum of Modern Art have given their support. Foremost among them is Monique Beudert of the Department of Painting and Sculpture. Her unflagging enthusiasm, her thoroughness, and above all her considered judgment have enriched both exhibition and catalogue immeasurably. I am deeply indebted to her.

Richard E. Oldenburg, Director of the Museum, and William Rubin, Director of the Department of Painting and Sculpture, have lent encouragement throughout the months this exhibition has been in preparation. John Limpert, Jr., Director of Development, deserves special thanks for his efforts in helping make an idea a reality.

In the Department of Painting and Sculpture, particular thanks are due Katherine Chabla, who handled the voluminous correspondence and many related tasks for this exhibition. Aurel Scheibler and Matthew Armstrong have assisted in the realization of this project in many ways, and I wish to thank them both.

A particular debt is owed the Department of Publications for producing this volume. I especially acknowledge the contribution of Harriet Schoenholz Bee, who edited the book and guided it through all the phases of its production. Stephen Doyle and Thomas Kluepfel provided an appropriately lively design for it and for the exhibition graphics. Nan Jernigan and Timothy McDonough oversaw the printing and production with patience and skill. Frederic McCabe, Director of the Department, was always helpful. Daniel Starr, of the Museum's Library, prepared the extensive and informative documentation, an invaluable contribution for which I thank him.

Richard L. Palmer, the Museum's Coordinator of Exhibitions, has shown his customary patience and commitment during the preparation of the exhibition. I am grateful to Jerome Neuner for his untiring attention to detail in the installation of the exhibition in the new galleries. Special thanks are owed the Department of the Registrar, particularly Kathy Hill, who admirably coped with the various challenges of assembly and disassembly. I am also grateful to Bruce Dow, Eliza Rand, and James Thomas.

The Conservation Department has manifested its usual professionalism during the installation of the exhibition, extending advice and assistance as needed.

The Department of Film is to be thanked for organizing exhibitions of films and videotapes to be presented in conjunction with the exhibition. These programs are being presented in the Roy and Niuta Titus Auditorium and in the Video Gallery of the Museum.

Many other members of the Museum's staff have contributed in various ways. I would like to thank Mikki Carpenter, Virginia Regan Coleman, Luisa Kreisberg, Carolyn Lanchner, Waldo Rasmussen, Richard Tooke, Beverly Wolff, and Sharon Zane.

Many friends and museum colleagues in this country and abroad have been generous in offering hospitality, information, and insights. I must thank the Australian Council, Visual Arts Board of Australia, and Mrs. John D. Lewis and Nick Waterlow for their assistance during the preparation of this exhibition.

For their valued assistance, I also wish to thank Pierre Apraxine, Artists Space, Glen Baxter, Michael Boodro, Hugh Davies, Donald Droll, Julia Ernst, Michael Findlay, Jane Fluegel, the late Emil Forman, Gabriella Forte, Christopher Gibbs, Anne d'Harnoncourt, Bruce Le Compte, Helen McEachrane, Thordis Moeller, James Mollison, Bernice Murphy, George Sadek and The Cooper Union Center for Design and Typography, Neil Selkirk, John Stringer, Daniel Thomas, Ragland Watkins, White Columns, and William Wright. I warmly acknowledge their contributions. K. McS.

Lenders to the Exhibition

Neue Galerie–Sammlung Ludwig, Aachen, West Germany
Stedelijk Museum, Amsterdam, Netherlands
Addison Gallery of American Art, Phillips Academy, Andover, Massachusetts
The Art Institute of Chicago, Chicago, Illinois
The University of Chicago, Chicago, Illinois
The Corning Museum of Glass, Corning, New York
Museum Folkwang, Essen, West Germany
Hood Museum of Art, Dartmouth College, Hanover, New Hampshire
Arts Council of Great Britain, London
The Tate Gallery, London
Los Angeles County Museum of Art, Los Angeles, California
National Gallery of Victoria, Melbourne, Australia
Walker Art Center, Minneapolis, Minnesota
The Solomon R. Guggenheim Museum, New York
The Metropolitan Museum of Art, New York
Rijksmuseum Kröller-Müller, Otterlo, Netherlands
Philadelphia Museum of Art, Philadelphia, Pennsylvania
Art Gallery of New South Wales, Sydney, Australia
Musée de Toulon, Toulon, France
Hochschule für Angewandte Kunst, Vienna, Austria
Museum Moderner Kunst, Vienna, Austria
Kunsthaus, Zurich, Switzerland
Crex Collection

Anne Abrons and David Sharpe
Mac Adams
Thomas Ammann, Zurich, Switzerland
Giovanni Anselmo
Ida Applebroog
Armando
Angelo Baldassare, Bari, Italy
Banque Paribas Nederland, N.V.
Marlene and Robert Baumgarten
H. E. Berg
Jake Berthot
Drs. A. Bitterman, Amsterdam, Netherlands
Barry Blinderman
Peter Bömmels
Jeanette Bonnier, New York
The Edward R. Broida Trust, Los Angeles, California
Phillip A. Bruno, New York
Eddo and Maggie Bult
Miriam Cahn
The Chase Manhattan Bank, N.A.
Lewis Zachary Cohen
Charles Cowles
Douglas S. Cramer, Los Angeles, California

Dia Art Foundation, New York
Antonio Dias
Gerald S. Elliott
Rodolphe d'Erlanger
FER Collection, Laupheim, West Germany
R. M. Fischer
Peter Fischli
Marsha Fogel
M and Mme Gilles Fuchs
William Garbe
General Cinema Corporation, Chestnut Hill, Massachusetts
General Electric Corporate Art Collection
Steve Gianakos
André Goeminne, Nazareth, Belgium
Arthur and Carol Goldberg
Jack Goldstein
Toni Grand
Graham Gund
Mr. and Mrs. Harvey J. Gushner
Gabriele Henkel
Tibor and Bente Hirsch, New York
K. H. Hödicke
Nancy Hoffman, New York
William J. Hokin, Chicago, Illinois
Mr. and Mrs. Morton J. Hornick
Hospital Corporation of America
Oliver Jackson
Neil Jenney
Nicole Jullien
Carole and Beldon Katleman
Jon Kessler
Kim Kingston
Cheryl Laemmle
Sydney and Frances Lewis
Loretta and Robert K. Lifton
Barry Lowen, Los Angeles, California
Marilyn Oshman Lubetkin, Houston, Texas
Peter Lüchau
Donald B. Marron
Marx Collection, Berlin
Metzger Collection
Robert Miller
Blake Nevius
Mr. and Mrs. Roy O'Connor, Houston, Texas
Gustavo Ojeda
Paine Webber, Inc., New York
Mike Parr
Judy Pfaff
Happy Price
Martin Puryear
Mrs. Samuel P. Reed
John Richardson, New York
Frederik Roos
Mera and Donald Rubell
Mr. and Mrs. Howard Rubenstein
Doris and Charles Saatchi, London
Sanders, Amsterdam, Netherlands
Patrick Saytour
Italo Scanga

Michael H. Schwartz, Philadelphia, Pennsylvania
Helmut Seiler, West Germany
Martin Sklar
Ned Smyth
Roland Soriano, Neuchâtel, Switzerland
Dr. Carlo de Stefani, Vittorio, Veneto, Italy
Marc Straus, Livia Straus, and Jeffrey Ambinder
Hardwin Tibbs
Unity Savings and Loan, West Hollywood, California
Vandrés
Viallat Family
Darío Villalba
Anders Wall, Stockholm, Sweden
David Weiss
Eighteen anonymous lenders

Salvatore Ala Gallery, New York
Brooke Alexander, Inc., New York
Galleria Lucio Amelio, Naples, Italy
Art & Project, Amsterdam, Netherlands
Jean Bernier Gallery, Athens, Greece
Galerie Beyeler, Basel, Switzerland
Galerie Bruno Bischofberger, Zurich, Switzerland
Mary Boone Gallery, New York
Grace Borgenicht Gallery, New York
Hal Bromm Gallery, New York
Paula Cooper Gallery, New York
Galerie Eric Fabre, Paris
Ronald Feldman Fine Arts, New York
Galleria Ugo Ferranti, Rome
Galerie Gmyrek, Düsseldorf, West Germany
Marian Goodman Gallery, New York
Nigel Greenwood Inc. Ltd., London
Galerie Max Hetzler, Cologne, West Germany
Ray Hughes Gallery, Brisbane, Australia
Max Hutchinson Gallery, New York
Galerie Krinzinger, Innsbruck, Austria
Carmen Lamanna Gallery, Toronto, Canada
Marlborough Fine Art, Ltd., London
Galerie Paul Maenz, Cologne, West Germany
Studio Marconi, Milan, Italy
David McKee Gallery, New York
Metro Pictures, New York
Galerie Nächst St. Stephan, Vienna, Austria
Galerie Alice Pauli, Lausanne, Switzerland
Staempfli Gallery, New York
Micheline Szwajcer Gallery, Antwerp, Belgium
Galerie Daniel Templon, Paris
Galerie Michael Werner, Cologne, West Germany

Photograph Credits

The photographs used in this book, for the most part, have been made available by the artists or the owners of the works of art. In addition, acknowledgment is made of the following photographers and sources:

David Allison, New York, 130 bottom, 131 bottom, 220 top, 221 top, 239, 359, 360–361; William H. Bengston, Chicago, 68, 242, 243; Larry Bercow, New York, 168 top, 169, 303 top, 303 bottom left; Jacob Burckhardt, New York, 173 left top and bottom, 250 top; Jeff Busby, Melbourne, 64, 65; Mimmo Capone, Rome, 52 bottom right, 53 left; Geoffrey Clements, New York, 60 top right, 60 bottom right, 61 right, 175, 224, 225 top, 288 top, 289 bottom left; Ken Cohen, 158 bottom; Prudence Cuming Associates, Ltd., London, 42, 43, 75, 134 left, 135; Kevin Cummings, 153 top left; Bevan Davies, New York, 73 top, 99 bottom, 122 bottom left, 123 bottom right, 223 top left, 254 bottom, 273 bottom, 282 top right, 282 bottom right, 305 top right; D. James Dee, New York, 23 top, 35 bottom, 49, 70, 71, 108, 109 top, 151 bottom, 192 top, 193 top left and right, 196 bottom, 204 top, 210 bottom left, 251 right; Delahaye, 154 bottom; Michael Denny, Friend & Denny, New York, 210 top left; Jean Dieuzaide, 155; Roy M. Elkind, 165, 268 top right, 268 bottom left and right, 269; Gea Evangelisti, Naples, 206 top left, 206 bottom; Eyris Productions, 251 left; M. Lee Fatherree, Berkeley, 170, 171; Allan Finkelman, New York, 295 bottom right, 322 bottom, 323; Rick Gardner Photography, Houston, 146 right top and bottom, 147 left top and bottom; Roger Gass, 164 bottom left; Phillippe de Gobert, Brussels, 199 left; Bill Gordy, 16 top left, 16 bottom; Carmelo Guadagno and David Heald, 206 top right, 207 bottom; Vincent van Haaren, Amsterdam, 92; Tom Haartsen, Amsterdam, 136, 137, 214 top, 310 right, 311 left; Greg Heins, Newton Center, Massachusetts, 30 bottom right, 321 bottom; Fenn Hinchcliffe, 241 bottom; Eeva Inkeri, New York, 30 bottom left, 34 top, 62 left, 84, 85, 140, 141, 142, 225 bottom, 288 bottom, 289 top, 320 left, 321 top, 332 top right, 332 bottom, 333 right; Bernd Jansen, Düsseldorf, 335; Bruce C. Jones, Rocky Point, New York, 118, 119, 147 bottom right; Kate Keller, New York, 22 top, 73 bottom, 195 top, 212 right, 213, 233 bottom, 318 top; Jennifer Kotter, New York, 192 bottom right; Julius Kozlowski, New York, 30 top left; Fritz Krinzinger, Innsbruck, 298 top; J. P. Kuhn, Zurich, 252 bottom, 253; François Lagarde, Paris, 154 top, 276 right; Nanda Lannfranco, Genoa, 247; J. Littkemann, Berlin, 38 right, 39, 81, 160 top, 190, 191 top, 208 top left, 218 top right, 218 bottom, 219 top; Ingeborg Lommatzsch, Berlin, 19 bottom left; Robert E. Mates, New York, 51 right, 254 top and center; Eric Mitchell, Philadelphia, 77; André Morain, Paris, 24 bottom left, 25, 52 top, 202, 203; Al Mozell, New York, 134 right; Service Photographique du Musée d'Art Moderne, Paris, 252 top; Kevin Noble, New York, 67 top left, center, and right, 126 bottom, 150 bottom left; Jon Nordhal, 15 top; Pelka/Noble, New York, 127, 204 bottom, 205 bottom,

279 top left, 340 right; Georges Poncet, Asnieres, 149; Eric Pollitzer, New York, 62 right, 63, 172 top, 174 bottom, 175, 229 top, 233 top right, 294, 295 top, 320 right, 324, 325; Adam Reich, New York, 143 bottom, 231 bottom left, 231 right; F. Rosenstiel, Cologne, 166 top right, 208 top right, 209 top left; Phillipp Schönborn, Munich, 110 top; Saporetti, Milan, 110 bottom, 111; Sylvia Sarner, New York, 143 top, 212 left; Paolo Mussat Sartor, Turin, 32 top right, 32 bottom, 33, 246 left top and bottom; Aurel Scheibler, Cologne, 233 top left; Harry Shunk, New York, 195 bottom left, 236–237; Eric Sigg, Lausanne, 262; Steven Sloman, New York, 30 top right, 31, 50, 176, 177 top left, 177 bottom, 255; A. Starewicz, Warsaw, 15 bottom; Ivan Dalla Tana, 228, 229 bottom; Jerry L. Thompson, New York, 289 bottom right, 300 left, 301; Steven Tucker, 106 left top and bottom, 107; Eileen Tweedy, London, 94; John Webb, Surrey, England, 286 top; Angelika Weidling, Berlin, 38 left; Greg Weight, 241 top; Neil Winokur, 282 top left; Dorothy Zeidman, New York, 256 top left, center, and right, 257; Alan Zindman, New York, 223 right, 283, 306 bottom; Zindman/Fremont, New York, 66, 67 bottom, 88 right bottom, 98 bottom, 128 bottom left, 129 top, 272, 296 left, 297, 306 top left, 328 top left and right, 329 top.

Salvatore Ala Gallery, New York, 246, 247; Brooke Alexander, Inc., New York, 228, 229, 232, 233 top right; Art & Project, Amsterdam, 311 left; Baskerville & Watson Gallery, New York, 126 top left and right; Galerie Bellman, New York, 184, 185; Blum Helman Gallery, New York, 164 top, 165, 222, 266, 267, 300, 301; Mary Boone Gallery, New York, 128 bottom left, 129 top, 244 top right, 272, 273 bottom, 282 top left and right, 282 bottom left, 283, 296 left, 297; Grace Borgenicht Gallery, New York, 168, 169 bottom, 302 bottom, 303 top, 303 bottom left; Byrd Hoffman Foundation, New York, 326, 327; Paula Cooper Gallery, New York, 224 top left and right, 224 bottom right, 225 top, 288, 289; James Corcoran Gallery, Los Angeles, 256 bottom left; Charles Cowles Gallery, New York, 26 top left and right, 27; Delahunty Gallery, New York and Dallas, 279 top left; Archives Denise Durand-Ruel, 198, 199 right; Galerie Eric Fabre, Paris, 154, 155, 276, 277; Ronald Feldman Fine Arts, New York, 34, 192 top, 193 top left and right; Fischer Fine Art, Ltd., London, 75; Xavier Fourcade, New York, 221 bottom; Librarie Jean Fournier, Paris, 314 top left, 314 bottom, 315; Frumkin Gallery, New York, 320 left, 321 top; Tracey Garet Gallery, New York, 231; Galerie Gmyrek, Düsseldorf, 218 top right, 219 top; Nigel Greenwood Inc. Ltd., London, 83 bottom, 200, 201; Ray Hughes Gallery, Brisbane, 29 bottom; Max Hutchinson Gallery New York, 294 top, 295 top, 295 bottom left; Phyllis Kind Gallery, Chicago, 68 top; Knoedler Gallery, New York, 158, 159; Galerie Krinzinger, Innsbruck, 280, 281 top, 281 bottom left; Galerie Yvon Lambert, Paris, 44, 45, 53 right; Lisson Gallery, London, 103 bottom, 180, 181 top;

Los Angeles County Museum of Art, Los Angeles, 256 bottom left; David McKee Gallery, New York, 50, 51 left, 254 top and center, 255; Metro Pictures, New York, 150 bottom left, 151, 204, 205 bottom, 340, 341; Robert Miller Gallery, New York, 30 top left, 30 bottom left and right, 31, 332 bottom; Galerie Nächst St. Stephan, Vienna, 298 bottom; New City Editions, Venice, California, 48 bottom right; Oscarsson Hood Gallery, New York, 322, 323; P. G. Berlinische Galerie, 275 right; Max Protetch Gallery, New York, 37 top, 72 top, 73 top; Sable-Castelli Gallery, Ltd., Toronto, 304 top left and right; Schellman & Kluser, Munich, 235; Galerie Six Friedrich, Munich, 284 top, 285; Holly Solomon Gallery, New York, 23 bottom, 195 bottom left, 210 bottom left, 211, 250, 251 left, 292 top right, 293; Sonnabend Gallery, New York, 328, 329 top; Sperone Westwater Gallery, New York, 86, 87, 88 left; Staempfli Gallery, New York, 212 left; Galerie Pablo Stähli, Zurich, 130 top, 131 top and right; Stedelijk Museum, Amsterdam, 162, 163; Walker Art Center, Minneapolis, 279 top right; Galerie Michael Werner, Cologne, 47 top left and right; 188 top, 188 bottom left, 209 bottom left, 209 right; Whitechapel Art Gallery, London, 47 bottom, 220 bottom, 305; Donald Young Gallery, Chicago, 258 top left and right.